11·15

THE SUPERMODEL
AND THE BRILLO BOX

THE SUPERMODEL
AND THE BRILLO BOX

BACK STORIES AND PECULIAR ECONOMICS
FROM THE WORLD OF CONTEMPORARY ART

DON THOMPSON

From the author of

The $12 Million Stuffed Shark:
The Curious Economics of Contemporary Art

palgrave
macmillan

First published in 2014 by PALGRAVE MACMILLAN® in the United
States—a division of St. Martin's Press LLC, 175 Fifth Avenue, New York, NY
10010.

Where this book is distributed in the UK, Europe and the rest of the world,
this is by Palgrave Macmillan, a division of Macmillan Publishers Limited,
registered in England, company number 785998, of Houndmills, Basingstoke,
Hampshire RG21 6XS.

Palgrave Macmillan is the global academic imprint of the above companies and
has companies and representatives throughout the world.

Palgrave® and Macmillan® are registered trademarks in the United States, the
United Kingdom, Europe and other countries.

ISBN 978-1-137-27908-8

Library of Congress Cataloging-in-Publication Data

Thompson, Donald N.
 The supermodel and the Brillo box : back stories and peculiar economics
from the world of contemporary art / Don Thompson.
 pages cm
 Includes bibliographical references.
 ISBN 978-1-137-27908-8 (alk. paper)
 1. Art, Modern—21st century—Economic aspects. 2. Art—Marketing—
History—21st century. 3. Art—Collectors and collecting—Psychology. I. Title.
N6490.T528 2014
 709.05—dc23
 2013036143

A catalogue record of the book is available from the British Library.

Design by Letra Libre, Inc.

First edition: May 2014

10 9 8 7 6 5 4 3 2 1

Printed in the United States of America.

CONTENTS

STEPHANIE

NEW YORK. On Monday, November 8, 2010, at 6:43 pm, at the brand new auction headquarters of Phillips de Pury at 450 Park Avenue, auctioneer Simon de Pury hammered down lot 12. This was a lifelike, nude waxwork of former actress and supermodel Stephanie Seymour. Designed to be mounted on the wall like a deer's head, it is titled *Stephanie* but known in the art world as *Trophy Wife.* The sculpture turns the representation of Seymour into a literal trophy, her nude upper body arching from the wall, breasts covered not very discreetly with her hands (illustrated in center section).

The sculpture, one of four identical versions conceived by Italian artist Maurizio Cattelan, was expected to bring between $1.5 and $2.5 million. De Pury predicted it might go as high as $4 million. After nine bids from six bidders—two of those bidding on the telephone—it sold in 40 seconds for $2.4 million, including buyer's premium (the additional amount charged by the auction house, above the hammer price). The successful bidder was New York über collector and private dealer Jose Mugrabi.

The very highest levels of the contemporary art world are brand- and event-driven. But over the history of marketing contemporary art, the fall 2010 Phillips auction stands out for its mix of brand, event, celebrity, back story, and astonishing prices. The presentation of *Stephanie,* and the

logic behind the auction of which it was a part, is a wonderful example of marketing high-end contemporary art.

Phillips de Pury is a medium-size art auctioneer operating primarily in New York and London. In celebrity quotient and prestige, Phillips runs a distant third to Christie's and Sotheby's, with about a tenth the annual dollar turnover of either. Those two auction houses sell almost 90 percent of all contemporary art over $2 million. Phillips wanted a greater share of this high value, much more profitable segment. The cost of gaining the consignment and promoting a $2 million work may be twice that of a $200,000 work, but the profit after expenses is five to ten times as large. Those consigning at an exalted price level generally prefer to do business with Christie's and Sotheby's, the assumption being that these houses will produce higher bids.

After a mediocre 2010 New York spring sale in which only one work sold at over $1 million, Phillips's strategic problem was how to create buzz for their fall contemporary art auction. Their expensively renovated new auction room on Park Avenue provided the setting.

Simon de Pury, as chairman and also chief auctioneer of Phillips, created what he called a Carte Blanche auction. He asked Philippe Ségalot to act as guest curator, just as a museum might invite an outsider to curate an exhibition. Ségalot was at one time the international head of contemporary art at Christie's, where he pioneered theme parties—one called Bubble Bash, another Think Pink—to attract younger buyers to the auction house. Later he became co-owner of the art advisory Giraud Pissarro Ségalot. Ségalot's major client is François Pinault, the French billionaire who controls the luxury brands Gucci, Balenciaga, and Stella McCartney—and also owns Christie's auction house. Pinault has a $2 billion collection of art by Jeff Koons, Damien Hirst, Cindy Sherman, and Richard Serra, and older works by Picasso, Braque, and Mondrian.

Ségalot was given freedom to choose the art for the Phillips auction and stage the sale of his dreams, with no interference from de Pury; he described it as "a self-portrait of my own taste." He assembled 33 works, with a total value estimated between $80 and $110 million (all figures US dollars). None of the 33 came from Phillips's regular auction consignors. Three came directly from artists and some from Ségalot's own collection. A few were owned by his private clients, as reported in *The Economist*: two from Pinault, one of which was *Stephanie*. The idea that the owner of Christie's would consign work to another auction house raised eyebrows.

A half dozen of the works were chosen for their newsworthiness. This usually means a branded artist or controversial subject. With *Stephanie,* it meant both. *Stephanie* was not the most expensive work, but it was the one featured in advertisements and on the cover of the auction catalog.

Phillips was founded in London by Harry Phillips in 1796. Bernard Arnault and his luxury goods firm LVMH acquired the firm in 1999 for a reported $120 million. A year later Arnault brought in art dealers Simon de Pury and Daniella Luxembourg to run the company and to challenge the dominant pairing of Christie's and Sotheby's. LVMH's strategy floundered among overly generous guarantees (that a targeted auction price would be achieved) given to consignors to attract auction lots. Arnault sold control to de Pury and Luxembourg in two tranches in 2002 and 2004. Luxembourg sold her share to de Pury in 2004. In 2008 de Pury sold a controlling share to Russian luxury goods group Mercury for $80 million, half of which reportedly went to paying down Phillips's bank overdraft. Two weeks after the Mercury purchase, the auction house bottomed-out, with a contemporary evening sale in London in which just 25 percent of the lots sold.

Simon de Pury generated more media attention than the auction house. For months before the auction he was familiar to television viewers as mentor and critic to aspiring artists in Bravo's *World of Art,* a "choose America's next great artist" TV reality show in which one artist was bounced each week until a winner (Abdi Farah) remained.

Under de Pury, Phillips contracted from a full-service auction house to a boutique, selling only contemporary art, design, jewelry, and photography. Sales went from $75 million to over $300 million in four years, reflecting the boom in contemporary art. Then came the 2008 crash. In 2009 Phillips's sales declined to $85 million, and the company bled red ink. Its reliance on contemporary art with its more volatile swings in sales volumes and price levels had left Phillips highly exposed.

However, with Carte Blanche and with Ségalot curating the sale, de Pury produced the most interesting innovation in art auctioneering in a decade. His first move was to time the sale to open the contemporary auction week, preceding the Christie's and Sotheby's sales.

Carte Blanche was an opportunity but also a huge risk. The $80 million minimum estimate for the 33 works represented almost as much as Phillips had sold in total in the first six months of 2010. To attract the works to Phillips rather than see them go to Christie's or Sotheby's, Ségalot and de Pury

gambled. They secured seven of the major pieces for the auction—including *Stephanie*—by guaranteeing a substantial minimum price to the consignors.

Five of the seven guarantees were provided by a third party, who was compensated by Phillips for assuming the risk. It was thought the third-party guarantor for most of these was the Mercury Group itself. The seven guarantees in total covered $65 million, at a cost to Phillips of probably between $4.5 and $6 million. I'll return to the subject of guarantees later in the book.

Ségalot received a percentage of the buyer's fees in compensation for his curatorial services (although the major benefit came with publicity of the event, which identified him as an important private dealer). Consigned works and payments went through his office rather than through Phillips so that the identity of sellers and some buyers remained hidden from the auction house. Ségalot further ensured anonymity by manning one of the auction phones himself, resulting in the oddity that having sourced work from his clients, he then bid on the same work on behalf of other clients. At the press conference following the auction, one reporter commented that he could have just eliminated the middleman, Phillips.

The cost of guarantees and the fee to Ségalot, together with heavy promotional costs, raised the break-even figure for the Carte Blanche auction to at least $95 million—almost twice Phillips's previous record for any single auction. Below a $95 million sales total, losses would have mounted quickly.

The other requirement was to generate high-level media coverage, ideally in *The New York Times* and *The Wall Street Journal*. Such auction world coverage normally goes primarily to the two major auction houses. The curated auction concept worked brilliantly; both papers previewed the event, with *The New York Times* offering a long article by art journalist Carol Vogel.

The Carte Blanche gamble paid off. The selling total, including buyer's premium, was $117 million, even with three works unsold. Following the auction, media stories praised de Pury's innovation and daring.

That describes the event; what about the back story to *Stephanie?* Former supermodel Stephanie Seymour, the center of Phillips's auction promotion, was at the time of the auction a 41-year-old veteran of 300 magazine covers, several *Sports Illustrated* swimsuit issues and Victoria's Secret catalogs, and two *Playboy* pictorials. Prior to her marriage to millionaire industrialist Peter Brant she had dated Axl Rose, lead singer of Guns N' Roses, and starred in their video *November Rain*. Before that she had had highly publicized

relationships with Charlie Sheen and Warren Beatty. In 1994 *People* magazine named her one of the 50 Most Beautiful People in the World. These and other facts were doled out in Phillips's press releases and in briefings to reporters, with the information that *Stephanie* would be featured on the cover of the auction catalog.

Her husband, Peter Brant, then 63, is a celebrity in his own right. He is chairman and CEO of White Birch Paper Company, one of the largest newsprint manufacturers in North America. He publishes the trade magazine *Art in America,* owns a polo team, and was for years the top-ranked amateur polo player in America. Brant was the executive producer (with PBS) of the 2006 Emmy Award–winning *Andy Warhol: A Documentary,* and of the films *Basquiat* (1996) and *Pollock* (2000). He had previously commissioned portraits of his wife by artists Julian Schnabel, Jeff Koons, and Richard Prince.

Brant is best known as an art collector. He has one of the world's largest collections of Andy Warhol and 2,000 other works of Abstract Expressionism, Pop, and contemporary art. This includes Jeff Koons's famous *Puppy,* a 13-meter tall, West Highland white terrier, executed in a variety of flowers, a companion work to one that had been displayed for six months at Rockefeller Center and outside the Bilbao Guggenheim.

Maurizio Cattelan, the then 53-year-old Italian artist and creator of *Trophy Wife,* provided another level of celebrity. In 2002 Cattelan and Ségalot visited the 53-acre Brant-Seymour estate in Greenwich, Connecticut. One wall in the library featured trophies of a gazelle and buffalo shot by Brant on a 1970 Kenya safari. Cattelan had the concept of creating for Brant a version of his wife that was like the gazelle, "hunted and mounted," the result, Cattelan said, of a "domestic safari."

Cattelan said he was afraid to broach the idea directly to Brant; he asked Ségalot to do it. Brant and Seymour agreed. Cattelan produced *Stephanie* in an edition of four: one for Brant, one for him, and two to be sold by dealers. Cattelan said the last two might first be offered for museum loan "so the world could share Brant's wife."

Stephanie is consistent with the body of Cattelan's work, which involves love, fear, or tragedy. His first high price at auction came in 2004 when *La Nona Hora,* a sculpture portraying Pope John Paul II struck down by a meteorite (illustrated), sold for $3 million. According to *The Economist,* Amy Cappellazzo of Christie's says that "It is a hallmark of bravery to own a Cattelan sculpture; it signals an ambitious collection."

Stephanie was not actually produced by Cattelan. As with many contemporary artists, Cattelan's work is produced by technicians. *Stephanie* was made by Parisian Daniel Druet, who uses the same technique employed for mannequins in wax museums. Cattelan's contribution was the concept.

Stephanie's back is arched, to match the neck of the gazelle. Brant said later that the work was not really intended as a trophy but rather like something the Greeks would have had on the front of a ship, an elegant woman's form arching from the prow of a sailing vessel, a way of displaying the status of the owner. Mouth color, glass eyes, and hair were added to the wax. The hair is almost waist-length, intended to be styled by the owner: formal, informal, or sexy. For the auction it was perfectly coiffed by celebrity New York stylist Frédéric Fekkai, who said, "We wanted to make her look like a goddess." The eyes have a catatonic gaze, thought to mimic a runway model. At the auction preview, those stopping before the sculpture were bemused or awed. Most made no comment.

A later, curious follow-on was the discovery that artist Urs Fischer had produced a companion, life-size paraffin figure of spouse Peter Brant, standing behind an armchair. Titled *Untitled (Standing)* (2010), it has 14 wicks extending from the paraffin. The owner can, if desired, turn the sculpture into a huge candle and Mr. Brant into a puddle of wax. Brant commissioned the work by Fischer without being told what would be produced. One of the edition of three surfaced at Christie's Post-War and Contemporary sale in New York in May 2012. It sold for $1.3 million.

Brant's fortune and art collection were at risk when Seymour filed for divorce in March 2009; the couple apparently had not done a prenuptial agreement before marrying in 1993. His wife's divorce petition claimed his worth as at least $500 million. In the midst of the divorce proceedings, Seymour revealed what else Brant might be giving up when she posed for the December 2009 issue of *Vanity Fair* wearing only a few drops of water. The magazine article, which included an account of the divorce proceedings, was also mentioned by Phillips's PR people.

In September 2010 Seymour and Brant suddenly called off the divorce. The sale of *Stephanie* proceeded. Brant, but not Seymour, attended the auction. He did not bid.

A jostling crowd of 660 attended the Phillips sale: 360 with numbered tickets, seated in the main auction hall; 150 standing; another 150 in a second hall, watching the proceedings on a television screen. Only 90 of the

660 had auction paddles, and only 32 bid. The others were there for the spectacle.

What else was offered at Carte Blanche? The most valuable work was Andy Warhol's 1962 *Men in Her Life*, estimated at $40 to $50 million and consigned by Jose Mugrabi, the same collector who purchased *Stephanie*. *Men in Her Life* is a two-meter-tall silk screen, highlighted with pencil, of pictures taken from a *Life* magazine feature on the then 26-year-old actress Elizabeth Taylor. The canvas has 38 blurred images of Taylor at the Epsom Derby, with Mike Todd, her third husband, at her left, and Eddie Fisher, soon-to-be number four, at her right. Beside Fisher is his then wife, actress Debbie Reynolds. The pictures are in seven rows, with varying intensity of reproduction. *Men in Her Life* has very low visual impact; it is hard to make out the images from more than 3 feet (1 m) away. There are four versions of the work.

Men in Her Life started at $32 million and was bid up in $1 million increments. It was hammered down at $63.4 million, becoming the second most expensive Warhol ever at auction (*Green Car Crash* brought $71 million at Christie's New York in 2007). Two telephone bidders dueled with $1 million increments over the final ten bids. The purchaser was thought to be the Qatari Royal Family. Even in an art world where the unexpected is routine, having the names of Taylor, Fisher, Reynolds, Warhol, and Qatar in the same paragraph attracted attention.

The great crowd pleaser was another conceptual work by Maurizio Cattelan, titled *Charlie* (illustrated). This is one of an edition of four, a remote-controlled version of Cattelan as a four-year-old child riding a tricycle. The boy moves his eyes in a cartoonish manner. *Charlie* is an example of what Cattelan dubbed his "mini-mes," his physical and emotional surrogates. The concept comes from the tricycle-riding boy in Stanley Kubrick's horror film *The Shining*.

As he was being auctioned, *Charlie* motored around the front of the auction hall, acknowledging bidders. Estimated at $2 to $4 million, *Charlie* sold for $2.99 million. After the gavel came down, de Pury said, "Thank you Charlie, you can leave us now." Charlie exited from the auction room, moving in reverse.

The most surprising of seven world-record prices at the auction came with Félix González-Torres's 1992 installation *Untitled (Portrait of Marcel Brient)*: 200 pounds (90 kg) of cellophane-wrapped candy, intended to be piled in the corner of a room and consumed by guests (similar work

illustrated). It was listed as "dimensions variable." Candy sculptures are González-Torres's signature work.

Untitled is one of only two works the artist did with blue candy. The story is that González-Torres was producing candy sculptures for dealer Xavier Hufkens in Brussels. To avoid shipping costs from his usual candy supplier in Chicago, he purchased from a local store. The blue candy is perceived as more valuable because of its rarity, and because it is the only work to bear a word on the original candy wrapper—PASSION. Estimated at $4 to $6 million, the installation sold for $4.4 million, far outpacing González-Torres's previous auction record of $1.65 million.

Takashi Murakami's 1997 *Miss ko2* (pronounced "ko-ko") is the first of the artist's large-scale sculptures of a character from the Japanese fantasy world and subculture of otaku, anime, and video games (illustrated in a different context). It represents the transformation of traditional cultures in Japan and around the world. *Miss ko2* is a 6-foot (1.8 m) tall fiberglass sculpture of a big-breasted cocktail waitress, a high-heeled secret agent character from a popular Japanese animated cartoon. *Miss ko2* is also one of an edition of four. Estimated at $4 to $6 million, it was hammered down to Jose Mugrabi for $6.8 million. Another from the edition sold for an earlier auction record for the artist of $567,000 at a 2003 Christie's New York auction. When it was first shown at Feature Gallery in New York in 1997, *Miss ko2* carried a list price of $19,500.

Paul McCarthy's 2005 *Mechanical Pig* was the great disappointment of the auction. She is life-sized, breathes rhythmically, and has pulleys to move her feet, tongue, and eyeballs. *Mechanical Pig* was estimated at $2.5 to $3.5 million but achieved a high bid of only $1.9 million, one bid short of the reserve price. *Mechanical Pig* went unsold.

Polite applause followed each fall of de Pury's gavel; more enthusiastic applause greeted each of the seven world record prices. Whether such applause is a response to the success of the artist, the skill of the auctioneer, or the daring of the successful bidder is never clear.

The sequel to this highly successful curated auction was—nothing. De Pury had announced this as the first of a planned annual series of auctions curated by art world luminaries. The widely held assumption was that in 2011 the curator would be artist Jeff Koons, who a year earlier had curated a New Museum exhibition of works from Dakis Joannou's collection, or even Peter Brant.

It didn't happen. Despite the success of the 2010 version of de Pury's concept, apparently neither Koons nor anyone else wanted to try and replicate what Ségalot had done. The 2011 and 2012 December sales reverted to being assembled and presented by de Pury.

In January 2013 de Pury and Phillips parted company, apparently over disagreements with the Russian owners. The auction house is now known just as Phillips.

Unresolved is why Jose Mugrabi or anyone else would pay $2.4 million for a waxwork of someone else's wife, when the same amount might buy a modest Monet or Picasso—or an actual trophy wife. Is it explained by branding? The great back story? Art world celebrity? Would anyone pay this for an equally glamorous wax statue of Brooklyn Decker, the 2010 *Sports Illustrated* swimsuit edition cover model and wife of tennis star Andy Roddick, if it were listed as created by Daniel Druet?

As an economist and contemporary art enthusiast, I have long been puzzled by the alchemy that causes a Warhol to be valued at $63 million rather than $5 million or even $100,000. Many works, like some in this Phillips auction, sell for a hundred times what seems reasonable. And the Phillips prices were realized at an auction held two years into a serious economic downturn.

This book is about the themes that swirl around the top of the art market: about collectors, artists, auction houses and dealers, and prices. In thinking about prices, remember that the operative part of the word contemporary is "temporary." Half the galleries advertising in a 15-year-old copy of *Artforum* are no longer around. Three quarters of the artists mentioned in the magazine are no longer represented in a mainstream gallery. Of the thousand artists who had serious gallery shows in New York and London during the 1990s, no more than 25 were offered in evening auctions at Christie's or Sotheby's in 2013. Half the artists offered in these evening sales in the 1990s no longer appear in their current evening sales. Half the works purchased at auction in 2013 will likely never again resell at their hammer price.

As you read about different works of art in this book and the prices involved, consider whether *Stephanie* and the others seem to be a decent investment. Not just "Will this art be important 25 years from now?" but "Will this art double in value in seven or eight years as would a moderate-risk bond portfolio?" For almost all art, the answer is no. And if no, what does this tell us about the art market?

A cautionary note. In 2012 the top six global auction houses combined achieved art market revenue of about $12 billion. The top 1 percent of lots sold produced 58 percent of that total. In 2012 there were 1,825 sales of over $1 million. The other 99 percent of the lots produced the remaining 42 percent. The curious contemporary art market described in the book is not related to your local auction house or local art dealer, nor to the 99 percent. It is the world of the top 1 percent—and in most cases, the one-hundredth of 1 percent.

THE COLORS OF CONTEMPORARY ART

THE WORLD OF CONTEMPORARY ART

On first visiting the Art Institute of Chicago and seeing Georgia O'Keefe's giant Sky Above Clouds IV *painting, the seven-year-old stared for a long time, turned to her mother and said, "Who drew it? I need to talk to her."*

—Quintana Roo, daughter of novelist Joan Didion

The ratio of good art to bad art is the same everywhere and is fairly constant. About 85% is not good; 15% might be good. For every 50 shows you see, one or two might throw you for a loop (and you and I will be thrown by different things).

—Jerry Saltz, art critic

There really is no single definition of what contemporary art is or is about. From the eighteenth to the early twentieth century, most artists or art collectors would have said that art is about beauty. Beauty was pursued as a human value, like truth or honesty. Beauty was represented in art as it was in literature, music, and architecture. Artists understood that human life included some suffering, but they believed that the beauty of art mitigated that. Artists said they sought to replicate the awe one felt on entering St. Peter's Basilica and encountering Michelangelo's *Pietà* (1498–1499).

In the twentieth century, much art ceased to be about beauty; it was now intended to be disturbing, to challenge moral taboos. Contemporary art had to capture the imagination rather than excite the senses. The same transition occurred with music and architecture.

In fairness, some contemporary artists claimed that their function was still beauty, but now it was to have viewers see something as being beautiful that they had never before imagined that way. At one extreme was Jeff

Koons's stainless steel rabbit. At another was Martin Creed winning the £20,000, 2001 Turner Prize for a light that went on and off every five seconds in an otherwise empty room. Titled *The Lights Going On and Off,* the work represented the clutter and consumerism of the modern world. Other artists applauded Creed's work, saying the evolution of contemporary art simply reflects the evolution of our consumer society.

Beautiful or not, the central characteristic of twenty-first-century contemporary art is that traditional artist skills of composition and coloration have become secondary to originality, innovation, and shock—however achieved. There are now few restrictions on methods or materials. As British contemporary artist Grayson Perry put it, "This is art, because I'm an artist and I say it is."

Different formal definitions of contemporary art are employed by different auction houses. At Sotheby's Contemporary Art sales, 1945–70 is "early contemporary" and post-1970, "late contemporary." Christie's uses the broader title "Post-War and Contemporary Art." Their categorization depends on the work rather than the date. Gerhard Richter's more abstract work is contemporary and his later photo-realist pieces are included in Modern and Impressionist sales. This mirrors the idea that contemporary art is more cutting-edge than that produced in earlier periods.

My working definition for the book is that contemporary art is that created after 1970, or similar to that which a major auction house has offered as contemporary. The descriptions and illustrations in the book provide a sense of what is included.

I discuss only two-dimensional works on canvas or paper and sculpture broadly defined to include an installation like *Stephanie.* If it is on film, if you can eat it, or if it involves sexual intercourse, it may be art, but I don't include it here.

Even saying I include "painting" is not straightforward. A painting should be easy to define; it is what results after paintlike materials are applied to a flat surface. But some paintings are collages, cartoons, or graffiti. Damien Hirst pours paint onto canvas mounted on a spinning potter's wheel to produce a spin painting. Chinese artist Cai Guo-Qiang produces gunpowder drawings, with the image being what remains after the powder ignites.

If words are painted on a surface, is this a painting? The Phillips auction in the first chapter offered a Christopher Wool work. It had black lettering

on a white background, painted in enamel on aluminum. *Untitled* (1990), 108 × 72 inches (274 × 183 cm) read

RUND

OGEA

TDOG

Intrigued by the clever spelling, five collectors bid the painting (that is how it was described) to $3.7 million.

If Phillips's 2010 fall auction offered a glimpse of the contemporary art market, perhaps Sotheby's and Christie's, each many times the size of Phillips, would produce a more representative picture. At Sotheby's the evening following Carte Blanche, the cover lot was Warhol's *Coca-Cola (4)*(Large Coca-Cola) (1962). In preauction theater, waiters circulated through the Sotheby's crowd, delivering six-ounce Coke bottles with straws. Estimated at $20 to $25 million, the silk-screen sold for $35.4 million, reportedly to hedge fund owner Steven Cohen, who phoned in his bid from a dinner party at his Connecticut home.

The following evening at Christie's auction, the star work was Roy Lichtenstein's *Ohhh . . . Alright . . .* (1964), a comic book panel reproduction on canvas of a red-headed woman holding a telephone to her ear. With an unpublished estimate reported as $42 million, bidding began at $29 million and rose in $1 million increments. The selling price was $42.6 million; the previous auction record for the artist was $16.3 million, set six years earlier.

Another much-discussed work was Jeff Koons's sculpture *Balloon Flower (Blue)* (1995–2000), one of five huge stainless steel sculptures from his *Celebration* series. The work sold for $16.9 million, above the $16 million estimate but well below the artist record of $25.7 million that a magenta version of the same sculpture brought in 2008 at Christie's New York.

Contrary to what the reader might think on contemplating these high numbers, no contemporary work is among the top 20 most expensive paintings. The most recent on the "most expensive" list was created in 1961. The four most expensive, with inflation corrected prices to 2013 and actual prices, are:

1. Paul Cézanne, *The Card Players* (1892–93), inflation corrected price $255 million (actual price $250 million), purchased by the Qatari

Royal Family, private sale by estate of Greek collector George Embirios in 2011;

2. Jackson Pollock, *No.5 1948* (1948), inflation corrected price $160 million (actual price $140 million), buyer thought to be David Martinez, private sale by David Geffen in 2006;

3. Willem de Kooning, *Woman III* (1953), inflation corrected price $157 million (actual price $138 million), buyer Steven Cohen, private sale by David Geffen in 2006;

4. Pablo Picasso, *Le Rêve* (1932), inflation corrected price $150 million (actual price $150 million, originally reported in media as $155.5 million), buyer Steven Cohen, private sale by Steve Wynn in 2013.

The three most expensive contemporary works were each auctioned in 2012–13. Number one is Gerhard Richter's *Domplatz Mailand* (1968), a cityscape of Milan, sold at Sotheby's New York in May 2013 for $37.1 million (£24 million). Number two is Richter's *Abstraktes Bild* (1994), sold at Sotheby's London in October 2012 for £21.4 million ($34.2 million). Third is Jeff Koons's *Tulips* (1995–2004), a mirror-polished stainless steel sculpture sold at Christie's New York, a month after the previous Richter, for $33.7 million (£21.3 million).

Consider these prices in the context of Tobias Meyer's rule about art pricing. Meyer said art prices must be judged against an anchor price like that for a prestigious New York apartment. If the apartment costs $30 million, the Rothko painting that hangs over the fireplace in the living room can have the same value.

Demand for high-end art is driven by a variety of factors. One is the expansion of private collections. In 20 years, the number of ultrahigh net worth (UHNW) individuals who collect art has probably multiplied 25 times. Many of those collections will be held within families long-term or presented to museums rather than resold. Another is the worldwide expansion of museums. In the first decade of the twenty-first century there were 200 new contemporary art museums planned or under construction.

Part of the buying frenzy and escalating prices comes from concerns about scarcity. Both private collectors and museum curators are told they face a now-or-never situation whenever a major work comes up for sale. Concerned that they may never have another opportunity to add a good work by this artist or from that period, they bid without consideration of past prices.

When an important work from the past comes up for sale, there is a price explosion.

Robert and Ethel Scull were among the best-known collectors of the 1960s. They purchased Willem de Kooning's *Police Gazette* (1955)—which is considered contemporary—from his dealer, Sidney Janis, for $1,900. They sold it in 1973 to Swiss dealer Ernst Beyeler for $180,000. It was later resold to dealer William Acquavella for $2.2 million, to Steve Wynn for $12 million, and to David Geffen for a reported $25 million. Geffen sold it in 2006 to Steven Cohen for $63.5 million. In 2013 it would be valued at $70 to $80 million.

Another factor is the better fit of contemporary art with twenty-first-century design, fashion, and architecture. Contemporary art reflects a collector's lifestyle and individuality, and her separation from her parents' taste, in a way that historical art cannot. Indeed, one of the dramatic cultural developments of the late twentieth century was the mass acceptance of avant-garde art. It is almost impossible to shock or outrage art collectors. One of the promoted works at the 2012 Art Basel Miami fair was an Airstream trailer packed with dildos. This was reported as a news story in many mass circulation newspapers, without editorial comment. Those strolling through commercial galleries no longer demand of the receptionist "Who buys this stuff?" There is no more shock of the new.

And then there is globalization of the art market, with collectors from emerging economies who are seeking the art popular in the West. In 2003 buyers who spent more than $500,000 for a single work at a Sotheby's auction came from 36 countries. In 2007 it was 58 countries. In 2012 buyers who spent over $1 million came from 63 countries. In 2007 China represented 4 to 5 percent of Sotheby's global commerce; in 2012, close to a third.

For all the publicity it receives, the contemporary art economy is not that big. There are about 10,000 museums, art institutions, and public collections worldwide. There are 3,000 auction houses (1,600 of those in mainland China), and about 425 decent art fairs each year. There are an estimated 17,000 significant commercial galleries worldwide; 60 percent of those in North America and Western Europe. Fewer than 5 percent of the galleries account for half the turnover. Gallery sales are about $15 billion, of which two-thirds or about $10 billion could be considered contemporary. The top six auction houses sold $12 billion of contemporary art in 2012. Sales through art fairs are estimated at another $3 billion.

Private and institutional trading (including private sales by auction houses) is the most difficult to estimate. In countries where collectors insist on privacy—notably France, Germany, Switzerland, Italy and Russia—private sales figures are far higher than those for auction sales. Most dealers guesstimate that overall private sales of contemporary art are close to the figures for auction sales: let's say another $12 billion. That produces a rough estimate for 2012 world contemporary art sales of $42 billion. That sounds like a lot of money in absolute terms, but think of it as about equal to the worldwide sales of Safeway Stores, or of FedEx. It equals the gross national product of Ethiopia or Yemen.

In a 2010 survey, art economist Clare McAndrew estimated annual art turnover at $52 billion; 48 percent of this at auction and 52 percent through dealers, agents, or purchases directly from the artist. If two-thirds of this is contemporary, we come out close to $34 billion. Update that by two years and it is not far from my figure.

There are many diverse art objects included in these sales figures. The Phillips auction in the previous chapter offered a second González-Torres consisting of two 40-watt light bulbs hanging from long extension cords. The catalog notified collectors that the work was from an edition of 20, plus two artist's proofs. Titled *Untitled,* the work represents the loneliness of life. It was accompanied by a certificate of authenticity. The catalog noted that "Félix González-Torres's work is ephemerally beautiful and deeply profound." The bulbs and cords brought $507,000.

In 2012 the Museum of Modern Art acquired, via a gift from New York financier Henry Kravis, the earliest known version of John Cage's *4'33".* It consists of three pages of onionskin paper, blank except for two vertical black lines. It is the score of a musical composition lasting four minutes and 33 seconds, during which time the performer never plays a note. To differentiate the movements, the performer opens and closes the piano lid three times. The vertical lines correspond to the period between openings; each inch of line equals eight seconds. *4'33"* was inspired by Robert Rauschenberg's *White Painting* (1951), which is white. Christopher Cherix, MoMA's chief curator of prints, was quoted, "How can you think of Rauschenberg without Cage?" The work was presented to the museum in honor of MoMA president Marie-Josée Kravis, wife of the donor. MoMA celebrated the acquisition with an exhibition in October 2013 titled *There Will Never Be Silence,* showcasing the many ways that artists have celebrated the Zen-like work.

Then there is experiential art. Consider Rirkrit Tiravanija's 1990 exhibition at New York's Paula Allen Gallery. Called *Untitled (pad thai)*, it consisted of the artist offering a free Thai dinner to all (mostly other artists) who attended the opening exhibition. The meal was the artistic contribution. What remained on display for the rest of the exhibition were remnants of the dinner: food scraps, cutlery, empty beer cans, and the propane burner. The gallery labeled it "social sculpture." It did not sell.

In 1993, Tiravanija was shown at the Aperto section of the Venice Biennale. For his experiential art contribution, the artist steered a canoe (intended to be viewed as a gondola) through the Grand Canal. From the canoe he served Cup-O-Noodles to passersby. The "installation" was titled *Untitled 1993 (1271),* and referenced Marco Polo's introduction of pasta to Italy after his return from the Orient. The art work was the canoe. This did sell; it was purchased by American collector Andy Stillpass, price not disclosed. Stillpass is said to have displayed it in his backyard suspended from a tree, as a conceptual sculpture. In 2004 Tiravanija won the Guggenheim Museum's Hugo Boss Prize for his work on sociability in the context of art.

My favorite example of conceptual art—and a story received with awe and skepticism when I retell it to an audience—concerns Yves Klein. He offered an art multiple called *Transfer of a Zone of Immaterial Pictorial Sensibility (1959–62).* Klein sold collectors an "immaterial zone," which they agreed to pay for in gold. Half of the gold was to be dumped into the Seine River, with the act witnessed by a curator, the purchaser, and two other artists. The scene was photographed; the collector received the photograph and a certificate confirming the amount of gold now at the bottom of the Seine. The size of the immaterial zone was related to the amount of gold in the payment.

To actually own the immaterial zone, the purchaser was required to immediately burn the certificate. Klein said this was the ultimate experience in art ownership. The collector kept the photograph. This was a work of art because the process had been conceived by a recognized artist. Klein kept the remaining gold. He said there was "more than one" purchaser.

Berlin artist Tino Sehgal creates art that is "making strange things happen in the world." For $100,000, he offers the artistic right to have a museum guard slowly remove all his clothes. The purchaser provides the guard; Sehgal sells the right to perform the work, or to loan it to a museum. Sehgal insists the transaction be in cash, without paperwork to blemish its purity. In 2011 MoMA held an exhibition of so-called immaterial art, and "borrowed"

a Sehgal. No performance was reported; perhaps the museum guards' union thought this was too far outside their contracted duties.

Then there is performance art, which takes many forms. American Andrea Fraser wanted to emphasize the "personality and presence" of the artist as a "female bad girl who gets personal straight away." Listed as *Untitled (2003),* her work is a video, arranged and produced by her New York dealer Friedrich Petzel. It records Fraser having sex with the collector—after payment of a fee—in a hotel room. She said the performance "was about taking the economic exchange of buying and selling art and turning it into a very personal, human exchange; the collector is allowed to be an equal partner in the performance."

Petzel emphasized that what the collector purchased was not the sex act but rather the 60-minute video of the encounter. *Untitled (2003)* was produced in an edition of five; one video to the collector in return for his payment, four to be sold by Petzel. Two of the four were reportedly purchased by European museums. I find it curious that, the disclaimer aside, no one questions the legality of her dealer's actions. Perhaps this reflects the general approach of law enforcement; avoid, whenever possible, anything that takes place under the banner of "art."

Another example of performance art at MoMA was Marina Abramovic's 2010 exhibition titled *The Artist is Present.* It offered nude men and women sitting, standing, and lying down. Several visitors had to be removed from the museum for inappropriate touching of the art. Abramovic said this followed a contemporary art tradition that dates to 1961, when Yves Klein (again!) had paint-splattered, naked women roll on canvas in front of an audience. The paintings in that series have brought high prices at auction.

Artists say that these forms of expression occur because of artists' rejection of the art market. They challenge the concept that art is composed only of objects to buy and sell, status goods to hang in a sitting room. The artist's body, or her performance, is seen as the ultimate non-commodifiable work.

What, then, is the status or value of a work for which there is no market, at least none without risking a term in a federal penitentiary? That question arose after the 2007 death, at the age of 92, of legendary New York modern art dealer Ileana Sonnabend.

The Sonnabend estate included works by Andy Warhol, Roy Lichtenstein, Cy Twombly, and Jeff Koons. Part of the collection had to be sold to

pay estate taxes: $331 million to the federal government and $140 million to New York State.

One of the best-known works in her collection was Robert Rauschenberg's collage *Canyon,* which includes a stuffed bald eagle. However, two federal laws prohibit ownership or trafficking in this national symbol. In 1981 Sonnabend secured a federal permit to possess *Canyon* or to lend it to museums. (The bird died and was stuffed before the laws went into effect.)

On the estate tax return, Sonnabend's children, Nina Sundell and Antonio Homem, listed the market value of *Canyon* as zero. Their argument, and that of an appraiser they retained, was that *Canyon* had no value because it was a federal crime to deal in such an object. If there was no possible market for the work, all that could be done was to donate it to a museum. In 2012 they presented it to MoMA.

Wrong about the market value, responded the Internal Revenue Service; *Canyon* had a high value "on the illicit market." The IRS valued *Canyon* at $65 million, and levied $29.2 million in estate tax and another $11.7 million in penalties on the estate for their undervaluation. Ralph Lerner, the art lawyer representing the estate, said that there was not even a black market for such a work, but the IRS disagreed. "For example, a recluse billionaire in China might want to buy it and hide it." Lerner said that would make a great plot for a James Bond movie. The estate sued the IRS in tax court; the IRS was reported to be searching for potential witnesses with experience "in selling art on the illicit market."

The incredible diversity of things that fall under the heading "contemporary art" is one reason most people respond to only about one in a hundred contemporary works—and seriously dislike many of the rest. If you attend an auction preview or a gallery show, walk around with your partner and ask, "If that work was the door prize and you won, how much would you pay to not have to take it home?" The rule is you have to hang it and live with it for a year; you can't just resell it. That is the concept of a negative price: It is like asking "How much would you pay to have your rebellious teenage daughter not have her boyfriend Zeke's name tattooed on her left breast?"

But taste and lust are subjective. The work in the auction preview on which you have placed the highest negative price will usually receive serious bids and be purchased by a collector who will then proudly exhibit it. As Jerry Saltz observes, "All art is for someone; no art is for everyone."

Artist Eric Fischl uses a dog and a cat to illustrate contemporary art. "Come here dog." The dog leaps to his feet, ears up. He trots over, wags his tail, puts his head on your lap, and looks in your eyes, awaiting instruction. The dog's actions are easy to understand. You and the dog enjoy linear communication.

Now call the cat. The cat slowly turns her head, twitches, and walks toward you but at a tangent. She rubs against a chair leg, flicks her tail, pivots, and sits with her hind quarters toward you. To understand the cat you have to interpret this nonlinear, indirect, complex, alien language.

Fischl says anyone who has shared a home with a cat and also has loved contemporary art understands that art is a cat. Translating the nonlinear, sometimes alien language of contemporary art is why it is sometimes so hard to understand what an artist is saying, and why artist, dealer, and collector (and the collector's spouse) come up with different translations.

The thing is, to the artist who created the work, contemporary art represents linear communication. To the artist, contemporary art is a dog.

THE ART MARKET CRASH OF '08

The art market went from burned bright to burned down; more artists made money from their work than ever before (although the number of artists who did make money was probably still less than one-percent of one-percent).

—Jerry Saltz, art critic

My previous book on the contemporary art market, *The $12 Million Stuffed Shark,* was first published in mid-2007. The final three months of that year saw the beginning of the economic recession. The resulting crash in art prices came in 2008. This chapter is included as a cautionary tale about that crash and how it could happen again.

The sharp drop in art values in 2008 and 2009 shattered the myth that there could never be a price bubble in the twenty-first-century contemporary art market. That idea had been aggressively promoted by many in the art trade, most vocally by Tobias Meyer, worldwide head of contemporary art at Sotheby's.

Meyer summarized the position nicely in a widely reported quote in 2006: "For the first time in history we are in a noncyclical market. But people don't get it. People make predictions from a market that once existed strictly in America and Europe. But there are new people entering this market all the time, coming here from Russia, from China, from Taipei, from anywhere." Meyer's logic was that any financial slump in the United States would be offset by demand from these new collectors.

There was a good basis for his conclusion. By 2007 China had emerged as the world's third-largest contemporary art auction market; the art markets of the Middle East and Russia were growing fast. As it turned out, before

and during the recession, most mainland Chinese buyers focused on purchasing their own art, most Indians purchased Indian art, and most Russian buyers repatriated their own historical art.

Secondly, it was argued that Western art prices were only weakly correlated to foreign art markets, or to housing prices, or to the stock market. This also turned out to be wrong. Price levels in contemporary art auctions in Hong Kong, Beijing, Dubai, and Moscow all cratered in the second half of 2008. The Chinese contemporary art market declined more sharply in 2009 than did the US market.

World art prices followed stock market and housing prices downward, but with a five- to seven-month lag. Auction prices were propped up by price guarantees given months earlier. While the United States actually went into recession in the fourth quarter of 2007, the decline in auction prices was most apparent after the first quarter of 2008.

A third assumption had always been that ultrahigh net worth (UHNW) collectors were insulated from economic fluctuations. This proved to be substantially correct; some continued to buy, but they offered lowball bids at auctions or demanded high discounts from weakened, vulnerable dealers and private sellers. Collectors were also fearful of the public relations impact of being seen to pay huge sums; at the same time their companies were laying off workers. Collectors without such a concern prospered. Los Angeles's Eli Broad described his 2008 purchases at Sotheby's and Christie's as "a half price sale."

As was true with the earlier art market crash of 1990, the common dealer caveat attached to sales was "You can have the work at that price, my old and dear friend, but only on your solemn promise that you will never, ever, tell anyone how little you paid."

By May 2008 everyone had accepted that Western economies were in recession. The clincher for the art world was the New York contemporary auctions that month, when more than half the lots either did not sell or sold below—sometimes way below—the presale estimates. There was not much bidding depth; even lots achieving good prices often had only two or three paddles in the air.

Monday, September 15, 2008, was the disaster point. American investment bank Lehman Brothers declared bankruptcy. Soon after, American International Group, the world's largest reinsurance group, announced it was insolvent. The next day the US Federal Reserve offered AIG an $85

billion bailout. Merrill Lynch was acquired by the Bank of America. Most financial institutions in the United States and Western Europe rushed to refinance. Comparisons were made with the beginning of the Great Depression in 1929.

On the same day as the Lehman bankruptcy, Sotheby's London opened an amazingly successful, two-day auction of Damien Hirst's art, starring *The Golden Calf,* a white bull in formaldehyde, which sold for $18.6 million to the Qatari Royal Family. But the Hirst sale was an anomaly; a month later the Frieze Art Fair opened in London. No dealer at Frieze boasted of sales made; instead, they talked of "new opportunities to connect with collectors."

The November 2008 contemporary auctions were worse than those in May. Sotheby's and Christie's catalogs were very thin. In the November sale, Sotheby's offered 29 works versus 72 a year earlier, and with much lower valuations. Any work estimated over $1 million was there because it carried a guarantee commitment made six to nine months earlier. As the sales approached, auction specialists told potential bidders that estimates could be ignored, which meant that reserve prices (below which the auction house will not sell) had been beaten down in discussions with consignors. Everything was moving in the same direction—the good, the mediocre, and the in-between. And this was happening at a time when interest rates were close to zero.

In the November 2008 sales Christie's achieved $114 million against a presale low estimate of $227 million, with 32 percent of lots unsold. Sotheby's sold $125 million against a low estimate of $200 million, with 35 percent unsold. Two lots were indicative. Sotheby's offered Roy Lichtenstein's *Half Face with Collar* (1963), consigned by dealer Gian Enzo Sperone. Estimated at $15 to $20 million and reportedly carrying a reserve that had been lowered three times to $8 million, it failed to attract a single bid. Christie's offered Francis Bacon's 1964 *Study for Self Portrait* with an unpublished estimate of $40 million and a reserve of about $25 million (also lowered substantially). This also did not attract a single bid. The slump in expectations continued. Sotheby's auctioneer Tobias Meyer stopped using his customary "Give me" phrase to solicit another bid, substituting a rising inflection "One more then?" with the implied "Please." The auction houses laid off staff at all levels and closed underperforming departments.

Edward Dolman, Christie's chief executive, said in *The Economist* at the end of 2008 that "Death, divorce and debt will continue to provide art works

for the auction market. But discretionary sellers, who don't have to sell, are likely to want to sit it out until things improve."

The use of auction house price guarantees to attract consignments had expanded tremendously in the 2005–2008 period and had proven profitable. In 2005 Sotheby's issued $130 million in guarantees; in 2007 it was $900 million. That figure does not include third-party guarantees arranged by Sotheby's and then resold to a third party. After Sotheby's lost $250 million in 2007–2008 on guarantees, and Christie's probably the same, price guarantees essentially disappeared. They were replaced where possible by irrevocable bids offered by collectors. Guarantees and irrevocable bids are described in a later chapter.

Total 2009 contemporary sales at auction for the two major auction houses in New York and London were $485 million, down two-thirds from 2007. The only bright spot in the year was Christie's Yves Saint Laurent sale in Paris in February. That sale produced $477 million over a two-day period, making it the most valuable single-owner sale in history. The Saint Laurent sale was unique; the depth and quality of lots offered made it a once-in-a-decade buying opportunity.

The key bidding support for Saint Laurent came from buyers representing Qatar, Abu Dhabi, and Dubai, who seemed willing to pay whatever was required to acquire art for their new museums. A consortium of museums from Qatar and Abu Dhabi (or Dubai; the story varies) offered $400 million, later raised to $420 million, to preempt the YSL estate going to auction. In the end the Middle Eastern buyers bid on and got the items they wanted; the YSL estate netted slightly less (considering costs and unsold lots) than it would have had the estate accepted the $420 million offer.

Immediately after that auction, Standard & Poor's rating service lowered Sotheby's corporate credit rating to BBB, one level above junk status, and Sotheby's stock bottomed out a month later at a 20-year low of $6.50, down from a high of $59.

By mid-2009, prices for museum-quality contemporary works had stabilized, down 10 to 15 percent from 2007—and these prices were being strongly supported by Middle Eastern and Hong Kong buying. Prices in the middle third of the contemporary market were down 40 percent; in the bottom third, down 50 to 60 percent. The number of million-dollar-plus

contemporary sales at auction—by far the most profitable segment for auction houses—dropped almost 80 percent from 2007 to 2009.

Actor and collector Steve Martin described the growth of galleries in New York's Chelsea art district in good times: "new galleries sprouted overnight lacking only fungi domes." As the recession took hold, he said, "the only things missing in Chelsea were tumbleweeds." It wasn't quite that bad, but about 20 percent of Chelsea galleries closed their doors over a period of 18 months beginning in February 2008. Every gallery that closed meant that 25 to 30 artists lost dealer representation. Many galleries that remained relocated to smaller, less expensive quarters (or sold from apartments), or cut costs by laying off employees and renegotiating rents. Some galleries went to an "open by appointment" model; others moved their best artists higher on the exhibition schedule in the hope of generating cash flow.

From 2007 to 2009 the number of significant art fairs around the world shrank from 425 to about 225. Fairs that survived offered more conservative and moderately priced art to attract older buyers and older money. Über galleries still brought one or two museum-quality feature works to a fair; the rest of the booth was occupied by art at lower price points, closer to $50,000 than a million.

Dealers often showed only one artist in their fair booth, reversing the Baldessari rule. British artist John Baldessari was known for telling students that they had to make dramatic new work in order to sell their older work. During the recession, galleries featured older works in booths and ignored the new.

Most Western museums suffered. Governments cut back on funding, and private donors either withdrew or cut back on previous commitments. Museums laid off employees and reduced hours. Sponsors and contributors to special exhibitions exercised a greater degree of influence over what was shown than would ever have been tolerated a couple of years earlier. "I will loan you this work if you agree to also take and show these other two." The impact was greater in the United States, where museums are more dependent on private funding than in Europe.

The top of the art market turned around in 2010, kick-started by three confidence-inspiring events. The first was the November 2009 sale at Sotheby's New York of Andy Warhol's *200 One Dollar Bills* (1962). Estimated at $8 to $12 million, it sold at $43.8 million. The second was the sale at

Sotheby's London of one of six casts of Alberto Giacometti's *L'homme qui marche I* (Walking Man I)(1960). Estimated at £12 to £18 million ($19 to $29 million), it sold to London collector Lily Safra for a record-setting £65 million ($103.8 million).

The third was the April sale at Christie's New York of the 1932 Picasso *Nude, Green Leaves and Bust* from the Sidney and Francis Brody estate. Estimated at $70 to $90 million, it sold for $106.5 million.

By mid-2011 prices at the top of the market had returned to 2007 levels; the middle and lower segments still lagged. The improvement came not because the economy turned around, but because many investors were now considering art as an asset class. It was seen not so much as a good investment but as a safe, alternative storehouse of value compared to stocks, real estate, or holding cash.

As the end of 2013 approached, there were mounting anxieties that a new price bubble had inflated. While trophy works would still be viewed as a storehouse of value, there was uncertainty about the middle market of contemporary, impressionist, and modern works.

So what are the market trend indicators? What do you look for? Not press releases from the auction houses, art fairs, or dealers; they have no incentive to tell you if things are shaky. Look at the middle 50 percent of contemporary auction sales. Museum quality works at the top will always find a buyer. A few lots will always go unsold, if only because the reserve prices are set too high. But if a lot more works in the middle 50 percent are bought in, or sold below estimate than the previous year, consider that a cautionary warning.

These two chapters provide an overview of the macro picture. More perplexing and more central to the world of contemporary art are questions like "What is the satisfaction when someone buys a waxwork *Stephanie* or the tricycle-riding *Charlie?* Or when one buys Félix González-Torres's candy, or Takashi Murakami's semi-pornographic statue of *Miss ko2?* And, why these prices?" This is the topic of the next chapter.

WHAT JOBS DO WE HIRE ART FOR?

The customer rarely buys what the company thinks it is selling him.

—Peter Drucker, management theorist

Dealers and auction specialists understand that every art purchase comes from a combination of motives. In his 2012 book *The Value of Art,* New York gallerist Michael Findlay identifies these as analogous to Zeus's three daughters, the Three Graces, represented in sculpture and painting by artists as diverse as Raphael, Peter Paul Reubens, Paul Cézanne, and Pablo Picasso.

The Three Graces are Aglaia (Beauty), Euphrosyne (Joy), and Thalia (Abundance). Thalia, in Findlay's terms, represents commerce, or the potential of art to appreciate in value. Aglaia, in his analogy, represents the intrinsic value that a collector beholds in a work of art. Euphrosyne represents the pride of possession and the status that comes with art ownership.

But a list of motives does not explain why one painting brings $10 million; another, $10,000. Dealers and auction house specialists do not usually claim to be able to identify or define what art will increase greatly in value. They say publicly that prices are determined by supply and demand. Privately they talk about a competition among superrich individuals or countries to accumulate iconic, readily recognizable items. Iconic, when applied to art, refers to a style of work that has become synonymous with the artist—Monet's *Water Lilies,* or Jackson Pollock's drip paintings, or Damien Hirst's spots. Iconic works are sometimes sought after by collectors because they "look like" work by the artist. With contemporary art, iconic is also used by dealers and auction specialists as a synonym for "expensive."

In proposing a more complete answer to motive and value, let me for a moment revert to my role as a business school professor and describe an idea central to what MBA students are taught about consumers. To understand why a customer acquires something, start by inquiring about the job the buyer wants the product to accomplish. People "hire" a product or service, because in the course of living their lives there are different jobs that need to be done at different times. Each job includes some combination of functional, emotional, and social dimensions—the same ones identified by Michael Findlay.

So the line of questioning starts, "Why do you hire this product? What is the job you want to accomplish?" Harvard Business School marketing professor Ted Levitt offered the classic example: No one buys a quarter-inch drill because they want to own a bulky tool; what they want to own is a quarter-inch hole.

A story about milkshakes further illustrates the idea. If this seems somewhat familiar as you read through, it is probably because it has been retold in different forms by another Harvard Business School professor, Clay Christensen, author of *The Inventor's Dilemma*. Christensen originated use of the term "rent" rather than "buy" in examining consumer motives.

The story involves McDonald's restaurants, in particular one outside of Chicago. McDonald's wanted to improve the lagging sales of its milkshakes, a product with one of the highest profit margins of anything they serve. The company started with traditional marketing research; they asked a panel of consumers to tell them what milkshake characteristics customers cared about. Should shakes be thicker? Chunkier? Cheaper? Sweeter? The panel produced clear answers. McDonald's milkshakes were modified, but sales remained flat.

McDonald's then asked other researchers to look at the problem. One of them, Gerald Berstell, chose to ignore the attributes of shakes, and instead to observe buyer behavior. He sat in a suburban McDonald's for 18 hours a day, watching. He discovered that 4 percent of milkshakes were purchased before 8 o'clock in the morning. McDonald's advertised shakes either as an adjunct to a Big Mac or as a kind of dessert; it was obvious only a few customers consumed them that way.

Berstell got lots of behavioral cues from purchasers. Early morning purchasers were alone, almost never bought anything else, and never consumed their shake in the store. These were commuters.

An early-morning milkshake was not exactly a traditional bacon-and-eggs breakfast. So Berstell asked, "What job are commuters hiring that milkshake to do at 7 a.m.?" He interviewed early morning customers, asking (in more understandable terms), "Tell me what job you needed done when you came here to hire that shake." The answers were pretty clear. The milkshake's job was to entertain during the commute, and to stave off hunger until lunch.

Then the researcher asked, "Tell me about a time when you were in the same situation but bought something other than a milkshake." Each customer had tried hiring other products to do the job; each product offered problems. Bagels with cream cheese or jam produced sticky fingers and risked spotting a shirt or tie. Dry bagels were boring and left crumbs in your lap. A donut was not very filling.

The viscous milkshake worked. It took 20 minutes to suck through a thin straw. It could be held in one hand or stored in the car's cup holder. Hands, shirt, and tie stayed clean. A shake might not be healthy, but that was not the job it was hired to do.

Once the job was obvious, McDonald's could change the attributes of the milkshake to better perform its job. The morning shake was made thicker, with a thinner straw. Tiny bits of fruit were included to add a dimension of anticipation—the slurp of random chunks—to the boring routine commute.

Focusing on the product and its attributes without regard to the job the customer needed doing missed the point. The morning customer needed to do a nontraditional job: provide sustenance and amusement for a morning commute. For that, they hired a milkshake.

Fans of the television series *Mad Men* may remember another clever example: advertising executive Don Draper pitches Kodak executives on how to present their new, high-tech Carousel slide projector (which they wanted to call "The Wheel"). Draper's presentation focused not on the new technology but on the job a projector is hired to do. "It is a time machine, the images take you back and forwards in time, to places you ache to go again, the way a child travels, on a carousel, to places we loved."

To apply the concept to contemporary art, don't think of it as a product. When a 46-year-old ultrahigh net worth male (the median demographic of a successful bidder at a Sotheby's New York evening contemporary art auction) acquires a Damien Hirst spot painting, it is rented to do a job. Now, what is the job?

Art is rented for different jobs in different rooms of the home. The most expensive art is usually found in the public rooms: the entrance hall, living room, and across from guest seating in the dining room. When someone comments about art performing a signaling function as to the owner's wealth and taste, it is usually public room art that is referenced.

Less expensive art is found in personal spaces like the bedroom. Why? After all, we spend more time in the bedroom; that wall is what we see the last thing at night and first thing in the morning. Perhaps bedroom art is intended to perform a different job than is public space art.

Michael Findlay quotes a prominent collector as saying that when she visits other collectors for dinner, she always asks to use an upstairs bathroom because she wants to see what art they have in their bedrooms. "People who are serious about art have what they really like where they will see it the most . . . if all the best art is in the living room, they are just in it to show off." Or, perhaps, to better display their cutting-edge taste.

The job-to-be-done idea also suggests that competition for high-end art comes not just in the form of art; it encompasses third homes, yachts, and G5 private aircraft. The market for high-end art has increased tremendously in the past decade not because buyers have more money; in relation to auction prices for the best art, they do not. Demand has increased because hiring art fulfills some job requirements better than hiring other things. There is more consumption of art because the alternative of a yacht or a G5 does not perform the job as well. If the perception of the job-that-art-does-best changes in the future, demand (and prices) for high-end art can be expected to decline.

The branded auction houses and branded dealers understand the job-to-be-done concept, but they cannot tastefully utilize it in their promotions. To mention pride of possession, prestige, or status would be unthinkable. Instead, they use their advertising budgets to highlight branded artists and to build their own brands. They use their catalog descriptions to offer expanded back stories that purchasers can retell.

The major exception to this rule comes in an auction house's private negotiations with museums. Here the approach is often not just "this is an important work," but "this iconic work will attract press coverage and will assist in the job of turning your institution into a destination museum."

If the job-to-be-done concept helps explain the purchase process for art, then what is the role of branding? The concept of branding is usually

thought of in relation to consumer products like Coca-Cola or Nike. Branding adds personality, distinctiveness, and value to a product or service; it also offers risk avoidance and trust. Every cultural and entertainment business tries to establish a brand that will be more important to consumers than the product. Disney is a brand that adds value. Twentieth Century Fox and Warner Bros. are not. Some film titles and plots are brands—Harry Potter or *Pirates of the Caribbean*. George Clooney and Steven Spielberg are brands. The first two weeks' audiences for new Disney-Harry Potter-Clooney-Spielberg movies may be 75 percent composed of those responding to the brand. Competing nonbranded movies have to rely on favorable reviews, a great title, or a lack of better options on a Friday evening.

With contemporary art, a great value-adding component comes from the branded auction houses: Christie's, Sotheby's, and to a lesser extent Phillips. They connote status, quality, and celebrity bidders with impressive wealth. Their branded identities distinguish these auction houses and the art they sell from their competitors. What do you acquire when you bid at an evening auction at Sotheby's? A painting, obviously. But also a brand-based promise that the job-to-be-done will be done—particularly if that job description includes an added dimension to the way people perceive you.

Galleries like Gagosian in New York or White Cube in London are respected brands; that differentiates their artists and art. Larry Gagosian's clients may substitute his judgment for their own and purchase whatever is being shown, to the point of buying from an Internet JPEG image without ever seeing the actual painting. The dealer brand becomes a substitute for collector judgment.

Collector's insecurities (usually about the art, not the price) are reinforced by the way that contemporary art is described. Part of the job-to-be-done includes minimizing that insecurity. If the collector cannot fathom the value code, there is added reassurance when the Christie's, Sotheby's, Gagosian, or White Cube brand is attached to the purchase.

A few artists have also achieved the status of recognized and respected brands. When an artist becomes branded, the market tends to accept whatever the artist submits as legitimate; few question its suitability for the job. No one is dismissive when you say "That abstract painting is a Roy Lichtenstein," a statement sometimes accompanied by "for which I paid $15 million at Christie's."

If you question the degree to which suitability-for-the-job really does apply to high-end art, consider a story told by Findlay about an art genie. You have visited Phillips's contemporary auction preview and considered bidding $1 million for *Stephanie,* which would occupy a place of honor in your living room. You can afford that amount, but you are pretty sure that Mr. de Pury has estimated the work correctly and that it will sell for at least $2 million.

On the way home from the preview you trip over a shabby old lamp on the sidewalk. There is a puff of smoke, and an art genie appears. "I will grant you the wish of purchasing the sculpture you lust after for even less than you expected—for $700,000 in fact. But there are two conditions.

"First, you can neither sell the sculpture, nor profit from it in any way. Second, you can show it to no one and discuss it with no one."

Absent the conditions, you would be ecstatic. With these two conditions, do you accept or ask for a substitute wish? If you ask for the substitute, what does that mean about the job you hoped *Stephanie* would do?

The job-to-be-done concept has been studied by cognitive researchers who conclude that a complex process may be taking place when we think about an art work. For example, the reaction to seeing a painting at an auction preview or at a dealer and knowing you might possess it is profoundly different from the reaction to seeing the same painting in a museum.

This was demonstrated in 2012 at a research lab in Berkeley, California, with experiments using functional magnetic resonance imaging (fMRI). The fMRI scanner is a tool of neuroscience, the basis for neuroeconomics, neuropsychology, and the other hot new areas of study with a neuro prefix. The fMRI shows, in real time, which parts of the brain receive increased blood flow when the subject is exposed to different images.

When a collector is shown a picture of a painting and told that it is available at a price he can afford, the fMRI shows the same parts of the brain lighting up as when the subject is shown a chocolate truffle. Certain back stories for the painting, in particular ones stressing prior ownership by a distinguished collector, trigger stronger responses than those for the painting alone. The truffle, or the trophy art, or the back story, activates the brain's anticipation-of-pleasure center by elevating the levels of dopamine, a chemical associated with feelings of pleasure and reward. If the subject is shown a similar painting but told it is owned by MoMA, a different part of the brain responds to the color, shape, and composition. There is no rise in dopamine. One cognitive science explanation is that the concept of ownership triggers

a neurological response to positive thoughts of life if the picture becomes part of it.

The chapters that follow are about the role of the back story and about the institutions that make up the market for contemporary art. As you read each, consider the job that art has been hired to do in each situation and how the brain might respond.

BACK STORY

The enjoyment we get from something derives from what we think that thing is.

—Paul Bloom, psychologist

How we value art is profoundly affected by our belief as to what the art is, who created it, and how it was created.

—Dennis Dutton, philosopher

The importance of branding in adding value to art may be self-evident. But how can value be added by the back story that comes with a work of contemporary art? Just before 9 pm on November 13, 2012, Sotheby's contemporary sale in New York offered as lot 40 a work titled *Brillo Soap Pads Box* (similar box illustrated). This is a plywood box painted with house paint, then silk-screened with the red and blue Brillo name and shipping box wording. It measured 17 × 17 × 14 inches (43 × 43 × 35 cm), was listed as "executed in 1964," and carried an estimate of $700,000 to $900,000. Its provenance included the original sale by New York's Leo Castelli Gallery and a subsequent sale by Galleria Sperone in Turin, Italy, from which the consignor had purchased it in the mid-1970s. The box was included in the *Andy Warhol Catalogue Raisonné.*

What could Sotheby's say about the back story of a silk-screened wooden box to help explain its high estimate? The excerpts that follow are from the much longer essay in the auction catalog.

Brillo Soap Pads Box . . . represents a motif that became absolutely synonymous with [Andy] Warhol and the Pop Art movement in the first half of the 1960s . . . it is no exaggeration to describe the present work as the vestige of a key revolution that took place in modes of artistic

creation with resounding and profoundly influential effects on wider perceptions of artistic authorship and indeed the very nature of the authentic art object. . . .

Brillo Soap Pads Box is the perfect continuation of Warhol's appropriation of commercial products and advertising design. . . . The series, as epitomized by the present work, is recognized as a major chapter in the history of Pop Art and, viewed from our perspective today, the subsequent influence of the *Brillo Boxes* on movements such as Minimalism, where seriality and industrial manufacture became standard benchmarks of artistic practice, readily testifies to the true significance of this body of work.

The box attracted nine bidders and sold for $722,500, so perhaps a good back story does contribute to value. Part of the back story is always the authenticity of the work or at least the direct relationship to an artist, but there is much more to it.

There is a yet another back story that the Sotheby's description ignored. The Brillo box design was created for the Brillo Company in 1961 by an Abstract Expressionist artist (and part-time commercial artist) named James Harvey. Harvey first learned of the appropriation when he attended a Warhol opening at the Stable Gallery in New York in May 1964. Warhol's boxes sold for several hundred dollars; Harvey's were valueless. But Warhol presented his boxes as art; Harvey sold his design to Brillo for use on a shipping container.

Some contemporary art produces vivid interpretations; with other work, the viewer just moves on. So the work's title, or the dealer or auction house through the back story, may offer an interpretation. "This is what this work means, how you should see it." If the back story is accepted, the brain begins to accept the illusion as reality. The interpretation, the back story, can be passed on by the owner to other viewers.

When you ask artists about the back stories presented with their art, it turns out that many were created by a dealer or collector. Art dealer Leo Castelli said (in 1966), "My responsibility is the myth-making of myth material, which handled properly and imaginatively, is the job of the dealer. I have to go at it completely. One can't just prudently build up a myth." Ask auction house writers who prepare catalog descriptions if they are familiar with the extensive behavioral literature on the impact of back stories, and they say

they are not. But they fully understand the role of the back story, that it may be more important than the art work itself.

The dollar value of the back story can be huge. In early 2008, artist Rachel Howard sold a spot painting for $90,000 at a New York auction. A few months later, another very similar spot painting by her sold for $2.25 million. The difference is that while Howard had created both, the second had Damien Hirst's (indistinct) signature on it. The second was titled *Amphotericin B* (similar painting illustrated). It is a 1993 spot painting, named after a pharmaceutical drug. Howard worked for Hirst as a technician until 2007, when she left to produce her own art. She was one of more than a hundred technicians employed by him, working under his direction to produce spot paintings and other work.

It is well understood in the art world that technicians produce Hirst's art; no buyer is misled. Howard is recognized as the best at producing spot paintings. "The spots I painted are shite," Hirst has been quoted. "The best person who ever painted spots was Rachel. She's brilliant. The best spot painting you can have by me is one painted by Rachel."

Tim Marlow, former director of exhibitions at Hirst's London gallery, White Cube, describes Hirst's spot paintings: "They're incredibly original and counterbalance the decline of originality in the history of painting. It's taking something that looks machine produced but is actually painted by hand. What we see is not what we see." This is the generally accepted back story of spot paintings: looks machine made but is not.

But that claim is also true of the Howard spots. The Hirst spot by Howard sold at auction for 25 times the price of the Howard spot by Howard. Is that multiple related to some other underlying reality of the work? Does part of the job-to-be-done relate to the context, to a need for authenticity to originate with the idea-producer rather than from the art-producer?

The idea that art has an underlying reality that one cannot observe directly has a long history. What matters in our deriving pleasure is not just its appearance but also what it really is, what it means, and where it came from. Context begins to explain art world phenomena like *Stephanie* and why we devalue fakes. I have searched for a better term to describe underlying reality. The best descriptors are just "back story" and "context."

We know that a back story involving a celebrity can increase the value of an object, sometimes hugely. Think of the considerable success over the

years of one-owner art sales at auction: Robert and Ethel Scull, Mr. and Mrs. John Hay Whitney, Jacqueline Kennedy Onassis, and the Yves Saint Laurent-Pierre Bergé collection. And then there was Elizabeth Taylor!

In December 2011, Christie's New York held an auction of Taylor's "Legendary Jewels." The back story of "owned by Elizabeth Taylor" was so powerful that visitors to the pre-auction exhibition required a timed ticket costing $30—the first time the auction house had ever charged to attend a preview. At the auction, many of the lots brought ten times the catalog estimates. These estimates came from jewelers Cartier, Van Cleef & Arpels, and Chopard; each was asked what they would sell the consigned item for at retail, absent the Taylor provenance.

Elizabeth Taylor was married eight times and showered with jewels by lovers and husbands, and by admirers such as Michael Jackson. The first lot offered at Christie's, a charm bracelet with a replacement value of $25,000 to $30,000, was unique in having individual charms that could be matched with the specific lovers or admirers involved. The charm bracelet sold for $326,500.

Christie's star item was *La Peregrina,* a pear-shaped 56-carat pearl that Cartier mounted as the centerpiece of a necklace of rubies, diamonds, and pearls. *La Peregrina* dates from the sixteenth century; it once belonged to Phillip II of Spain and appears in a painting by Velasquez. It was purchased by Richard Burton in 1969 for $37,000, as a gift for Taylor on the occasion of their second marriage. Cartier provided an estimate for Christie's of $2 to $3 million, which incorporated the Phillip II–Velasquez provenance.

It sold for $11.8 million, a world record for a piece of pearl jewelry. The $9.3 million difference between auction and retail was the value of the back story of Taylor and Burton, which had been heavily promoted by Christie's.

The same back story factor applies to art, even more so because the intrinsic value of an art work is harder to quantify than that of a piece of jewelry. The value of celebrity provenance for a work of art is such that some lawyers insist on a warranty from the dealer (auction houses will not provide one) that the work was previously owned by the named celebrity. If the warranty is provided and it turns out that the celebrity provenance is incorrect, the buyer has the right, without time limit, to rescind the purchase and receive a full refund.

If a great back story has such a dramatic effect on jewelry, how about music? We know that the best seats in a Washington concert hall for a

performance by violinist Joshua Bell sell quickly for $225. *Washington Post* reporter Gene Weingarten wondered how much someone would pay to hear the same concert if no one told them that the music or the musician was great. He had Bell, dressed in jeans, sweatshirt, and baseball cap, set up at the entrance of a Washington subway station with his $3.5 million, eighteenth-century Stradivarius. Bell left the violin case open at his feet, seeded with a few dollars in coins, and played the first 45 minutes of the concert he had offered in Washington two weeks earlier.

Over 45 minutes, Bell made $32. The first dollar came from a woman who spent several minutes studying his violin, then pronounced it to be of "really good quality" and walked off, offering no comment on the music. When others have performed this street performance experiment with a classical violinist wearing a tuxedo but with a paper bag over his head, suggesting he may be famous and not want to be recognized, receipts doubled or tripled.

Put Joshua Bell's experiment in an art context. As this was being written, German American abstract expressionist Hans Hofmann had three works on display at MoMA. Assume one is worth $2.5 million if offered at auction with the MoMA-collection provenance. Now assume the Hofmann work is taken down, reframed in a plain shadow frame, taken to Alto, a nice restaurant close by (between Fifth and Madison Avenues), and hung on the wall with a "$2,000 or offer" price tag. Absent the Hofmann brand and the back story of its MoMA history, how much attention would it receive? How much would be offered?

How about art on a very large scale? In October 2010, a giant contemporary art installation was unveiled in the Turbine Hall at London's Tate Modern museum. This was a carpet of 100 million tiny porcelain sunflower seeds, each hand-fired and hand-painted by 1,600 (mostly female) craftsmen from Jingdezhen, the "porcelain capital" of China. The Tate said that the seeds took two and a half years to manufacture.

This was an installation by Ai Weiwei, a Chinese artist also known for his political activism (Ai's story is told later in the book). The seeds were first presented as a tactile experience; visitors could walk on them and touch them. After the first day or so, someone suggested that porcelain dust might be carcinogenic; the exhibit was roped off.

Each of Ai's works has a back story that relates to social conditions or protest. At the Tate opening the story was that the sunflower seed concept

originated with the Cultural Revolution, when Mao depicted himself as the Sun, and his followers as sunflowers whose heads faced wherever he went, to bask in his glory.

Following the Tate show, Ai added additional meanings. One concerned his childhood during the Cultural Revolution, when possession of a large quantity of seeds was a sure sign that the owner was an important member of the Communist Party. A second was that seeds represent a political statement about the relationship between rulers and the ruled in China. During the famine years under Mao, sunflowers were one of the few always-available sources of nourishment.

In November 2010, Ai's Danish Gallery Faurschou, offered for sale an 80-kilogram (176-pound) sack of seeds for €300,000 ($360,000). At Art Basel Miami in November 2010, the Swiss dealer Urs Meile offered two tons of seeds priced at $670,000 per ton. In February 2011, Sotheby's London offered as the first lot in a contemporary art sale a 100-kilogram (200-pound) pile of Ai's seeds with an estimate of £80,000 to £120,000 ($120,000 to $180,000). After spirited bidding, Sotheby's seeds sold at £349,000 ($559,000), three times the high estimate. If you calculate value-by-weight, that price makes Ai's Turbine Hall installation worth about £150 million ($240 million). At the Faurschou "80-kilo sack" price, Turbine Hall is worth much more. Following its show, the Tate purchased 8 million of the 100 million-seed installation directly from the artist with the price unannounced.

Neither Faurschou, Urs Meile, or Sotheby's sales included seeds that were actually part of the Tate Modern show. The meaning of "Ai Weiwei seeds" in these sale contexts is not obvious. Perhaps it was the indirect connection with the Tate show, or the role of Ai as concept-creator, or perhaps it was his political interpretations of sunflowers.

What makes the high prices achieved by dealers and by Sotheby's even more interesting is that 100 kilograms of the same hand-fired, hand-painted seeds can be purchased in Shanghai for about $13,000, and probably in Jingdezhen for a bit less.

A back story for art can relate to the social history of the period: nineteenth-century France for Impressionist painting, 1950s and '60s postwar America for Pop, or the post-Mao transition period for modern Chinese art. Sometimes it is the social history of the artist, embellished by the auction house through the description in the catalog. Michael Findlay cites one of

his favorites, from a Christie's catalog description of a work by Haitian artist Jean-Michel Basquiat:

> painfully aware . . . of becoming a mascot for the genteel and predomi-
> nantly white world of art. It was this fear which would lead to his inse-
> curity, in part coming to fuel his dependency on drugs in the coming
> years, and that would result in his paintings . . . filled with passion, with
> an anger that once again seems linked to the graffiti of his early years.

Findlay comments, "White folks. Fear. Raw energy. Anger. Graffiti. A B-movie script." It is a back story that offers huge opportunity for embellishment when the successful bidder later displays and describes the work for her friends.

When there is little else to use, a back story can relate to a single year. In September 2012, Sotheby's Alex Branczik narrated a video describing an upcoming sale in London of *Yves Klein's RE 9-1* (1961), part of his *Reliefs éponges* series. It was probably difficult to decide what to say about a work that one newspaper critic described as "Small raised donuts [they are actually compacted sponges] glued on a pebbled surface, the whole saturated with blue paint."

So Branczik's video, and the Sotheby's catalog description, focused instead on 1961, the year *RE 9-1* was executed. The work then represented "the same momentous year in history that John F. Kennedy [became] president, the Berlin Wall was constructed, the trial of Adolf Eichmann took place in Jerusalem, and Yuri Gagarin became the first man in space." How a discussion of the events of 1961 related to the sponges, or to a price estimate of £2 to £3 million ($3.1 to $4.8 million), was left to the viewer's imagination. *RE 9-1* sold for £3.8 million ($5.9 million).

Yale psychologist Paul Bloom discusses the idea of context in his 2011 book *How Pleasure Works*. He calls it essentialism: the hidden reality that matters in how we buy, consume, and derive pleasure. Bloom provides examples of experiments by psychologists who manipulate the information people receive to reveal the importance of beliefs about an object and its origins. One experiment reinforces the idea that people will derive greater pleasure from an object, and pay more for it, if they think it was owned or even touched by a celebrity. Bloom uses a less obvious example than Elizabeth

Taylor's jewelry: George Clooney's sweater. Bloom says that when he asks subjects in an experiment how much they would pay for Clooney's sweater, the average offer is a lot more than the cost of a new sweater.

If you tell bidders, "You can buy the sweater but you can't tell anyone that it is from Clooney," the value is decreased. The sweater brings more if unwashed. It brings slightly more dry-cleaned than washed.

Most college art history students have seen a textbook reproduction of *Le Rêve*, Picasso's 1932 portrait of his mistress, Marie-Thérèse Walter. The painting was owned by Las Vegas casino owner Steve Wynn, who paid $48 million for it in 1997 at the historic Victor and Sally Ganz sale at Christie's New York. In 2006 Wynn agreed to sell it to collector and hedge fund manager Steven Cohen for $139 million.

The weekend before the painting was to be shipped, Wynn invited friends to dinner; the group included celebrities David and Mary Boies, Nora Ephron, and Barbara Walters. When Wynn told them about the pending sale of *Le Rêve,* they asked to see it. Wynn suffers from a visual impairment, retinitis pigmentosa, which limits his peripheral vision and renders him a threat to proximate objects. He backed up as he related the back story to *Le Rêve* and put his elbow through Marie-Thérèse's left forearm. After a week the story leaked, with identification of the celebrity witnesses. Every newspaper reported some variation of "Wynn's $40 million dollar elbow," the amount he asked from his insurer, Lloyds of London, to compensate for the decreased value of the painting.

The sale to Cohen was canceled. In eight weeks, Manhattan conservator Terence Mann completed what was reported as a $90,500 restoration (using an interface of acupuncture needles), such that the damage was invisible. Six months later the work was loaned to a major exhibition, where it was the most admired and commented-on Picasso on view.

Protracted negotiations between Wynn and his insurer ensued. Wynn argued that *Le Rêve* was, post-restoration, worth only $85 million. The matter ended up in US District Court in Manhattan. Lloyd's settled with a reported $39 million payment. Lloyd's had no way to recover the loss from anyone else because Wynn was both the insured party and the party that caused the loss.

Art market observers estimated the new value of *Le Rêve* as closer to $175 million, with its expanded back story overwhelming any loss from

minor damage. In March 2013, Wynn completed the sale to Cohen for $150 million.

The nature of our aesthetic appreciation of art is also related to the back story and to authenticity. In 1962 American first lady Jacqueline Kennedy charmed the French Minister of Cultural Affairs, André Malraux, into agreeing to send the *Mona Lisa* on temporary loan to the White House, to be displayed in the West Sculpture Hall, then on to New York's Metropolitan Museum. Officials at Paris's Louvre museum were horrified at Malraux's initiative. The painting was deemed far too fragile to travel; it was already slightly curved, with a small fissure on the rear side. It was feared that any vibration during transport could be harmful.

It turns out the Louvre owns a wonderful copy of *Mona Lisa,* identically framed, and rumored to be occasionally substituted when the original is being inspected or cleaned, so visitors will not be disappointed. Art critic Robert Hughes said he suggested a simple compromise for the Louvre's dilemma; send the replica to Washington. The French response was that news of the substitution would inevitably leak, and Americans would feel resentful for a decade.

Over a million Americans filed past Leonardo's masterpiece. The average wait in line was two hours. Hughes said of the spectacle, "People came not to look at it, but to say they'd seen it. The painting went from art to icon of mass consumption."

How many of the million would have waited in line if they knew they were to view a perfect copy? How many would have been angry to learn they had lined up to see an original that turned out to be a copy? But why would any viewer be offended if they could not describe what it was that they had missed? Malraux agreed with Hughes; he said that most people did not line up to see the *Mona Lisa,* but to later tell friends they had seen it.

A final and dramatic tale of back story and the nature of aesthetic appreciation involves art collector Hermann Goering, Hitler's second in command and designated successor. Reichsmarschall Goering collected art on a massive scale, as did Hitler; each wanted to acquire enough art to open the best museum in Europe.

After the British rout at Normandy, Goering stole, swapped (offering Jewish owners unimpeded passage to Switzerland or Spain), and sometimes purchased thousands of works in occupied France, Holland, and Belgium. What Goering really wanted to acquire was a work by Johannes Vermeer.

He considered Vermeer the most talented of Aryan artists. Goering was also envious because Hitler already had two works by Vermeer.

Goering was tipped off that a Dutch art dealer named Han Antonius van Meegeren seemed always able to locate one of the scarce Vermeers. Goering paid van Meegeren a visit, and he proved a persuasive negotiator.

After a few weeks van Meegeren delivered to Goering a spectacular painting, *The Woman Taken in Adultery* (sometimes translated as *Christ with the Adulteress*). Without negotiation, Goering offered in exchange 200 Dutch paintings he had seized since the beginning of the occupation, and van Meegeren accepted. The works involved in the swap were worth the equivalent of about $11 million; this represented the highest price paid to that date (and for 40 years after) for any painting.

At the end of the war Goering was tried at Nuremberg and sentenced to death. Much of his collection, including *The Woman Taken in Adultery* was found by the Allied Forces Search Art Team. With the work were documents identifying van Meegeren as the source. Dutch authorities arrested him. He was charged with treason for collaboration and for selling national cultural property to the enemy. The penalty on conviction was death.

Van Meegeren confessed, not to treason but to having forged the Vermeer he sold to Goering. He also confessed to forging three other Vermeers, including *Christ and the Disciples at Emmaus*. *Emmaus* was then on display in the Boijmans Gallery in Amsterdam.

At first, no one was persuaded by van Meegeren's story. To prove his assertion, he was allowed to paint another Vermeer in his cell, which he titled *Jesus Among the Doctors*. He showed the court how he mixed a synthetic resin with his pigments and baked the finished canvas in an oven so the paint would be rock hard as after centuries of aging. He explained how he had stripped the paint from seventeenth-century canvases to retain the craquelure and reused the original stretchers. Experts who testified before the court judged his new painting as superior to the one he had sold to Goering.

Charges of collaboration and treason were dropped. Instead, Van Meegeren was charged with forgery, convicted, and sentenced to a year's imprisonment. A week after sentencing he died of a heart attack.

Goering was badly shaken when told that his Vermeer was a forgery. His US Army interrogator noted that when Goering was told of the forgery, "He looked as if for the first time he had discovered there was evil in the world."

The Vermeer was perfect; it produced the same aesthetic satisfaction as if authentic. It performed the job of impressing all of Goering's visitors. Why would this worldly man, awaiting execution, care so much? For five years he had been misled as to the history and context of his favorite work of art, and about its true fitness for the jobs it was intended to perform.

An interesting postscript to this story came after the tale of van Meegeren's fakes was publicized. The year following his death, an experiment took place in front of another Vermeer masterpiece, hanging in the Rijksmuseum in Amsterdam. Researchers queried viewers as to what they saw. Many described deep and intense feelings.

Other viewers were asked the same question, but first provided with an additional back story—that they were viewing one of the famous van Meegeren forgeries. Those viewers expressed none of the intense sentiments. "It is just a picture about another time." Remove the back story and context, leave only the substance of the painting, and you get a very different emotional and visceral response.

Authenticity can be what the artist says it is. Consider Damien Hirst's taxidermy shark. In January 2005 the shark was purchased by Steven Cohen. It was decrepit. The fins were falling off, the creature was gray and mottled, about to disintegrate. Hirst purchased another great white shark of the same size and ferocity as the original, injected ten times the amount of formaldehyde used on the first shark, mounted the replacement in a tank, and swapped it with Cohen for the original, which was discarded. Cohen loaned the new shark to the Metropolitan Museum in New York.

If anyone else had submitted a substitute work of art, it would be rejected as a forgery. This one was accepted by one of the world's great museums. The new shark acquired authenticity, with the same back story and context as the original, because Hirst said so. Those viewing the shark accepted it as original, even though the accompanying museum descriptions revealed it was a replacement.

Our appetite for back stories is not surprising. What is the most common voluntary activity among Americans? It is not socializing, nor is it making love. Studies show Americans devote an average of four minutes a day to sex, and four hours a day to television, movies, books, and computer and video games—to involvement in worlds created by others. Other Western societies are probably similar. It may just be part of satisfying the same appetite when

collectors spend more time telling guests the back story to their art than they spend viewing that art.

By this point the reader has probably realized that a back story is most relevant for an artist who is already branded. For González-Torres or Basquiat, Klein or Hirst, the back story can increase a value already accorded by popular consensus. An interesting back story for a work by Thompson adds nothing.

AUTHENTICATING WARHOL

This may be the first time in history that a signed, dated, and dedicated painting personally approved by an artist . . . has been removed from his oeuvre by those he did not personally appoint.

—Richard Dorment, art critic

The issue of authentication and its relationship to the value of a work of art goes far beyond the *Mona Lisa* and shark examples in the last chapter. Is a work, personally signed and dated by an artist, authentic without question? The artist referred to in the Richard Dorment quote above is Andy Warhol; the painting is from a series of ten identical silk screens created in 1966, each known as a "Bruno B" *Red Self Portrait*. Each of the ten was signed and dated by Warhol.

American collector Joe Simon-Whelan, a close friend of Warhol, purchased a *Red Self Portrait* from dealer Michael Williams in 1989. Two years earlier it had been auctioned at Christie's New York. Several years after the purchase, Simon-Whelan submitted the painting to the Andy Warhol Art Authentication Board. The board was a not-for-profit creation of the Andy Warhol Foundation for the Visual Arts, set up in 1995 and charged with determining the authenticity of works attributed to Warhol.

In 2002 the board concluded "that said work [*Red Self Portrait*] is NOT the work of Andy Warhol, but that said work was signed, dedicated, and dated by him." The board stamped the picture with DENIED on the back of the canvas in indelible red ink.

Simon-Whelan did further research on the provenance of his painting and resubmitted it to the board. It was again stamped DENIED; it became known as the double-denied Warhol. Double-denied created great interest in the art community because, unlike most controversies over the

attribution of a work of art, the *Red Self Portrait* situation initially seemed straightforward.

The issue of authentication gained new importance in the first decade of the twenty-first century. When art sells for millions of dollars, confidence in its attribution can open the door to selling for a fortune. Not having confidence can make a work close to worthless. There has been a shift in the cost-return trade-off of whether to sue an expert who offers a negative opinion on authenticity or refuses to provide a positive one.

In 2003 the Warhol board rejected another *Red Self Portrait,* this one owned by the distinguished London art dealer Anthony d'Offay. This version had an extensive history. It was signed by Warhol, dated, and also inscribed to his Swiss dealer, Bruno Bischofberger, who in 1969 had purchased it directly from the artist. It was included in Rainer Crone's 1970 catalog raisonné of Warhol's work. That catalog was revised and republished three times during Warhol's lifetime, and the artist personally approved the reproduction in color of the work on its cover. He signed a copy of the catalog owned by d'Offay.

The work was sold by Bischofberger to a private collector in Germany and exhibited at the Hamburger Bahnhof Museum in Berlin. During the exhibition, a postcard depicting the image was produced and copyrighted by the Warhol Foundation. The work was later purchased by d'Offay.

D'Offay had promised *Red Self Portrait* to the Tate Modern and the National Gallery of Scotland as part of a 700-work, part-charitable donation and part-purchase arrangement. The package was valued at £125 million ($193 million). D'Offay offered it for £26.5 million ($41 million), the amount he had originally paid, with the valuation balance as the donation. Tate Modern's director, Nicholas Serota, said he believed the Warhol self-portrait to be unquestionably genuine. Nevertheless, d'Offay withdrew it from the package offer.

In fairness, it is difficult to determine the authenticity of some of Warhol's mass-produced images, which include soup cans, Coke bottles, and celebrities. His idea was that art could be mass produced as a commodity, with most (but not all) of his works made by technicians in a studio called The Factory.

His silk screens started with a photograph sent to a lab and transferred to an acetate plate. Warhol worked on the acetate to get the desired look. The

acetate was then used to imprint an image on a silk screen, the most impor-
tant part of the creative process. Then it was printed on canvas. Most of the
steps were carried out by technicians, but it is accepted that only Warhol ever
worked on an acetate. He contracted out the final stage to commercial print-
ers, where workers often ran extra copies in case an earlier one was flawed, or
as part payment for their work, or just because they could.

These working methods make it harder to ascertain what was and was
not a product of the artist; Warhol wanted to blur the distinction between
artist product and mechanical reproduction. Twenty years after his death,
the Andy Warhol Authentication Board was forced to pass judgment on
which works produced by technicians should nevertheless be accepted as
authentic.

The deciding factor appears to be not whether his hand touched the
work, or even whether he approved it prior to sale, but whether there was
the "presence of the artist, whether the work had his direct supervision." I
say "appears to be" because no specific reasons were given by the board at
the time they rejected the Simon-Whelan or d'Offay works, or for most of
the other works they rejected. Scholars disagree on even the "presence of
the artist" criterion; they make the point that it was the practice of blurring
authorship that helped produce Warhol's place in art history.

The board, which interpreted its role as defending the integrity of War-
hol's work, in this case argued that Warhol was not diligent in signing his
work, or in approving the cover of his own catalog raisonné. Georgina Adam
of *The Art Newspaper* said the problem was that "The Foundation wants
Andy Warhol to be a high artist with high ideals; they want him to be like
Leonardo da Vinci. They don't want to think that he just signed a lot of stuff
without even looking at it, but he did."

Following the second "Denied," Simon-Whelan filed a lawsuit against
the Warhol Foundation. At the time of requesting the authentication, he
had signed a waiver that prevented him from ever suing on the usual tort li-
ability grounds of negligence, product disparagement, defamation, or fraud.
Instead he sued under antitrust law, alleging monopolization and market re-
straint. He claimed that the board was denying authenticity of his and other
Warhol art to reduce the supply in the market and protect the value of the
collection owned by the foundation. This became the first antitrust lawsuit
against an authentication board to survive motions to dismiss.

The Warhol Foundation in its defense claimed (and has always claimed) that it and its authentication board are separate institutions and that decisions of the five-member board were independent and arms-length. Some critics questioned this, citing the fact that Joel Wachs, head of the foundation, nominally chaired the board and had the power to appoint its members (although Wachs did not take part in the authentication proceedings). Foundation sales agent and former Warhol assistant Vincent Fremont attended meetings as a consultant. In addition, two full-time employees of the board were paid by the foundation.

The legal waiver that a Warhol collector signed to protect board members from tort lawsuits also explicitly authorized the board to change its mind about the status of a work in the future. That provision was said to produce a chilling effect on any criticism of the board's work from dealers and collectors, who feared they might antagonize board members.

In November 2010 Simon-Whelan abandoned his lawsuit, saying he was unable to proceed against a foundation with assets of half a billion dollars, which had just spent $7 million to defend itself in pretrial proceedings. He signed a settlement agreement in which he explicitly withdrew his complaints relating to breaches of antitrust law. The agreement stipulated that "There is no evidence that defendants have ever engaged in any conspiracy, anticompetitive acts or any other fraudulent or illegal conduct in connection with the sale or authentication of Warhol artwork."

Another Warhol story involves Gerald Malanga, who had worked as an assistant in The Factory. In 2005 Malanga sued artist and collector John Chamberlain who had owned a Warhol painting called *315 Johns,* images of Chamberlain arranged in a large grid. The painting had been authenticated by the Warhol board. Chamberlain says he had sold it privately for $3.8 million.

Malanga asserted that *315 Johns* was not genuine, that it was produced in 1971 by him in his studio in Great Barrington, Massachusetts, as homage to Warhol. He said Warhol never knew of its existence. Malanga said he lost track of the painting; although it ended up with Chamberlain, it belonged to him.

Chamberlain claimed that he acquired the work in an art swap with Warhol. During litigation that went on for five years, the court asserted that it was not bound by the findings of the Warhol Authentication Board.

The Malanga case was settled in April 2011, a day before it was to go to trial. The terms of settlement remain confidential. The Warhol Authentication Board reiterated that it reserved the right to change its opinion about *315 Johns* on receipt of new information, but there is no indication that it reconsidered.

A final puzzle is how to evaluate a *Brillo Soap Pads Box* that Warhol never saw. That issue surfaced with a case involving the late Pontus Hultén, who helped found or shape the Moderna Museet in Stockholm, the Pompidou Center's Musée National d'Art Moderne in Paris, and the Los Angeles Museum of Contemporary Art (LAMoCA).

Hultén claimed that Warhol authorized the production of 100 Brillo boxes for an exhibition that Hultén curated in Stockholm in 1968, and that Warhol gave him a cardboard box template to use. Fifteen wooden Brillo boxes were painted and silk-screened in Sweden. There was not enough time to produce others for the show, so Hultén ordered 500 cardboard boxes from the Brillo factory in Brooklyn, New York. These were stacked on both sides of the entrance to the exhibition.

Another 105 wooden boxes were produced for Hultén several years later, for a 1990 Pop Art exhibition in Russia. Hultén said he was authorized by Warhol to extend the series. The boxes were made by two carpenters at the Malmö Konsthall gallery in Sweden and later exhibited in 1992 at a Bonn museum where Hultén was artistic director.

Many of the wooden boxes were later sold. In 1994 the Belgian dealer Ronny van de Velde purchased 40 boxes from Hultén for £640,000 ($992,000). Van de Velde then applied for and received authenticity stamps from the Warhol Authentication Board. In 2004, London dealer Archeus Fine Art purchased 22 boxes for a reported £650,000 ($1.2 million). Gallery owner Brian Balfour-Oatts approached the board prior to purchase; the board confirmed the boxes as genuine. Archeus immediately sold ten boxes to Anthony d'Offay, through Christie's, for £476,000 ($737,000). The remaining boxes went to an American collector for an undisclosed amount.

The board learned in 2007 that only cardboard boxes had actually been exhibited in Stockholm. It reclassified the fifteen wooden boxes made around the time of the show as "Stockholm type-boxes" and referred to them as "exhibition-related copies." The later wooden boxes are reclassified as "Malmö type boxes;" the board referred to them as "exhibition copies." The board did not revoke the already-issued certificates of authenticity, but

their use of the word "copies" was thought to convey the same impression. The cardboard boxes actually shown in Stockholm would now be considered authentic and would be very valuable had they not been discarded after the Moderna Museet show.

Neither set of wooden boxes, nor the cardboard boxes, were made by Warhol, supervised by him, or ever seen by him. The deciding factor in this case was whether they had been on public display in Stockholm in the Warhol-authorized exhibition.

None of the five most expensive Warhol works sold at auction, including *Green Car Crash* (1963), which sold in 2007 for $71 million, and *Men in Her Life*, mentioned in the first chapter, which sold in 2010 for $63 million, has ever been submitted for authentication. As reported in *The Economist,* the most expensive known Warhol to have sold privately, *Eight Elvises* (1963) brought "over $100 million" in 2008 and was also never submitted to the board. At the highest levels, owners were either not willing to take a chance on a decision or believed collectors were not deterred by the lack of one. The five auctioned Warhols, the *Eight Elvises,* and all the works from his most important period (1960 to 1965) are listed in his catalog raisonné. What authentication would have added is assurance that the work examined is the same one listed in the catalog.

If authenticating a Brillo box is that complicated, how do you authenticate conceptual art? Think of Felix González-Torres's installation of blue wrapped candy, auctioned by Phillips and described in the first chapter. Visitors are expected to eat the collector's candy until most of the installation is consumed. Then the collector orders more. How do you authenticate a pile of candy that has been refreshed many times?

The answer is that with the original purchase the collector acquires a certificate of authenticity that proves the work is directly descended from González-Torres. It is the certificate that can be sold or traded. Lose the certificate, and the collector can only hope to find someone to reissue it. Otherwise, the collector is out of luck—no insurance company will issue a policy on the paper certificate.

Much of the insistence on authentication comes from museums. No museum aspiring to have a representative collection of contemporary art can be without at least a small sample of Warhols. But few curators will take the reputational risk of buying, or even publicly accepting as a gift, an

unattributed work that might later become controversial. At the same time, several major museums have forbidden their curators from giving opinions on authentication matters, with or without a legal release.

A final example of real-versus-not involves Peter Brant, who took 16 individual 20 × 16-inch Warhol *Jackie* paintings and assembled them into one larger *Sixteen Jackies,* offering it at Sotheby's New York in May 2011. Warhol had produced five Jackie grids; this was not one of them. If the component paintings were authentic, was the assembly authentic? The board was never asked for their opinion. Estimated at $20 to $30 million, *Sixteen Jackies* sold at auction for $20.2 million, with two bidders.

In October 2011 the Warhol Authentication Board announced it would close. President Joel Wachs said the decision was motivated by the legal costs of defending their decisions. He said at the time, "It's absurd, we want our money to go to artists, not lawyers." The board cost $500,000 a year to operate, with legal fees amounting to many millions. The funds came from sale of Warhols owned by the foundation.

When asked who would authenticate Warhols after the board's dissolution, Wachs said it would be "the same process used for all artists." That involves seeking opinions from recognized experts on the artist's work, and looking at provenance—who has owned it, who has shown it, and what labels are on the back.

With or without a board, the issue of authentication remains. Thomas Hoving, former director of the Metropolitan Museum of Art in New York City, once estimated that up to 40 percent of the high-end art market is made up of forgeries. These are not restricted to Old Masters; there are fake Damien Hirst spot and spin paintings, unauthorized piles of Félix Gonzáles-Torres candy, and a great many Warhols that never saw the inside of the Factory.

The art market functions only if there is confidence that works are authentic. Other than the decision of an authentication board or the judgment of a dealer or an auction specialist, the other way of creating confidence is a catalog raisonné entry.

A catalog raisonné is a scholarly undertaking, a compilation of all of an artist's works that the compiler is willing to verify. The catalog is usually prepared by an expert who has no economic interest in the artist's work. The evaluator starts with a visual examination to determine if the work "looks and feels" right, and then focuses on composition, brushstroke, and

the signature. He tries to reconstruct the ownership history of the work. A final inquiry can be undertaken by a forensic scientist, using tools such as an electron microscope to check the composition of pigments. An opinion is then rendered. A positive opinion results in the work's inclusion in the catalog, with information about any exhibitions, books, and articles in which it is mentioned. If the work is considered not authentic, only the current owner is informed. The work is returned unmarked.

Since so much is dependent on inclusion in the catalog, pressure by owners to have their work listed may take the form of threatened or real lawsuits. As far as I know, litigation to force inclusion of a work in a catalog has so far been unsuccessful, but the time and money involved to defend a suit are daunting. Sometimes even delay leads to the courts. The owner of Jean-Michel Basquiat's *Fuego Flores* (1983) sued the artist's authentication board for either an immediate decision or payment of $5 million in damages. The lawsuit was dismissed. The board then declared the work authentic.

The result of these many threats is that all experts become reluctant to provide opinions about authenticity. Peter Stern, a prominent New York art lawyer, recommends to clients that they never volunteer an opinion about any art work unless the owner signs a comprehensive waiver promising not to sue. Jack Cowart, executive director of the Roy Lichtenstein Foundation, says that when an auction house calls to ask for his expertise, he "savours the surrealistic moment," then recommends other authorities in the field. Martin Harrison, editor of the Francis Bacon catalog raisonné, will now comment on a suspect work only that "it is unlike any authenticated work."

The concern goes beyond formal authentication. In 2012 the Courtauld Institute of Art in London arranged an academic debate on 600 drawings attributed to Francis Bacon. The debate had to be canceled a week before it was scheduled to take place, because many of those invited declined due to "the possibility of legal action."

Other authentication boards have been dissolved because of liability concerns. The Roy Lichtenstein Foundation and the Noguchi Museum in New York have both stopped authenticating work. Each moved their catalogs online and labeled attributions as "works in progress." The Pollock-Krasner Authentication Board, formed by Jackson Pollock's widow Lee Krasner, was terminated in the late 1990s after litigation with collectors claiming their Pollocks were genuine. One dismissed lawsuit involved a man with a painting signed "Pollak." The Basquiat estate authentication committee

disbanded in 2012 after 18 years in existence and the review of 2,000 works of art.

In continental Europe, the job of authentication is administered by the artist's heirs. They inherit and can bequeath the "moral right" to pronounce on authenticity, and to seize and destroy fakes. This leads to a mishmash of authentication, some diligent, some less so. The widow of French painter and sculptor Henri Léger was said to automatically reject any work—and there were many—that her husband had painted for his other female companions. There is now a category of Léger work described as "rejected, presented to lovers." That is not just a European phenomenon. In 2012, Lee Krasner refused to authenticate *Red, Black and Silver,* consigned to auction by the estate of Pollock's late mistress Ruth Kligman.

Sometimes a board delivers unexpected good news. In November 2009 Sotheby's New York offered a 1965 Warhol *Self-Portrait* that the artist had in 1967 signed and given to teenager Cathy Naso, who worked in various after-school part-time jobs in The Factory. Concerned that her gift might be stolen, Naso secreted it at the back of a closet in her family's Connecticut home. It remained there for four decades. It was never recorded in Warhol's catalog raisonné, and was submitted to the Authentication Board with only the oral history presented here. The board stamped it authentic. It was estimated by Sotheby's at $1 to $1.5 million, and was hammered down to collector Laurence Graff for $6.1 million.

COLLECTING AND INVESTING

MUGRABI, SAATCHI, SANDRETTO, AND THE VOGELS

Today people believe more in art than in the stock market.

—Jose Mugrabi, art dealer

You become a collector when you buy a painting and realize that you have no more room on your walls to hang it.

—Michael Findlay, art dealer

The great early museums—the Hermitage, the Prado, and the Louvre—had as their patrons monarchs and princes of the church, who were motivated by the belief that art equals civilization. The entrepreneurial collector as museum patron, Abby Aldrich Rockefeller at MoMA or Joseph Duveen at Tate Britain, is a more recent development.

We understand what motivates a collector to seek immortality with a museum wing in his or her own name. But absent that, what motivates an individual to assemble a vast collection of contemporary art, more than could ever be properly shown in multiple homes and involving the expenditure of jaw-dropping amounts of money? An obvious condition is that the collector possesses jaw-dropping amounts. A modest Warhol might cost two weeks' income for a successful hedge fund operator. Put that in perspective. Many readers would happily pay two weeks' income for a work of art they loved.

What other motives are there? What job does art-in-bulk do for collectors at any level? Should we simply accept the insight of historian Kenneth Clark: "Asking why one collects is like asking why we fall in love; the reasons

are various." What follows are four stories of collectors who differ in their motivations for collecting and in their financial resources.

New Yorker Jose Mugrabi and his sons Alberto and David illustrate how individuals with great wealth can become art market participants who influence prices. The Mugrabis have the biggest Warhol collection in the world outside of the Andy Warhol Museum in Pittsburgh. The count is at least 800, with some estimates higher. Jose Mugrabi was the consignor of Warhol's *Men in Her Life,* which sold at $63 million.

Jose, 73 at the time of writing, is the son of Syrian Jews who ran a grocery store in Jerusalem. At the age of 16 he was sent to Bogotá, Colombia, to live with an uncle and work in the fashion industry. At 22 he started a wholesale fabric business that flourished. Colombia, he says, was a dangerous place to raise children. "A little kidnapping, you have to go with a bodyguard, you have to have an armored car." The family moved to New York.

The transition from textiles to art started in 1987, four months after Warhol's death. Mugrabi was visiting Art Basel when he saw his first paintings by the artist. "I liked the pictures," Jose says, "the paintings impact me. The feeling I had about the others, nothing. Then [with Warhol], I feel something." Jose bought the four-painting Warhol version of da Vinci's *Last Supper* for $144,000 each. In 2009 he estimated their value at $4 to $6 million.

The Mugrabis built their collection over 25 years. They credit their collecting model to Charles Saatchi, an English art patron turned private dealer (his story is next). But Saatchi purchased multiple works from a great many artists while the Mugrabis collect only a preferred few.

Jose's interest lies with the Pop movement. Alberto, 42, and David, 40, are more interested in younger artists like Damien Hirst, Richard Prince, and Jeff Koons. Jose describes the family's preferences as artists who represent what America gives the world (Warhol's *Coca-Cola*), or artists that represent its commercial culture (Prince, Koons, Hirst, and Basquiat).

The family is best known for their Warhols. Beyond those, the Mugrabis own what is believed to be one of the most valuable private collections of contemporary art in the world. It includes 3,000 works; 100 or more by each of Hirst, Basquiat, George Condo, and Tom Wesselmann. Before the 2008 economic downturn, the Mugrabis estimated the value of the collection as "approaching a billion dollars."

The family are private dealers on a massive scale. "We're market makers," Alberto is quoted as saying. "You cannot have an impact buying one or two pictures per artist. We want inventory; [it] gives you staying power." In the commodities sector, an analogy would be controlling enough of the futures market in silver to be able to move the price. The Mugrabis buy and sell works directly, through dealers, and in as many as 50 auctions a year. During contemporary auction weeks in New York, the family has been known to have 30 works offered among three auction houses.

During the 2007–2009 art recession, David Mugrabi said the family did a lot more buying and much less selling. In November 2008 they acquired Warhol's *Marilyn (Twenty Times)* (1962) for $3.98 million. In 2013 the painting might be worth more than $40 million. A few months later, and for under $5 million, they purchased 38 Warhols bearing images of Marilyn Monroe from Zurich dealer Bruno Bischofberger. "A down market is when you find bargains."

In 2009 the Abu Dhabi Royal Family reportedly offered the Mugrabis "several hundred million dollars" for their 15 best Warhols, including *Marilyn (Twenty Times),* for the planned Abu Dhabi Guggenheim Museum. Jose reportedly countered with a price of $500 million and was turned down. Alberto has said that nearly everything in their collection is for sale. "If we don't want to sell a picture, we ask like three times what the estimate would be." In the Abu Dhabi case, $500 million was probably not far off the 2009 market value and a bit less than the value of the 15 in 2013.

It is accepted in the art world that the Mugrabis and one or two others account for 30 to 40 percent of all Warhol purchases at auction each year. The family attends most major evening contemporary auctions. Jose is famous for his auction uniform: blue jeans, a black T-shirt, and a baseball cap. He never bothers with an auction paddle; the auctioneer knows who and where he is. Although most important collectors bid from the privacy of an auction skybox or via telephone, the Mugrabis want to be seen as involved when a Warhol comes up. They want a visible bidding war, not a bargain. Dealer Francis Naumann says, "What threatens them at an auction is not the presence of other aggressive bidders, but cautious bidders." Alberto said, "If it's good for Christie's and Sotheby's, it's good for us."

Northern California art dealer Richard Polsky says that in 2006 he consigned a Warhol *Flower* painting. "The estimate was $1 million, but the

Sotheby's auctioneer made it clear that the Mugrabis would be in the audience and would like to see it get $1.5 million. And that was almost exactly what it ended up selling for." The Mugrabis apparently bid until *Flower* reached the desired price point. Jose Mugrabi defends his efforts to prop up prices rather than seeking bargains as being in the best interest of other Warhol collectors and the market in general.

Most of their collection is stored in two warehouses, one in Newark, New Jersey, the other in a duty-free zone in Zurich. The warehouses are required not only because of the number of works, but also because some have special storage needs. For example, Damien Hirst sharks and sheep in tanks need to be dismantled and refrigerated. Unlike others who have assembled huge collections—Charles Saatchi, or Don and Mera Rubell in Miami—the Mugrabis have no plans to open a museum of their own.

The family's influence is such that an artist or art trend is sometimes described simply as "That was bought by the Mugrabis," or "The Mugrabis did not want it." Because of the number of times Warhols appear at auction, his prices have become, according to *The Economist,* a bellwether for the art market, the Dow Jones index for contemporary art prices. This raises the question, What happens if the Mugrabis, for whatever reason, decide to dump Warhol, or Hirst, or Basquiat, or one of their other artists-held-in-bulk, and the word becomes "The Mugrabis are selling"? Would that shake confidence in the entire contemporary art market? Would other Warhol collectors-in-bulk—Peter Brant or S. I. Newhouse, for example—also bail because no one wanted to be last out the door?

Charles Saatchi is Britain's most prominent collector of contemporary art. He has been described both as the greatest art patron of his time and as an art commodity broker disguised as a patron. He is the only modern collector to create an art movement. The success of the yBas (Young British Artists), the first internationally recognized art movement in postwar Britain, was in large part due to his acquisitions and the resulting publicity.

Media articles, auction houses, and collectors describe a piece of art or an artist as "collected by Saatchi," or "owned by Saatchi," or "coveted by Saatchi." As with the Mugrabis, each description is likely to drive up interest and prices for the artist. Less fortunate is an artist labeled as "sold off by Saatchi."

Jose Mugrabi describes Saatchi as the first and best-known example of the collector-dealer who also performs the roles of curator and publicist. Saatchi fills other roles. He was curator, financial backer, and owner of the art shown at the 2006 *USA Today* exhibition, and earlier at the 1997 *Sensation* show, both at the Royal Academy in London. In each case, Saatchi contributed to the cost of the installation in return for freedom in curating and installing art that he owned.

For 20 years Saatchi displayed his art in an old factory space in St. John's Wood in London. In 2001 he moved his art to the Saatchi Gallery, located in the former home of the Greater London Council at County Hall, halfway between the Tate Modern and Tate Britain museums. He showed Hirst's shark and Tracy Emin's *My Bed*—an unmade bed complete with underwear and condom wrappers, where Emin spent four days contemplating suicide. He also showed work from artists just months out of art school.

When Saatchi purchases an artist's work, or displays it in his gallery or loans it to other museums, the cumulative effect is to validate the work and the artist. Each stage also increases the value of Saatchi's holdings. Over time he has sold many of his pieces, sometimes in quantity, and often at huge profit. Saatchi has always been generous in lending art to museums for exhibitions, although often with the condition that additional pieces he owns also be accepted and shown.

In April 2006 Saatchi established an Internet site called Saatchi Online (www.saatchionline.com). It allows posting of art work for sale from around the world, accompanied by the artist's biography and contact details. There are weekly curated online shows selected from the work submitted. The site acts as a payment intermediary in return for a 30 percent commission on the selling price. It shows 50,000 artists and draws 76 million page-hits a day, with reported average sales of 800 works a day. Saatchi Gallery director Rebecca Wilson has said that the gallery "sells more art in a month online than most bricks-and-mortar galleries do in a year." Saatchi Online may be the most important innovation ever for new artists and beginning collectors.

In 2007 Saatchi and auction house Phillips de Pury struck a unique deal. With the new Saatchi Gallery about to open on King's Road in the Chelsea area of London, they agreed that the gallery would drop its planned admission charge of £9.75 ($19) and become "the first completely free, major

contemporary art museum in the world." Phillips would offer a subsidy, said to be £2.50 ($5.25), for each visitor.

Simon de Pury estimated that with free admission, first-year attendance would go from 600,000 (the level at the former Saatchi Gallery in County Hall) to over one million. In return, Phillips would be featured on the Saatchi website, providing exposure to young artists and collectors. Phillips was allowed to have an exhibition space within the gallery and to offer temporary selling shows.

There was an informal agreement that Saatchi would use Phillips when selling works at auction. According to de Pury, "They would naturally return the loyalty and support we have shown in enabling the Saatchi Gallery to be free for all exhibitions." The agreement was not exclusive; Charles Saatchi attracted notice in 2010 when he consigned two Martin Kippenberger paintings to Christie's instead of Phillips.

Another part of the agreement involved auctions. For each of six Phillips evening contemporary sales—three in London and three in New York—the firm attempts to attract 70 to 72 important consignments, plus lower priced work for the accompanying day sales. When the number of consignments fell short, Saatchi would offer art from his 3,500-piece collection. The works were sometimes listed with the provenance of having come from Saatchi or been shown at the Saatchi Gallery. On occasion, close to 25 percent of a Phillips auction was composed of work consigned by Saatchi. Saatchi's seller's commission (assuming he was required to pay one, which is unlikely) and the buyer's premium went to Phillips as an offset to their Saatchi Gallery subsidy.

Phillips withdrew from the Saatchi agreement in April 2011. The gallery sponsorship has been taken over by three financial institutions: BNP Paribas, Deutsche Bank AG, and Standard Chartered Bank.

In July 2010 Saatchi offered to donate his gallery lease and £25 million ($40 million) in art to the British nation, with the gallery to be renamed MoCA London. Saatchi first held talks with Arts Council England, the organization that represents the government in funding cultural groups, but negotiations broke down over whether Saatchi could retain the right to sell and then replace works from the donated art.

The Mugrabis and Saatchi are passionate about art, but seem to view it principally as a business. For collecting driven purely by passion, a

great example is Patrizia Sandretto Re Rebaudengo, 53, from Turin, Italy. Re Rebaudengo is the surname of her husband Agostino, scion of an important Piedmont family. Sandretto Re Rebaudengo started collecting in 1991. Her hobby became a passion and evolved to being close to a full-time career.

In 1992 she took her two young sons to the Kunstmuseum in Bonn and observed, "It was such a joy to see families enjoying the arts." She realized that Turin had no similar place where contemporary art could be enjoyed by everyone, and she decided to create one. In 1995 she founded the Italian contemporary art foundation, Fondazione Sandretto Re Rebaudengo, initially to share her own expanding collection with the world. Her first show was *English Art Today,* with Damien Hirst, Douglas Gordon, Julian Opie, and Anish Kapoor.

Why begin with British artists? After starting her collection with sculpture by Italians Mario Merz and Piero Manzoni, she visited London in 1992 and was taken by Nicholas Logsdail of Lisson Gallery for a tour of artist studios. She reacted as enthusiastic collectors (with resources) do. She fell in love with what she saw and brought to Turin works by Opie, Gordon, Tony Cragg, and two major works by Kapoor. Damien Hirst and other British artists came later.

That was the beginning. She later developed relationships with artist Robert Fisher, who produced site-specific work for her in Turin, and with California video artist Doug Aitken, who produced *Electric Earth,* a video that won the International Prize at the Venice Biennale in 1999.

Later she focused her patronage on women artists and those from economically and socially troubled nations, notably Palestinian artist Mona Hatoum. In 2004 the Fondazione's entire exhibition cycle was devoted to women.

Collecting and loaning works for shows was not enough. "I thought I could do more." In 1997 her Fondazione set up its first gallery in the family's eighteenth-century palazzo in Guarene d'Alba, a small town outside Turin. In September 2002 the Fondazione opened a center for contemporary art in the São Paulo district of Turin, in a converted derelict factory. It has gallery space, a bookstore, an auditorium, and a café—the latter accessible from the street so it could be used as a neighborhood meeting place.

Her gallery now has 1,100 works of painting, sculpture, photography, video, and installation representing 40 Italian and foreign artists. Francesco

Bonami, a well-known curator, is artistic director of the foundation, but Sandretto Re Rebaudengo has final approval of every purchase.

The Fondazione lends works to exhibitions around the world. In 2012 it provided work to London's Whitechapel Gallery for a series of three exhibitions. The first included what became the featured work, Maurizio Cattelan's 1996 *Bidibidobidiboo,* a lifeless squirrel slumped on a kitchen table, surrounded by an empty liquor glass, unwashed dishes, and the suicide gun (illustrated). The title comes from the Fairy Godmother's song in *Cinderella.* The question posed: What forced this poor creature to such a desperate end?

Richard Armstrong, director of the Guggenheim Museum, to which Sandretto loaned six works for its 2011 Cattelan exhibition, says, "You observe her life force, from which derives her willingness to share, her curiosity and her pleasure in art." Nicholas Logsdail says, "Look at the quality of what she's done, it is bloody marvelous."

Passion-driven collecting not supported by great financial resources is exemplified by Herbert and Dorothy Vogel. Herbert, born in 1923 to a Russian immigrant garment worker, served in the US Army and then joined the US postal service as a night-shift mail sorter. Dorothy, 13 years younger, was a librarian with the Brooklyn Heights public library.

They had no children. They lived in a small, rent-controlled apartment on Manhattan's Upper East Side. They had no car, and they took no vacations. Their night out was a trip to a nearby Chinese restaurant. Their living expenses were met by Dorothy's modest salary. Herbert earned $23,000 a year; that was their art purchase budget.

They attended art openings. Dealers describe their approach as surrounding and double-teaming the artist. They would recount their passion for art, emphasize their lack of money, and sometimes bemoan their short stature, until the artist agreed to sell to them directly, provide a discount, and allow them to pay in installments. They avoided gallery fees, which did not endear them to dealers.

In the process, they made friends with emerging, little-known artists: Franz Kline, Barnett Newman, Jackson Pollock, and Mark Rothko. They bought works by Donald Judd, Richard Tuttle, and Sol LeWitt. The latter became their mentor. Their collection eventually also included works by Roy Lichtenstein, Robert Mangold, and Cindy Sherman.

Sometimes artists rewarded their passion by presenting them with a work. One report had them receiving a collage from environmental artist Christo in return for cat-sitting. They preferred works they could carry home on the subway or, as a last resort, by taxi.

Over 30 years they amassed an astonishing collection: 4,500 works of minimalist and conceptual art. They stored as much as they could in their one-bedroom apartment, on walls, in their one closet, and under their bed. As their collection grew, they got rid of their sofa and much of their other furniture to make space. Dorothy Vogel always denied the art world tale that she kept art in her oven.

Mike Wallace visited their small apartment to report on their collection for the TV show *60 Minutes.* Sotheby's James Stouraton included them in his 2007 book, *Great Collectors of Our Time,* along with the Rockefellers, Rothschilds, and Gettys. In 2008 there was a television documentary, *Herb and Dorothy.*

In 1992, after Dorothy's retirement, they presented their collection to the National Gallery of Art in Washington; they chose that institution because it charges no admission. Three months were required to transport the art. In an interview with the Associated Press, Herbert said he and his wife had long realized they could become millionaires. "But we weren't concerned about that aspect; we are caretakers rather than owners." They never sold a work.

Their names are carved into the benefactors' wall in the atrium of the National Gallery. To thank them for their bequest, the gallery presented them with a small annuity. They used it to start collecting again. Herbert Vogel, art connoisseur, died in May 2012 at the age of 89. He is survived by Dorothy and one cat.

These four examples represent a range of motivations and resources for collecting. Of these, the Mugrabis and Saatchi rank high in annual published lists of top contemporary collectors. Below is my consensus list of 22 top collectors.

Number one on most lists is Sheikh Saud bin Mohammed bin Ali al-Thani and his daughter Sheikha al-Mayassa al-Thani of the Qatari Royal Family. The Sheikh, who in 2013 retired in favor of his son, collected Islamic art, Arabic art, fine jewelry, and photography. The Sheikha is more interested in contemporary art; she is discussed later in the book.

THE 22 TOP COLLECTORS
(IN ALPHABETICAL ORDER)

Roman Abramovich and Dasha Zhukova, Moscow and London (steel, mining, professional soccer, and investments). Abramovich has paid record prices for his modern and contemporary holdings. In 2008, Zhukova opened the Garage Center for Contemporary Culture in a huge former bus depot in Moscow.

Bernard and Helene Arnault, Paris (luxury goods, LVMH). *Forbes* magazine has named Arnault Europe's richest man. He is building a museum designed by Frank Gehry, the Louis Vuitton Foundation for Creation, in Paris's Bois de Boulogne.

Leon and Debra Black, New York (investment banking). Leon Black is a private equity investor, a philanthropist, and the purchaser of *The Scream,* the most expensive work ever sold at auction.

Peter Brant and Stephanie Seymour, Greenwich, Connecticut (newsprint manufacturing). They have a contemporary art collection that is heavy on Andy Warhol. On their front lawn is Jeff Koons's topiary *Puppy,* a version of which once sat in the plaza outside Rockefeller Center in Manhattan. At the front of the grounds is an old stone barn, now the Brant Foundation Study Center, housing curated exhibitions of the family collection.

Eli and Edythe Broad, Los Angeles (financial services and housing development). Broad is the founding chairman and principal supporter of Los Angeles's Museum of Contemporary Art and creator of the Broad Art Foundation, which has loaned work to 400 museums throughout the world.

Steven and Alexandra Cohen, Greenwich, Connecticut (hedge funds). Cohen is the owner of Damien Hirst's *Shark* and Jasper Johns's *Flag* (the latter reportedly purchased in 2010 for $110 million). Other acquisitions include Andy Warhol's *Superman* at $25 million, de Kooning's *Woman,* purchased privately from David Geffen for a reported $137.5 million, and Picasso's *Le Rêve* from Steve Wynn for $150 million.

David Geffen, Los Angeles, a record producer and founder with Steven Spielberg and Jeffrey Katzenberg of DreamWorks SKG, has a $1 billion collection of contemporary art. In 2006 he reportedly sold four works, including Pollock, De Kooning, and Johns, for $421 million.

Laurence Graff, Gstaad, Switzerland (jewelry). Graff is an English jeweler best known as a supplier of gems to the wealthy. He owns a famous Warhol, *Red Liz.*

Kenneth and Anne Griffin, Chicago (hedge funds). The Griffins' most publicized acquisition was Jasper John's *False Start* from David Geffen for a reported $80 million. The family has made substantial donations to the Art Institute of Chicago.

Bidzina Ivanishvilli, Tbilisi, Georgia (banking, industrial enterprises). Ivanishvilli is prime minister of the former Soviet state of Georgia and owner of an art collection featuring many works by Picasso and Freud. He purchased Picasso's *Dora Maar au Chat* (1941) for $95.2 million at Sotheby's in 2006.

Dakis Joannou, Athens (hotels and construction). He is the founder of the Deste Foundation in Athens, which promotes contemporary art and culture.

Jose Mugrabi and family, New York (art dealers).

Samuel and Victoria Newhouse Jr., New York (publishing). S. I. Newhouse is the chairman and CEO of Advance Publications, which owns Condé Nast, publisher of *Vogue, Vanity Fair,* and *The New Yorker* magazines. For many years Newhouse has been listed by *ARTnews* as one of the most important art collectors in the world; at one time he owned Jackson Pollock's famous *No.5, 1948.*

Philip Niarchos, Paris, London, and Saint Moritz (shipping and finance). Niarchos is a Greek shipping heir and board member of the MoMA in New York. He owns contemporary works by Basquiat and Warhol, as well as Vincent van Gogh's *Self-Portrait with a Bandaged Ear.*

François Pinault, Paris (luxury goods, PPR and auctions). Pinault owns Chateau Latour, Yves Saint Laurent, and Christie's auction house. His art collection is valued at $1 billion and includes in-depth holdings of Murakami, Cy Twombly, and Sigmar Polke.

Victor Pinchuk, Kiev, Ukraine (steel, investment advisory). He is the founder of the Pinchuk Art Centre, one of the largest centers for contemporary art in Eastern Europe.

Mitchell and Emily Rales, Potomac, Maryland and New York (manufacturing). Rales is the founder of the by-appointment-only Glenstone Art Museum in Potomac, 15 miles (26 km) from Washington. In 2015 a new building will open, five times the size of the current one, and Glenstone will become a major destination to view contemporary art.

Don and Mera Rubell, Miami and New York (medical practice). The Rubell Family Collection in Miami, Florida, is one of the world's largest, privately owned contemporary art collections.

Charles Saatchi, London (advertising and art dealing).

Lily Safra, London and Monaco (inheritance). She was the purchaser of Alberto Giacometti's *Homme qui marche 1*, at Sotheby's London in February 2010 for $103.7 million.

Sheikh Saud bin Mohammed bin Ali al-Thani and daughter, Doha, Qatar, and London (government).

Steve Wynn, Incline Village, Nevada, and New York (gambling resorts). Steve Wynn is a major collector and art patron, whose collection has been shown in several of his Las Vegas casinos.

The collector list changes constantly; many individuals go through a collecting cycle. They establish an emotional connection with a particular school of art, build a collection, donate art to museums, and after a few years, move on to other passions. The magazine *ARTnews,* which each year publishes a list of the top 200 collectors, says about a third of the names in any year will have been replaced by others in five years.

CONTEMPORARY ART
AS AN ASSET CLASS

Works of art, which represent the highest level of spiritual production, will find favor in the eyes of the bourgeois only if they are presented as being liable to directly generate material wealth.

—Karl Marx, philosopher

If some of the most expensive contemporary art is purchased for speculation, does that imply that art should be considered a good investment? Can contemporary art fill other financial objectives, for example, as a currency hedge or inflation shelter? Is the art trading success of the Mugrabis or Saatchi the rule or the exception?

Since 2007 the Luxembourg office of professional services firm Deloitte Touche Tohmatsu Limited (Deloitte) has organized an annual conference on art and finance. Why Luxembourg? It is the home of many art investment funds for the same tax and discretion reasons the Grand Duchy is a center for other investment vehicles.

A central issue at each conference has been the role of contemporary art as an asset class alongside equities, bonds, and real estate. Most conference attendees, and most financial analysts, respond negatively to the idea of contemporary art either as an investment or as an asset class. Contemporary art is described as high risk, illiquid, opaque, and fad-and-fashion driven. All art has high transaction, storage, and insurance costs. Art markets are essentially unhedgeable. Finally, there are always issues of authenticity.

In spite of all these concerns, the number of art investment funds has grown substantially in recent years. Deloitte estimated that at the end of 2012 there were 47 funds operating, with $1.6 billion in assets. Most were in the United States and United Kingdom. In China (where there is little

regulation of such funds) there were 63, offered by banks, trust companies, and asset managers, with these representing about half the world's art-related assets under management. There were a few other funds in each of Russia, Dubai, Brazil, India, and South Korea.

Deloitte cites total funds under management as $960 million. This is suspect, because some of the Russian and Chinese funds allow investors to contribute art rather than capital, often without independent valuation. Several funds invest in the work of only one emerging artist, a form of artistic venture capital speculation. But whatever the actual total, there is no question that art is being used as an investable asset class.

Most art investment funds are unregulated and best described as "cautious" in terms of the amount of information they provide. Two-thirds of the funds I have tried to track no longer exist. Some—Fernwood, Chase, Merrill Lynch's Athena Fund, and Christie's Fund among them—simply were unable to raise hoped-for capital of $75 to $125 million each. Others, such as Castlestone's and the Emotional Assets I Fund, were abandoned. One fine art consultancy estimated that 20 of the 50 funds it was tracking failed or disappeared during just six months of the 2008 art market crash.

Still, new funds keep coming. The typical art fund prospectus specifies acquisition of modern and contemporary art works at $1 million and over, with a 15 percent annual target rate of return, a 2 percent per year management fee and a 20 percent performance fee levied on returns above the target amount. A few funds say they would permit major investors to display art works in their homes.

Each prospectus emphasizes that art investment is more tax-efficient if done within a fund. Many countries tax capital gains on art and collectibles at a higher rate than on other investments; in the United States there is a federal rate of 28 percent on fine art versus 15 percent on stocks and bonds. An art fund operating out of New York but registered in an offshore domicile such as the Cayman Islands or Luxembourg pays no capital gains taxes in that jurisdiction. The entire profit can be reinvested in further art purchases or be distributed as a dividend to shareholders to be taxed at a lower rate.

The degree to which tax rates impact art investment was apparent in the November 2012 New York auctions, which came the week of the presidential elections and represented the last chance to divest art at a major auction during the 2012 tax year. Tobias Meyer of Sotheby's said that major

consignments from Peter Brant, Steven Cohen, Steve Wynn, and television impressario Doug Cramer were motivated in part by a concern that a re-elected president and Congress might raise capital gains rates on fine art. Each of these collectors consigned a work valued in excess of $10 million.

Generally funds (and the Mugrabis) say their investment strategy is to buy and hold for a minimum period of five years. A couple of funds have tried to include a ten-year investment lock-in period, but few investors were willing to commit for that length of time. Most funds have a shorter lock-in period, others make withdrawal subject to a 90-day waiting period.

The most important concern with all funds is the level of price appre-ciation required. To cover management fees, transaction costs when dealing through an auction house or dealer, and storage and insurance costs, the whole art portfolio has to earn at least 10 percent a year, and probably 15 percent, just to break even.

There is also the issue of whether a fund can pursue high returns and at the same time offer liquidity when an investor needs to redeem. What hap-pens if there is a stock market recession and art markets decline? Will there be investor redemptions and resulting forced art sales? Will fund managers sell appreciated art from the portfolio, then manufacture good short-term financials by hanging on to underperforming art, valuing it at acquisition cost?

A target rate of 15 percent return each year above those costs means a fund (or any art portfolio) has to at least double in value every five years. It is not just individual works that need to double in that period: the en-tire portfolio must. Art market indices suggest that the best that can be done long-term is a 4 percent annual increase; the highest figure for long-term performance I have seen is 6 percent, the lowest about 3.2 percent. To achieve a much higher rate of growth, fund managers need either extraordi-nary skill or great timing.

With enough art funds operating, some may achieve high returns for a few years. Consider a 2009 Scott Adams *Dilbert* cartoon. Dogbert the CEO proposes an investment strategy to the pointy-headed boss: "We'll start ten mutual funds, each with randomly chosen stocks. Later we'll build our ad-vertisements around whichever one does the best purely by chance. My goal is to be the premier provider of imaginary expertise."

Ignoring *Dilbert,* some speakers at the Deloitte conferences put for-ward what they claim as compelling arguments for contemporary art, either

as an investment or at least as a store of value in uncertain times. The basic argument for art price appreciation is one of scarcity. It is said that there are more new billionaires each year than top works of contemporary art coming to market. Some of those billionaires will create their own museums, keeping their art off the market and creating demand for more contemporary works.

The argument continues that at middle price points, the demand for creative "tangible assets" will continue because so many ultrahigh net worth (UHNW) individuals have lost money (or failed to achieve a reasonable return) on traditional assets. Anyone who lost money during the 2008 recession on financial products they did not understand will be tempted by passion investments that offer an emotional return as well as a some promise of a financial return. However, it requires a considerable stretch of faith to go from saying there will be demand, to saying that prices will appreciate annually at double-digit rates.

Art is sometimes presented as providing a hedge against currency volatility. This has been true in the recent past, with the dollar wavering and the euro unstable. Auction house specialists tell anecdotal art-as-store-of-value stories. They say tens of millions of dollars arrive by wire transfer from offshore accounts in the British Virgin Islands, the Cayman Islands, or Panama; the art is then shipped to Switzerland or Luxembourg and disappears into an art storage facility in a duty-free zone.

A work of art can also be more easily passed to heirs without attracting the attention of the tax authorities than can real estate or shares. This was a topic of conversation at Paris's 2012 FIAC art fair. UHNW fairgoers had suddenly realized that French authorities really intended to introduce a 75 percent tax rate on high-income earners and might include art valued over €50,000 in the country's wealth tax. There was a sudden demand for transportable art (and a few offers to swap high-value apartments for it), as wealthy families contemplated shifting assets to England, Belgium, or Switzerland. A French court later ruled that the proposed tax was unconstitutional, but the government said it would reintroduce it in different form.

Art may also provide a moderate hedge against inflation. This has been of greatest interest to Chinese or Brazilian collectors who anticipate inflation rates of 8 percent or higher. After 2011 the art-as-inflation-shelter argument also caught the attention of those who believe the US dollar is in a period of

decline. If half the US national debt is owed to foreigners, the temptation to solve the problem through continued printing of money is strong; the long-term outcome is expected to be a weakened dollar.

Yet another argument is that art should be part of a diversified portfolio because in a recession, art prices fall more slowly than do stock prices. There are several reasons why this is true. Few collectors use credit to purchase art; in a credit crunch the art market is less exposed when bankers decide to stop renewing loans.

The investor psychology called "anchoring" also acts to stabilize prices. Individuals attribute a value to an object based on what they paid for it. A collector will refuse to part with her Franz Kline for $2 million because she paid $3 million, so that is what it is "worth." She holds to this concept even in the face of evidence that no one will pay the higher price. Anchoring explains why the American housing market deflated so slowly after the mid-2008 crisis; many sellers would not accept a price below the purchase cost, until the point came where they could no longer deny the enduring weakness of the market. Anchoring is more powerful for valuable assets; the decline stretches over a longer period. This helps explain why after mid-2008, there was less price deflation at the high end of the art market.

The other explanation for the slow fall of art prices is the illiquidity, in-efficiency, and lack of transparency of the private art market. Auction houses accept fewer works and offer works of lower value in a recession. Distressed art is offered for confidential resale through dealers and agents; neither the sale nor the price is ever made public.

The most compelling argument for art investment would seem to be the dramatic media stories detailing works that resold for ten times their acquisition price—think of the Murakami *Miss ko2* example or the discussion of the Mugrabis and Saatchi cited earlier. Those very few, hugely profitable trans-actions are the ones that appear as news stories. Sotheby's PR department reported with great enthusiasm the sale of Jean-Michel Basquiat's *Head* for $1.9 million in May 2011. This had been purchased in 2002 for $158,000, yielding a 32 percent annual rate of return before expenses.

No news headline described the resale of Roy Lichtenstein's *Still Life With Mirror,* purchased in 2008 for $9.6 million and auctioned at Phillips de Pury in May 2011 for $6.6 million, producing a negative return of 18 per-cent a year. No newspaper art section trumpeted Damien Hirst's *Midas and*

the Infinite, butterflies and manufactured diamonds mounted on enameled canvas. It was purchased in 2008 at Sotheby's London for £825,000 ($1.48 million) and resold at auction three years later to Israeli investor Hezi Bezalel for £601,000 ($947,000). The seller suffered a negative rate of return of 20 percent a year.

And no news story headlines a fact attributed to Sergey Skaterschikov of Skate's Research. "No work of art purchased for more than $30 million has ever been resold at a profit." I have searched records looking for an exception to this; as far as I can tell, and at least for reported sales at auction, Skaterschikov is right.

Reading about art investment successes is like reading about the 1-in-40 drill holes that find oil. No newspaper reports on the 39 dry holes, or on *Midas and the Infinite.* You never read about the four out of five contemporary works that Christie's or Sotheby's, or even Phillips or Bonhams, reject for their evening auctions because the artist is no longer in fashion.

One exception to the many caveats about art investment fund returns seems to be Philip Hoffman's Fine Art Fund (FAF). Located in a Georgian townhouse behind the Dorchester Hotel in London's Mayfair, FAF was launched in January 2003. I spent time with Hoffman at Art Basel Miami in 2011.

Hoffman says of his clients, "They have no interest whatsoever in art; they look at paintings as a diversification of their investments." FAF has the industry-typical "2 and 20" fee structure; the company deducts 2 percent of committed capital each year as a management fee and to cover expenses, and it takes a 20 percent performance fee on any annual earnings above a hurdle rate, in their case 6 percent.

FAF at one time announced a 25 percent return on invested capital for its art transactions. Hoffmann's announced figure in 2013 for his first fund, launched in 2004, is "gross returns of 19 percent, net returns of 6 percent."

FAF publishes results quarterly, with assets valued by Christie's and Sotheby's and audited by KPMG. The fund has $100 million invested, with investors from 16 countries. The minimum investment at the time I interviewed Hoffman was $200,000, with a five-year commitment and the option of three one-year extensions. In 2013 the minimum was $1 million. FAF will not allocate more than 7 percent of the fund to one investment; they would not, for example, undertake a $10 million purchase on their own. They will take a share in syndicated deals.

Investors are all individuals. Pension funds and investment banks have so far stayed away, perhaps because of the relatively low amount of capital involved.

The Fine Art Fund Group has a very different operating model than the standard buy-and-hold fund. Their operating premise is that the art market is opaque; a trader with inside knowledge and available capital is well positioned to take advantage of market imperfections. And, of course, there is no art world prohibition (or concept) of insider trading.

There are several different strategies used by FAF and similar funds to exploit imperfections in the art market. One involves distressed art: acquire art at a discount from sellers who require immediate liquidity for reasons of divorce, death, or insolvency. A second involves geographic arbitrage: exploit differences in auction prices for art from particular artists or regions. Buy mid-price level Picassos in the London market and resell in Hong Kong (this and other examples are my own, not theirs).

A third strategy is regional and involves short-term holding of art from a particular country or artist. A fourth is an emerging-artist strategy: invest in and hold work by emerging artists who are identified as having great potential.

A final strategy, and one that really does require inside information, is showcasing. That involves acquiring work by an artist who will soon have a major museum show or is arranging placement of work in a museum show.

FAF has publicized several successes: a Peter Doig purchased at Sotheby's in 2005 for $880,000 and sold a year later at $1.8 million for an annualized profit of 86 percent; and a Frank Auerbach purchased in April 2005 for $234,000 and sold in December 2008 for $675,000, a 54 percent annualized profit.

The FAF model obviously requires that decision makers have long experience in auction houses or as dealers. Hoffman was at Christie's for 12 years, and at age 33 was the youngest member of its International Management Board. The FAF supervisory board is chaired by Lord Gowry, former chair of Sotheby's.

What principal mistake does Hoffman warn against? "Don't buy what everyone else is buying; you may be too late, coming into the market just as the savvy investors are bailing out." The November 2014 contemporary art auctions in New York raised exactly that concern, about the savvy bailing out. About 30 works offered at Christie's and Sotheby's came either from

major collectors such as Steven Cohen (who had a dozen works on offer) or by art investment consortia. These 30 made up a substantial total of the value of work being offered by the two auction houses, with many of the 30 having been purchased recently. When insiders in any market start selling, regular investors get very nervous.

In the end, and whether done in a personal art portfolio or in an art fund, trying to predict the future group consensus on the value of an art work is what economist John Maynard Keynes called a beauty contest. Keynes's example came from the 1930s, when *The New York Times* asked readers to choose the six prettiest female faces from a hundred photographs. A new automobile went to the entrant whose choices most closely matched the majority choice of the other entrants.

Keynes said an entrant should consider not their concept of beauty but rather who other judges will think the most beautiful. The best approach would be to pick the six faces that you think others will choose as the prettiest.

Keynes said the stock market was a beauty contest. A canny investor should choose not what he thought to be the most promising stock, but the stock he thought other investors would choose as promising.

Buying contemporary art as a store of value may make sense; buying it as an investment is a beauty contest. You predict what other buyers will consider valuable in the future. A gallery owner or investment advisor who tells you "This artist will sell for far more, five years from now" is acting as a judge in a Keynesian beauty contest. Caveat emptor!

THE CONTEMPORARY ARTISTS

CATTELAN, MURAKAMI, AND AI

I don't design, I don't paint. I absolutely never touch my works.

—Maurizio Cattelan, artist

The 1990s New York art scene looked [to me] like porn; sex was inside the museum and linked to beauty; in Japan it was in magazines and books.

—Takashi Murakami, artist

Life is art. Life is politics.

—Ai Weiwei, artist

The upper echelon of the contemporary art world includes artists of diverse backgrounds. Some have become famous and generated high prices for being great at drawing or coloration, some for being innovative, some for being controversial, and some for being celebrities. Understanding the diversity produces a better overview of the whole.

This chapter offers sketches of three artists who mix innovation, celebrity, and some controversy: Maurizio Cattelan, Takashi Murakami, and Ai Weiwei. The first two are on the top 20 contemporary artists list later in the book. The third, Ai, is certainly the best-known Chinese contemporary artist.

Maurizio Cattelan, the architect of the arched-back wax nude of Stephanie Seymour, is a conceptual artist, rendering provocative work on culture, death, and religion. Depending on the work referenced and whom you ask, he is a provocateur who mocks the system, an innovator, or an artist with an endless supply of sight gags. He is no fool. In a 1999 interview he said, "We live in the empire of marketing, spectacle, and seduction, so one of the roles

of artists and curators is to deconstruct these strategies, to resist their logic, to use them and/or find new means of activism against them."

His work combines performance art and sculpture, the latter designed by him and produced by technicians. In 2012 his retrospective at the Guggenheim in New York consisted of stuffed horses, sleeping dogs, the suicidal squirrel mentioned earlier, and many self-portraits, paintings, and photos. He is loved by curators and wealthy collectors, among the latter François Pinault, who calls him "one of the best artists of our time."

Cattelan was born in Padua, Italy, in 1960. His childhood was marked by economic hardship at home, punishment at school, and mistrust of authority. Prior to his art career he worked as a cook, a gardener, a mortuary assistant, and he was a sperm donor. He had a short but successful career as a furniture designer, which led him to be recognized first in art and design magazines, then by gallerists. At no point did he receive any formal art education. He now lives and works in New York and Milan.

He began making art, he says, because of all the beautiful women who seemed attracted to artists. He describes his early art career as riddled with insecurity and failure, focused on "the impossibility of doing something."

So what sort of art is created by someone who has an abundant sense of humor, a history of insecurity, and no formal art training? Lacking inspiration for his first solo exhibition in 1989, Cattelan closed the gallery and hung a sign reading *Torno subito* ("Back soon"). The sign was both the exhibition title and the art exhibit. In 1992 his participation in a show at the Castello di Rivara in Turin consisted of knotted bed sheets dangling from an open window. It was titled *Una Domenica a Rivara* ("A Sunday in Rivara.")

Asked to contribute a work to a group art show in Milan in 1992, Cattelan filed a report on the theft of an "invisible exhibition" to Italian police. He framed his stamped copy of the report and exhibited (and sold) the report. In 1993 when Cattelan was asked to exhibit at the Venice Biennale, he sublet his space to an advertising agency. The agency used the space to install a large advertisement for Schiaparelli perfume. Cattelan titled it *Working Is A Bad Job.*

In 1994 at the Daniel Newburg Gallery in SoHo, he tethered a live donkey beneath a crystal chandelier. The donkey defecated; the New York Department of Health closed the show after the first day. In 1995 for his first solo show at the Emmanuel Perrotin Gallery in Paris—titled *Errotin, le Vrai Lapin*—Cattelan persuaded the gallerist to dress up each day for five weeks as a giant pink penis wearing rabbit ears. Cattelan followed this up in 1999

by duct-taping Massimo De Carlo, his Milan dealer, to the gallery wall. He called the work *A Perfect Day.* It turned out less than perfect for De Carlo, who was hospitalized. So far only his distinguished New York dealer Marian Goodman seems to have escaped "Cattelanization."

When Cattelan was invited in 1996 to a group show at the De Appel Foundation in Amsterdam, he chose theft as his offering of representational art. He had friends abscond with another artist's exhibition from a nearby art gallery—and reinstalled it as his own. He called it a "temporary reframing" and retitled it *Another Fucking Readymade.* The police called it something else; it took considerable negotiation by the Foundation to have Cattelan un-arrested.

In 1997 in Dijon, Cattelan excavated a coffin-size hole in the floor of the museum gallery to make the point that he preferred death to the pressure of making art. Also in 1997, for a show at Galerie Perrotin, he secretly had duplicates made of each work by Belgian artist Carsten Holler on display at the gallery next door. Even the Holler press release was copied. The point, Cattelan said, was to question identity.

Cattelan's formal projects, where something more recognizable as an art object was displayed, have relied heavily on perceived back stories. One was 1999's *La Nona Ora* (The Ninth Hour) (illustrated), a wax sculpture of Pope John Paul II in papal regalia, struck down by a meteorite. The possible back stories for the work are limited only by imagination. When one version was on display at Warsaw's Zacheta Gallery in 2000, two right-wing parliamentarians destroyed it. Another version of *La Nona Ora,* of the edition of four, sold in 2004 for $3 million.

His 2000 sculpture *La Rivoluzione Siamo Noi* (We Are The Revolution) has his own effigy hanging from a Marcel Breuer–designed clothing rack, dressed in German artist Joseph Beuys's (famous) felt suit. Cattelan appended his claim, "I am not really an artist," intended as a reversal of Beuys's declaration that "every man is an artist."

In 2001 Cattelan produced *Him,* a schoolboy kneeling in prayer, with the child's head replaced with the realistic likeness of Adolf Hitler. The piece is described in *The Economist* as representing the question, "If the Fuhrer asked for absolution, would God forgive him?" One version (also of an edition of four) is owned by American collector Stefan Edlis, who says, "When people see this, they react with gasps, tears, disbelief. The impact is stunning. Politics aside, that is how you judge art." Another version of *Him* reportedly sold for $10 million.

In Milan, Cattelan installed wax models of three adolescent boys, hanging by their necks from an oak tree in a public square. The sight distressed one Milanese so much that he climbed a ladder and cut down two of the figures—then fell from the ladder, sustaining head injuries. The Milan fire department cut down the third figure to calm an anguished crowd. The Milan police announced they would determine whether the installation was a work of art. If so, the injured saboteur would be charged. If not, Cattelan would be charged with mischief. There was a long period of debate, in the press and among prosecutors. The issue just faded away; no one was ever charged.

As Peter Brant learned from delivery of the nude wax statue of his wife, if you ask Cattelan to produce a work of art, you should confirm the final details before shaking hands. In 1999 London art dealer Ben Brown commissioned a portrait of his grandmother. Cattelan delivered a wax statue called *Betsy,* a wax, lifelike old lady crammed into a small fridge. When François Pinault commissioned a work in 2009, Cattelan produced a tombstone inscribed with the epitaph, "Pourquoi Moi?" Pinault accepted it.

In 2004 Henry-Claude Cousseau, director of the École Nationale Supérieure des Beaux-Arts in Paris, also commissioned a Cattelan work with no prior knowledge of what would be delivered. The École is a repository of medieval and Italian Renaissance sculptures and copies of paintings; its chapel was originally built for Marguerite de Valois, who had been married to France's King Henry IV.

What the École received was a sculpture titled *Now,* a life-size wax effigy of the assassinated John F. Kennedy in a coffin. Cattelan said the sculpture was appropriate given the history of the École, because Kennedy is "a kind of secular saint." A second version of the sculpture was shown at the Carnegie Museum of Art in Pittsburgh.

Like Damien Hirst, Cattelan produces taxidermy animals: an ostrich, donkeys, and full-size horses suspended in midair. His back story is that taxidermy presents a state of apparent life premised on death. In 2004 his taxidermy horse *The Ballad of Trotsky,* suspended from the ceiling, was purchased by Bernard Arnault for $2.1 million; Cattelan had sold the horse in 1996 for $5,000.

Most recently he produced *L.O.V.E.* (2011), a 36-foot, white marble sculpture of a hand, the middle finger extended, the others chopped off. It was installed in Milan's Piazza Affari, in front of the city's stock exchange.

The sum of these works has made Cattelan Italy's best-known and probably highest-priced contemporary artist. He has had solo exhibitions at MoMA, LAMoCA, and the Pompidou Center, plus five appearances at the Venice Biennale. As his Guggenheim retrospective opened in 2011, Cattelan announced that he would no longer make art. He walked into the show carrying a tombstone reading "THE END." Most commentators interpreted the announcement as a publicity stunt. In 2013 Cattelan showed new work (a horse), titled *Kaputt* at the Bayeler Foundation in Basel.

The imagery of Japanese artist Takashi Murakami, also introduced in the first chapter, blurs the lines between art, consumer culture, and pop. If Maurizio Cattelan is sometimes referred to as the Italian Damien Hirst, then Murakami can be viewed as his country's Andy Warhol. At age 50, he works outside Tokyo in what he calls—as did Warhol—his factory. There are actually two factories: One in Asaka, Japan, houses his art-producing corporation KaiKai Kiki. A second is in Long Island City, New York. At the peak of his output, when Murakami was producing work for François Pinault's Palazzo Grassi at the 2007 Venice Biennale, he was said to employ 200 technicians.

In his self-marketing, Murakami travels the world, seeking and receiving media attention, and making appearances at museum exhibitions of his work. His public uniform is often a white T-shirt and army-green baggy pants, his long black hair tied in a samurai bun. He promotes the myth that he spends every night in a sleeping bag on his studio floor, rather than, say, in his Upper East Side Manhattan town home.

Art writers like to comment on the one way that Murakami differs from Warhol. For most of his career Warhol took his subject matter from the everyday (the Brillo Box, the Campbell's soup can), and sought to place it with the wealthy. Once Warhol achieved fame, few could afford his paintings. Murakami takes from the mundane and sells to everyone: million-dollar sculpture and paintings to the wealthy, limited-edition Murakami-designed Vuitton handbags to the middle, and designer T-shirts, mouse pads, mugs, stuffed animals, key chains, and iPhone cases to the lower-end market.

Murakami grew up in Japan after World War II, at a time when popular culture included manga comic books and anime cartoons. The American occupation introduced the world of Walt Disney. He attended Tokyo National University to work on a doctorate in *nihon-ga,* a style of painting that

combined Japanese and Western styles and subjects. He concluded that such painting was irrelevant in modern Japan; instead, he produced art based on manga, anime, and *otaku,* the nerdy, geek subculture that developed around video game enthusiasts. He sought recognition for his art in the West, intending to exhibit it at home following Western acceptance.

As with Warhol, Hirst, and Cattelan, his sculpture and paintings are produced by technicians. His input comes at the design stage and with final approval. Instead of silk screening, as Warhol did, he produces full-size drawings, then pastes in digital images. He scans the final drawing in a computer and colors the work using Adobe Illustrator software. Technicians reproduce the finished image on canvas.

The process produces a unique Murakami style; his canvases show no evidence of brushstrokes. He calls the paintings "Superflat," and claims to intentionally avoid any illusion of depth and perspective. He says that this continues a two-dimensional imagery that runs through Japanese art history and is found in manga and anime. He also claims that Superflat is a commentary on postwar Japanese society, in which differences in social class and taste flattened.

In 1993 he created his alter ego, his Mickey Mouse. He called it Mr. DOB, and presented it as a Japanese icon. DOB is a contraction of the phrase, "Dobojite dobojite," meaning "Why? Why?" Mr. DOB has a circular head with the letter D inscribed on his left ear and the letter B on the right ear. The face is O-shaped, making the name legible. Murakami put DOB on key chains, T-shirts, and mouse pads. Japanese teens, male and female, acquired DOB tattoos.

The character is rendered both in paintings and as balloon sculptures. In one sculptural version, DOB exists in a forest of mushrooms, a reference to the two atomic bombs dropped on Japan. In the November 2011 auction at Christie's New York, a grouping of sculpted cartoon mushrooms titled *DOB in the Strange Forest* (1999) sold to Larry Gagosian for $2.8 million. As with Warhol, any discussion of Murakami's work is considered incomplete without mention of its selling price; Murakami says that equates to artistic value.

Murakami is now better known for his sculptures than for his paintings. One of the works in the Carte Blanche auction was *Miss ko2* (1996) (illustrated in another context). She is a character from the *bisjoujo* ("beautiful young girl") game *Viable Geo. Miss ko2* is a intended to be an innocent schoolgirl, nearly 6 feet (1.8 m) in height, with huge eyes, blond hair

extending below her tiny waist, and disproportionately long legs. She wears a transparent waitress outfit, revealing her nipples and large breasts. Some Western critics have described the work as pedophilia.

Murakami says that *Miss Ko2* just represents a Japanese obsession with young girls with wide eyes who wear uniforms. "Japanese critics see no pedophilic connotations . . . in Japan, sexy means submissive and demure. Making a life-size figure is no different than making a 'Dutch wife' [a sex doll]." Produced in an edition of four, *Miss ko2* sold at Carte Blanche for $6.8 million.

In 1997 Murakami moved on from the *Miss ko2* ideal to create *Hiropon* (slang for heroin). This is another sculpture of a girl, this time over 7 feet tall (185 cm), a blue-haired, very buxom female wearing a bikini, and skipping a rope created by milk spurting from her enormous breasts. Also in an edition of four, a *Hiropon* sculpture sold for $623,500 at Sotheby's New York in May 2008.

In 1998, Murakami created a male counterpart, *Hiropon My Lonesome Cowboy,* a fiberglass statue (in an edition of five) of a male nude with spiky blonde hair, a swirl of ejaculate erupting from his erect penis to form a lasso over his head (illustrated in different setting). When the statue was auctioned at Sotheby's New York in May 2008, the catalog compared it to early nineteenth century Japanese printmaker Katushika Hokusai's often-reproduced 1820 woodcut *The Great Wave of Kanagawa.* The comparison was derided as absurd; the price was not. *Lonesome Cowboy* brought $15.2 million.

In 2010 Murakami became the third artist (after Jeff Koons and French artist Xavier Veilhan) to exhibit at the Chateau de Versailles. Several thousand people, including Prince Sixte-Henri de Bourbon-Parme, a descendent of Louis XIV, demonstrated and signed a petition protesting that Murakami's art was an affront to the traditions of the Chateau, that it "shattered the harmony" of the Sun King's residence. The prince unsuccessfully sought a court order to halt the exhibition.

The works shown included one version of *Miss Ko2* in a corner of the mirrored Salon of War (illustrated) and a 26-foot frog, *Tongari-Kun,* in the Hercules Salon. Jean-Jacques Aillagon, director of the museum, said that the exhibition drew just over a million visitors, double the normal number for the same period.

Murakami's sexualized sculptures and Superflat paintings have shaped the world's perception of contemporary Japanese art to such an extent that

artists producing more conventional work sell at relatively low prices. Makoto Aida, whose work is as well known as Murakami's in Japan, has a top auction price under $700,000—one twenty-fourth of Murakami's top price, and one-fifteenth of what a top Chinese contemporary artist brings in China.

In 2008 Murakami was ranked by *Time* magazine as one of the world's 100 most influential people. He was the only visual artist to make the list. Murakami claims that this status only holds in the West, that he is criticized and disliked in Japan by people who object to his elevating a subculture to high art.

Chinese artist Ai Weiwei, at age 55, is probably the number one rock star in the world of contemporary art. In 2011, in its annual Power 100 list, London's *ArtReview* magazine named Ai "the most influential art person in the world." That means bigger than Larry Gagosian, bigger than Sheikha al-Mayassa al-Thani of the Qatari Royal Family. *ArtReview* said Ai was chosen because of his political activism as much as for his art. "His activities have allowed artists to move away from the idea that they work within a privileged zone limited by the walls of a gallery or museum . . . he is breaking down the barriers between art and life." Damien Hirst is the only other artist to have topped the *ArtReview* list, in 2005 and 2008. In 2012 Ai was ranked as number three, but he and Gerhard Richter were still the only artists in the top ten.

Ai is not in the top 25 of Chinese contemporary artists in terms of annual sales. His fame does indeed come from being China's most politically daring artist, and from being "Warholesque" in his self-promotion and his factory production of art by as many as 20 assistants. Most of his work is conceptual; it speaks to Chinese themes, but it somehow resonates well with Western sensibilities. Most of it is intended as political comment on China's government and society.

A man of Falstaffian dimension, Ai lives in a Beijing compound with his wife, artist Lu Qing. In China he is considered a "princeling" as the son of Ai Qing, a famous revolutionary poet and comrade of Mao Zedong in Yan'an before the 1949 takeover. His father was later denounced as rightist for a poem he wrote during the Cultural Revolution. Father and family were banished to an 18-year exile in the remote region of Xinjiang, during which the father was assigned to cleaning latrines. Ai Qing's poetry is now taught in Chinese schools.

In the 1980s Ai left China for New York. He studied briefly at Parsons School of Design where his teacher, the artist Sean Scully, told him that his drawing showed "no heart." Ai was shamed and dropped out of school, but not before becoming a disciple of Marcel Duchamp, a French contemporary artist known for his readymades. Ai then worked as a street artist in Times Square, charging $25 for a portrait.

His main source of income seems to have come from playing blackjack in Atlantic City. He was a rated player; casinos provided him with limo transport and complimentary rooms and meals.

He returned to China in 1990. He came to the world's attention as co-designer, with architects Herzog and de Meuron, of the Bird's Nest stadium for the Beijing Olympics. To protest the government's human rights record, he boycotted the opening ceremony. He said of the Bird's Nest, "The deep irony is that its architecture was so powerful, it worked to blind many Western leaders to the reality of China."

Ai's market is primarily in the United Kingdom, Western Europe, and the United States. His work is not widely collected in China, perhaps because of fear that it carries a not-so-subliminal political back story. A planned showing of his work at the Ullens Gallery in Beijing in 2011 was "indefinitely postponed."

The political concern is not unfounded. His recent works come with a layered and subtle back story that relates to social conditions or protest. His best-known installation is the carpet of porcelain sunflower seeds at London's Tate Modern, whose meanings were discussed earlier. Another of his works is a series called *Tree* (2011) (illustrated). There is an edition of 12; each tree is 19 feet high and 20 feet wide (5 × 5.4 m). Each is constructed from dead tree trunks gathered in the mountainous regions of southern China, fastened together with a Taoist process using giant screws. Each has white porcelain "rocks" at its base.

There are two separate back stories to the *Tree* series. When *Tree #11* was shown at Art Basel Miami in 2011, it was said to symbolize how China's rapid growth has damaged the environment. Galerie Urs Meile in Lucerne, Switzerland, which exhibited *Tree #11* at the fair, later said that each tree represents the Taoist ideal—a temporary union of heaven and earth in which the natural and synthetic are the same. Karin Seiz, artistic director at Urs Meile, said each tree was priced at €350,000 ($468,000), not including transportation.

In 2013, The Art Gallery of Ontario in Toronto showed Ai's *Zodiac Heads/Circle of Animals*, 12 giant bronze animal heads based on the Chinese Zodiac. Other editions have shown at New York's Pulitzer Plaza and London's Somerset House. Each head is 4 feet (1.1 m) high, mounted on a 6-foot (1.9 m) spike. The set recreates the fountain clock, created in the eighteenth century by two Jesuit missionaries, at Yuanmingyuan (the Old Summer Palace) in Beijing.

The original heads were looted by French and British troops during the Opium Wars in 1860. The Chinese cite the looting (and the burning of the palace) as an example of humiliation at the hands of the West. Seven of the original 12 heads—the tiger, monkey, horse, rat, ox, rabbit, and boar—were rediscovered when offered for sale in the West. The most expensive of these was the horse, reportedly purchased by Macau casino owner Stanley Ho for $8.75 million in 2007.

Two heads, the rat and the rabbit, were offered in the Yves Saint Laurent auction in 2009. The successful Chinese bidder, acting for the China National Treasures Fund, refused to pay as a protest. Those heads remained in France until 2013 when they were gifted to China by François Henry Pinault of Christie's auction house as part of an exchange that resulted in Christie's being allowed to hold auctions on the mainland. Five heads are still missing.

Ai said the meaning of his reproduced heads is "looting and national symbolism, a dialogue between past and present, but also real versus fake."

One of Ai's most controversial performance works occurred in 1995. Titled *Dropping a Han Dynasty Urn*, it was exactly that. The act was recorded as a photo-triptych. The pictures show Ai dropping an ancient ceramic vase that shatters on impact. He has said that the meaning of this is "creating new by destroying old, a commentary on the destruction of China's rich cultural history, its collective memory, by the government." A catalog of his work for a 2012 show at the Hirshhorn Museum in Washington says the smashing of the vase "captures the moment when tradition is transformed and challenged by new values."

Usually in exhibitions the photo triptych is displayed behind a set of unbroken Han urns that have been dipped in colorful paint. The meaning of these is "history painted over and commodified, made more friendly."

He has taken apart Ming furniture and reassembled it in absurd shapes, one titled *Table With Two Legs Up The Wall*, a reference to a government

edict. Beijing-based curator Philip Tinari has called this a new school of art, "ancient readymade."

In 2008 at *Documenta,* an exhibition in Kassel, Germany, Ai showed an installation called *Fairytale,* with 1,001 Ming and Qing Dynasty marble chairs and 1,001 Chinese volunteers sitting on them. The back story is that each chair is a metaphor for the time his father spent in exile; one household item the family was allowed to take with them was a traditional yoke-back chair. *Fairytale* means continuity combined with changing traditions. Some chairs were later sold through the Lisson Gallery in London, each at $100,000.

Ai's most publicized (and embarrassing for authorities) political protest involved accusing contractors and state officials of corruption and negligence around the shoddily built "tofu schools" that collapsed during the 2008 earthquake in Sichuan province. At the 2009 *Documenta* show he presented an art memorial to the 5,000 students who died in the quake; the memorial consisted of children's school backpacks. In Chinese characters, they spelled out the words of one grieving mother, "She lived happily in this world for seven years." In response, the Chinese government closed down his blog site and removed his name from local search engines.

In January 2011 the municipal government of Shanghai issued an order that Ai's new three-story studio in Shanghai be demolished. Ai described the order as retribution for his continued political activism and announced that he was sponsoring a *He xie* (river crab) feast at the studio to protest the destruction order. The Mandarin word is a play on the word for harmony, which the Communist Party claims to promote. In China, harmony had become a synonym for obedience and censorship. Chinese whose communications are blocked by the state say they are being "harmonized."

Ai had his technicians produce 3,000 painted porcelain crabs for sale, with the crab fest and studio destruction as their back story. Ai invited eight rock bands to the party and anticipated a thousand supporters would show up. He was placed under house arrest in Beijing two days before the planned feast, and his studio was razed a day ahead of the scheduled date. The crabs were all snapped up by collectors.

In April 2011 Chinese authorities arrested him at Beijing airport. Worldwide protests by arts and civil rights communities resulted. The official announcement was that Ai was detained for "unspecified economic crimes." Two weeks after his detention, Xinhua, the government's official

news agency, said that a company he controlled, Beijing Fake Cultural Development Ltd., had evaded "a huge amount of taxes" and destroyed documents. Ai was released on June 22, after 81 days in solitary confinement. As part of his release terms, he was forbidden foreign travel. As of fall 2013, he was still held under house arrest, with 24-hour surveillance.

A major retrospective of Ai's work toured Western galleries in 2013–14, but had to be presented in the absence of the artist. Matthew Teitelbaum, director of the Art Gallery of Ontario (where Ai's retrospective showed in late 2013), pointed out the incongruity of the situation. "How can you present an exhibition of a contemporary artist and not have the artist present? The artist owns his or her work, owns the ideas, owns the public presentation, owns the interaction with the audience. . . . [The artist should be present] to explain, to defend, to advocate."

In Toronto, that job devolved to Teitelbaum, who traveled to Beijing prior to the show to visit Ai in his Beijing studio and record his responses.

DAMIEN HIRST, ARTIST AND MARKETER

I think becoming a brand name is a really important part of life. . . . I always treat [art] as an all-or-nothing situation; there is no way I am going to settle for half.

—Damien Hirst, artist

Damien Hirst is the richest artist the world has known. Estimates of his wealth range from £250 million ($385 million) to £400 million ($620 million). He is worth more, at age 48, than Pablo Picasso, Andy Warhol, and Salvador Dali combined at the same age—and these three are at the top of any list of artists ranked in monetary terms. Hirst is the art world's 0.001 percent. He was a central character in my book *The $12 Million Stuffed Shark;* however, his story is ever-changing and highly relevant to an appreciation of today's art market.

In 2008 Hirst bypassed his major dealers, Gagosian in New York and White Cube in London, to sell art fresh from his studio through a Sotheby's London auction. Hirst did not have an exclusivity clause with these dealers. Still, going directly to auction meant bypassing both of them and breaching the oldest unwritten rule of the artist-dealer honor code: "Thou shalt not screw thy dealer."

According to Frank Dunphy, Hirst's business manager then, his dealers were told of the auction on the morning of Sotheby's public announcement. In a piece that appeared in *The Economist,* Dunphy quoted Larry Gagosian, "It sounds like bad business to me. It'll be confusing to collectors. Why do you need to do this?"

There were rumors that White Cube then leaked a list of 200 unsold Hirst works in its inventory to an art magazine, as retribution for being

bypassed. Tim Marlow, White Cube's exhibitions director, denied leaking the list but confirmed that there were "more than 100 works" in stock. Other dealers described the idea of a branded artist going directly to auction as "the sum of all fears," borrowing the title of a Tom Clancy novel about nuclear terrorism. It was thought unlikely that Gagosian or White Cube would turn against Hirst over his direct entry to the secondary market; they were forced to take part in the auction to support clients who had invested in Hirst's art, and in order to protect the value of their own inventory.

There are two kinds of art transactions. The first is primary art, fresh-from-the-studio and sold into the market for the first time, through a dealer if the artist has one. Then there is the secondary market, previously owned art resold by dealers or auction houses. With a few exceptions (notably Phillips de Pury and Chinese houses), major auction houses do not handle primary art or works less than five years old (except as part of a charity auction). They certainly do not auction single artist primary art in bulk. The Hirst sale was a first for a major auction house.

Almost all of the Hirst pieces offered at Sotheby's were made by technicians specifically for the auction. (At this point, Hirst employed 130 technicians in six studios.) The works included formaldehyde-filled tanks of dead sharks, zebras, pigs, and a calf. There was a "unicorn" that was actually a foal, also in a tank. There were cabinets filled with drugs. There were spot paintings, spin paintings, and pinned-butterfly compositions. The sale, with an estimate for 223 works of £68 to £99 million ($122 to $176 million), was held at Sotheby's Bond Street auction rooms in London on September 15 and 16, 2008.

So many people registered to attend that Sotheby's opened two ante-rooms in addition to the main salesroom. The action was viewed on a television screen while attendants relayed bids. Sotheby's retained New York architect Peter Marino to convert its cluster of back-office spaces into a suite of rooms to accommodate VVIP buyers.

Titled *Beautiful Inside My Head Forever,* the auction began the day that Lehman Brothers announced bankruptcy. Television stations showed pictures of Lehman Brothers employees carrying boxes of personal possessions from their offices in London and New York, with the screen caption reading "Black Monday." There was foreboding in the City of London and on Wall Street about the economic future; the art world worried that if the auction failed, it might undermine confidence in the whole contemporary

art market. There seemed little concern within the salesroom as bidders took assigned seats.

Hirst stood to gain enormously from the Sotheby's auction, both from publicity and from the chance to net more in two days than in a year of dealer sales. Sotheby's waived their consignor's commission, so Hirst took home a hundred percent of the hammer price from each completed sale. Sotheby's earned the buyer's premium and reaped the publicity from a sale that was reported by news media around the world.

The auction house produced a three-volume catalog, at a reported cost of £135,000 ($240,000), and couriered complimentary sets to 800 clients. Those not on the preferred list could purchase a set for £90 ($160). It was not only the auction catalog that was heavy. Several of Hirst's formaldehyde tanks were plated with gold. The floors of Sotheby's display rooms had to be reinforced to hold the weight.

Dealer Jay Jopling of White Cube purchased the first lot of the evening, a triptych of synthetic diamonds, butterflies, and household gloss, for £850,000 ($1.5 million). Jopling and Gagosian's representative between them bid on more than half the items offered. Hirst did not attend the auction; he said he spent the evening playing snooker at his favorite pub.

Could an art market wracked by economic crisis absorb this huge offering from one artist in less than two days? The *Beautiful* auction sold 216 of the 223 lots offered, for a total of £111 million ($198 million). Three-quarters of the lots sold above their average estimates. The total obliterated the record for a single-artist auction set by a 1993 sale of 88 mostly minor works by Pablo Picasso that grossed $20 million. The British tabloid the *Sun* called the *Beautiful* sale "Shark 'n Awe." Hirst said, "People would rather put their money into butterflies than banks." Alberto Mugrabi called the bidding "a way to escape from reality." At the conclusion of the second day's session, auctioneer Oliver Barker donned a pair of white gloves, the auctioneer's version of an Oscar for best performance.

The star lot was *The Golden Calf*, a bull preserved in formaldehyde, with 18-carat gold hooves and horns, a gold Egyptian solar disk on its head, and outsize reproductive organs. It was hammered down on the phone to a representative of Sheikha al-Mayassa al-Thani of the Qatari Royal Family for £10.4 million ($18.6 million). As reported in *The Economist*, Alexander Machkevitch, a Kazakh mine owner, bought three butterfly canvases, a spot painting, and three cabinets for a total of £11.7 million ($20.9 million).

Over the next two weeks, media reports said 20 percent of the buyers (45 works) defaulted, which means that when the auction house followed up, the buyers said, "I don't know what I was thinking, I won't go through with the purchase." This occurred in spite of the fact that Sotheby's sweetened its normal terms by offering buyers a six-month, interest-free payment period. That was by far the highest proportion of defaults in any Sotheby's or Christie's auction over their 500-year combined existence. Sotheby's had provided no guarantees; defaulted work was offered to the under-bidder, unsold work was returned to Hirst. There has never been any indication that legal action was undertaken against any of those who defaulted.

The auction and Hirst's orchestration of it were thought so extraordinary that in 2009 the Tate Modern museum in London mounted a show called *Pop Life,* for which it re-created one of the Sotheby's preview galleries for the Hirst sale, treating the sale and the art market itself as a work of art.

Hirst works in London. He was born in Bristol and grew up in Leeds, an industrial city in the north of England. His skills as an artist-marketer are unsurpassed. Hirst is one of a very few artists who can claim to have altered the art world's concept of what art and an art career can be. The Damien Hirst story provides a great overview of the evolving roles of the artist, auction house, and dealer.

Hirst is best known for four signature works. The first is *A Thousand Years* (1990), a representation of life and death in which flies and maggots are hatched inside a vitrine and migrate over a glass partition toward a cow's rotting head. Some insects are electrocuted en route by a bug zapper. A visitor could see *A Thousand Years,* then revisit it a few days later and see the cow's head smaller and the pile of dead flies larger. *A Thousand Years* represents the cycle of life: feed, reproduce, and die. Both Hirst and his critics have named *A Thousand Years* as his most important work.

Hirst's second signature work is *The Physical Impossibility of Death in the Mind of Someone Living,* a taxidermy tiger shark in a tank filled with formaldehyde. The shark sold in January 2005 to Steven Cohen, for an amount generally reported as $12 million. This made it, at the time, the second most expensive work ever by a living artist, after one by Jasper Johns. Hirst described the concept of the shark: "It looks alive when it's dead and dead when it's alive."

Hirst's titles are an integral part of marketing his work. If the shark were just called *Shark,* the viewer might well say, "Yes, it certainly is," and move on. If it were displayed with that title in a seafood restaurant, it would attract

minimal attention. Calling it *The Physical Impossibility of Death in the Mind of Someone Living* forces viewers to stop, ponder, and create a meaning. The title and inferred meaning become the back story.

Because scarcity bestows art value, we assume that a very expensive work is one of a kind, or at least one of a limited edition series. To protect the value of the first shark, it was assumed that Hirst would never produce a competing version. Not so. As of 2012 Hirst had sold at least nine sharks, all with different titles. The most expensive brought $17.2 million. Each collector except Cohen purchased knowing other sharks might follow.

The third work is *Mother and Child Divided* (1993). It consists of four glass cases, with a narrow passageway between pairs. The first two each hold one half of a cow, split lengthways from nose to tail. The next two hold a calf similarly split. *Mother and Child* also illustrates how the title invites the viewer to create a mental back story. Hirst won the 1995 Turner Prize for *Mother and Child Divided;* the award recognizes the best exhibition by a British artist under the age of 50.

The fourth work is a life-size platinum cast of a human skull, from an eighteenth-century Portuguese sailor. Human teeth from the original skull were added. It was fabricated by artisans from the Bond Street jeweler Bentley & Skinner, at a reported cost of £12 million ($21 million), with Hirst maintaining creative control. It was featured on every television news show in Britain and on the front pages of newspapers around the world.

Titled *For the Love of God,* the skull is encrusted with 8,601 small industrial diamonds, with a single large pear-shaped pink diamond embedded in the forehead. The title is said to have come from Hirst's mother uttering these words on learning of her son's next project. It was displayed in June 2007 at Hirst's London dealer White Cube, in an upstairs room lit only by spotlights focused on the skull. Entrance was by timed ticket, for groups of ten, each allowed in for five minutes.

White Cube offered the work for sale at £50 million ($88 million). Alberto Mugrabi said he offered $35 million but the offer was rejected. Hirst then announced it had sold. It later emerged that the purchaser was an investment consortium that included Hirst, Jay Jopling, owner of White Cube, and Frank Dunphy. Dunphy later said the 2011 offering price for the skull had escalated to £100 million ($154 million).

There are about 4,500 Hirst works in existence, mostly spot and spin paintings, but also butterfly installations and cabinets of pharmaceutical

products. The spot paintings are just that: grid arrangements of random colored spots on a white background. All but the five earliest were executed by technicians (one spot painting illustrated). There are four rules for the technicians who paint his spots: use glossy household enamel; make all dots the same size; never repeat a color in any single sequence; and have gaps between the spots that are the same diameter as the spots. No two canvases are identical. Each painting is given a pharmaceutical name. Some drugs, like S-Methoxy NN, have recreational uses, while others, Moxisylyte, Calcein, and Myristoycholine Iodide do not (at least that I know of).

Spin paintings are created on a spinning potter's wheel, with Hirst or a technician throwing paint at a rotating canvas. Spin paintings represent the energy of the random. Hirst says he got the idea in 1975 from watching it being done by presenter John Noakes on *Blue Peter,* a children's program on BBC.

Hirst's London dealer, White Cube, has reportedly sold 500 butterfly installations and spin paintings and 800 spots, at an average price of close to £200,000 ($352,000) each. Gagosian, Hirst's New York dealer for most of his career, has sold fewer but at a similar price. Signed photographic reproductions of a spot painting entitled *Valium* in an edition of 500 were sold for $2,500 each.

Hirst's noncommercial ventures include the hugely successful RED charity auction featuring works by 100 artists, organized with U2 front-man Bono and held at Sotheby's New York in 2008. RED raised $42 million (£23.5 million) for African AIDS relief.

Immediately after Hirst's *Beautiful* auction, his dealer and auction sales dried up, partly from the market downturn, partly from the Sotheby's sale overdose. At about this time, Hirst was approached by Ukrainian steel magnate Victor Pinchuk, founder of the Pinchuk Art Center in Kiev, then the largest center for contemporary art in Eastern Europe. Pinchuk said his museum preferred to collect Bacon, Picasso, and Rothko, but there was no way to form a collection in depth of those artists. Instead, he would focus on art from 2000 to the present. The Art Center already had an impressive collection of Hirsts, but Pinchuk wanted to add something unique.

Hirst agreed to do 25 Prussian-blue paintings, echoing Picasso's blue period. Assistants would prepare the canvas and paint the background, but Hirst would do the rest. The Pinchuk museum could then boast the world's only collection of blue period Hirsts. He described his painterly style as early

Francis Bacon. The subject matter included sharks, skulls, and butterflies, a continuation of the themes and motifs of life, death, and art. The price to Pinchuk was a reported €25 million ($32.5 million). Hirst negotiated the transaction himself; he described the price as "wholesale."

The blue paintings were universally panned by British critics. "Dreadful," said *The Times of London*. "A memento mori for a reputation," wrote Adrian Searle of *The Guardian*. "About the level of a not-very-promising first year art student," said Tom Lubbock in the *Independent*.

The story around the paintings is that Pinchuk expressed concern not about the reviews, but about the lack of provenance: the paintings had never been shown at any other museum. Hirst then approached the august Wallace Collection Museum in London, housed in a beautiful townhouse off Oxford Street. The museum is known for its French eighteenth-century paintings, sculpture, and objets d'art. Hirst offered the Wallace the opportunity to exhibit his blue period paintings (normally the museum approaches the artist). The last living artist to have been granted a show at the Wallace was Lucien Freud.

Hirst contributed the cost of redecorating the galleries and of hanging the show. The two designated rooms were redecorated with matching blue wall silk and gilt at a reported £250,000 ($440,000). The show was titled *No Love Lost*; the reference is to a song from a novel about the "joy divisions," groups of Jewish women who were used in concentration camps for sexual pleasure.

No Love Lost: Blue Paintings by Damien Hirst showed from October 2009 to January 2010, drawing four times as many visitors as the Wallace had during the same period the previous year. On closing, the 25 works were shipped to the Pinchuk Art Center.

In 2008, the year of the *Beautiful* auction, Hirst's work brought $270 million at auction. In 2009 his auction sales were $19 million, down 95 percent, with only two works—both butterfly paintings—exceeding $1 million. In 2010 the figure was $15 million; in 2011 it was $25 million. His average price was $830,000 in 2008 and $215,000 in 2012. Hirst works created from 2005 to 2008 that resold at auction in 2009 and later have shown an average loss of 30 percent in value, with about a third of the 1,750 works going unsold. Alberto Mugrabi admits to having purchased 40 percent of the Hirst works that did sell at auction in 2009 and 2010, to protect the value of the family's extensive Hirst inventory.

Hirst laid off 45 technicians during the period 2008 to 2012.

Another example of Hirst's work reverting to earlier price levels was the round, 84-inch (213 cm) diameter, butterfly painting *Sanctimony* (2007), which came up at Sotheby's contemporary sale in New York in November 2012. When it was first acquired from the Marianne Boesky Gallery in 2007, it sold in the range of $2.7 to $3 million. Sotheby's had estimated it at $1.2 to $1.8 million. Two bidders, one on the phone, took the painting from an opening bid of $850,000 to $1.1 million, where it stalled. With buyer's premium, it sold at $1.3 million.

In 2011 Larry Gagosian launched a project aimed at reviving the Hirst market. He announced that in early 2012, his 11 galleries in 8 countries (3 in New York, 2 in London, 1 each in Beverly Hills, Paris, Geneva, Athens, Rome, and Hong Kong) would simultaneously hold a "worldwide one-man Hirst exhibition" titled *The Complete Spot Paintings 1986–2011*. Gagosian referred to this simultaneous show for one artist as "a historic first."

What motivated the Gagosian spectacular, coming four years after Hirst's auction betrayal at Sotheby's? The art world consensus was that Hirst's dealers still had substantial inventories of his work, many of these spot paintings. More important, Gagosian had a large number of clients who had been unable to resell their Hirst works during the recession. The market was, well, spotty.

What could Gagosian do to try to create a market and boost prices? *The Complete Spot Paintings* show was his answer. The exhibit opened in the 11 galleries simultaneously in January 2012 for a five-week run. Only 120 of the 331 spot paintings on display were nominally on sale; the others were said to be on loan from collectors in 20 countries. They ranged from bright to muted, very large to tiny. The very first spot painting was dated 1986. The newest, completed days before the show, contained 25,781 spots, each ¹⁄₂₀ of an inch (.125 cm) in diameter. The smallest, from 1996, was 1 × 1.5 inches (.4 × .6 cm) and contained half a spot. The biggest, from 2011, had four 60-inch (24 cm) spots.

Promotional material for the show suggested that there were multiple meanings and back stories for the spots. The long-accepted story, according to White Cube's Tim Marlow: "Looks machine made but is not." Hirst was quoted on one occasion as saying that spot paintings were inspired by snooker; a little later, that spots are happy things, made "to create paintings without angst."

The origin may be simpler. During Hirst's early school days, his father painted the door of their house at 24 Stanmore Place in Leeds, with blue spots. Hirst says, "I used to tell people I lived at the house that had the white door with blue spots."

After the Gagosian show was announced, the press and other artists renewed the criticism that Hirst's work was produced by technicians. Actually, the practice has a very long history. The idea of an artist-as-sole-creator of a work only became common in the mid-eighteenth century. Prior to that studio assistants were often used, the artist was often not named, and art works often not signed. Laura Paulson, senior director for contemporary art at Christie's New York said, "The idea of art changed to be less about individual brushstrokes and more about the image. The studio assistant, who became an alter ego, enabled this process."

The technical prowess behind Hirst's technicians' spots is actually quite impressive. The crispness, edging of lines, colors, spacing, and lack of any indication of brushstrokes really does suggest mechanical perfection rather than a human hand. Critics of spot paintings should be challenged to take a small paint brush and household paint and produce a perfect circle, with no variation in color tone, no furry edges, and no visible brush lines. And then to produce 119 similar circles, perfectly spaced, on the same canvas.

Just before the opening of the Hirst show, Gagosian announced a Spot Challenge: Anyone who visited all 11 galleries during the exhibit and had their card stamped at each would receive a limited edition and "personally dedicated" Hirst print. The value was thought to be about $2,500, depending on the size of the print (assumed to be small), and how many would be given out. Seven hundred people signed up online for the challenge. The *Art Market Monitor* suggested a more challenging contest: The winner would be the first to correctly count the spots in all 331 paintings. For that, there were no takers.

Jeff Chu, a writer for the business magazine *Fast Company*, and Valentine Uhovski, from the website Socialite Rank, completed the challenge in eight days; if you check flight schedules, that time is incredible. Seven people finished inside of two weeks. Christina Ruiz, a columnist for the *Art Newspaper*, visited the 11 galleries on an extreme budget and said she spent $3,250.75 (of her own money). Blogger Jennifer Bostic did the trip on a less extreme budget; she spent just over $13,000. Reuters blogger Felix Salmon estimated the cost, using business class travel and good hotels, at $108,572.

The New York Times quoted a collector as saying, "I would only do it if I had no life, no job, someone else was paying my way, and Scarlett Johansson came with me."

One hundred twenty-eight intrepid travelers completed the challenge—none of them with Ms. Johansson. In September 2012 it was announced that the limited edition spot print would be large, 69 × 53 inches (130 × 117 cm); the value is probably between $6,000 and $10,000.

Following the Gagosian spectacular, 70 of Hirst's works, including *The Physical Impossibility of Death in the Mind of Someone Living* and *For the Love of God,* were shown at a retrospective show at the Tate in London, timed to run during the 2012 Olympic Games held there. The show smashed box office records at the Tate Modern, attracting 463,000 paying visitors over five months, 3,000 a day. With a £14 admission ($21), the exhibition took in £6.5 million ($8.8 million). It was the highest grossing show at the Tate ever. The gallery would not reveal whether anyone had paid the £36,500 ($49,400) asking price for a limited edition plastic skull on sale at its gift shop.

Hirst's auction prices continued to languish. In December 2012 Hirst's company, Science Ltd., announced that "Larry Gagosian and Damien have reached an amicable decision to part company." No replacement gallery was announced. Speculation was that the divorce was initiated by Gagosian, motivated by the supply of work on the market and Hirst's declining prices.

Hirst has been widely praised for the way he has galvanized interest in the arts and for raising the profile of British art. Many have also praised his art. Charles Saatchi concludes that "General art books dated 2105 will be as brutal about editing the late twentieth century as they are about almost all other centuries. Every artist other than Jackson Pollock, Andy Warhol, Donald Judd, and Damien Hirst will be a footnote." Whatever else Hirst's career tells us, the art world of the early 2000s was a far different and more interesting place than if he had not existed.

ARTISTS LAUDED, ARTISTS DISDAINED

There is nothing either good or bad, but thinking makes it so.

—William Shakespeare, Hamlet

It's an article of faith in the art world that some people have an eye for [good art] and some people don't; the disagreement arises over which do or don't.

—Nick Paumgarten, art journalist

Other than Cattelan, Murakami, and Hirst, who are the great contemporary artists? Philippe Ségalot says that there are no more than ten great artists in any one generation; these ten will see their prices grow, while other artists fade. The identity of the ten varies, however, depending on which dealer you ask and what they sell or own.

I have asked dealers, auction specialists, and art advisors, "Who are today's great contemporary artists?" Not surprisingly, no two offered the same list. What follows is a consensus ranking of 20 major contemporary artists for 2013—and for comparison purposes, a ranking I compiled in the same manner in 2008. Inclusion in each is based partly on opinions, on auction records, and partly on Walter Sickert's oft-quoted 1910 comment, "Have they so wrought that it will be impossible henceforth, for those who follow, ever again to act as if they had not existed?"

There are no women on either list. On each, Marlene Dumas, Elizabeth Payton, Lisa Yuskavage, Cecily Brown, and photographer Cindy Sherman would have ranked between 25 and 50. This does not mean that female artists do not bring high prices. The record is $10.7 million for Louise Bourgeois's *Spider* (1996) at Christie's New York in 2012. As of the end of 2012, ten works by female artists had each exceeded $3 million at auction.

A lot of list-churning has taken place in the five years following 2008. On the 2013 list there are more non-US artists and more nonwhite artists than in 2008. Several artists were not considered for the 2013 list because so much of their work is no longer considered contemporary—notably Francis Bacon (British, 1909–92), Willem de Kooning (American, 1904–1997), and Li Keran (Chinese, 1907–89).

Ségalot claims that there is no old-boy bias in today's listings; there are so many dealers, curators, advisors, and critics checking new art that fine artists are quickly recognized.

20 TOP CONTEMPORARY ARTISTS

2013 NUMBER ONE	2008 NUMBER ONE
Gerhard Richter (German, 1932–)	Damien Hirst (British, 1965–)

THE NEXT NINETEEN, ALPHABETICALLY	THE NEXT NINETEEN, ALPHABETICALLY
Jean-Michel Basquiat (American, 1960–88)	Francis Bacon (Irish/English, 1909–1992)
Maurizio Cattelan (Italian, 1960–)	Joseph Beuys (German, 1921–1986)
Chen Yifei (Chinese, 1946–)	Peter Fischli/David Weiss (Swiss, 1952– and 1946–2012)
Richard Diebenkorn (American, 1922–93)	Lucian Freud (English, 1922–2011)
Damien Hirst (British, 1965–)	Jasper Johns (American, 1930–)
Jasper Johns (American, 1930–)	Donald Judd (American, 1928–1994)
Anish Kapoor (Indian, 1954–)	Martin Kippenberger (German, 1953–1997)
Jeff Koons (American, 1955–)	Willem de Kooning (American, 1904–1997)
Roy Lichtenstein (American, 1923–97)	Jeff Koons (American, 1955–)
Liu Xiaodong (Chinese, 1963–)	Roy Lichtenstein (American, 1923–97)
Takashi Murakami (Japanese, 1962–)	Takashi Murakami (Japanese, 1962–)
Richard Prince (American, 1949–)	Bruce Nauman (American, 1941–)
Rudolf Stingel (German, 1956–)	Robert Rauschenberg (American, 1925–)
Wang Guangyi (Chinese, 1957–)	Gerhard Richter (German, 1932–)
Andy Warhol (American, 1928–87)	Ed Ruscha (American, 1937–)
Yan Pei-Ming, Chinese, 1960–)	Richard Serra (American, 1939–)
Yue Minjin (Chinese, 1962–)	Antoni Tapies (Spanish, 1923–)
Zeng Fanzhi (Chinese, 1964–)	Cy Twombly (American, 1928–)
Zhang Xiaogang (Chinese, 1958–)	Andy Warhol (American, 1928–87)

Gerhard Richter is number one by almost any metric, not least because he holds the auction record for a living artist, for *Domplatz, Mailand* (1968), depicting the Milan city square as a blurred photo. It brought $37.1 million at a Sotheby's New York auction in May 2013 (estimated at $30 to $40 million). The record was earlier held by Jasper Johns for his *Flag* (1965), which brought $28.6 million at Christie's New York in 2010.

Rankings aside, Richter is considered the most influential living painter. Now in his 80s, he has been painting since 1962. His early work included abstracts and figurative works, portraits, still lifes, and paintings of photographs. His more recent work is Abstract Expressionism, brushing swaths of primary color onto huge canvases, then taking a squeegee loaded with a single pigment and dragging it across the surface. The result is spectacular. Richter is the subject of my favorite recent art documentary movie, Corinna Belz's 2012 *Gerhard Richter Painting*.

The art shown at the most prestigious art fairs suggests that American, German, and British artists are still most in demand, with French and Italian artists close behind. At Art Basel in 2012, about a quarter of the works on display were by Americans, with a quarter by artists from the other four countries combined.

If one believes that curated exhibitions predict the art that will find popularity in the art world five years hence, then it would seem that American and Western European artists will soon lose dominance. The four major exhibitions of the summer of 2012—*Documenta* in Kassel; Manifesta in Genk, Belgium; La Triennale in Paris; and the first-time Kiev Biennale—presented art from countries that are emerging politically and or artistically. Only 10 percent of the art shown at these four exhibitions came from American artists, with Britain, France and Italy jointly comprising another 10 percent. The difference between fairs and exhibitions demonstrates the degree to which the art world is opening up and internationalizing.

Leading contemporary Chinese artists still command prices well below those achieved by Western artists. Zhang Xiaogang's *Forever Lasting Love* (1988) sold at the Ullens auction in Hong Kong in 2011 for HK$70 million ($9 million), breaking Zen Fanzhi's auction record of HK$67 million ($8.6 million) produced at Christie's Hong Kong in May 2008.

Way outside my top 20 list, indeed outside any top 200 contemporary list, there are artists who get lots of publicity, are widely recognized

and collected, are wealthy from their art sales, but are ignored or disdained by art world insiders. These artists will never be offered a place in a MoMA or Tate Modern exhibition, or be on any curator's list, or star in a feature story in any glossy art magazine. Here are three examples. Each has produced work that is treasured by many; their exclusion is a reflection on the culture of art's inner circles.

Thomas Kinkade, who was the most widely collected American painter, died in April 2012 at age 54. Kinkade was probably one of the five wealthiest American artists at the time of his death. He was better known in the United States than Andy Warhol was at his death. Kinkade's success puzzled and infuriated art critics.

Kinkade painted pastel cottages with flowering arbors, nestled in quaint hamlets. The windows in his houses glowed; he branded himself "The Artist of Light." He created a nostalgic world that collectors responded to. Kinkade's paintings and prints were sold in shopping malls and single-artist galleries on the main streets of small towns.

The disdain shown by art critics is not easily explained. One suggestion is that Kinkade produced kitsch—although even art critics have difficulty defining where the line is. Extreme kitsch is easy; a Vienna museum's search for the kitschiest merchandise produced a faux Fabergé painted plastic egg that opens up to reveal what they called a bad imitation of the figures from Klimt's 1908 painting *The Kiss*. The egg is also a music box that plays Elvis Presley's *Can't Help Loving You*. It sold for €130 ($170).

A more conservative definition comes from critic Clement Greenberg, who said kitsch was anything that was conventional studio art rather than avant-garde. Andy Warhol's soup cans were considered postmodern kitsch. Damien Hirst famously said, "I produce pure kitsch, but I can get away with that stuff because I am considered a high artist."

Kinkade became rich not by selling paintings but by selling reproductions, each customized with pink or yellow highlights added by assistants. But Warhol and Hirst also had multiples produced by assistants. One of the things that sets Kinkade apart from these two is that his work has no irony and no postmodern references. He never included a formal back story.

A more important difference, at least to the art world, is that Kinkade's work was not sold through an established gallery and thus was never vetted by a dealer acting as gatekeeper. Art in a single-artist gallery is equivalent, in

terms of prestige (or scorn), to that in a vanity gallery where the artist pays for the privilege of being shown. Vanity art is not worthy of review in any publication, not because of the quality of the work (no critic ever reviews it), but because of where it is shown.

By far the most popular contemporary United Kingdom artist in terms of numbers of sales is Jack Vettriano, age 62. Vettriano may be the second-wealthiest UK artist after Hirst. His work is not offered in mainstream galleries but does occasionally appear at major UK auction houses. In 2004 his best-known painting, *The Singing Butler* (28 × 36 inches) (62 × 79 cm), made £745,000 ($1.34 million) at Sotheby's London. This does not show a butler singing, but rather a couple dancing on a beach, the woman barefoot in a red ball gown. A butler and maid hold umbrellas for them against threatening weather.

After Vettriano painted the picture in 1992, he submitted it to the Royal Academy summer show. It was rejected without comment. In February 2012 *The Singing Butler* was displayed at the Aberdeen City Art Gallery; Richard Demarco became the first newspaper critic in 20 years to review any of Vettriano's works positively when he wrote about the Aberdeen show in *The Scotsman*.

Most of Vettriano's images are of romantic liaisons and feature red lips and nails, stiletto heels, and undone French cuffs. A recent show was titled *Love, Devotion and Surrender*. Vettriano says it is to his sales advantage that the art establishment ostracizes him: "People don't like to be told they lack taste."

Many do love Vettriano's work; his collectors include Jack Nicholson, Jackie Stewart, and Sir Tim Rice. His original oils sell for £35,000 to £135,000 ($50,000 to $200,000). Three million of his prints and nine million posters hang in UK homes. Each year, his UK print sales exceed those of Picasso, van Gogh, and Monet combined. The *Guardian* newspaper has reported that Vettriano earns £500,000 ($760,000) a year in print royalties alone.

The upper level of the art world loves him less: "a purveyor of dim erotica," "the Jeffrey Archer of contemporary art," and "a painter who just colors in." Richard Calvocoressi was widely quoted when, as director of the Scottish National Gallery of Modern Art, he said, "We think him an indifferent painter and he is very low down our list of priorities (whether or not

we can afford his work, which at the moment we obviously can't)." Sculptor David Mach responded, "If he was a fashion designer, Jack would be right up there. It's all just art world snobbery."

No national UK art collection has shown Vettriano's work, with one exception. In 2010, a member of the Scottish Parliament filed a private member's bill that would require Vettriano's contribution to Scottish culture to be recognized by his work being represented in the National Galleries of Scotland. Keenly aware of where their funding comes from, the Scottish National Portrait Gallery in Edinburgh agreed in February 2011 that Vettriano's self-portrait, *The Weight,* would be placed on temporary display.

My third example of nonrecognition and critical disdain is an artist whose work is neither sentimental nor romantic. It is graffiti. Banksy is a household name in England, ranked by *The Times of London* as the fifth richest artist in the United Kingdom. He has been featured in a major documentary film, *Exit Through The Gift Shop,* and his work has been exhibited internationally. It is said that most secondary students in the United Kingdom have a Banksy poster in their bedroom or study.

In 1993 his sprayed, then stenciled graffiti and signature began appearing on trains and walls around Bristol. He said he gave up freehand graffiti when he discovered that stencils were more "quick, clean, crisp and efficient." By 2001 his graffiti was all over the United Kingdom (example illustrated). The typical scene is whimsical or subversive: rats with drills, police officers walking large fluffy poodles, a Beefeater writing "Anarchy" on the wall, a military helicopter with a pink bow, Winston Churchill with a mohawk. One of his most famous works was stenciled on the Israeli West Bank concrete security barrier at Bethlehem in 2005. It is an escape hole in the wall, revealing "Paradise," a beach on the other side.

Banksy and his then-manager Steve Lazarides posted pictures of the street works on his website. When there were lots of clicks on an image, they would turn it into a print, which Lazarides would then sell from his car. Soon galleries and the department store Selfridges began selling his prints. Works from Banksy's first edition, *Rude Copper* (2002), originally sold for £40 ($65), and now bring upward of £10,000 ($16,000).

Barely Legal, one of his most publicized shows, was held in Los Angeles in 2006. It had 30,000 visitors in 36 hours; many waited 90 minutes for admission. The show featured an 8,000-pound elephant painted red with gold

fleurs-de-lis. The elephant in the room, Banksy said, was global poverty. Los Angeles's manager of animal services voiced concern that the paint might be toxic and ordered the animal hosed down. Also displayed was Banksy's portrait of Mother Teresa with the caption, "I learnt a valuable lesson from this woman. Moisturize every day."

Banksy also produces revisionist art. Disguised in a trench coat and fake beard, he installed *Mona Lisa (with a yellow smiley face)* in the Louvre, and a pastoral landscape surrounded by crime scene tape at the Tate. He then placed a taxidermy rat carrying a miniature can of spray paint labeled *Banksus militus vandalus* in London's Natural History Museum. That museum's guards were perplexed as to the rat's legitimacy; it was 24 hours before it was removed.

Banksy's real identity has never been publicized. He claims anonymity is necessary; after all, what he does is illegal. Actually his identity is not entirely secret. He is a 38-year-old from Bristol, whose moniker as a tagger artist was Robin Banx. He has a silver tooth, wears a silver earring, and is known for his love of Guinness. He is said to be a former apprentice butcher, then an unsuccessful political cartoonist. A 2008 *Daily Mail* story published his name and photo. No subsequent news story has repeated it, because "his fans don't want to know." Many in the art world have met him but suffer memory lapses (perhaps hoping to protect his marketing gimmick) when asked for details.

There are four books of photographs of his work. He self-published the first three: *Existencilism, Banging Your Head Against a Brick Wall,* and *Cut It Out.* His fourth, *Wall and Piece,* was published by Random House and, it is said, sold 240,000 copies.

Banksy now produces street art for publicity and credibility, and paintings and prints for sale. A record price was set at Sotheby's London in October 2007, when *The Rude Lord,* an eighteenth-century portrait overpainted to show the subject offering a middle-finger salute, was hammered down at £322,900 ($660,000). His top auction price is $1.9 million for a painting, *Keep It Spotless* (2007), a satirical Damien Hirst spot painting auctioned at Sotheby's New York. Banksy is collected by Angelina Jolie and Brad Pitt, Keanu Reeves, Jude Law—and Damien Hirst. His limited edition prints sell for £7,000 ($10,500).

His collectors pay vandals to remove sections of stone walls, bus stops, and water towers where Banksy has created art. In 2013 the London company

Sincura Group, which specializes in "obtaining the unobtainable" for its clients, held a private auction of Banksy's *Slave Labour* (48 × 60 inches) (106 × 132 cm), a wall mural cut from the side of a Poundland supermarket in the working class London suburb of Wood Green. It showed a barefoot boy, hunched over a sewing machine. It sold for £750,000 ($1.1 million).

The mural depicted a child in a sweatshop sewing Union Jack bunting, and was reported to be Banksy's critique of the Queen's Diamond Jubilee celebrations. The town council tried to block the sale, arguing that "The work was given freely by Banksy to our area and should be on show," but to no avail. *Slave Labour* sold at auction for £750,000 ($1.1 million).

Banksy is critical of these sales, and of "hedge fund managers who want to chop [graffiti art] out [of the wall] and hang it over the fireplace." He encourages people not to buy anything that was not created for sale in the first place.

What is perhaps the ultimate Banksy story came the first day of November 2013, and involved a work that was specifically created for sale. For a month previous, Banksy had been stenciling provocative images on buildings in Manhattan, Brooklyn, and Queens, during what he described "an artist residency on the streets of New York." The street art was widely reported on the front page of *The New York Times* and in other print and broadcast media.

In late October, New York's Housing Works Agency, which provides support for homeless patients living with HIV/AIDS, had a woman walk into its thrift shop to drop off a painting as an anonymous donation. She said the painting was worth a lot of money and someone would contact Housing Works with details. The next day the organization received a call from Banksy's team, authenticating the work and asking that it be auctioned.

The painting, titled *The Banality of the Banality of Evil,* showed a man in a Nazi uniform sitting on a wooden bench, staring at a lake and snow-covered mountains. The work had been purchased from another thrift shop for $50. Banksy added the image of the Nazi and the bench, and signed the painting. The title comes from Hannah Arendt's book about the trial of Adolf Eichmann.

The foundation displayed the work in the window of the thrift shop and offered it for sale in a well-publicized Internet auction. The opening bid was $74,000. In four days *Banality* attracted 138 bids. The $50 painting, now an original Banksy, sold for $615,000.

Ralph Taylor, a specialist at Sotheby's, said of Banksy, "He is the quickest-growing artist anyone has ever seen." Banksy responded to the compliment by posting a painting on his website; it featured an auction room full of attentive bidders, with the caption, "I can't believe you morons actually buy this shit." He then released a limited edition print with the same title.

Banksy's then-manager Steve Lazarides, also from Bristol, set up a gallery housed in a former sex shop on the ground floor of a building in SoHo. Lazarides did not qualify as a "gatekeeper" but he does authenticate Banksy gallery works for Sotheby's and Christie's. No one authenticates the street murals; Banksy says that would be like writing "a signed confession on letterhead." Those murals that appear on his official website (www.banksy.co.uk) are accepted as authentic. In 2012 Banksy and Lazarides parted ways; the artist established a new sales and authentication company called Pest Control.

Banksy says he is not impressed with his sales. "The art world is the biggest joke going," he said in a *New Yorker* interview in May 2008. "It's a rest home for the over-privileged, the pretentious, and the weak."

Banksy may be one of that world's most successful jokes, but he is not on anyone's list of noted contemporary artists. It is not at all obvious why Cattelan makes the list and Banksy does not. Are his jokes not as subtle or clever? Banksy says, "I'm not so interested in convincing people in the art world that what I do is 'art,' I'm more bothered about convincing people in the graffiti community that what I do is really vandalism."

How about a new artist who achieved almost instant financial success—and critical acclaim as well? That is the subject of the next chapter.

JACOB KASSAY'S
WILD PRICE RIDE

Who is diddling with Jacob Kassay's prices?
—Lindsay Pollock, art journalist

Can an emerging artist become wildly successful just through clever marketing and some creative price-enhancing strategies employed by dealers or collectors? To put "successful" and "emerging" in context, consider the sobering statistics on prospects for aspiring artists. London and New York each have about 40,000 resident artists, and probably more than that in Berlin, Los Angeles, and Beijing combined. Of the 80,000 in London and New York, 75 might eventually become mature artists with seven-figure incomes, and another 300 might show in mainstream galleries and earn six-figure incomes from their art. On the next tier are several thousand artists with some gallery representation who supplement their income waiting on tables, teaching, or writing, or who receive support from their domestic partners or from their local welfare authority.

There are thought to be 15,000 artists walking the streets of London or New York at any one time, calling on dealers and seeking representation. The über galleries shun almost all. Most mainstream dealers pay only passing attention to submissions in the form of completed works or JPEGs dropped off by a dozen new artists each week. Largely from recommendations by gallery artists and collectors, and from talent-spotting at MFA graduating shows, a gallery will take on one or two new artists a year. London dealer Victoria Miro is far more generous than most; she says she looks at work from hundreds of artists every year, visits 50 studio shows, and may include work from five to ten newcomers in her group shows. From these,

she takes on one new artist each year; she may also add two others who move from other galleries.

That leaves thousands of artists in London, New York, and elsewhere, who offer their work through artist cooperatives, on the Internet, or privately. Most will move on from the professional art world after two or three years, to be replaced by a new cohort of graduates.

Few aspiring new artists ever achieve recognition; even fewer manage it quickly. Then there is Jacob Kassay, an artist trained in photography. Kassay went from artist obscurity to having his work sold at evening auctions, and saw his prices increase forty-fold and then slump—all in a 12-month period.

On November 9, 2010, at Phillips de Pury's contemporary day sale in New York, Kassay's work came to auction for the first time. *Untitled* (2009) was estimated at $6,000 to $8,000 to reflect his gallery's asking price. The 48 × 36 inch (120 × 90 cm) silver painting was bid up to $86,500, 14 times the high estimate.

One year later, another Kassay silver painting of the same size was offered at Phillips's evening contemporary auction. This time, Kassay was promoted in Phillips's auction advertisements alongside Richard Prince, Christopher Wool, Anish Kapoor, and Cindy Sherman. Estimated at $80,000 to $120,000, the silver was hammered down for $206,500.

In the 12 months between the two Phillips auctions, there were articles about Kassay in a staggering number of serious publications, including *Artinfo, Art + Auction, The New Yorker, The Art Newspaper, Art in America,* and the *New York Observer.* Each article discussed his art by focusing on his prices. Someone did one incredible public relations job. His short but dramatic history is a great example of the curious economics of the contemporary art market.

Kassay was born in Buffalo, New York. He graduated in 2005 with a BFA in photography from the State University of Buffalo. He moved to New York City and found representation with Eleven Rivington, a Lower East Side gallery owned by Augusto Arbizo. The gallery is a 900-square-foot space located in a developing art district of Manhattan; it specializes in early-stage emerging artists. Shortly after, Kassay gained representation in Paris with Galerie Art:Concept and in Brussels with Xavier Hufkens.

His silver paintings are both conceptually and technically interesting. They are described as beginning with Kassay priming a canvas with acrylic paint, leaving areas of different paint density and roughness. A technician

puts the canvas through a photographic process that involves electrolysis in a silver-electroplating tank to produce a mirrorlike surface with lines and textures reflecting the unevenness in the primer. The silvering process scorches any area of the canvas not covered by acrylic, resulting in brown burn marks around the edges. Apparently the process is such that Kassay, together with a technician, could easily produce one painting a day.

Arbizo has described the effect as "simultaneously painting, sculpture, and interactive installation; the reflective surfaces come alive with the presence of an audience." *Artinfo* writer Andrew Russeth described it as "the appearance of elegantly abused luxury goods." That is a great phrase, but it does not really qualify as a back story. The story that his dealers seemed to prefer involved emphasizing Kassay's age; youth plus high price promises a brilliant future.

Some of Kassay's silver surfaces are semi-opaque, reflecting movement and color with an effect like out-of-focus photography. The most reflective works bring the highest prices; they are a cross between monochromatic painting and metallic sculpture. His work has been loosely compared to that of Robert Ryman (one of Kassay's heroes), to Rudolph Stingel's metallic surfaces, or (by a dealer, and this is a major stretch) to Andy Warhol's *Oxidization* series. Kassay also produces video, fabric, and performances, but his reputation is as "the silver painting guy."

Most midlevel galleries show an emerging artist at a $2,500 to $5,000 price point for a first show. If the show sells out, a second show 15 to 18 months later will be priced at $6,000 to $9,000. If that show is successful, a third 18 months after that might be $12,000 to $15,000. Kassay's debut show at Eleven Rivington in 2007 opened with his silver paintings priced at $4,000 for his standard, 48 × 36 inch size. His gallery prices rose to $8,000 a year later.

The week after the first Phillips auction, at a charity auction to benefit The Kitchen (a nonprofit that supports emerging artists), a similar Kassay silver painting now with a stated gallery value of $12,000 came up for bids. It was hammered down at $94,000 to a telephone bidder who beat out dealer Zach Feuer, bidding for a client. The Kitchen allows donating artists to take a portion of the purchase price; it is unknown whether Kassay did. If so, he may have netted far more from the charity auction than from any gallery sale to that point.

Another 48 × 36 inch *Untitled* (2009) came up as the first lot in Phillips de Pury's May 2011 evening sale in New York. As with all the previous silver

paintings, the consignor was not identified. This *Untitled* was estimated, this time based on the earlier auction results, at $60,000 to $80,000. It was hammered down in 40 seconds at $290,500, also to a telephone bidder. This marked a $200,000 price increase in six months.

As it turned out, this was Kassay's top auction price. A month later the decline started, with another silver *Untitled* (2009) of the same size and estimated at £50,000 to £70,000 ($82,000 to $115,000) sold to a telephone bidder at Phillips London for £145,250 ($239,000).

In September 2011 a rumor spread that two of Kassay's silver paintings had been purchased by Christie's owner François Pinault. In October 2011 in London and again at Phillips, the same size *Untitled* (2010) sold for £163,250 ($257,000)—an increase over June that turned out to be a blip, perhaps a result of the rumor. Phillips's New York sale in November 2011 offered another *Untitled* (2010) silver painting, this one estimated at $80,000 to $120,000. It sold in 50 seconds, with 9 bidders and 21 bids, for $206,500. Another November 2011 auction brought $180,000. The $110,000 drop over six months may have reflected an oversupply coming to auction or the diminished lust of bidders as more of his works came on the market.

In mid-2010, Eleven Rivington had raised the gallery list price for his 48 × 36 inch silver paintings (there are also smaller ones) to $9,000. After the first Phillips day sale, the list price went to $15,000. In 2011 it went to $18,000, then $20,000.

At the time it hit $20,000, Oliver Antoine, Kassay's Paris dealer at Galerie Art:Concept announced there were 80 names on waiting lists for a silver at Kassay's three galleries. It is not clear whether these were "let me look" lists or "I'll take one if and when one becomes available, sight-unseen" lists. In either case, there were at that time probably no other artists (and certainly no emerging artist) in the United States with an 80-collector list.

Following the $290,000 auction sale, a blog post by Lindsay Pollock discussed what insiders had been speculating: that Pace Gallery president Marc Glimcher was, directly or indirectly, bidding up Kassay's work as one means of poaching him. Glimcher responded to a query by writer Sarah Douglas in a text message: "Pace, I'm sorry to say, has had nothing to do with the recent escalation of the prices of Mr. Kassay's work." He added, "Now I'm hoping this will turn into a case of life imitating journalism." Glimcher conceded that he had bid $180,000 on the work that sold for $290,000.

The art world was still rife with rumors about Kassay being poached; several other dealer names were added to the mix. In October 2011 Augusto Arbizo of Eleven Rivington stopped giving media interviews about his artist.

Glimcher's admission that he had personally bid so much for a Kassay work actually seemed to rule out Pace as a poacher. It was thought that no gallery hoping to move an artist would bid work that much over its gallery price. There is danger to an artist when their market price rises too quickly, especially if market machinations are seen to be at work. For any gallery looking to poach Kassay, offering a substantial signing bonus or a guaranteed monthly advance would seem to make far more sense.

There is a short-term logic to the artist's own dealer bidding up prices. Astronomical price increases produce art world chatter to the point that perhaps ten collectors around the world conclude they must own a Kassay. Alberto Mugrabi, when asked about Kassay (whom he had not heard of) said, "That's the most amazing thing about the art world; at $8,000 a work is not that interesting. At $80,000 it becomes more interesting. At $800,000 it is the talk of the town."

There is a longer-term downside to bidding up auction prices. Once the ten collectors are satisfied, there is little demand at a dramatically higher price level. Collectors expect modest, staged price increases, never multistage jumps. Those on the waiting list expect to buy at the original price, which the gallery will not now honor. The artist ends up with an unsuccessful show and may now be perceived as out of favor because he became too successful, too fast.

Another problem occurs if a Kassay silver is sold for $20,000 at Eleven Rivington and the purchaser almost immediately consigns the work to an auction house. Selling work for far less than it might bring on an open market is an invitation to speculators to purchase and flip.

There is yet another risk. If several silver paintings are consigned to the same auction cycle with high estimates, some or all may fail to reach their reserve and go unsold. Again, Kassay becomes perceived as out of favor, thereby damaging his future auction and gallery sales. What should Augusto Arbizo have done about Kassay's prices?

What he did in November 2011 was offer his last remaining Kassay silver painting, stored in the back room of his gallery and shown only on request, at what he announced as "the secondary market price" of $180,000.

There were apparently no takers from the waiting list. Arbizo announced the next Kassay show would be "in late 2012, with prices to be announced then."

Pricing gets even more complicated when dealers try to achieve higher than gallery prices by taking the work to an art fair. Prices at a fair for a hot artist with a waiting list start at gallery list price plus a third of the difference between gallery price and auction price. A buyer may be willing to pay this to avoid the waiting list. More important, with an art fair purchase there is no dealer resale contract preventing the buyer from immediately consigning the work to auction. In December 2010 Arbizo displayed two smaller Kassay silvers at the Eleven Rivington booth at the NADA Art Fair in Miami, priced at $8,000 each. Both sold quickly. At least one of these soon reappeared at auction.

In June 2011 Kassay was the subject of an imaginative dealer initiative at the Art Unlimited section of Art Basel. Art:Concept and Xavier Hufkens jointly showed a ten-painting Kassay installation. In one of those ploys that can probably only be used once, they announced that works in the installation were for sale only as a set, and only to a museum. No private collectors need bid. Press reports suggested an asking price north of $450,000.

The initial assumption in the art community was that no museum would offer this much for the work of a 27-year-old emerging artist, nor would a museum want to acquire ten silver paintings. Any museum with an interest would ask that the quoted price be discounted substantially, 50 to 70 percent or more. A discount would be justified in return for the validation that comes with acquisition by a respected institution. Hufkens said at a press conference that the ten-work set sold to an unidentified institutional buyer for $400,000. If the selling price is accurate, it suggests a purchaser other than a museum.

The museum "limitation" was brilliant. There was extensive publicity, with each discussion using "Kassay" and "museum" in the same sentence. This was the first suggestion of the institutional acceptance that signals the highest level of validation of an artist's work.

The inclusion of Kassay's and other "paint-almost-wet" art in Phillips's auctions is controversial. It blurs the line between auction house and gallery, and stretches the longtime auction house convention of not reselling a work within five years of its initial sale at a gallery. The gallery's role is to manage the artist's career with sequential shows, managed prices, and placement of work with influential collectors or museums. An auction house offering

primary art inhibits these activities and might discourage the artist's gallery from mounting new shows. Auction houses compromise by listing the gallery selling price as the estimate, as Phillips initially did. The consignor understands the game, hopes bidders will also, and expects the work to sell for far more than its gallery value.

Another result of escalating prices is the pressure on Kassay to keep turning out silver paintings rather than moving on to something new. Arbizo was adamant that he does not apply such pressure. But satisfying 80 people on the waiting list, even at $20,000 for each painting with half to the artist, would yield Kassay $800,000, for what might be less than three months' work. This is a delicious outcome for an artist six years out of art school, who was quoted in *The New Yorker* as saying, "I was eating ramen my first year in New York."

The wild price ride of Jacob Kassay illustrates one of the key antagonisms between dealers and auction houses. Should an artist's market price be managed and increased systematically by a dealer? Should major auction houses agree not to sell a work of art for a period of time after its first gallery sale? For Kassay, this would mean that his art could only be purchased by those who were vetted by a dealer as "important." Or was the Kassay process reasonable, with the price for primary market art determined by the final two bidders at each auction, with each successful bidder able to jump the queue?

After all the rumors, Kassay did not jump to an über gallery. The late 2012 show at Eleven Rivington never materialized. In January 2013 Kassay's name was removed from Eleven Rivington's list of artists represented. In April 2013 the artist announced he was joining Gallery 303, located on 24th Street in New York. This gallery also represents emerging artists.

In 2013 *Forbes* magazine named Jacob Kassay as a category finalist in its "30 Under 30" prodigy competition for "Art and Style." (The winner was fashion designer Carly Cushnie, who produces red-carpet cocktail dresses).

Kassay has expanded his art output to what he refers to as disambiguation. His new works are uniquely shaped large monochromes, created of previously cut canvases and stretched over frames produced to accommodate the shapes. Staples and loose strands of thread remain on the work. Kassay said he would still be represented by his two existing European galleries, and would continue to produce and show his silver paintings.

THE AUCTION HOUSES

BEHIND THE GAVEL

When you put together an auction, it's like putting on a play. You must have changes of rhythm, you must have your high moments, you must have less exciting moments, and you must orchestrate it.

—Simon de Pury, auctioneer

There are two markets, the regular market for the average collector and the super-market for global icons. The last group is smart and gravitates toward the very top.

—Tobias Meyer, auctioneer

So far auction houses have been described as a marketplace in which prices are both transparent and determined by the highest bidders. The activities of the two major auction houses are best understood against a different reality: The ongoing function of each is to continuously build its own brand.

For the consignor, Christie's or Sotheby's is assumed to bring a higher gavel price for a lot. For the bidder, these brand names reduce uncertainty. For the successful purchaser, dealing with one of these auction houses identifies one as an individual of both cutting-edge taste and money.

Auction house promotion of a consignment emphasizes the branded artist, the back story of the art, and, sometimes, the identity of the consignor. The latter involves persuading bidders that Mr. and Mrs. Internet Mogul are perceptive, widely admired collectors whose taste in art should be emulated. The consignor's reputation is burnished by newspaper and art magazine stories repeating material in the auction house's press releases.

Until the late 1980s Sotheby's and Christie's relied primarily on attractive, designer-clad, and socially connected women to make consignors and

collectors comfortable with the auction process. The houses relied on specialists (formerly called experts) to make them comfortable with the art.

The reliance has now shifted to the use of press relations, advertising, and activities supporting auctions. The latter include transporting featured works to a collector's own city (or home) for viewing, production of glossy in-house magazines, online commentary about forthcoming auction works, and holding private receptions.

The first line of contact is through post-auction press releases intended to set the stage for future consignments. These focus on how many record prices were achieved and how many works sold above the high estimate. A few art world commentators are given off-the-record briefings identifying the countries buyers came from and details of the extraordinary marketing efforts that produced the auction results. All this information goes to the public but is not targeted for them. It is primarily intended to present an image of auction house prowess to potential consignors.

The public relations departments of the two major auction houses do a fabulous job. Media coverage focuses on auctions as events and only secondarily on the items being sold. *The New York Times* offered a full page of coverage in the first section of the Sunday paper on the background to the works being offered at the November 2012 Sotheby's and Christie's contemporary auctions. The results of each auction received extensive coverage the morning after, also in the front section. The *Times* offered additional coverage in the Arts and Metro sections. The business section of the *Times* almost never carries auction news.

Christie's and Sotheby's are the only two commercial enterprises (with one exception) for which selling prices are reported in news media around the world regardless of the general indifference of most readers to the items being sold. The other enterprise is the stock exchange.

Auction specialists build personal relationships with potential consignors through invitations to luncheons, dinners, cocktail parties, and exclusive previews, offering appraisals and authentication and, sometimes, as a last resort, offering employment for their offspring. A major target group is previous buyers; every successful bidder is both a potential repeat buyer and a potential seller. Auction houses have an ongoing problem keeping up their specialists' enthusiasm for these relationship-building activities. Most accepted their auction house position assuming the business was art-centric rather than customer-centric.

The first step in staging an evening auction is production of the sales catalog. Here the potential bidder finds a description of each painting, a list of collectors and dealers who have owned the work, and a list of where it has been shown or written about. The catalog mentions whether the work has been previously auctioned at Christie's and Sotheby's; rarely is another auction house listed.

The physical weight and printing quality of a catalog can be impressive. The November 2012 catalog for Sotheby's contemporary sale in New York was 2 inches thick, 477 pages (for 72 works), and weighed close to 5 pounds. It was printed on heavier paper and with better color separation than the finest magazine.

The catalog format is intended to position the auction house as an institution of scholarship. The catalog rhetoric recounts a back story for each major work, one the new owner inherits and can retell. Every work comes from an historic or at least romantic setting. Previous owners were a "Distinguished Midwestern Collector" or had a "Noted Private Collection," or the work was "From the Collection of a Gentleman (or Lady)." While no one is supposed to know who the actual consignor is, art world insiders may—often Carol Vogel reports the actual "who" in *The New York Times*. No auctioned work ever appears at auction described as having come from an acrimonious divorce, or from a banker under indictment. At the bottom of the catalog entry is the selling price estimate, which seems quite reasonable given the back story.

No important client is ever required to purchase a catalog. Each major house couriers it on request, although most recipients now have it delivered as a digital file to their computer or tablet. A smaller, lightweight catalog is provided to those who attend the auction.

For the most important lots, private showings take place in a half-dozen cities, with the works transported by private jet for by-invitation viewing. Christie's preview showing of Elizabeth Taylor's gems spent five days in Moscow, part of that on public display at GUM department store in the center of the city. When a bidder purchases via a telephone bid and is later identified as from Russia, the reaction may be amazement that someone would spend tens of millions on something they have not seen. Jussi Pylkkanen, Christie's president for Europe, the Middle East, Russia, and India, estimates that 20 percent of high-end lots sold by the auction house go to bidders who first saw them in a traveling exhibition.

The next stage is the host-city private showing the evening before the auction preview opens to the public. A specialist will also arrange a private showing for an important client at the gallery, before or after public exhibition hours.

The preview mimics the opening of a museum show rather than a commercial sale. The layout is important. Where a work is hung signals its status. The feature works occupy places of honor; at Sotheby's New York, these lots are facing the gallery entrance, just to the right, or the left, or in an alcove to the right of the main entrance—usually in that order of importance. Less important (and less expensive) works are grouped in separate galleries to the extreme left of the entrance or at the back of the room.

The challenge is to carry over the enthusiasm of the preview to the evening auction. For the November 2012 Sotheby's contemporary sale, the auction house repainted the salesroom a dark, semigloss blue, and added the same color slipcovers to chairs. This was thought to be a more appropriate setting for contemporary art than the off-white color that served for the Impressionist sale the previous week.

Admission to the auction is by emailed ticket with restricted seating. Having a larger crowd does not affect the bidding for a major contemporary sale. At each auction there will be no more than 30 active bidders in the auction hall, with perhaps 40 bidding by telephone or Internet. Many attend the evening auctions not just because they are a place to be seen, but because they offer the fascinating spectacle of people bidding amounts that are unimaginable to many in the audience.

What can each house do to try and gain a consignment, when dealing with consignors who know they can play the two auction houses off against each other? In 2010 art works from the estate of Mrs. Sidney F. Brody of Holmby Hills, California (adjacent to Beverly Hills), were the subject of fierce competition. The featured work was the previously mentioned *Nude, Green Leaves and Bust* (1932) by Picasso. The two auction houses pursued the Brody consignment for its own sake, but also in the hope it would attract other consignors to piggyback on the publicity and collectors it would attract.

The estate lawyers first asked Sotheby's to waive the consignor charge; Christie's responded by waiving theirs. Christie's immediately offered to rebate a large part of the buyer's premium and to provide price guarantees.

These were reported as $150 million for 28 lots, with 27 provided by a guarantee offered jointly by the auction house and a third party. One work was to be covered with an auction house regular third party guarantee. Reportedly, Sotheby's again matched; at least one of their proposed guarantors was the same party approached by Christie's.

One of the houses presented the trustees with a mock-up of the proposed catalog with optional covers, plus an architectural sketch of how the works would be displayed in the auction preview. Each house suggested the option of selling some of the works privately.

Christie's suggested flying some of the art to six major cities in pursuit of UHNW (ultrahigh net worth) collectors and inserting full-color auction announcements in several major newspapers. Sotheby's matched.

Mrs. Brody had always said that her works by Picasso, Giacometti, Matisse, and Degas showed best with the décor in her California home. Christie's offered to hang the works in galleries redesigned to simulate that décor, and to install a black-and-white tile floor duplicating that in the Brody home.

There may have been other requests; some consignors ask for assurances on the identity of the auctioneer, where the work will be placed in the catalog, where the work will be hung during the preview, or the number of clients the auction house will contact directly before the sale. If every proposal by one house is matched by the other, a final choice may come down to interpersonal factors: who is the seller or the trustees most comfortable with.

The Brody collection went to Christie's. It sold in New York for just over $224 million (£148 million), with the Picasso bringing a then-record $104 million (£70.2 million). To put that $224 million figure in context, the 11,700-square-foot Brody home that had housed the collection had 9 bedrooms, 8 bathrooms, a tennis court, pool, and guesthouse, and stood on 2.3 acres (.93 hectares). Described as a modernist masterpiece, it was designed by architect A. Quincy Jones and decorated by William Haines.

The home was listed at $24.95 million (£16.8 million), which included high quality replicas of the art works that had been sent to auction. It sold for $14.9 million—less than 7 percent of the value of the art it once held.

Christie's PR department kept the press informed of the consignment's progress. Well before the auction, Carol Vogel wrote a long story in *The New York Times* titled "Christie's Wins Bid to Auction $150 Million Brody

Collection"; she discussed the four-month battle and concluded that Christie's had probably won by offering the highest guarantee. The *Times* was later persuaded that the featured Picasso in the collection was newsworthy enough to cover with a separate front-page Sunday Arts and Leisure section article extolling the work and discussing how it was expected to sell for over $100 million. That article was about value although it appeared in the Arts section.

The day following the auction, almost every newspaper in the United States carried news of the record price achieved for the Picasso. A week later, another *Times* article by art critic Roberta Smith, titled "The Coy Art of the Mystery Bidder," discussed the possible identity of the Picasso purchaser.

While a loan was not part of the Brody transaction, many consignments—both of art and in the example that follows, of jewels—are secured with the offer of a substantial loan from the auction house. Some claim the art market is the largest unregulated money market in the world. When auction catalogs say the house has "an economic interest" in a lot, the reference is often to a consignor loan.

The Elizabeth Taylor consignment came to Christie's because in 2006, at a time when her own jewelry company was filing for bankruptcy, Taylor obtained "a multimillion dollar line of credit" from the auction house. In return, she agreed that her property would be auctioned by Christie's after her death.

Lending can be fabulously profitable for the auction house. The opening offer (almost always the subject of negotiation) is that the house will advance up to 50 percent of the low estimate of an art work to be consigned at an interest rate of 3 points above the auction house's cost of funds. To hold a work for a future auction or secure a low estimate or to avoid a guarantee, a consignor may be given a higher percentage-of-value loan and/or a lower interest rate.

If the art security is not immediately consigned for auction—and even if the loan is repaid—the owner is restricted from selling the property anywhere but at that auction house for a stated period of time.

Much of the auction house's profit from lending arises from an additional condition, that the consignor will pay "normal" (which means full) commission. The auction house may then arrange a third-party guarantee

for the consigned art at a very low fee, because the guarantee price is set at the loan value.

The auction house receives an interest premium over its own cost of capital, plus a commission higher than the level that might otherwise have been negotiated. Assume the loan is for four months, the commission discount is 5 percent, and the guarantee fee is 1.5 percent. The auction house has now earned the equivalent of a 20 percent annualized return on the loan. That return comes from a risk-free transaction if a third party has guaranteed the value of the underlying art security.

Loans can be substantial. In 2012 Peter Brant, introduced in the first chapter, used part of his contemporary art collection as security to help recapitalize White Birch Paper, the family newsprint business. Brant pledged 56 works to Sotheby's, by artists including Warhol, Prince, Koons, Lichtenstein, and Basquiat, in return for a loan reported as $50 million.

As the financial side of the business becomes more important, auction houses find that investment banker skills are as important as art expertise. Dominique Lévy, former head of Christie's private sales, says that "In the past [specialists] had to . . . know how to look at the painting and price it in the current market . . . today specialists have to know about guarantees and financials and interest rates and the cost of every step of marketing." Christie's contemporary art deputy chairman, Brett Gorvy, said of the change, "This is business, it ain't art history."

Sometimes, even after years of preparatory work, a consignment that seems a sure thing nevertheless ends up with the competition. In 2009 Christie's 600-lot auction of the collection of Yves Saint Laurent and Pierre Bergé lived up to its billing as the "Sale of the Decade." The three-day extravaganza brought €374 million ($484 million).

Art world experts were perplexed as to why, at the eleventh hour, the consignment ended up with Christie's. Sotheby's had long cultivated a relationship with Bergé. They had held several sales in New York of property from the Bergé collection, and had recently given him a multimillion dollar unsecured bridge loan. There was also reported to be animosity between Bergé and François Pinault, owner of Christie's, dating back to Bergé's 2002 creation of Pierre Bergé & Associés as a competitor to Christie's Paris.

The story is told that Sotheby's alienated Bergé by pressuring him to sign a formal consignment agreement while his longtime partner Saint Laurent lay

ill in a Paris hospital. Christie's François de Ricqles, a longtime friend of Bergé, negotiated a rapprochement between Bergé and Pinault. Christie's offered an advance of €50 million ($78 million), secured by receipts from the estate auction whenever it was held. Part of the loan repaid the Sotheby's advance.

Christie's also agreed to Bergé's request (which Sotheby's had apparently resisted) that the auction be held in Paris's Grand Palais. The rental was reported as €105,000 ($135,000) for the three-day period. Even with this expense, Christie's probably grossed €40 million ($51 million) from the sale and netted €15 to €20 million ($20 to $26 million) after costs.

After the negotiation, promotion, travel, and previews, there is the evening of the auction. Many attendees arrive early to be seen, to socialize, and to take part in obligatory exchanges of "what work are you here for" at the entrance to the auction room. The auctioneer is central to the choreography and psychology of the evening. He is not identified by name in the catalog or before the auction. To do so, it is argued, would position him (for a major evening auction, it is virtually always a male) as something other than a professional whose role is to help determine the correct value for each consigned work.

Sotheby's Hugh Hildesley claimed that running an auction requires entertaining the 90 percent of the people in the auction room who have no intention of bidding while eliciting bids from the lustful 10 percent. As The Reverend Hugh Hildesley, the auctioneer had for 11 years been rector of the Church of the Heavenly Rest, located a few blocks from Sotheby's Upper East Side headquarters. He said auctioneering was similar to his old job: "Both had to do with client development."

Hildesley says if he takes much more than two minutes per auction lot he loses the 90 percent, and the energy drop in the room affects the 10 percent. The ideal is a 70–72 lot auction in just over two hours. For that period the auctioneer must be persuasive, without repeating the same gestures or phrases too frequently. He must keep a restless audience engaged in something other than checking their mobile phones, particularly the bidders who are waiting until their target lot comes up. He varies his pitch, tone, and body language, implying excitement for an item in which there may be little.

The auctioneer introduces each item in the same way, "Number twenty-six, the Warhol." He never mentions actual attributes of the work although

he may mention a distinguished consignor or provenance. The description and back story are in the catalog; to embellish those would break the rhythm.

In a high-end contemporary auction, as many as half the bids come by phone or on the Internet. There are 15 or more phones in the salesroom, manned by auction house specialists and a few expensively tailored young women (whom dealers refer to as auction babes), often chosen because they speak languages such as Russian or Cantonese. The auctioneer usually knows the identity of the person on the phone; the specialist hand signals to the auctioneer the level of commitment of the bidder while simultaneously conveying to the bidder the level of excitement in the salesroom.

Telephone bidders are essential to the perceived importance of a lot. Is the salesroom bidder up against an Emirate museum, a Russian industrialist, or a New York dealer sitting in a skybox high above the auction room? As a further indication of global interest, the front of the auction room features a large conversion board showing each bid increment in multiple currencies. Every bidder is perfectly competent to calculate their bidding position in the auction currency; the board is there to signal the global status of the event.

When a lot elicits no initial interest, the auctioneer maintains the flow by picking fictitious bids "off the chandelier" on behalf of the consignor. If these are not followed by real bids after the reserve price is reached, he says something like "can I have one more . . . all done now . . . last chance . . . any more then?" and passes the lot.

The auctioneer bypasses any bidder who does not maintain his ideal pace of a bid every one and a half seconds, said to be enough time to raise a paddle but not enough to think about the new bid. He comes back to them immediately if their paddle again goes up to keep them involved.

The auction cadence slows as bidders drop out. Dealers or agents bidding for clients on a mobile phone create a longer delay than the auctioneer likes. Some collectors and dealers sitting in the auction room intentionally slow the pace by bidding on their cell phone through the auction phone bank. The auctioneer waits for these known bidders and for any VVIP bidding from the skyboxes in the auction room. Typically the longest bidding period for any lot is about three and a half minutes. The record sale of Edvard Munch's *The Scream* in 2012 at Sotheby's dragged on for just under ten minutes, which might itself be close to a record.

The assumption that the auction process produces a reasonable price for a painting through interacting bids from participants is simply wrong. From

the moment that multiple bidders seek the same lot, the auctioneer's role is to play on rivalries and egos, to encourage bidders not to back down. Comments like "Last bid . . . are you back in . . . are you sure . . . no regrets . . . not yours, sir . . . don't let him have it" play directly to this.

The "no regrets" comment is emphasized in auctioneer training; it comes from the so-called endowment effect. Endowment, a concept in cognitive psychology, refers to the fact that people value objects more when they think of them as their own. They hold on to stock market investments well past the point at which evidence suggests they should sell them. They would insist on a higher price to sell an old coffee cup that is theirs than they would pay for an identical one they see in a market.

The endowment effect means that values change during the auction process. An under-bidder feels regret. The reference point of briefly being high bidder and then losing the lot it is very different from having the money and deciding to bid. When the bidder momentarily holds the high bid, the endowment effect cuts in. He will pay more not to lose. His reference point changes to "This was mine, this should be mine." There is regret at losing. The auctioneer plays on that.

Art value and spirited bidding can come just from the back story recounted in the catalog description. In November 2011 Sotheby's London auctioned *Bridge No. 114,* the work of artist Nat Tate, with an estimate of £3,000 to £5,000 ($4,600 to $7,700). The catalog description detailed Tate's incredible story: a tormented abstract expressionist artist and lover of Peggy Guggenheim, who destroyed most of his own art work before his tragic suicide by jumping from the Staten Island ferry. Wow!

The catalog went on to list galleries where he had exhibited, and to quote from personal and professional statements from David Bowie and Gore Vidal. The latter described him as "an essentially dignified drunk with nothing to say." After spirited bidding, the Tate sold for £7,250 ($11,200), well over estimate, to a telephone bidder on the line from Australia.

If you are struggling to place the artist's work, there is a reason. Nat Tate is a character from William Boyd's novel *Any Human Heart.* Boyd also created the paintings that survived Tate's suicide. The nonexistent artist's name is a combination of "National Gallery" and "Tate." Bowie, Vidal, and Sotheby's were in on the joke.

The auction proceeds went to the Artist's General Benevolent Fund, founded in 1814 by J. M. W. Turner. The telephone buyer, British television comedian and commentator Anthony McPartlin, did not request that the sale be rescinded. There is no indication how much of the real back story he retells to guests.

CHRISTIE'S, SOTHEBY'S, AND THEIR COMPETITORS

I asked her what she collected. "All famous names," she answered. I pressed her for specifics. "You know, Sotheby's and Christie's, those names."

—Michael Findlay, art dealer

There are four main elements to our business model—product, distribution, communication, and price. Our job is to do such a fantastic job on the first three that people forget all about the fourth.

—Bernard Arnault, CEO of LVMH

Christie's and Sotheby's are the world's two major value-adding auction houses. Their evening contemporary art auctions produce headline prices for the work of an elite set of artists. Inclusion in an evening auction confers final legitimacy on an artist.

Christie's and Sotheby's share 80 percent of the Western world's auction market in high-value contemporary art. In 2012 Christie's did $6.3 billion in total art sales, up 10 percent from the previous year, and Sotheby's $5.4 billion, down 7 percent. The two constitute what an economist calls a duopoly, a competitive pairing that dominates a market. Think of Visa and MasterCard with no-fee credit cards, or the Republican and Democratic parties competing in the American electoral college, or Coke and Pepsi.

Most firms in a duopoly learn to coexist in a mutually profitable manner. For all their hundred-plus years of competition, Coke and Pepsi have waged endless advertising battles but never reduced the price they charge their bottlers for syrup. The exception to the peaceful duopoly rule is Sotheby's and Christie's, who regularly compete with each other for consignments in a manner that can see either house selling at a loss.

Whatever the level of profitability, Philip Hoffman of The Fine Art Fund says of competing with the two, "They've attracted the best experts that money can buy, they've got huge departments and offices all over the world, they've got massive client reach . . . why would you sell a $5 million lot with the number three house when you have the choice of number one or number two?"

A London or New York evening sale at either house fills the salesroom to capacity. Tickets are required. Dress is upscale-casual; there is lots of air-kissing. Simply attending is an indicator of social status. VVIPs get to sit in a private skybox, VIPs in preferred seats in the main salesroom, and VOPs (O for ordinary; yes, that term is used) are sometimes herded to an adjoining room to watch the auction on a large screen.

The two houses have evolved to be mirror images of each other. They compete for the loyalty of the same collectors, for material from the same great estates, and for the same specialist talent. They each conduct auctions in ten cities and have offices in 76. Any move by one is soon matched by the other.

Their public images differ depending on which is publicly owned and which private at a point in time. Christie's was traded on the London Stock Exchange from 1973 until 1998, when François Pinault took it private. Sotheby's was public from 1977 to 1983, when Michigan billionaire Alfred Taubman and his associates privatized it. Taubman took Sotheby's public again in 1988 and divested his controlling interest in 2005.

Today Christie's and Sotheby's generate favorable press with their auction results; Sotheby's occasionally attracts negative press comment with its quarterly financial results. Combined annual sales for the two houses have become a bellwether for the health of the art market, largely because auctions are the only part of that market that seem to offer transparency.

In his time as CEO of Sotheby's, Bill Ruprecht, now 57 years old, has presided over an impressive corporate turnaround. When he took the job in 2000 the company, along with Christie's, was in the midst of a commission-rate fixing scandal. Alfred Taubman was sentenced to a jail term and Sotheby's former president Diana Brooks was placed under house arrest. Sotheby's was fined £13 million by the European Commission and required to offer rebates to customers. Christie's cooperated in the investigation, agreed to the rebates, and escaped major penalties.

The high costs of the settlement forced Ruprecht to trim operating expenses, to reduce headcount, and in 2003, to sell Sotheby's Manhattan

headquarters building for $175 million. The fix worked. The company reinstated its dividend in 2006 and bought back its building for $370 million in 2008.

The financial crisis and art world recession hit just after the buyback. Sales for the two auction houses fell from $4.9 billion in 2008 to $2.3 billion in 2009. Lots were offered at much lower price points. The drop reflected not just a reluctance to buy at almost any price, but also a general unwillingness by collectors to risk consigning to auction.

The art recession had passed by mid-2010. Both houses had almost completed the transformation of their business models: smaller staffs, reduced salaries and bonuses, fewer traveling previews and lavish receptions. They were never forced to take the more serious steps of cutting whole departments, closing foreign offices, or moving from the expensive premises they occupied in New York and London.

The bright spot for both houses was private sales, which more than tripled between 2008 and 2013. These gained popularity when consignors needed money but did not want to be seen to be selling off assets, and buyers did not want to be seen spending large sums at the same time their companies were laying off employees. Ruprecht said the growth in private sales represented his company's efforts to become more than just a "monosyllabic advocate of one [sales] channel."

The practice of offering price guarantees and of rebating buyer premiums to some consignors resurfaced in 2010, and expanded in 2011 and 2012. This reflected a renewed unwillingness to let the other guy get important consignments.

While overall prices for contemporary art dropped sharply during the art recession, prices for the very best, museum-quality works held steady or moved up. The three top prices achieved for art sold at auction came in 2010 and 2011. These were Giacometti's *Walking Man I* (1960), which sold for £65 million ($100 million) in February 2010; Picasso's *Nude, Green Leaves and Bust* (1932), auctioned three months later for $106.5 million (£70 million); and Edvard Munch's *The Scream* (1895), which took the most-expensive-at-auction title in May 2011 when it sold for $119 million (£73.9 million). These record prices in the midst of a continuing recession reemphasize how little correlation there is between buyer behavior at the high end of the contemporary market and the overall health of the economy.

Asked about the Sotheby's rivalry with Christie's, Ruprecht simply said that much of his company's energy is spent building relationships with individual families over long periods of time. "We hope to continue to be successful in relationships where we are not in a gun-slinging match with a competitor." It is generally believed that Christie's and Sotheby's ten highest-spending clients account for 10 percent of their worldwide revenue, not just for art, but for jewels, wine, and second homes. The clients would include the Qatari Royal Family, Russian oligarchs, and US hedge fund managers.

An auction house actually has only limited opportunity to rely on relationships. Most consignments from individuals reach the auction room through the four D's: Death, Divorce, Debt, and Discretion. The fourth refers to a change in collecting focus—pursuit of a different passion, or redecorating, or simply profit taking.

For death, debt, and discretion, each house hopes that consignors have established their loyalties well before the event. In the case of divorce, consignments are usually negotiated by lawyers, who are bound by due diligence to request a proposal from multiple auction houses. About 25 percent of the art consigned to evening contemporary auctions comes from dealers, most of whom will solicit a proposal from each house.

The battle for consignments occasionally involves Phillips. For important works, Phillips usually wins only if it can offer a higher guarantee, or some special perk such as a position on the catalog cover. Phillips competes by focusing on new, blue-chip emerging art; they promote the house as number one in that segment. Miami collector Don Rubell concurs, "It's the cutting edge art that [Phillips] does well; we forget that some of the artists we now see at Sotheby's and Christie's were sold here first."

Sometimes Phillips competes by offering a sale that earns little or no profit, just for the prestige of having done it. On May 13, 2010, Phillips offered 22 works in New York on behalf of ML Private Finance, an affiliate of Merrill Lynch. The proceeds were to be applied to the settlement of art collector Halsey Minor's $21 million debt to ML.

The auction grossed $19.5 million. Phillips was reported as promising ML 108 percent of the hammer price on all items. That figure means that Phillips charged no consignor's fee and rebated 8 percent of the buyer's premium. Their gross profit was the difference between 8 percent and the buyer's premium of about 12 percent. This would not have covered catalog and promotion costs.

The extravagant terms came about because ML asked the court to assign the auction to Christie's, while Minor requested Phillips. The latter made an offer that Christie's would not match. Phillips must have undertaken the sale for the distinction of staging the single consignor event, although what contribution a known back story of "insolvency" made to the value of art or the brand of the auction house is unclear.

Christie's and Sotheby's are a major influence on how contemporary art is priced, both through the transparent selling prices they achieve and in the way they offer art—effecting what is known in economics as a price ratchet. A ratchet turns in only one direction, and then locks in place. A price ratchet means that prices are free to move up but hardly ever move down.

The ratchet concept is easily understood when applied to labor markets: in good economic times, wage negotiations are always for up, never down. A price ratchet in art occurs when two collectors at Christie's bid up the auction price of a Jean-Michel Basquiat to twice the gallery price, and this becomes a new reference price for all galleries, a price below which no consignor will now want to sell.

The ratchet works in other ways. If the record price for a Franz Kline is $9.3 million, almost four times the $2.4 million record for a Cy Twombly, and a Kline suddenly sells for $40.4 million (which happened at Christie's in November 2012), then how much is the next comparable Twombly worth? At Christie's, his *Untitled* (1969) came up 17 lots after the record Kline sale and was bid up to a record $5 million. As one journalist put it, when a rising tide is perceived, it floats a lot of art.

Another example of the ratchet effect at work is seen when a lot comes up in an evening sale with an estimate and reserve above the most recent comparable sale, but there is little or no interest. The auctioneer will chandelier-bid the work up to the reserve and say "pass," or it will go to whoever provided a guarantee. If this happens two or three times in a row, at either auction house, work by the artist is no longer accepted for consignment for evening auction. This means that an auction price index generally only ratchets up; artists whose work falls in value drop out of the index.

The ratchet effect has an impact on dealers. If two collectors bid up the price of a Jacob Kassay silver painting to several times the gallery list price, the dealer is forced to increase the primary market price. If the artist's next show does not sell at the higher price, he risks being out of favor and possibly dropped by the auction house.

The new guys on the world auction stage are Beijing Poly Auction House, the largest in China and third largest in the world, and China Guardian Auctions, second in China and fourth in the world. Both have representative offices in London and New York. Both cover categories including oil painting and sculpture, Chinese ceramics and ink painting. Initially their US operations will focus on attracting consignments for sale in China. Later, they say, they will auction both Western and Chinese art in New York and London.

Will US collectors send art to China for sale via a little-known auction house? The two Chinese firms think they will and are willing to be patient.

Evidence of how the firms emulate their Western competitors came with China Guardian's first auction of modern Chinese paintings in Hong Kong in October 2012. The outcome was spectacular; sales of HK$450 million ($58 million), two and a half times pre-auction estimates. This seemed to result from two things. One was a succession of very low estimates. The second was the fact that the auction house paid the costs of flying in 100 VIP bidders from the mainland to Hong Kong.

There are a number of long-established regional auctioneers across the United States that handle the same level of art that Christie's and Sotheby's offer in day sales. The auctioneers service customers in their own regions; some achieve a national reach through the Internet. Among the best known are Bonhams & Butterfields in San Francisco (established in 1865); Heritage Auctions in Dallas (1976); Leslie Hindman Auctioneers, Chicago (1982); Doyle New York (1962); and Freeman's in Philadelphia (1805). None of these is likely to offer a $25 million Warhol or even a $5 million work, but $100,000 sales are not uncommon.

Where do you go to find bargains at a high-end art auction? Many experienced collectors would say Drouot, the Paris auctioneering group. France was the center of Western avant-garde art for 100 years; after World War II, New York gained ascendency. Consider the 40-work collection from movie star Alain Delon, auctioned in October 2007 at Drouot. The artists included Pierre Soulages and Jean-Paul Riopelle. With minimal catalog descriptions and little advertising, the 40 works sold for €8.7 million ($12.4 million). Observers thought this was two-thirds what the collection might

have brought in a London day sale at Christie's or Sotheby's. Several of the works were immediately flipped and reoffered in London.

A potentially game-changing legal decision for New York auctioneers came in 2012, via the small William J. Jenack auction house in Chester, New York. Chester is a town of 4,000 people, 60 miles north of New York City. In 2008 Jenack auctioned a lot described as a "19th century, Fine Russian Silver/Enamel Covered Box with Gilt Interior," attributed to silversmith Ivan Petrovich Khebnikov.

Albert Rabizadeh bid by telephone. His successful bid was $400,000; the auction house catalog estimate was $4,000 to $6,000. Rabizadeh received from Jenack the standard auction invoice listing the object and the amount owing. The seller was identified as "consignor #428." Rabizadeh did not take possession of the box and refused to honor the invoice.

Jenack sued Rabizadeh for breaching his agreement to purchase. Jenack won and Rabizadeh appealed. At the appeal level, Rabizadeh's lawyer raised a clever procedural issue. He cited the New York General Obligations Law, known as the Statute of Frauds (with roots in medieval English common law), which covers agreements that the legislature thought should be made only in writing. Under "goods sold at public auction," it requires the written contract to contain both the name of the purchaser and the name of the seller. Jenack had not disclosed the seller's name and refused to do so.

An Appellate Division panel sided with Rabizadeh, deciding that no name meant no contract. Justice Peter Skelos noted in his decision that whether it was "common practice" to name the auctioneer rather than the consignor was irrelevant; the panel's decision was determined by the statute. There was no valid contract for Rabizadeh to breach. The panel further concluded that consideration of a change in the law to eliminate that requirement for the name of the seller may be warranted, but that was for the legislature, not the courts. The case was appealed on the basis that the ruling was a threat to the way that New York auction houses did business—which it certainly was. Christie's joined in the appeal, supporting Jenack. It was thought unlikely that the Court of Appeals would reverse, but it did. Ignoring all the arguments before it, the Court decided that since the auction house was the seller's agent, Jenack's name alone satisfied New York's requirements.

It is not clear whether the Rabizadeh decision would have required that there must always be disclosure of the seller for an auction contract to be

valid. It would have meant that in an auction in New York State, if the high bidder defaults and the auctioneer intends to enforce the contract, it must reveal the consignor's name to the bidder.

The more interesting question was whether anyone who purchased at a New York auction within the limitations period, say the previous year, could have voided that sale on the basis that no name was produced. Auction houses and previous consignors were nervous.

There are many reasons consignors insist on confidentiality when they contract with an auction house, from privacy concerns and divorce issues to money laundering. If upheld, the Rabizadeh case could have changed how collectors sell, causing them to consign to Paris or Hong Kong, or through a dealer who has no legal obligation to disclose their identity.

The strange parallel universe that is the high-end contemporary art market, and the sense that to enter the auction room is to step through a looking glass, was never better illustrated than in the November 2012 New York contemporary auctions. These began two weeks and two days after Hurricane Sandy ravaged the US East Coast.

Tuesday was Sotheby's sale, which grossed $375 million for 58 lots. Wednesday it was Christie's turn; that sale grossed $425 million for 68 lots. In just over four hours of auctioneering, the two houses averaged $200 million per hour. Works at Sotheby's included a Mark Rothko oil on canvas, *No. 1 Royal Red and Blue* (1954) for $75.1 million, and Andy Warhol's gruesome blurred silkscreen image (one of an edition of three) of *Suicide* (1962–64), a man jumping to his death from a high-rise building. It brought $16.1 million. Auctioneer Tobias Meyer noted the "deeply intellectual" nature of *Suicide*, "that gives you a reminder of your own mortality."

At Christie's there was Jeff Koons's complex sculpture *Tulips* (1995–2004), seven stainless steel flowers with transparent color coating, one of an edition of five produced by technicians. It was on display in a reflecting pool, outside the auction house's Rockefeller Center entrance. It brought $33.7 million, at that point a record for a living artist.

After the two auctions, a Christie's official estimated the combined wealth of those who had bid in the auction rooms, on the phone, and online as, "Oh, say, $200 billion." That sounds inflated, but if you think of 60 to 70 bidders, some representing oil interests or heads of state, it may not be.

One bridge and a 30-minute ferry ride from the auction rooms in Manhattan is Staten Island, the fifth borough of New York. Staten Island has an area three times that of Manhattan and is home to half a million people, most of moderate income living in modest single-family homes. It was the part of New York hardest hit by Sandy. Twenty-six people died there, half the total for all of New York City. Hundreds of homes were destroyed. On the day of the Sotheby's New York auction, 40,000 people were still without power and 30,000 were homeless. Search-and-rescue teams were still looking for bodies inside wrecked buildings.

In the auction rooms there seemed little awareness of any of this, or of what $16 million might buy other than an Andy Warhol image of a suicide jumper. One dealer explained the extraordinary prices for the two days: "People just don't know where to put their money now."

Back on this side of the looking glass, Lewis Carroll would have smiled.

THE SCREAM

I thought I should make something—I felt it would be so easy—it would take form under my hands like magic. Then people would see! . . . People would understand the significance, the power of it. They would remove their hats like they do in church.

—Edvard Munch, artist

God help us if we ever take the theater out of the auction business or anything else, it would be an awfully boring world.

—Alfred Taubman, former controlling shareholder of Sotheby's

What better way to illustrate the theater of the auction process than with the story of the most expensive work ever put under the hammer? In May 2012 Edvard Munch's *The Scream* was offered as lot 20 at Sotheby's Impressionist & Modern Art Evening Sale in New York. One of the best-known images in modern art, it was consigned by Petter Olsen, a Norwegian real estate developer and shipping heir whose father was both friend and patron of the artist.

When Munch created *The Scream* in 1895, he had just turned 30. He was penniless, a chain-smoking alcoholic recovering from a failed romance. He feared that he would be overtaken by the mental illness that he thought ran in his family. When he showed his earlier painting *The Sick Child* (1885), there was a media debate in Oslo on whether he was sane.

Munch wanted his painting to reflect psychological reality rather than visual experience. *The Scream* shows an androgynous figure beside a hill in Ekeberg, a district in Oslo, with a bridge in the background, framed by a blood-colored sky (another version illustrated). The figure grasps its cheeks in dread.

At the bottom of the hill is the "madhouse" where Munch's sister Laura was confined for schizophrenia. Down the street from the madhouse is a slaughterhouse. It is said that from the hill one could hear both the cries of mentally disturbed patients and of animals being herded to slaughter. The bridge itself was a common suicide spot, the local equivalent of San Francisco's Golden Gate. Many art historians say the work does not actually represent a scream, but rather a figure blocking out the screams around him.

Munch always refused to explain the painting; he sometimes repeated the warning, first put forward by an Oslo newspaper, that his work was so subversive, it could produce chicken pox. He created black-and-white lithographs of *The Scream* for European magazines and offered them for sale with the promise that the black-and-white version would not cause disease. That is hard to beat as an early example of an artist back story.

The Scream became one of the most recognizable images in art history and popular culture. It has been reproduced and commercialized more than any picture except Leonardo's *Mona Lisa*. The existential dread in the composition has been referenced by everyone from Andy Warhol to Homer Simpson, who called it "The face that launched 1,000 therapists." Child actor Macaulay Culkin mimicked the open-mouthed expression of horror in promotional ads for the 1990 movie *Home Alone*.

Munch created four versions of *The Scream* between 1893 and 1910. Norwegian authorities agreed to an export permit for the one being auctioned because the other three remain in Norway, one at the National Gallery, two in the Munch museum. Sotheby's 1895 version is the third in the series of four, and the only one to come up at auction. The tempera-on-cardboard version at the National Gallery is the best known and thought to be the most valuable. The Sotheby's pastel-on-board is ranked number two in both reputation and value.

Sotheby's version has 12 colors; the figure in the foreground has one blue nostril and one brown. Some art dealers think the pastel medium lowers the value; others say the lines and colors are more vivid than in the other versions. Sotheby's version has one unique feature: the frame is inscribed with an 1892 Munch poem about walking along a fjord, said to have inspired the work: "My friends walked on/I remained behind/trembling with Anxiety/I felt the Infinite Scream in Nature."

While *The Scream* is certainly not contemporary, the way it was offered and marketed illustrates auction house handling of high-end art.

Sotheby's was a predictable house to offer the work; it had for years worked to build a Munch auction market. In 2008 Philip Hook and Simon Shaw started discussions with Petter Olsen about a possible sale of *The Scream*. It is unclear whether Olsen's lawyer conducted negotiations with Christie's before settling on Sotheby's. Sotheby's believes they simply made a great offer that was accepted. Market observers think there must have been at least one round of "will you top this" negotiation, given the potential value of the consignment.

As with the Brody estate, any negotiation would have started with waiving the consignor commission. They would have discussed what portion of the buyer's premium would be passed to Olsen, whether there would be a guarantee and at what level, and what the auction house would charge for arranging it. There would have been negotiation on the catalog estimate and on the reserve price below which *The Scream* would be withdrawn. Finally, they would agree on the amount of publicity that Sotheby's would undertake.

The Scream came to auction with a catalog entry "[Price] Estimate on request." Those who asked were referred to Simon Shaw and given not a range but a single number: $80 million. That figure was cited as the highest presale estimate ever set by an auction house. This was not quite accurate; it equaled the midpoint of Christie's $70 to $90 million presale estimate for *Nude, Green Leaves and Bust*. The $80 million estimate for *Scream* was announced in so many media stories that probably few enquired of Shaw after the first day.

Few Munch works come up for auction, so collectors did not have much of a sales history to rely on. In 2008 Sotheby's had sold Munch's *Vampire* for $38 million; this was the artist's auction record. This painting of a woman kissing a man's neck is an earlier work in his *Love* series, which culminated in *The Scream*. *Fertility*, a Munch pastoral scene, was estimated for a 2010 sale at $25 to $35 million but failed to reach its reserve price of about $20 million.

Sotheby's took a substantial risk in offering an estimate this high. Only four art works had exceeded $80 million at auction. The most expensive pastel ever sold at auction was Edgar Degas's *Danseuse au repos* (1879), which brought $37 million at Sotheby's New York in November 2008. New York art dealer David Nash, a former Sotheby's executive, said when the number was announced, "They would be better off to put a more realistic estimate and let the market determine what the final price is going to be." Simon

Shaw said the estimate was based on recent sales of modern iconic master-pieces, not specifically on sales of Munch.

Monaco art dealer David Nahmad is part of the art-dealing Nahmad family described by Christopher Burge as having "sold more works of art than anybody alive." Nahmad said before the auction that he might bid on *The Scream* at a price below $80 million, but not above. "It is a fraught investment; the name 'Munch' is not as instantly recognizable as others. . . . If I have the choice to buy a Picasso or a Munch, I would prefer to buy a Picasso; everybody knows everything about Picasso, Matisse, Cézanne, Monet. If you go to somebody in South America and say there's a Munch to buy, he'll say, 'Who's he?'"

Sotheby's advertised *The Scream* in virtually every major art publication and in major newspapers around the world. The ads involved an image of the work, with the caption "Masterpiece." The hype was overwhelming; one reference compared the work to the *Mona Lisa.*

Prior to the sale, the auction house printed limited edition hardcover books on the work, to be presented to top clients. Sotheby's also created a limited edition catalog dedicated solely to *The Scream,* with five signed essays on the artist's work. They produced two promotional videos, one shot on New York's Roosevelt Island to evoke the work's waterside setting, the other with images of clouds in a blood-red sky.

As part of the pre-sale public relations, Sotheby's David Norman wrote an article in the auction house's newsletter describing how he and colleagues Philip Hook, Stephane Cosman Connery, and Simon Shaw were summoned in 2010 for a "secret *Scream* mission." They flew to Oslo, were met by an unmarked black sedan, and driven to a warehouse on the outskirts of town. He continues, in the best tradition of Ian Fleming and with a better back story than any promotional release:

> We signed in at the guard's station, were buzzed through a double set of doors and escorted to a cold, bare room with a single fluorescent light and one table pushed against the center of the longest wall. We waited. A few minutes later, two men carried in a large, reinforced box. Automatic screw drivers spun with a grinding sound, one by one pulling up each screw. The lid was opened, the protective paper pulled aside and there before us was the most familiar image in the world— yet it was a shocking surprise to us. Before the endlessly referenced,

infinitely disseminated image of angst and existential drama (a 20th-century notion which Munch felt and expressed decades in advance), we were struck by the work's chromatic brilliance. The blazing red-orange and lemon-yellow currents of pastel streaming across the sky, set against the near lapis blues and verdant green of the harbor and landscape, led us to a surprisingly joyous round of exclamations. A work that expressed misery was also a work of dazzling color.

Sotheby's flew the work to private viewings in North America, Europe, and Asia (but surprisingly, not the Middle East!), so that potential bidders could decide whether the image fit with their existing collections. A hundred fifty collectors viewed *The Scream* at a private viewing at Sotheby's in London; 5,500 others at the public viewing. Bags were checked at the door; some visitors had to undergo body scans. The painting was protected by layers of glass.

In New York 350 collectors viewed the work at a private reception. Sotheby's hired a design firm to create a dramatic installation. *The Scream* was spotlit in an otherwise dark room, perhaps in homage to an artist who had wanted viewers of his work to act as if in church. Guests were asked to leave their champagne behind when in the presence of the work. Because of a concern about crowds, *The Scream* was not made available for public viewing in New York.

To produce a different kind of press interest, and to keep the auction house name front and center, a never-identified individual from Sotheby's London enlisted British bookmakers Ladbrokes to run betting markets on the auction hammer price and on the nationality of the successful bidder if that were to become public. Ladbrokes's only previous involvement with art was taking bets on who would win the Tate Museum's Turner Prize. The shifting odds were reported in the British papers and by Carol Vogel in *The New York Times*. The final odds on the selling price, including the buyer's premium, were 3 to 2 that the work would exceed the auction record of $106.5 million, and 3 to 1 on a price exceeding $150 million. The final odds on a purchaser were 5 to 2 on a Russian, 3 to 1 on an Asian or European, and 4 to 1 on an American.

The bookmaker stopped taking wagers four days prior to the auction because too much money was coming in on the "over $106 million, will set an auction record" side, particularly from the Middle East. The concern was

that bidders might wager on their own intentions, creating a near-sure thing. Ladbrokes also offered 10 to 1 odds on the picture selling for less than $45 million—almost a certain impossibility because Olsen would have negotiated a higher reserve price.

Ladbrokes decided on their own to offer odds, which ended up at 21 to 1, on *The Scream* being stolen somewhere between its first showing in London and its final sale in New York. Two other versions of the image had been stolen from Oslo museums. In 1994, thieves climbed through a window of the National Gallery on the first day of the Olympics in Lillehammer. They left a note in place of *The Scream*, thanking the museum for its lousy security. A decade later, masked gunmen raided the Munch Museum and departed with its version of *The Scream*, plus another Munch work. All three paintings were eventually recovered.

Philip Hook, of Mission-to-Oslo fame, estimated there were ten potential bidders for the Munch. His logic was that collectors won't usually spend more than 1 percent of their net worth on an individual artwork. That calculation limited likely bidders to those worth $8 billion and up. If that was the case, all Sotheby's promotion outside that small set of collectors was primarily intended as brand enhancement.

There is another theory that wealthy collectors will spend 7 percent of their investable assets on art. This definition would produce a bidder's pool of those with over $1.15 billion in such assets—about 1,200 people worldwide. This would better explain the broad international exposure given the work.

Discussion of specific potential buyers started with the Qatari Royal Family. While *The Scream* had not been taken to the Middle East, agents representing the family would have been offered the chance to examine it. The list of possible bidders included the Getty Museum in Los Angeles, one of the new museums in Abu Dhabi, plus international collectors who have pursued masterpieces in the past. One was Geneva-based billionaire Lily Safra, who spent $104.3 million for Alberto Giacometti's sculpture, *Walking Man I*. Another was American cosmetics executive Ronald Lauder, who paid $135 million in the private acquisition of Gustav Klimt's *Portrait of Adele Bloch-Bauer I* for his New York museum. A longshot candidate was Las Vegas casino owner Steve Wynn; he had just concluded a $740 million divorce settlement, which he said had slowed down his collecting pace. That pace picked up again with the purchase six months later of Jeff Koons's *Tulips* for $33.7 million (£21.3 million).

Also mentioned were Greek shipping heir Philip Niarchos, and Russian industrialist and Chelsea football club owner Roman Abramovich, whose partner Dasha Zhukova was building a new Gorky Park Museum in Moscow. Simon Shaw offered the possibility of a Japanese bidder; Shaw said that for the Japanese, *The Scream* is a particularly resonant image because Munch was so heavily influenced by Japanese printmaking.

As one indicator of the current art era, only three public institutions were ever mentioned. Excepting the Getty, Qatar, and Abu Dhabi, the concept that a museum might have the resources available to bid on an iconic painting seemed unrealistic.

The evening of May 2, 2012, at 7:42 p.m. eastern daylight time, *The Scream* came up as lot 20. The sequence in which work is listed and sold is part of the psychology of the auction. Normally a featured lot comes up between lots 25 and 30; the earlier placement indicated there were other strong works sequenced later. The positioning is aimed at keeping bidders in their seats deep into the auction.

An expensive work is usually followed by three or four with lower estimates. The spacing builds peaks of interest and provides a reference price, which makes later estimates seem more reasonable by comparison. If there are several works by the same artist, as was true at Sotheby's, the best is offered first so unsuccessful bidders can try for another later.

The Sotheby's sales room held 800 people, all attending by invitation, plus reporters and camera crews from around the world. Tobias Meyer opened the bidding at $40 million, higher than the existing auction record for a Munch.

Meyer coaxed bid after bid from eight initial bidders, three in the room (dealers, probably bidding for a client), and five on telephones. Ben Frija of Galleri K in Oslo, in the auction room, and Patti Wong of Sotheby's Asia, on the phone, both dropped out at $73 million. There were five bidders still in at $80 million.

At $100 million bidding was down to two telephone bidders, one with Charles Moffett, another with Stephane C. Connery, both of Sotheby's. After just under ten minutes of bidding, the hammer fell to Moffett's bidder at $107 million. The buyer's premium brought the total cost to $119.9 million, the price of a moderately impressive yacht. *The Scream* is thought to be the eighth most expensive painting ever sold, publicly or privately, when prices are adjusted for inflation. The sales room audience erupted in applause when

the hammer fell. Several Sotheby's officials said the sale marked the high point of their careers.

Moffett's successful bidder was later revealed as New York collector Leon Black, lead partner of buyout firm Apollo Global Management. Black, age 62, is number 107 on the *Forbes 400* list, with an estimated net worth of $3.5 billion. He sits on the boards of both New York's Metropolitan Museum and MoMA, and is said by *The Wall Street Journal* to have a $750 million art collection, with works by Picasso, J. M. W. Turner, van Gogh, and Raphael. He had never been mentioned in pre-auction speculation.

When his identity was revealed, it made the front page of *The New York Times* and was prominently reported in almost every daily newspaper and on television news shows. No mass media reports the purchase of a yacht, or a private Boeing 737 jetliner, or a small Greek island for the same amount.

With all this money at stake, one would assume that Sotheby's must have made a huge profit on the consignment. They probably did not because of the sweetheart deal negotiated with Petter Olsen. To obtain *The Scream*, assume Sotheby's agreed to forego the seller's commission and rebate half the buyer's premium to Olsen. Sotheby's would also have assumed all costs related to the auction, including promotion.

Sotheby's buyer's premium in New York was 25 percent up to $50,000, 20 percent from $50,000 to $1 million, and 12 percent above $1 million (it has since increased). For a sale at the hammer price of *The Scream*, the effective premium was just a shade over 12 percent. Let's assume, as did most art specialists, that the give-back was half of the 12 percent. So of the total $119.9 million, Olsen would receive about $113.5 million, and Sotheby's would retain $6.4 million.

The extensive media promotion of *The Scream*, the receptions, the foreign transport and insurance would have cost at least $5 million. So Sotheby's did a little better than break even on the sale. To put this in context, they made about as much profit as they would on a $4.5 million dollar sale in which no concessions on commission or premium were given.

The hammer price at which Sotheby's broke even was about $83.5 million. Below that, they would have lost money on the consignment. If *The Scream* had sold at its estimate of $80 million, Sotheby's would have lost about $200,000. If they gave back more than 50 percent of the buyer's premium, their losses would be greater. An $80 million sale plus a 75 percent give-back would have produced a loss of $3.6 million. Offering a consignor

MAURIZIO CATTELAN, Stephanie,
(2003)
Wax, pigment, synthetic hair and
metal, 43 ⁵/₁₆ × 25 ⁹/₁₆ × 16 ⁹/₁₆ in.
(110 × 65 × 42 cm). Photo, Achim
Hatzius, reproduction permission
courtesy of Maurizio Cattelan's
Archive.

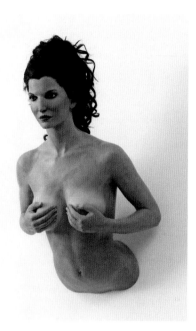

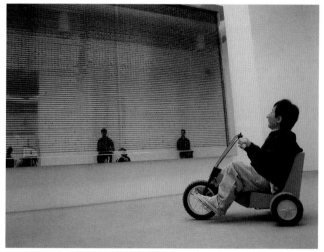

MAURIZIO CATTELAN, Charlie, *(2003)*
Tricycle, steel, varnish, rubber, resin, silicone, human hair, electric
motor, and fabric. 36 × 32 × 22 in. (82 × 89.5 × 56 cm), from
an edition of four. Photo Zeno Zotti, Courtesy Maurizio Cattelan's
Archive.

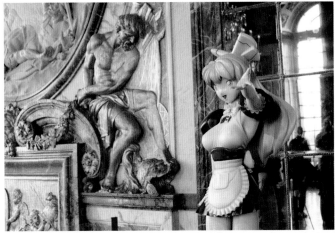

TAKASHI MURAKAMI, Miss ko2 (1997). Oil paint, acrylic, synthetic resin, fiberglass and iron. 75 × 25 × 32 inches (183 × 63 × 82 cm), from an edition of four. Image Patrick Aventurier/Getty Images, shown as exhibited at Chateau de Versailles, 09 September 2010, permission Getty Images/ Chateau de Versailles.

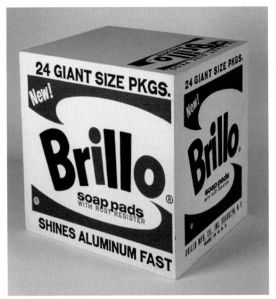

ANDY WARHOL, Brillo Soap Pads Box (1964), silkscreen ink and house paint on plywood, 17 × 17 × 14 in. (43 × 43 × 36 cm), image and permission © The Andy Warhol Foundation for the Visual Arts, Inc. / SODRAC (2013).

BANKSY, Street Art Seen from Oxford Street, London *(2008). Photo credit: John Meek / The Art Archive at Art Resource, NY.*

MAURIZIO CATTELAN (1999) La Nona Ora *(The Ninth Hour)(1999)(of Pope John Paul II). Dimensions variable. Polyester resin, human hair, fabric, clothing, accessories, stone and carpet. Photo Attilio Maranzano, courtesy Maurizio Cattelan's Archive.*

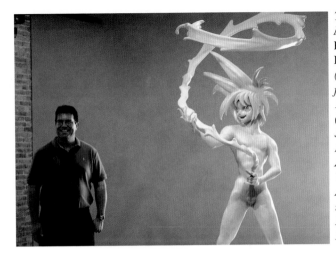

TAKASHI MURAKAMI, Hiropon My Lonesome Cowboy (1998). Oil, acrylic, fiberglass and iron. 100 × 46 × 36 inches (25 × 117 × 91 cm). Shown at Punta della Dogana, Venice (28 August 2010). Photo Vincenzo Pinto/ AFP/Getty Images, reproduction Getty Images/Punta della Dogana.

AI WEIWEI, Tree #11 (2009–2010). Wood from dead tree trunks collected in southern China. 227 inches high × 245 inches long × 208 wide (500 × 540 × 460 cm). Stockamp Tsai Collection. Image and permission courtesy: Galerie Urs Meile, Beijing-Lucerne (Karin Seiz). Exhibition view: Art Basel Miami Beach 2011, Art Kabinett

DAMIEN HIRST, Ferrocene (2008), household gloss on canvas 36 × 52 inches (914 × 1321 mm)(4 inch spot). Image: Photographed by Prudence Cuming Associates © Damien Hirst and Science Ltd. All rights reserved, DACS 2013.

ZHANG XIAOGANG, Bloodline–Big Family : Family No.2 *(1993), oil on canvas, 110 × 130 cm (30 × 40 in.) Image copyright and permission Beijing Zhang Xiaogang courtesy of Pace Beijing.*

ARTIST UNKNOWN, Statue of Chairman Mao, *(about 2010), property of Beijing Municipality, shown in 798 Art District.*

YUE MINJUN, Gweong Gweong (1993), oil on canvas, 72 × 98 in (182 × 250 cm), image and image copyright permission courtesy Yue Minjun Studio.

Architect's rendering of Guggenheim Abu Dhabi, Gehry Partners LLP, images by ArteFactoryLab, Image and permission courtesy of TDIC, Abu Dhabi

EDVARD MUNCH, The Scream *(1895), pastel on board in artist's original frame, 36 × 27 inches (79 × 59 cm). Image from* The Scream *media preview at MoMA New York October 24 2012. Photo credit Robin Marchant. Image credit Getty Images Entertainment.*

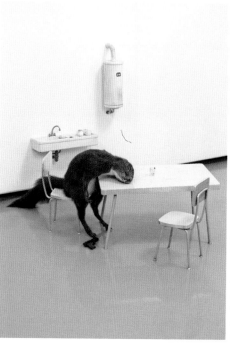

MAURIZIO CATTELAN, Bidibidobidiboo *(1996), Taxidermy squirrel, ceramic, Formica, wood, paint, steel, 17 ³/4 × 23 ¹/2 × 22 ³/4 inches (45 × 60 × 58 cm). Image from Zeno Zotti, courtesy Maurizio Cattelan's Archive.*

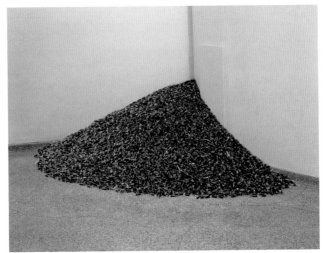

FELIX GONZALEZ-TORRES, Untitled (Public Opinion), *1991.*
Licorice candies individually wrapped in cellophane, endless supply,
ideal weight: 700 lbs (317.5 kg). Dimensions variable. Photo credit
and permission, The Solomon R. Guggenheim Foundation / Art
Resource, NY.

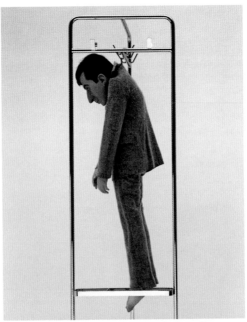

MAURIZIO CATTELAN, La Rivoluzione Siamo
Noi *("We are the Revolution")(2000). Polyester resin,*
wax, pigment, felt suit, and metal coat rack. Edition of
3. figure: 48 ³⁄₄ × 14 × 17 inches (123.8 × 35.6 × 43.2
cm); coat rack: 74 ³⁄₄ × 18 ¹⁄₂ × 20 ¹⁄₂ inches (189.9
× 47 × 52.1 cm). Photo credit and permission,The
Solomon R. Guggenheim Foundation / Art Resource,
NY.

so much that the break-even point is above the estimate is one sign of competition in a duopoly getting out of hand.

Olsen had declined Sotheby's offer of a price guarantee. If he had accepted a guarantee at $80 million, the fee would have been something like a third of the difference between that amount and a higher selling price. Declining the guarantee saved Olsen (and cost Sotheby's) $9 million, a third of the difference between $107 million and $80 million.

A trophy work like *The Scream* is expected to bring in additional consignments for the auction and to produce higher prices for other lots through its halo effect. This halo is the reason a restaurant wine list has $250 bottles; the $40 bottles now seem more reasonable.

Sotheby's did attract more consignments; their auction offered 72 works, compared with 31 for Christie's the previous evening. The Sotheby's offering included five other Munch works, which the consignor said were offered only because of the presence of *The Scream*. A collection from the estate of financier Ted Forstmann probably came to Sotheby's for the same reason; those works brought $83 million.

The overall result was a Sotheby's sales total of $330.5 million. This was their highest ever for an Impressionist and Modern auction. The old record was $286 million, set in 1990.

The Scream did not seem to produce higher prices for other works in the auction. Sotheby's offered three other works with eight-figure estimates. Picasso's 1941 portrait of Dora Maar entitled *Femme assise dans un fauteuil* was estimated at up to $30 million and sold at $29.2 million. *Human Head* by Joan Miró was estimated at up to $15 million and brought $14.8 million. Soutine's portrait *Chasseur de chez Maxim's* carried an estimate of up to $15 million and sold at $9.7 million. Four of the five other Munch works sold at the low end of an estimate. The fifth, *Sommernatt,* offered with an estimate of $2.5 to $3.5 million, failed to sell.

The real return to Sotheby's came with the publicity around the sale. Events leading up to it were reported for weeks, and the record price was noted in every major news medium in the Western world, often as a feature story.

Christie's Modern and Impressionist sale the day before the Munch sale at Sotheby's had far weaker material, and nothing to rival the attention-grabbing power of *The Scream*. Christie's put much of their marketing emphasis on Cézanne's watercolor study for *Card Players;* it was estimated at

$15 to $20 million and sold for $19.1 million. The Christie's sale was described by Carol Vogel as "anemic, devoid of the sky's-the-limit bidding that can give these big-money evenings their excitement." Of the 31 lots offered at Christie's, 28 sold, bringing a total of $130 million.

Christie's avoided share-of-interest competition with *The Scream* by devoting most of its spring 2012 auction advertising and promotion to its Postwar and Contemporary Art sale, which came six days after their Modern and Impressionist sale. The strategy was a spectacular success. An 8 × 7 foot (2.4 × 2 m) Mark Rothko *Orange, Red, Yellow* from 1961 brought $87 million, breaking the record for the artist set at Sotheby's in 2007. World auction records were set for 11 more artists, including Jackson Pollock, Barnett Newman, Gerhard Richter, and Yves Klein (and yes, none of these is strictly "contemporary," but they are postwar). The total auction brought in $389 million from 56 lots, the highest total ever for a Christie's postwar and contemporary auction. Sotheby's contemporary total two days earlier was $267 million.

The Scream benefited from branding of the artist and the art work, a great back story, and rarity. It also benefited from basic market economics; the demand for iconic, museum quality art far outstrips supply. The sale also benefited from globalization of the art market. A decade earlier, an evening Impressionist and Modern sale would have attracted bidders from five or six countries. For Sotheby's May 2 auction, bidders came from 32 countries. The eight initial bidders for *The Scream* were said to have come from seven different countries.

THE OPAQUE SIDE
OF AUCTIONS

Art prices are determined by the meeting of real or induced scarcity with pure, irrational desire, and nothing is more manipulable than desire. . . . A fair price is the highest one a collector can be induced to pay.

—Robert Hughes, art critic

Few things are transparent about any contemporary art auction, even one as highly publicized as *The Scream*. Other than the price at which the hammer drops, almost everything else is opaque. Which bids came from raised paddles? Were early bids taken off-the-chandelier by the auctioneer? How was the estimate arrived at? If the auction house guaranteed a price to the consignor, did the guarantee have the result of inflating the estimate? What was the reserve price, below which the auctioneer would not sell? What checks were made on the authenticity of the item being auctioned?

And of at least gossipy interest, who is really bidding? A visible bidder in the room may be an agent for someone else; a telephone bidder may be anyone. The extreme case is the eastern European or Asian collector who for personal, political, or tax reasons, works through a lawyer, thus guaranteeing client anonymity. The lawyer retains a local dealer, who then bids through a second agent in the auction city. In that situation the auction house may never learn the identity of the real buyer, and may not want to. The house receives a wire transfer of funds and ships the work to a duty-free warehouse in Geneva or Luxembourg.

What should we make of the pre-sales estimates included in the catalog? Auction house specialists say that these estimates are set by examining both recent work sold by that artist at auction and price trends since the sale. The size, composition, historical importance, provenance, rarity, and existing

back story of the piece are taken into account. At the high end, a single artist show at a major museum may increase the artist's selling price by 50 percent. For a work featured in that show, the increase may be 100 percent. Generally the low estimate is set at 60 to 70 percent of the best auction price achieved by a similar work of the artist, and the high estimate at 80 to 90 percent. But a formula is just a starting point; in the end, estimate setting is part of the negotiation process with the consignor.

There are two very different approaches to consignor estimates. One, sometimes called "come-hither," involves setting a low estimate to encourage bidding. This is the auction house's preferred strategy. Low estimates result in a high sell-through rate, with few lots being passed. The logic for come-hither is that bidders attracted by the low estimate become caught up in the endowment effect and commit to the chase.

The second approach, sometimes referred to as "kiss-my-ass-if-you-want-this-great-work," involves setting the low estimate close to dealer retail. Kiss also has an underlying logic. The risk-adverse bidder with no easy way to judge the published estimate may choose to bid to the low estimate or to the halfway point between low and high. A high estimate that deters informed collectors may still attract casual buyers.

A consignor who negotiates a very high estimate for a featured lot may end up with the catalog notation "Refer Department." This is intended by the auction house to imply that the lot was difficult to value. Some potential bidders read it as implying "probably not worth bothering with"; to others it may imply "a trophy."

The auction house responds to Refer Department inquiries with a tentative estimate, say $14 to $16 million. If the first few callers are not deterred, the quote may edge up to $15 to $17. If $14 to $16 brings a succession of "Too much, no interest" responses, the auction house encourages the consignor to lower his expectations.

In 2012 Sotheby's began to ask consignors for what they called "performance-related commissions," where the auction house earns a higher commission if the hammer price exceeds the high estimate for a lot. This was justified as compensation for undertaking additional promotion. It also produces something of a conflict of interest; the auction house sets the estimates; a performance-linked commission provides an incentive to set them conservatively. At the time of writing, Christie's had not adopted the practice.

When auction houses get an estimate seriously wrong, it is usually not because their specialists were mistaken. The house may have consented to the high estimate as a way of signaling how much they want the consignment. Or the agent for a consignor has played one auction house against another, suggesting that refusing a higher estimate will cause the house to lose the consignment. The advisor then tells the consignor, "See what I got you." If the lot fails, it is the fault of the auction house, not of the agent.

The first five lots in an auction almost always sell above the high estimate. That is no accident. The auction house places works with come-hither estimates at the beginning, to encourage bidding and start the sale with a sequence of overestimated successes. Fewer lots sell above high estimate as you go deeper into the auction. A consignor who insists on a Kiss estimate may see their work come up in the final third of the auction list.

Then there is the reserve price set on each work, the confidential amount below which the auction house will not sell. Reserves are so common that each auction house has a special catalog symbol to indicate any work that does not carry a reserve. The level of the reserve is always claimed to be a secret; specialists maintain that if the reserve price were known, the auctioneer would have to open bids at that level, producing fewer bidders and less excitement. However, Alberto Mugrabi said in a *New York* magazine interview, "They [auction houses] will tell you where the reserves will be—within a range." That is, presumably, if and only if you are a VVIP client.

The reserve is most often set at 80 percent of the low estimate, and never higher than 100 percent. The auctioneer will often signal when bidding has reached the reserve. When Tobias Meyer says, "I'm selling then," that is the meaning. After the signal, any bids he acknowledges are real, not taken from the chandelier.

The ability to lower reserves a few hours before an auction is one of the advantages of going second in the Christie's–Sotheby's alternating two-day sale format. In May 2011 Sotheby's Impressionist and Modern sale in New York stuttered with hesitant bidding and many unsold lots. The next morning, Christie's specialists got on the phones and persuaded many consigners to lower their reserves. They could not lower the estimates, which were printed in the catalog. The strategy worked. In a weak market, the auction house whose sale comes second almost always has a lower unsold rate than the first.

There is another circumstance in which reserves might be lowered at the last minute. Just prior to an auction, a specialist realizes there is little or no bidder interest in a lot. The specialist calls one or more important collectors—say, Gagosian and Mugrabi—and signals that it might be possible to acquire the work at a lower price. The collector tells the auction house what their highest bid would be. The specialist calls the consignor and relays the information. Alexander Rotter, a Sotheby's director, was quoted in a 2013 *New Yorker* magazine article, "The buyer can't say 'I'll give you this' and make it a sure thing, but we can relay that information to the consignor and say 'This is a good price; you might consider lowering your reserve.'"

Guarantees provided to consignors are mentioned earlier. A guarantee is the amount the auction house will pay the consignor, even if the hammer price for the lot is lower. Guarantees have a checkered history; they date at least to 1971, when 47 Kandinskys were consigned to Sotheby's from the Guggenheim Museum in return for a guaranteed total price for the consignment. In 1973 the Scull collection went to Sotheby's with a similar guarantee. Guarantees disappeared in the mid-1970s, but resurfaced in the late 1980s as part of the market boom driven by Japanese art buying.

In 2001 LVMH owner Bernard Arnault purchased Phillips auction house and made the decision to offer very generous guarantees to lure consignors from Christie's and Sotheby's. In November 2001 the collection of Nathan and Marion Smooke went to Phillips with the then-largest guarantee in history, estimated by *The New York Times* at $185 million. Christie's had dropped out after their reported offer of an $80 million guarantee was rejected. The Smookes' single-source collection of French and German paintings went to auction with what Phillips hoped was an irresistible come-hither estimate of $80 to $115 million. The auction grossed $86 million; the loss on the guarantee was close to $100 million. In 2002 Arnault announced accumulated auction house losses of $400 million, largely attributable to losses on guarantees. He sold the company to Simon de Pury reportedly for one dollar, plus assumption of existing debt.

The auction house typically opens guarantee negotiations with a consignor by asking for 50 percent of any amount realized above the guarantee amount. This is their compensation for assuming risk. If the level of the guarantee is modest, the fee becomes compensation for superior knowledge and good negotiating. The 50 percent figure is always negotiable; a 10

percent fee to provide a modest guarantee for a sought-after consignment is not uncommon.

If an auctioned lot does not reach its reserve price, the auctioneer says "pass" and the work is "burned," an auction-world term for rejected or unwanted. But work with a guarantee is never passed; it is bid up on behalf of the guarantee provider and hammered down at the guarantee amount. It has been sold to the guarantor and can be reoffered with no stigma of having been burned.

To limit their total exposure, or, in Sotheby's case, to clean up its balance sheet, the auction house sometimes brings in a third party to co-insure part or all of the risk. The third-party guarantor can be a collector, a dealer, or a financial institution. Publicly identified guarantors include dealers David Nahmad, Adam Lindemann, and Bill Acquavella, and wealthy collectors Peter Brant, Steve Wynn, Steve Cohen, S. I. Newhouse, and the Qatari Royal Family. Guarantors are sometimes collectors who want to acquire the work, sometimes art experts who think they are better at estimating value. The identity of the outside guarantor is normally confidential; the existence of a third party is indicated by a catalog symbol beside the lot number.

Third-party guarantees are sometimes placed and sometimes auctioned off to interested guarantors. The auction house pays the third party a fee, which may be more or less than the fee the auction house negotiated with the consignor. The fee paid to the third party will be higher if the market is weak closer to the auction date or if the auction house has itself provided a very generous guarantee.

Providing a third-party guarantee can be very profitable. A New York private dealer guaranteed Félix González-Torres's *Untitled (Portrait of Marcel Brient)*, which sold for $4.6 million at Phillips de Pury's Carte Blanche sale. The fee for providing the guarantee was about $750,000. The same individual is said to have provided a guarantee for the Brody consignment to Christie's of Picasso's *Nude, Green Leaves and Bust,* which sold for an auction record $106.5 million, and for Giacometti's *Grande Tête Mince,* which brought $54.3 million. The dealer is thought to have earned about $8.5 million in fees from those two transactions.

As reported in *The Economist,* in November 2011 dealer Guy Bennett, acting as agent for the Qatari Royal Family, provided Christie's with a guarantee on their feature lot, Roy Lichtenstein's painting *I Can See the Whole Room! . . . and There's Nobody in It!* (1961), for an amount rumored to be

$33.5 million. Bennett placed the winning bid for the Lichtenstein at $43.2 million, including buyer's premium. Assuming he negotiated a 60/40 split with Christie's on the overage, the actual net cost to his client after credit for the guarantee fee would have been just under $40 million.

In May 2011 the party providing the third-party guarantee ended up with Jeff Koons's porcelain sculpture *Pink Panther* (1988), which was estimated at $20 to $30 million. It sold to a single bid for $16.9 million, likely the guarantee amount. Several dealers thought the sculpture had been handicapped by an excessive estimate, and the selling price was reasonable.

Sometimes the auction house gets burned from offering a guarantee. Details of one case surfaced in 2009 when George Weiss, a Connecticut money manager and art collector, sued Christie's for breach of contract for, he said, reneging on payment of a $40 million guarantee it had offered to win a consignment. The work was Francis Bacon's *Study for Self-Portrait* (1964), consigned on behalf of his family trust. *Study* was offered at the November 2008 auction of postwar and contemporary art, just at the point the art economy was collapsing, with an estimate of $40 to $60 million.

Weiss had asked Christie's and Sotheby's to each make a proposal for his consignment. According to his court filing, Christie's offered him two options. The first was a $40 million guarantee along with a small but undisclosed "enhanced hammer," meaning he would also receive a share of the buyer's premium. The second option was 108 percent of the hammer price (which meant he would receive 8 percent from the buyer's premium) but no guarantee. The Sotheby's offer on *Self-Portrait* was apparently of less interest to Weiss.

Weiss chose the Christie's option with the guarantee. His agent, London private dealer Ivor Braka, delivered the agreement to Christie's. The papers were apparently not signed, but Weiss claims he was told by Christie's Christopher Burge that the deal was in place. After the Lehman Brothers insolvency in September 2007, Christie's withdrew the guarantee. Weiss argued it was still binding on the auction house. At auction, the painting did not attract a single bid.

The details of Christie's settlement offer to Weiss are subject to a confidentiality agreement; *The New York Times* cited "those with knowledge of the lawsuit" as saying that Christie's agreed to pay the family trust close to the $40 million figure.

Christie's now owned the painting. They reoffered it in a London auction in June 2012 with an Estimate on Request of £20 million ($31.5 million). It sold for £21.5 million ($33.9 million).

Most auction lots are locked up and guarantees finalized three to six months prior to the auction. The time gap means that an unanticipated art market slump can produce huge losses for guarantors. In 2006 the major spring and fall auctions at Sotheby's and Christie's in New York and London listed just under a billion dollars in combined guarantees. In 2007 the figure was just over a billion. In the fall of 2008, with the onset of the art world recession, the losses began. For the major fall auctions, Sotheby's reported a loss on guarantees of $52 million; Christie's loss must have been similar. The 2009 spring auctions produced a combined loss for the two firms of another $150 million, for a total of close to a quarter of a billion dollars.

Auction house guarantees then almost disappeared. Sotheby's provided $626 million in total guarantees in 2008, but only $9 million in 2009. By late 2011, as the art market again flourished, guarantees had returned. By mid-2012, guarantee levels were approaching 2007 levels.

In 2008, to compensate for the disappearance of third-party guarantors, Sotheby's reinstated the "irrevocable bid," an idea that had been around since 1991 but seldom used. Christie's quickly followed. The irrevocable bid is a variation of a guarantee, one that does not leave the auction house at risk.

The concept is simple. When a consignor wants an assured minimum price that neither the auction house nor a third-party guarantor will provide, the auction house approaches a collector or dealer who might be interested in the work. The outside party agrees to bid (with the undertaking irrevocable) to a maximum amount. This becomes the equivalent of a guarantee. If the bid provider acquires the lot, they are charged only a partial (and negotiated) buyer premium.

The original practice was that if the bid provider was outbid, they could continue to bid and still receive a lower buyer's fee. If another bidder won, the excess over the irrevocable bid amount was shared between the bid provider and the consignor (or depending on the agreement, with the auction house). The percentage of the upside going to the bid provider depended in part on whether they also asked for a lower buyer premium. A typical arrangement was 50 percent of the upside if the provider takes the lower buyer premium, 80 percent if they do not. A higher, more risky irrevocable

bid resulted in a higher percentage to the bid provider. Christie's called this percentage a financing fee.

Under the irrevocable bid system, the auction house earned a smaller total fee but was able to auction a work that would not otherwise have been consigned to them during a recession. The auction house did not incur a liability that would appear on their books. They were responsible if the bid provider defaulted, but this did not have to be shown as a contingent liability.

In early 2011 Sotheby's changed the way they compensated an irrevocable bid provider. They now paid a fee to the person offering the irrevocable bid, only if he is not successful in acquiring the lot. If he is successful, he pays the full buyer's premium and earns no fee. At Christie's, the fee is still paid whether or not the provider of the irrevocable bid is successful.

Sotheby's William Ruprecht bragged, "I can assure clients they are bidding in a fair, transparent, and level playing field; I could not offer those assurances elsewhere." Marc Porter of Christie's responded by pointing out that by not paying a fee to a successful bidder, Sotheby's created a moral hazard for the consignor. The auction house was offering an incentive to a bidder for refusing to continue to bid.

A criticism of guarantees and irrevocable bids holds that a consignor with a guarantee becomes a dealer who has sold a work of art, then tries to make an additional profit by using the auction house as an agent. The counterargument is that a guarantee is just another form of bid, one offered prior to the auction. If that bid is high enough, it wins. The auction house compensates the early bidder for undertaking the risk of paying more than if they had bid at the auction. The market benefits because the consignor's caution is overcome, and the work is exposed to a larger audience.

One other effect arises when an auction house offers a guarantee or irrevocable bid. It allows them to tempt the consignor with a very high estimate, as long as the low end of the estimate is no higher than the bid. Sotheby's Oliver Barker is quoted as saying, "When irrevocable bids come into play, sometimes the estimates are rather aggressive; you are managing the seller's heightened expectations. It takes out the auction magic in a way."

Beyond estimates, reserves, and guarantees, auction transactions sometimes raise issues of attribution and self-dealing. Two examples are illustrative. The first demonstrates a different aspect of art fakes. It involves art dealer Tony Shafrazi, who in February 1990 purchased a painting from

Christie's contemporary art sale for $242,000. The work is an untitled, "reverse-acrylic and colored oilsticks on canvas" attributed to Jean-Michel Basquiat, known for his graffiti art and neo-expressionist painting. Basquiat had died two years earlier.

According to the auction catalog, the painting had been acquired by consignor Carlo Diaz "directly from the artist." It was later revealed that, unknown to Shafrazi, the artist's father Gerard Basquiat and art dealer John Cheim (whose gallery represented the Basquiat estate) had several days prior to the sale informed an attendant at Christie's that the painting was "not right."

They said they requested that Christie's remove the work from sale. It was determined during a later court hearing that the person they talked to at Christie's may have been junior; Basquiat and Cheim did not follow up by communicating their concerns to anyone with more authority. Christie's went ahead with the auction.

In 1991 Shafrazi sold the work to Milan collector Guido Orsi. When Orsi wanted to negotiate the price, Shafrazi showed him the Christie's catalog, the provenance of the work, and disclosed the purchase price. Orsi later claimed to have based his decision to purchase from Shafrazi on the attribution of authenticity in the Christie's catalog. "Christie's said it was ok; that was good enough for me."

In 2006 Orsi agreed to loan the painting to an exhibition in Milan. The curator of that exhibition also thought it was "not right." Orsi sought a certificate of authenticity from the Authentication Committee of the Estate of Jean-Michel Basquiat, a committee chaired by Gerard Basquiat with John Cheim as a member. Not surprisingly, authentication was quickly denied.

Orsi joined Shafrazi in suing Christie's for fraud, deceptive business practices, and breach of contract. They alleged that the auction house had failed to disclose to Shafrazi the allegation that the picture might be fake. The issue was whether Christie's had been reckless in its representation that the Basquiat was authentic. Christie's officials testified that the auction house routinely verified an art work through library research, reviewing the catalogs raisonné, reviewing books about the artist, checking prior exhibition catalogs, and consulting other experts.

If Christie's was found to have lacked diligence, the further issue was whether Shafrazi's reliance on the misrepresentation could be relied on by Orsi or any other subsequent buyer. Orsi argued that it could and sought

damages in excess of $2 million, which he claimed as the current value of the Basquiat if authentic, plus punitive damages of $5 million for the misrepresentation. Christie's challenged several of the facts alleged by Orsi and said they believed that "the suit has no merit."

The judge noted Orsi's assertion that "when Christie's provides a warranty concerning the authenticity or provenance of a painting, the custom and practice of the art industry is that the provenance of the work has been firmly and permanently established." Christie's was referred to by the court as a "market maker," a financial term that had never before been used in a court of law to describe an auction house, but a term that suggested Orsi might have been justified in relying on Christie's attribution.

The court ruled that Shafrazi had no claim to damages because he had resold at a profit; in any case the five-year limit on the auction house liability had expired. The judge left in place the allegation of fraud, and with it Orsi's claims for damages.

The remainder of the Orsi complaint was dismissed in November 2011 by a judge of the Supreme Court of the State of New York on the basis that had the claim gone to a jury trial, there was insufficient evidence that Christie's knew the work was fake. There was no reference to the lower court finding that Christie's knew or should have known that downstream purchasers would rely on statements in its catalogs. If the facts had been slightly different, if, for example, Gerard Basquiat and John Cheim had taken their concerns directly to a senior member of Christie's management and the sale had still gone ahead, the legal outcome might well have been different.

The critical part of the Orsi case remains unresolved. The New York trial court held that a subsequent purchaser of a forged work sold by an auction house could pursue a fraud claim against the auction house, even if the house had not met the later purchaser, and even though the auction catalog stated that the warranty applied only to the original buyer. (The "terms and conditions of sale" at the back of the catalog state that the auction house only warrants the description of the item being auctioned that appears in boldface or italics. The other information, often including the previous ownership and back story, is not warranted).

This is only a lower court finding, and in any case only applicable in New York State. Until it is resolved, its implications must cause sleepless nights to auction executives. If this interpretation were to stand, every sale at auction would produce a potential perpetual liability for the auction house.

Any subsequent buyer, no matter how many intervening sales occurred, could bring a fraud claim against the auction house as market maker, so long as the buyer had relied on the auction catalog attribution. Only works with an iron-clad provenance would be accepted for auction; major works offered privately would be inherently suspect.

Even more interesting is what might happen if the work had previously been sold by another auction house. If Christie's accepts a work that had previously been auctioned by Sotheby's, could Christie's later sue Sotheby's because it relied on their attribution?

Another case involves the role of an auction specialist advising a client. The relationship of the auction house to a consignor or a potential bidder is complex. The auction house acts initially as the consignor's agent, with a fiduciary duty to act in his interest. That relationship is governed by a written consignment agreement. The relationship with the buyer is governed by the catalog's Conditions of Sale, which includes warranties and disclaimers.

But once someone indicates they intend to bid, the auction house assumes an obligation of fair dealing with both parties, especially where one has less expertise and relies on the auction house's advice (although proving either condition is another matter).

In 2009 collector Halsey Minor, founder of CNet, a tech media website, filed a class action suit against Sotheby's in US district court in San Francisco. Minor is mentioned earlier in the context of his art being auctioned by Phillips.

Minor claimed that the auction house "conceals information concerning its own significant economic interests in property that it places at auction." In a May 2008 auction, Minor purchased Edward Hicks's 1846–48, bible-inspired painting *The Peaceable Kingdom With the Leopard of Serenity*. He said he was influenced by the advice of Dara Mitchell, head of Sotheby's American paintings department, that it was a great painting.

Minor did not attend the auction but left the winning bid. The presale estimate was $6 to $8 million, with a $5 million reserve. Minor's bid was $8.6 million plus buyer's premium, a total of $9.67 million.

Minor later learned that the auction house was selling *Peaceable Kingdom* on its own behalf, the painting having been acquired as security for a defaulted loan that Sotheby's had made to its consignor, jeweler Ralph Esmerian.

Minor refused to pay for *Peaceable Kingdom*. Sotheby's sued and he countersued. He alleged that by failing to disclose the loan, the auction

house "had disguised itself as a sincere honest art adviser to plaintiff, while in reality acting as a self-profiteer." Minor's attorney argued that if buyers knew that a painting was being sold to satisfy a debt, they would keep their bids low, understanding that the debtor may not have the option of refusing a low bid. Minor's suit also asked for a court order requiring Sotheby's to make fuller disclosures about any ownership stake it has in items it auctions.

In a March 2010 decision, Judge Barbara Jones of the US District Court, Southern District of New York, ruled in favor of Sotheby's. The judge said, to the amazement of many art world observers, that the auction house's economic interest in the Hicks was as security and not equivalent to an "ownership interest." (Sotheby's discloses an ownership interest in the catalog by including a triangular symbol; no symbol was used for the Hicks). Judge Jones also ruled that Sotheby's had no fiduciary duty to Minor to voluntarily disclose existence of Sotheby's interest.

After Minor's refusal to pay, Sotheby's sold the Hicks privately for $7 million. The lower price may have reflected falling art prices between May 2008 and the later sale, or perhaps the fact that the Hicks had been burned by being offered so frequently in a short time period.

Halsey Minor appealed the decision in November 2010. There was no indication of progress at the time of this writing; the appeal may have been abandoned.

There has always been tension between auction houses and dealers: condescension on the part of auction specialists, and resentment by dealers about encroachment and lost market share. There is also a symbiotic relationship between the two. Some of the work in evening contemporary auctions is consigned by dealers. And dealers are among the important few who provide third-party price guarantees to auction consignors.

But the art dealer world is under attack, and evolving; über dealers are on the ascendancy, mainstream dealers on the decline. And the nature of auction house and dealer competition is changing. That is the subject of the next section of the book.

THE ART DEALERS

GAGOSIAN AND THE EVOLUTION OF THE ÜBER DEALER

I adore Larry Gagosian, but I always hear the theme music from "Jaws" playing in my head as he approaches. He is clearly the most successful art dealer of the last couple of decades and his beautiful and well-installed shows have finally earned him the respect of a grudging art world.

New collectors, some of whom have become billionaires many times over through their business nous, are reduced to jabbering gratitude by their art dealer, who can help them appear refined, tasteful and hip, surrounded by their achingly cool masterpieces.

—Charles Saatchi, collector and private dealer

Larry Gagosian is the most dominant art dealer in history, whether ranked by influence, number of galleries, or annual sales. He is the über-über dealer. His global empire currently comprises 13 galleries: 3 each in New York and London; 2 in Paris; 1 each in Los Angeles, Rome, Geneva, Athens, and Hong Kong. There is also a "temporary space" in Rio de Janeiro. In 2012 and prior to his newest London gallery, Charlotte Burns of *The Art Newspaper* estimated that Gagosian's total gallery space was 153,000 square feet (14,200 square meters). This is more than 3 football fields, and about 10 percent more than the exhibition space of the Tate Modern. Gagosian says the sun never sets on his galleries. Considering the 12 time zones between Los Angeles and Hong Kong, he is just barely correct.

He represents 76 artists, and he works with 32 others, meaning he shares them with other dealers. He has 165 employees worldwide and offers 60 to 70 art exhibits a year, each 3 to 5 weeks in length. His galleries have about $1.1

billion in worldwide sales annually, well over $3 million for each working day of the year. He accounts for between 2 and 3 percent of the world's contemporary art market and 15 percent of the high end of that market.

Gagosian's artists include Jeff Koons, Ed Ruscha, Richard Prince, Andreas Gursky, and Zeng Fanzhi. Until December 2012 he represented Damien Hirst. He represents the estates of Andy Warhol, Roy Lichtenstein, Pablo Picasso, and Alberto Giacometti. His megacollector clients include S. I. Newhouse, David Geffen, Eli Broad, François Pinault, and Steven Cohen.

Gagosian's art career began in 1975, at the age of 30, in the Westwood Village area of Los Angeles. Legend has it that he borrowed $75 for patio rent from his mother, purchased art posters for $2 each, mounted them in aluminium frames, and sold each for $15. By 1980 he had a gallery space and was the west coast dealer for artists Eric Fischl, Richard Serra, and Frank Stella, each of whom had primary representation with New York galleries. Even at that early stage in his career, he made most of his money brokering secondary art sales between Los Angeles collectors.

He began working in New York with famed dealer Leo Castelli, who had been the first to show Jasper Johns and Robert Rauschenberg in the 1960s, and represented Warhol in the 1970s. Castelli said of Gagosian's connoisseurship, "He has a great eye; of two great paintings, Larry can determine what makes one greater."

Working with Castelli brought Gagosian to the attention of the premier collectors of the day, including Newhouse, Geffen, and Saatchi. In 1989 he opened a gallery on Madison Avenue in a space once occupied by Sotheby's. A year later he opened a Richard Gluckman-designed gallery on Wooster Street in SoHo.

Representation by Gagosian boosts an artist's prices, particularly those of a younger artist such as John Currin or Cecily Brown. Gagosian received a lot of publicity after taking on Currin in 1993. Currin's auction record at that time was $430,000; within several years, one of his works sold at auction for $848,000. Shortly after that sale, Gagosian sold a Currin painting privately for $1.4 million. Before she joined Gagosian, Brown's abstractions sold for $15,000. Two years later one sold at London's Frieze Art Fair for a reported $800,000.

His two best-known successes were with mature artists Cy Twombly and Takashi Murakami. When Gagosian took on Twombly, the artist had moved to Italy and was not producing much work. Before joining Gagosian

in 2004, Murakami was represented by Marianne Boesky; the top price for his work at auction was $625,000. Gagosian promoted Murakami heavily and helped arrange and finance a major exhibit for him at LAMoCA. Murakami's *Hiropon My Lonesome Cowboy* (illustrated in different setting) later sold at auction for $15.2 million. Yes, these are the publicized success stories; they are what artists remember. No one publicizes failures.

Gagosian owns a townhouse on East 75th Street known as the Harkness Mansion, a home in East Hampton named Toad Hall, one in the Holmby Hills neighborhood of Los Angeles formerly owned by actor Gary Cooper, and one in St. Bart's. He travels the world in a Bombardier Global Express private jet, list price $42 million. He is one of the few dealers to get away with breaking the rule that you should never be seen to live better than your artists (or in his case, than some clients).

Gagosian's personal art collection is such that in 2010 he held a "non-selling" show of $1 billion of his own art at the Manarat Al-Saadiyat, a temporary exhibition pavilion on Abu Dhabi's Saadiyat Island, near where the government is building franchised Louvre and Guggenheim museums. The exhibition was titled RSTW, an acronym for "Rauschenberg, Ruscha, Serra, Twombly, Warhol and [Christopher] Wool." It was curated by Anne Baldessari, president of the Fondation Picasso. Two of the works are reported to have been purchased and shipped to buyers outside the Emirates.

Gagosian does the same things that many other branded dealers do; he both does them very well and is seen to do so. He has some of the best physical facilities, managers, shows, and catalogs. He gives his managers complete freedom so long as the galleries remain profitable. He moves easily between the two sides of the art market, the primary market of new work from his artists and the secondary or resale market. The secondary market is the profit generator.

Gagosian, like other über dealers, does not just sell a primary market painting, he tries to place it. This means selling to the right collector. The market evaluates an artist in part by the collections he is part of. First in line for placement are museums, then branded collectors—Pinault or Broad or Cohen. Next are collectors with whom the gallery has a long-standing relationship. The gallery then publicizes those museums or collectors that have demonstrated faith in the artist by acquiring his or her works.

Gagosian shows often sell out prior to opening. The new work is displayed on a private section of the gallery website; privileged collectors receive

a password and have a limited time to decide whether to commit. The ulti-
mate manifestation of trusting the dealer's judgment and brand is to spend
$100,000 and up on a work of art that a collector has seen only as a JPEG on
a computer screen or heard of on the phone. This is the best example of the
idea of buying with your ears rather than your eyes. Being able to sell this
way is one of the defining characteristics of the über dealer.

A new buyer with no track record with an über dealer might be allowed
to purchase a work by a lower-tier artist. But art world wisdom holds that it
is pointless for him to try and buy a work by a hot artist, unless a major client
calls on his behalf or he is either a celebrity or recognizably a member of the
1 percent. Why would a dealer with a desirable artist sell to a one-time buyer,
or worse, to one who may turn around and flip the work at auction? The new
buyer can be placed on a waiting list for the artist, but there is little chance
of his ever rising high enough to be summoned.

The size of his art empire allows Gagosian to take full advantage of the
economic oddity that when an artist is hot, the relationship of supply and
demand reverses. If the artist creates enough work to show simultaneously in
several galleries and at several art fairs, greater buzz produces higher prices.
Each show, each fair, each art magazine mention produces more critical ap-
praisal, more buzz, and more collectors on the waiting list. The reassurance
of the dealer is reinforced by the behavior of the crowd. Greater supply pro-
duces greater demand.

One of Gagosian's assets is his access to the homes and art storage facili-
ties of some of the world's great collectors. As collector David Cramer tells
it: "I was in Larry's office once and I saw pictures of pieces that were in my
home." He surmises that Gagosian took the photos when Cramer was an-
swering the phone.

It is said that in earlier days Gagosian offered paintings that might
not have been for sale, showing collectors photographs, transparencies, or
pages torn from art magazines. Los Angeles collector Eli Broad says, "I
remember telling him I wanted a Susan Rothenberg horse. There are only
about a dozen. He called this art dealer in St. Louis, who had one in his
home but it was not for sale." It was, after Gagosian offered $300,000 of
Broad's money.

Part of the value of Gagosian representation is that he supports his art-
ist's prices at auction. If a work looks to be selling below current market
price, Gagosian, like the Mugrabis (and sometimes in partnership with

them), will bid it up to where he thinks it should be, and if necessary buy the work himself. His clients know he does this, and it offers reassurance. Jose Mugrabi was asked by *The Wall Street Journal*'s Kelly Crow what would happen to market prices for some of Gagosian's artists if the dealer were not there to support them. He responded, "I shudder to even think of it."

Gagosian competes with auctions and art fairs for the attention of collectors by presenting exhibitions of not-for-sale work by high-profile contemporary and modern masters. Often these shows come with a new, scholarly catalog on the artist's work. A recent example was Gagosian's New York showing of Pablo Picasso from April to June 2011. The exhibition was overseen by scholar John Richardson and co-curated by Picasso heir Diana Widmaier Picasso and Gagosian director Valentina Castellani. It included 80 works dating from 1927 to 1940. Some were from private collections and never before seen in the United States. Others were on loan from MoMA, the Metropolitan Museum, and the Guggenheim.

Why would a dealer mount nonselling shows? They are expensive to assemble, transport, hang, and insure. They occupy space that otherwise would be used to display works for sale. But they usually produce huge publicity and convey an image of success, of being so much on top of the art world that it is unnecessary to always sell.

The nonselling show also emphasizes the special connections the gallery has with collectors, museums, and the artist's foundation or estate. "Where did they get this stuff that no museum has shown?" It shouts, "This dealer is trusted by collectors and museums with their great art; he may be what I am looking for." It also reminds collectors to keep the gallery in mind if they want to sell in the future.

It is also true that the nonselling label may be misleading. Works on loan from museums are certainly not for sale. For works from private collections, the dealer is often receptive to an offer "to be passed on to the owner."

Gagosian has the clout to operate without paying much attention to what other dealers are doing. In April 2012 the Salzburg and Paris dealer Thaddaus Ropac announced he would open a new gallery in the Porte de Pantin area of Paris the following October, with a show of 38 secondary market paintings and sculptures by Anselm Kiefer. Six weeks later, Gagosian announced the opening of his second Paris gallery in the Le Bourget airport complex—also with an Anselm Kiefer show. Ropac was reportedly furious: "I have been planning my show for two years." A Gagosian spokesperson

simply responded, "Kiefer is one of the gallery artists; he will be making all new work for our show." Kiefer provided work for both shows.

Gagosian's galleries are organized along an account management plan, similar to those used by Procter & Gamble and by the William Morris Agency in Los Angeles, where Gagosian had his first job after university. In Gagosian's system, however, account managers are assigned to artists, not collectors. Collectors are associated with whomever they dealt with on their first contact with the gallery, unless they are either potentially important buyers or a celebrity, in which case Gagosian himself takes over. He is, after all, the owner.

Each account manager stays in touch with their artists, answers questions, organizes shows, and makes sure the artist is happy. Millicent Wilner, Gagosian's London account director for Damien Hirst prior to his severing relations with Gagosian, says she phoned or emailed the artist every day. Gagosian may not meet or talk with many of his artists in the 18 months to two years between shows.

Account managers work largely on commission, earning a 10 percent share of the gallery's profit each time a work is sold. Kelly Crow quotes Sam Orlofsky, a New York gallery director, as saying that jockeying to represent an in-demand artist is reminiscent of *Glengarry Glen Ross,* the David Mamet play in which real estate salesmen fight over leads. The reality apparently is that experienced managers have worked out an informal but binding system as to who gets what share of a commission.

With a very few exceptions—the late Jean-Michel Basquiat and Jenny Saville being two—Gagosian has neither nurtured nor represented new artists. He has a long history of poaching mature artists. He waits until an artist represented by another dealer has had a breakthrough show, an auction spike, or a museum show, and then approaches with a seductive offer. This can include promises of publicity and rebranding, a better price list, receptions, a catalog, a signing bonus, or a substantial monthly advance against future sales, and a prominent position in his next Art Basel booth. Sometimes the courtship takes months. Other times, infatuation is immediate. There is a quickly negotiated divorce from the current dealer, followed by an announcement that has been described as similar to that for a second wedding.

His contacts and connections are equally seductive. In November 2009 he held a show for Takashi Murakami at his Rome gallery. The opening night dinner for a hundred collectors began with a private tour of the Sistine

Chapel, followed by a catered dinner in one of the Vatican's sculpture galleries. During an Art Basel Miami fair he reserved a whole floor of a boutique hotel and hosted a party for 800.

There are several oft-repeated stories of Gagosian poaching. One involves John Chamberlain, a then 83-year-old sculptor who works with scrap car parts. For decades Chamberlain was represented by Pace. At auction, his work sold for upward of a million dollars. In late 2010 Pace declined to take some works Chamberlain had arranged to have produced with the assistance of a Belgian technician. Gagosian heard the story, visited Chamberlain's studio on Shelter Island, New York, and said, "I want it all." Chamberlain resigned from Pace a few weeks later; his first show with Gagosian was in May 2011. Chamberlain explained, "Larry is always ready to go." The not-so-hidden subtext to this was that Gagosian probably also secured future control of the artist's estate.

Another story involves recruiting a mature artist who needed financing to fabricate large sculptures. Jeff Koons's *Celebration* series of large-scale sculptures and paintings of balloon dogs, Easter eggs, Valentine hearts and diamonds was conceived in 1994. Gagosian advanced funds, then presold sculptures at $2 to $8 million each to collectors Peter Brant and Eli Broad and dealers Jeffrey Deitch and Anthony d'Offay. The preselling allowed the investor to either take possession of the art when it was ready or to resell at a profit. It is the art world's version of a financial option.

Koons's sculptures proved to be a great investment. In November 2007 Sotheby's sold a Koons heart sculpture for $23.6 million—at that time, a record price for a living artist. A few months later, Christie's sold another for $25.7 million.

In 2003 superstar Richard Prince ended his long-term relationship with dealer Barbara Gladstone to "work independently," by which Prince meant he would join Gagosian. It was disclosed in a 2011 court filing that Gagosian had negotiated a 40/60 sales split agreement with Prince; the standard sales split with an artist is 50/50. A few other galleries (London's White Cube is one) are reported to have negotiated commission splits with star artists, but it is not common.

A recent lawsuit suggests the complexity of Gagosian deals. In September 2012 billionaire Ronald O. Perelman sued Gagosian, with whom he had a long-term relationship as client and friend. He characterized Gagosian in the suit as "the most powerful dealer in the contemporary art world." The

complaint stated that Perelman's art fund MAFG had committed to pay Gagosian $4 million, in five $800,000 installments, for Jeff Koons's granite sculpture *Popeye*, scheduled to be completed in December 2012. At the same time, Perelman purchased from Gagosian a Cy Twombly painting for $10.5 million and a Richard Serra sculpture for $12.5 million.

In 2011 Perelman learned that Koons would miss the delivery deadline. He decided to cancel that purchase and apply the credit to an unpaid balance on the Twombly. Perelman argued that because the value of Koons's work "rises at light speed," *Popeye* would be worth as much as $12 million on completion. Perelman wanted much of the difference between $4 and $12 million credited, to reflect his period of ownership.

Gagosian claimed that he had no incentive to retake possession of the sculpture because he had contracted to give Koons 70 percent of the profit from any resale before the work was finished, or 80 percent thereafter. Gagosian said he resold *Popeye* to an unnamed buyer for $4.5 million, and credited $4.25 million to Perelman. Perelman claimed that the contract with Koons had not been disclosed, and that it "detrimentally affected Gagosian's ability and willingness to repurchase or resell *Popeye* above the price paid [by Perelman]"—implying that the $4.5 million resale price was artificially depressed.

Kelly Crow points out that Gagosian has no immediate family. His is a sole proprietorship; there are no partners, no shareholders, and no heir apparent. He is quoted as saying he has no succession plan, that he lives "in complete denial" about succession.

This should raise concern about the value of his artists' work were Gagosian no longer active. Part of that value is the cachet that a work "came from Gagosian." The brand equity is not the gallery, it is the owner.

His success partly explains why his gallery system is so extensive, but there is more to it. The whole dealer universe is being pressured to greater size and scale by the internationalization of the market and the increasing role of art fairs. Gagosian is simply at the forefront of the response to these factors.

The first wave of his expansion, to Los Angeles and London, was probably undertaken in part to mitigate problems inherent in sharing artists with other galleries. When an artist has different representation in each region, there is always conflict. Every gallery wants the best work for their solo shows and the best for each art fair they attend. The artist may end up being shown

at different stands at Art Basel, with different price levels and discounting policies. Three different galleries contact collectors and museum curators, saying "Come to my booth and see this artist."

The expansion to the second London gallery on Britannia Street and a later expansion to Paris were thought to be motivated by artists rather than collectors. A Gagosian gallery director said that the 14,000-square-foot (1,400-square-meter) Britannia space permitted Gagosian to say to Richard Serra, "Look at this space, do something with it." Others think attracting Damien Hirst, who was producing giant sculptures at the time, was also a factor.

The Rome gallery is located in a former bank building with Corinthian columns, close to the Spanish Steps. The choice of this city seems to have had little to do with collectors, but may have been Gagosian's bid to secure the estate of gallery artist and longtime Rome resident Cy Twombly. Pepi Marchetti Franchi, the gallery's Rome-born director, adds that Rome was also intended as an inducement for other gallery artists who were attracted by the opportunity to show in multiple European capitals.

Expansion to Athens is harder to explain; the city is certainly not a major art market. The best explanation is that the gallery eases access to a half dozen major local collectors, most notably Dakis Joannou.

For an über dealer in a strong market, there is not much financial risk in expansion. When paintings by an established artist sell for $500,000 and up, four sold-out shows—sometimes in less than six months—can cover the cost of renovating new premises. The problem comes in finding a manager to fill the role of the absentee gallery owner, one who can earn a profit without alienating either collectors or gallery artists. Dealer Marianne Boesky, who has two locations in Manhattan, explains her decision not to expand to Berlin: "How can I be really engaged in a city that far away?"

The über galleries—Gagosian with his stable of 76 artists, or Zwirner with 50 artists and estates, or Pace with 62, or White Cube with 52—have no trouble taking part in major art fairs. Consider the resources required to do the "fair marathon," the six weeks that start with the Frieze Fair in New York in May, continue two weeks later at the Hong Kong art fair, and end with Art Basel in mid-June. Gagosian did 12 fairs in 2012, and Zwirner did 15—one every two weeks during the prime fall and spring seasons.

A dealer with worldwide reach is better able to compete with auction houses for top-end consignments. In October 2008 heirs of the dealer Ileana

Sonnabend, who died at the age of 92, sold 25 works from her postwar art collection to settle taxes on her billion-dollar estate. The 25 included Jasper Johns, Robert Rauschenberg, and Andy Warhol. Ten of the paintings were brokered by Gagosian and went to two of his regular customers, reported to be Russian oligarch Mikhail Fridman and American Steven Cohen. The gallery then released a written statement: "The substantial private sales made recently from the Sonnabend collection clearly convey the important message to collectors and institutions that some private galleries, such as Gagosian, can more effectively handle transactions of this scale than their auction counterparts."

A museum show casts a huge vote for any artist. If the best things that can happen to an artist's career are representation at an über gallery or a huge price at auction, the next best is a retrospective at MoMA, LAMoCA, or a similar high-profile institution. It is something every artist hopes a dealer can arrange.

Gallery size and resources may be a factor in choosing an artist for a museum retrospective. Many museums ask a dealer to contribute to the cost of an exhibition by one of their artists. Dealers used to pay for the opening reception; now they are often asked to help choose, assemble, and ship the art, to pay for the catalog, or to produce advertising.

An extreme example was the fall 2007 retrospective for Takashi Murakami at the Los Angeles Museum of Contemporary Art. Paul Schimmel, LAMoCA's then chief curator, sought help from Gagosian, from Emmanuel Perrotin (who represents Murakami in Paris), and from Blum & Poe in Los Angeles. Each gallery approached collectors for work to be exhibited. Each contributed a "six-figure" sum to finance the museum show, and purchased $50,000 in tickets for the opening night's gala.

Blum & Poe paid for Japan Airlines to fly *Oval Buddha* from Tokyo. This is a 19-foot-tall Murakami aluminium and platinum sculpture, intended as the show's feature exhibit. The gallery was thought to have presold *Oval Buddha*, but on the understanding that it would be a centerpiece at LAMoCA.

Curators argue that über dealers are so wealthy, it is realistic that they partner with underfunded institutions. But the suspicion remains that a dealer's ability and willingness to contribute might influence the decision of whom the museum should exhibit. Artists certainly perceive their chances

of appearing in a museum show to be enhanced if they are represented by a wealthy and well-connected gallery.

The pervasive influence of an über gallery like Gagosian goes further. The gallery has a public relations department to create a positive buzz around an artist and to provide information for media articles. Publicity increases the interest of contemporary art curators and the public. The gallery may offer work to a museum at a substantial discount or offer deferred payment terms. For an important institution, a work may simply be donated.

Now the artist is represented in one or more branded museums, with no historical test ever having been applied. There is little downside for the museum. If 10 or 20 years after it acquires a work the artist has achieved no further critical recognition, the museum can quietly sell off the no longer needed art.

Who are the other über dealers in contemporary art? What follows is a list of 12 in rough order of importance. As with my earlier list of artists (and estimated revenues), these are a consensus from those I asked for opinions.

Two dealers who seem to closely follow the size-and-scale Gagosian model are David Zwirner and Arne and Marc Glimcher of Pace. The David Zwirner Gallery is the most often mentioned heir apparent to Gagosian.

Zwirner insists any direct comparison with Larry Gagosian would be misleading. He sees himself as a talent finder, a gallerist for primary art who has expanded into secondary art dealing. Zwirner says that artists come to him because he offers an alternative to the Gagosian model rather than a duplicate. "You don't take the spotlight away from artists by having a big personality and attracting a lot of attention; you stand shoulder-to-shoulder with them."

The Pace Gallery celebrated its fiftieth anniversary in 2010; it is often listed as the second most powerful contemporary art gallery in the world. The Glimchers rival Gagosian in showmanship. What does Pace do when a show overflows to more than one of its New York galleries? In May 2008 Arne Glimcher hired a fleet of 30 pedicabs to shuttle collectors between three Pace sites in Chelsea, all showing Zhang Huan's sculpture, ash paintings, and woodcuts. Zhang, who lives in Shanghai, was transported in a rickshaw to a dinner in his honor in the Meatpacking District.

My favorite example of an über dealer who has not followed the Gagosian-Zwirner-Pace trend is Marian Goodman. She is 84 years old, a

12 ÜBER-DEALERS FOR CONTEMPORARY ART

1. *Gagosian Galleries* (13 locations described above)

 (Larry Gagosian, age 68)

 2012 revenue: about $1.1 billion

 Artists: Ed Ruscha, Jeff Koons, Takashi Murakami

2. *Pace Gallery* (7 locations: 4 in New York, 2 in London, 1 in Beijing)

 (Arne Glimcher, age 67; Marc Glimcher, age 48)

 2012 revenue: $475 million

 Artists: Zhang Xiaogang, Willem de Kooning, Chuck Close

3. *David Zwirner Gallery* (3 locations in New York City, 1 in London)

 (David Zwirner, age 48)

 2012 revenue: $250 million

 Artists: Luc Tuymans, Neo Rauch, Dan Flavin

4. *Hauser & Wirth* (4 locations: home gallery in Zurich, 2 in New York,
 1 in London)

 (Iwan Wirth, age 42; Ursula Hauser, age 72)

 2012 revenue: $250 million

 Artists: Louise Bourgeois, Matthew Day Jackson

5. *L&M Arts* (1 location each in New York and Venice, California)

 (Robert Mnuchin, age 79; Dominique Lévy, age 44)

 2012 revenue (projected over 12 months): $290 million

 Artists: Jasper Johns, Donald Judd, Paul McCarthy

 (The 2013 ranking would be lower. The two principals decided to each
 run separate galleries in New York, and to close the one in California.
 How the artists and revenue will divide was not clear at the time of
 writing.)

6. *Acquavella Galleries* (1 location in New York City)

 (William Acquavella, age 74)

 2012 revenue: $375 million

 Artists (focus on secondary market): Mark Rothko, Lucien Freud, Zheng
 Fanghi

7. *Marian Goodman Gallery* (1 location each in New York and Paris; one to
 open in London in 2014)

 (Marian Goodman, age 84)

 2012 revenue: $170 million

 Artists: Gerhard Richter, Thomas Struth, Jeff Wall

8. *Matthew Marks Gallery* (3 locations: 2 in New York, 1 in Los Angeles)

 (Matthew Marks, age 49)

 2012 revenue: $120 million

 Artists: Ellsworth Kelly, Brice Marden

9. *Gladstone Gallery* (2 locations in New York, 1 in Brussels)

 (Barbara Gladstone, age 77)

 2012 revenue: $120 million

 Artists: Anish Kapoor, Matthew Barney, Keith Haring

10. *Paula Cooper* (2 locations in New York)

 (Paula Cooper, age 74)

 2012 revenue: $120 million

 Artists: Rudolph Stingel, Sol LeWitt, Carl Andre

11. *White Cube Gallery* (3 locations: 2 in London, 1 in Hong Kong)

 (Jay Jopling, age 49)

 2012 revenue: no estimate

 Artists: Damien Hirst, Mark Bradford

12. *Lisson Gallery* (1 location each in London and Milan)

 (Nicholas Logsdail, age 75)

 2012 revenue: no estimate

 Artists: Anish Kapoor, Robert Mangold, Julian Opie

**The list does not include the private dealing operations of Sotheby's and Christie's, each of which, if ranked as a gallery, would probably be numbers 2 or 3. It also does not consider private dealers who do not maintain public galleries.

sliver over five feet tall, and refuses to talk about the business aspect of art. She is one of those who prefer the title "gallerist" to "dealer." She does not take on mature, successful artists represented by other dealers. "No poaching, ever."

She is perhaps best known for her representation of Gerhard Richter, considered the world's foremost living painter. As she tells *The Economist*, she manages the Richter market as what she calls "an honest game." She sells Richter's work at less than it would bring in the secondary market, but selects buyers carefully, preferring those who will later donate the work to a museum. She considers auctions as "a necessary evil," and does her best to keep Richter's work from appearing there.

Most of the galleries mentioned above (one notable exception being Goodman) were never intended to be receptive to "just looking." Part of the psychology of the gallery derives from the decor. Most often it is windowless and not intended to be welcoming. The interior architecture is dominated by white-walled display areas, called "white cube," with wood or concrete floors, recessed lighting, and minimal distractions from color or clutter in the reception area. The decor reinforces the perception of being museum-like, that what is being viewed is art.

There is actually a debate as to which white is best for a white cube. Edward Winkleman, author of *How to Start and Run a Commercial Art Gallery,* describes the subtle psychological impact associated with each shade. In his first New York gallery, Winkleman used Benjamin Moore's White Dove, which has a yellow tinge, to produce the warm ambience of a British pub. When Winkleman moved to a new space on West 27th Street he used Benjamin Moore's Super White to connote a "sense of examination and interrogation." The Gagosian galleries in New York and Los Angeles use a shade of white developed by architect Richard Meier, called Meier White. Meier says it allows a collector to perceive the colors in a painting correctly, no matter what the light source.

Gagosian, Zwirner, and Pace are the peak of the art market pyramid. They and other über dealers represent artists who have achieved great commercial success, but these are far less than 1 percent of all contemporary artists. Most artists have representation by a dealer at least one level lower on the art pyramid. Many of those dealers face far more difficult problems than what color to paint an expensive new art space. The mainstream dealers, and their struggles, are the subject of the next chapter.

THE ARTFUL DEALER

We would all like to think that the work itself is all that's important and that defines an artist's success, but we all know that that isn't necessarily the case. Artists who emerged on the scene at the same time, ran in the same circles, and achieved recognition for similar pieces experienced very different market receptions for their work.

—Geoffrey Parton, director, Marlborough Fine Arts

For all the growing importance of the über dealer, mainstream dealers still run most of the art game. They exist one level of the dealer pyramid below the über but they are the gatekeepers to the world of contemporary art. It is at the mainstream gallery where an artist's work is first seen and considered by serious collectors. These galleries, not über dealers or auction houses, decide which artists get to aspire to the highest levels of the art world.

Each mainstream dealer typically represents 15 to 25 artists who might be offered a solo or group gallery show every 18 to 24 months. The dealer promotes the artist with art journalists, museum curators, and collectors. The gallery expects to lose money on a new artist's first two or three gallery shows; it is prepared to do this in the expectation of profit on later shows and on secondary-market resales. If the artist is successful at this gallery level, they will be shown at minor art fairs and later by mainstream galleries in other cities. The most successful artists will have their work appear at major fairs and in local auctions. These artists will be the ones reviewed in art magazines.

Mainstream dealers cluster in the same cities where über dealers are found, particularly New York, London, Los Angeles, Paris, and Beijing. These are destination cities for collectors. There are strong mainstream galleries in secondary cities, but a dealer and his artists are usually better off as the fiftieth gallery in New York or London than as the first in Seattle or São

Paulo. The need to maintain contact with an important mainstream dealer is one reason many contemporary artists choose to locate in or close to a destination city.

If these five are the most recognized cities for contemporary art, what is the least well recognized? I nominate Havana. Cuba's art culture has flourished in spite of the US embargo, strangling bureaucracy, and limits on freedom of expression. Ask around the city and you will be directed to the studios of contemporary artists such as Esterio Segura, Abel Barroso, and Los Carpinteros; prices are negotiable as long as there are not tour groups present. Galeria Habana now shows at several important Western art fairs.

Havana's ISA art school is one of the best in the world. Weekend visitors, when no administrators are around, can view student art and negotiate a purchase directly with the artist—sort of a perpetual MFA grad show. Buyers contribute to one of the great oddities of the contemporary art world. The Cuban state pays its four million workers an average salary of $19 a month. A private security guard or restaurant worker may make $80 a month but forfeit some food rations or health care benefits by leaving the state system. A top student at ISA with work in demand by foreigners may earn $1,000 or more each month with all her materials and gallery space supplied by the state. She will be in the top 10 percent of Cuban income earners, and probably the top 1 percent of all Cuban artists. Yale and Columbia MFA grads may have chosen the wrong school!

The quality of Cuban contemporary art is well recognized by dealers in the United States and Europe, who are planning for the scramble for artist representation that will begin on the day that Cuba opens up.

Back in the Western world, the most serious threat to mainstream galleries is the one discussed in the previous chapter: the poaching of their most successful artists by über galleries. When artists depart, they take some of their collector base with them. The reality for a mainstream dealer is that even if she chooses artists well, for every ten new ones taken on, four will not be commercially well received and will leave the gallery after one or two shows. Three will show for a few years before departing, two will have long, moderately profitable careers, and one—maybe one—will be well received and achieve high prices. And only one artist in 200, and that is 200 of the "one-in-ten" stars, will ever have work offered at Christie's or Sotheby's evening auctions.

The one-in-ten has to generate enough dealer profit from shows, art fairs, and secondary sales to justify the investment in the other nine. If that one artist is poached, the mainstream gallery's economic model is threatened.

Sometimes an established artist turns to an independent agent to manage their career and the result is shows with rival galleries. In 2012 Hauser & Wirth gallery showed Sterling Ruby on Savile Row in London, where Ruby was already represented by Sprüth Magers, located just down the road. Artist Peter Doig arranged a show in London with Michael Werner, even though he had for a decade been represented by Victoria Miro in the same city. In each case the artist was not being poached by the new gallery; they were just being shared.

Even without poaching and sharing, the traditional mainstream gallery model is under attack from multiple directions. The attacks exploit the structural weaknesses of the gallery system: high markups, and promotional efforts focused locally while the art market is increasingly international. Art fairs, auction houses, and the Internet do a far better job of reaching international clients.

For über dealers, art fairs now represent up to 70 percent of annual sales. For many mainstream dealers the figure is far lower. The top fairs may not accept a dealer who cannot bring enough work by branded artists. Or the dealer may be accepted but be unable to fund travel and staffing costs. The irony in this is that art fairs were established by dealers as their ultimate weapon against encroachment by the auction houses. It was only when a few dealers gained relative dominance and the best fairs became more selective that some mainstream dealers began to be excluded.

The cost of attending multiple fairs can be daunting. A single booth at Art Basel is $680 per square meter (10 square feet) or $55,000 for an average 80-square-meter booth; at Frieze New York it is $53,000, and at the Armory Show in New York, $35,000. The cost of insurance, shipping, partitions, lighting, producing catalogs, sending installers ahead to prepare the art fair stand, and flights and hotels pushes the total for each to six figures. Marketing costs can range north of $100,000, including advertising, dinners, and entertainment. The money is required up front; if four fairs come close together, a dealer can have well in excess of a half million dollars out there. Lesser fairs such as Pulse and Scope (both satellite fairs to Art Basel Miami) run about 40 percent the cost of the majors.

The decline of the traditional gallery model appears to be universal. March 2013 saw the closing of Paris dealer Jerome de Noirmont's Avenue Matignon gallery. Noirmont represented artists Jeff Koons, George Condo, and Shirin Neshat. He said in a letter to clients, "The future appears to be in specialized niches, simple-structure galleries, and in the branding of megagalleries." He said that to continue he would need more artists, more employees, and more space. He decided instead to close and set up an agency to work with artists and dealers.

A few months earlier, Los Angeles dealer Margo Leavin announced that she would close her gallery after 42 years. Leavin represented artists John Baldessari, Claes Oldenburg, and William Leavitt. She didn't blame the existence of art fairs but the shift in values they produced. "People are not seeking the thoughtful, complete statement that artists make when they create gallery exhibitions . . . collectors are conditioned to viewing in a shopping center environment."

Also in 2013, after 16 years of running his own D'Amelio gallery in the Chelsea area of Manhattan, Christopher D'Amelio closed and signed on to co-direct David Zwirner's 20th Street gallery. The decision came not from gallery sales; D'Amelio said that 2012 was the best year in the gallery's history.

D'Amelio said that while his gallery was one of the top 25 in New York, the top 10 and particularly the top 5 were so enormous that being midsized made it increasingly hard to find and retain artists, to get admitted to art fairs, and to get press coverage for artists and shows. The only solution was to grow, but that required a long and risky commitment.

There are two other threats, discussed in later chapters. One is the expansion of private dealing by auction houses, when the auction house acts as an agent and sells privately. Dealers compete with auction houses for customers, but more importantly, they compete for the consignment of art for resale. The second threat is the migration of lower value art sales from high-markup, brick-and-mortar galleries to the digital world with its lower markups.

The process of collecting has also changed. Auction houses and fairs condition younger collectors to bypass dealers. Many collectors no longer acquire the depth of knowledge prerequisite to connoisseurship. They buy what the art consultant or the specialist at Christie's or the writer at *Frieze* magazine advises.

The layout of most galleries reflects the distinction between art and the art market. The front of the gallery is museumlike space where art work is exhibited. In most mainstream galleries there are no posted prices (and never in an über gallery). A list may be available if you ask. Negotiations take place and sales are finalized in a separate room at the back or upstairs.

Each work does come with a price. How is that determined? Prices at a gallery signal the status of the dealer, the reputation of the artist, and the status of the intended purchaser, in that order. The starting price point for an emerging artist is set by the dealer's reputation. In a mainstream gallery, for an oil painting on canvas by an artist with no gallery history, one gallery might start at $5,000, another at $8,000. The figure chosen is high enough to convey the status of the gallery but low enough to be acceptable for a first show. An über gallery that took on a comparable new artist might ask $15,000 for a similar work; on resale the über gallery provenance will justify a higher price.

If the artist's first show sells well, a second show 18 to 24 months later will be priced at 50 percent above the first. A third show will be at double or more the prices of the first. Exhibitions, prizes, or other recognition for the artist in the interim results in more rapid price escalation.

The pricing-by-reputation rule reflects the reality that, in the art market, price creates value rather than reflecting it. This is what economists call the Veblen effect: Buyer satisfaction comes from the art but also from the conspicuous price paid. The same principle holds with a designer handbag or a diamond engagement ring. It is demonstrated in economists' experiments with wine. Blind taste tests show that many people prefer an inexpensive wine. When the test is repeated with wine prices shown, the same subjects will say that they get more pleasure out of drinking the less-preferred, more expensive wine. High price adds to value.

If the final selling price incorporates a discount, buyer satisfaction is greater. Friends assume the collector paid the asking price, and value and status are related to the perceived price.

Another pricing rule for all dealers is that an artist's list prices are never reduced from those at an earlier show. A price decrease would signal that an artist was out of favor; demand for their work would fall instead of rising. A decrease would also cause collectors to question the dealer's artistic judgment. A single exception to this norm is a show where the artist has experimented with new media or artistic styles.

If a gallery artist has two badly received shows in a row, the dealer will almost always drop the artist rather than decrease list prices for the next show. Prices can restart at a lower level if the artist finds representation at a new gallery; there is then no concern about betraying previous buyers. In an art world recession like that of 2008, galleries still do not drop list prices, but they may offer wildly generous private discounts. The list price still signals gallery and artist status; the discount produces sales and earns gratitude from collectors.

For mature gallery artists, auction prices for comparable work establish a ceiling on dealer pricing. When new price levels are recorded at auction, dealers consider raising their own prices.

Dealer markups in the primary art market are pretty straightforward; the dealer normally keeps 50 percent of the selling price. Markups in the secondary market can be as low as 5 percent on an expensive work acquired specifically for a favored client, and as high as 300 percent on works purchased for inventory.

Relationships between dealer and artist often reflect tension because artists resent the size of the dealer commission. There is also stress because a dealer's relationship with a gallery artist often encompasses the roles of financier, critic, advisor, and friend.

The concerns go beyond markups and criticism. Every artist seeks the recognition and ego enhancement that comes from appearance at fairs, representation in other countries, placement in art museums, and write-ups in *Art in America*. The mainstream dealer has limited ability to deliver these, even to the one-in-ten. The dealer may also have a conflict of interest. Media promotion and showing at fairs generates attention from collectors but also from other dealers. It may precipitate poaching by a dealer higher on the pyramid, who views this suddenly promoted artist the way a real estate developer eyes an empty corner lot in a prime location.

What strategies are available to a mainstream dealer in this shifting competitive environment? If auction houses and art fairs command a greater market share and some sales are migrating to the digital world, what is the future for brick-and-mortar, mainstream galleries, or for clusters of mainstream galleries like those in New York's Chelsea?

Some mainstream dealers deter poaching by efforts to keep their artists happy, whatever that takes. Others survive by having replacements available: promising foreign artists or new graduates from elite MFA programs. A

gallery without high-demand artists can cut back on retail space (or drop it altogether) and spend more effort on midlevel fairs and on digital marketing.

A gallery also has the options of focusing on emerging artists and shifting to lower-rent premises. This happened in New York during the art recession when several galleries moved from Chelsea to the Lower East Side. Curiously, the right strategy seemed to be to move farther away from über galleries rather than to cluster near them. As Chelsea saw the arrival of ground-floor megaspaces for Pace, David Zwirner, Andrea Rosen, and Hauser & Wirth, the cost of upper-floor gallery space increased at the same time traffic decreased. With so much to see at ground level and a limited art attention span, fewer collectors were willing to climb stairs.

Another option for the dealer is to focus on the secondary art market, resale art with fewer overhead costs. But a secondary market strategy is never as straightforward as it seems. Primary sales from in-demand gallery artists produce the collector contacts that lead to secondary sales. It is a circular process that works less well once the circle is broken.

The key to survival for a dealer outside of the top tier is probably constant monitoring of the market. Evaluate where and what customers are buying, and what is being sold online. Then choose an approach that fills a market niche, and be willing to constantly evolve. London dealer Sadie Coles describes this as "recontextualize and replenish the gallery program by keeping an eye on the general landscape." Few mainstream dealers seem able to do it. Dealer after dealer that I talked to responded with some version of "This is how I have always sold art, this is how art will be sold in the future."

I searched for a good example of a knowledgeable dealer who either started up or expanded during the art recession of 2008–2010, hoping to identify what strategies were followed. October 2011 saw the opening in London of Ordovas gallery, run by Pilar Ordovas. In spite of the looming second dip in a double-dip recession, she chose to locate not in modest quarters in east London but rather in expensive quarters in the West End, on Savile Row near established dealers Daniella Luxembourg, Hauser & Wirth, and Sadie Coles.

Ordovas spent 14 years at Christie's. At the time she left she was international director and deputy chairman for Postwar and Contemporary Art in Europe. She is known for setting sales records: for Lucian Freud, whose *Benefits Supervisor Sleeping* sold for $33.6 million in New York, and for Francis Bacon, whose *Triptych (1974–1977)* sold for £26.4 million ($46.1 million).

She was responsible for nine of the top ten sales at Christie's London during her time as director. She then spent two years as a director of Gagosian Gallery in London.

She said her gallery would create a scholarly model for modern and contemporary art and would stage historical exhibitions. She will not represent living artists although she may ask a contemporary artist to curate a show about artists who have influenced him. For example, Jeff Koons could do a show on Salvador Dali. Her idea is to find artists who may have been overlooked and reconsider them with a fresh perspective.

In the first year of her new gallery, she mounted three exhibitions. She opened with *Rembrandt-Bacon: Irrational Marks* in October 2011. The exhibition focused on what Rembrandt had meant to Francis Bacon, a question that no gallery had addressed before. She got extensive publicity from persuading the Musée Granet in Aix-en-Provence, France, to loan their most important work, Rembrandt's *Self-Portrait with Beret* (1659) to her new gallery. She modestly explained that it helped that her gallery is next to a police station.

Ordovas says her revenue model is to provide "one-on-one client services," which means that she brokers private sales. In particular she deals in the works of Freud, whom she knew well. "I wanted to make sure that if anyone was going to sell a Freud work or if any of his work needed to be researched or written about, then it was going to be me undertaking the sale or the research and writing."

It is obvious that the expense of mounting these nonselling shows is considerable, and everyone's first question is, "Is this viable?" Apparently it is. Ordovas illustrates the most opaque aspect of the contemporary art landscape, the private dealer.

The conclusion is interesting. Even with Ordovas's background in the auction and dealer world, with her specialized knowledge of twentieth-century art and unsurpassed collector contacts, she had to find a niche market. She concluded that it was more promising to go head-to-head with the private dealing functions of major auction houses than to open as a traditional mainstream dealer.

Ordovas agrees that there are pressures on the mainstream gallery, but suggests a caveat. She says that galleries will do well if they focus on artists who prefer security and personal attention rather than insisting on being shown at five fairs a year. She thinks many mature artists fit this description,

but that younger artists are more restless, have a greater expectation of publicity and international exposure, and are more open to being poached.

In 2012, the world of the mainstream gallerist was portrayed in Bravo's television reality program *Gallery Girls,* the story of seven young women who dream of living a chic existence in New York City, with exciting careers in art galleries. *The New Yorker* reported that actresses for that show were recruited with an email: "This gallery girl will inspire others with her wit and charm, but she should also be sly-as-a-fox when it comes to the politics of New York City's art gallery world."

The early episodes of the show presented gallery girls as unpaid interns at galleries showing mediocre art. They were recent college grads whose work lives incorporated nudity, backstabbing, and a *Sex in the City* approach to designer shoes. Dialogue from the first episode included "You have, like, the artsy people, and then you have, like, the older cougar women who are trying to be young and they're not, and then you have, like, the young trendy girls that are trying to like, fit in and like, be relevant, that's like, how the art world is."

Like, no. The world of the mainstream dealer is many things, but not like that.

WHEN AUCTION HOUSES AND DEALERS COLLIDE

Everyone has a plan until they get punched in the mouth.

—Mike Tyson, boxer and philosopher

The symbiotic relationship between auction houses and dealers is shown in several ways. About 20 percent of the work in evening contemporary auctions is consigned by dealers. A few dealers provide third-party price guarantees to auction consignors. Dealers purchase at auction on behalf of clients, for inventory, or to get a feature work to front their booth at a top art fair. Dealers also need auction houses to dispose of unwanted inventory.

Prices achieved at auction also serve as reference points for dealer pricing. The transparency of auction pricing provides banks a starting point in valuing dealer inventory and determining lines of credit. When auction results exceed expectations, inventory values increase, and dealer credit lines expand or their interest rate declines. And it is auction results, not dealer performance, that determines how the health of the art market is perceived—up or down, frenzied or flat.

Direct competition between auction houses and dealers is fairly recent. Some date it to 1989, when Sotheby's contracted for the disbursement of art from the British Rail Pension Fund. Others date it to the expanded use of auction house guarantees by Sotheby's president Diana Brooks, following the art world crash of 1990.

Charles Saatchi's consignment of 133 lots of paint-barely-dry contemporary art at Sotheby's London on December 8, 1998, was a milestone in the history of direct competition. There were 97 artists involved. A few had auction track records, but many had never had dealer representation at any

level. It was enough for Sotheby's that the art carried the branding of Saatchi ownership. Identical art from the Thompson collection would never have been considered. The success of the event validated the idea of offering branded primary art at evening auction, a practice that other auction houses, notably Phillips, have dabbled in since.

Recall that in September 2008, Sotheby's London hosted the *Beautiful Inside My Head Forever* auction of Damien Hirst's works. The offering of 223 works of art, straight from Hirst's studio, with most produced specifically for the auction, bypassed Hirst's dealers. There was speculation that Sotheby's offered Hirst a share of the buyer's premium, giving him much more of the selling price than the average 70 percent he received on sales through his dealers. Sotheby's also went beyond anything his dealers had offered in terms of extended payment schedules.

Dealers react to this and other primary sales (think of Jacob Kassay at Phillips) by saying that auction houses care only about profit, not about developing the artist. Auction houses respond that their job is matching buyers and sellers; with sales of primary art they provide publicity and branding to the artists involved.

More intense competition between the two selling channels of distribution arises with auction houses' private treaty sales of secondary art, a mainstay of many dealers' business models. These are negotiated between buyer and seller, but with the auction house as intermediary.

An auction house, like a dealer, can be involved on one or both sides of a private transaction, sometimes taking on a work of art and seeking buyers, sometimes being asked by a buyer to locate or negotiate for a work. And sometimes, knowing a work hangs in a collector's home, seeking out another collector who might lust after the piece, then returning to the current owner with an irresistible price. There is a tale of an auction house specialist borrowing a work of art from a client, purpose unstated, and returning it a week later with an offer. During the week, the work hung "on temporary loan" in the potential purchaser's home.

Private sales through both auction houses and dealerships showed yearly increases after the art market crash. Emilio Steinberger of Haunch of Venison in New York said, "The market went down, values were uncertain, auctions were uncertain, a gamble. Auction houses stopped offering guarantees, major auctions went down-market, and private sales increased." The commission structure helped drive private sales to auction houses. Properties

acquired for auction produced no commissions for auction house specialists who brought them in (except for year-end bonuses), while properties acquired for private sale produced an immediate commission of as much as 10 percent of the profit on a transaction.

New York is the center for private dealing, thought to outsell London about two to one. Sotheby's and Christie's are the major auction house players. The amounts involved are huge. For 2012 Christie's reported $1 billion in private dealing sales, up 26 percent in a year; Sotheby's reported $907 million, up 11 percent. If each private treaty department were ranked as a dealership, Christie's would be a close second to Gagosian, and Sotheby's number three. Each is gobbling up high-end market share from dealers around the world. Christie's Marc Porter says, "Within a decade it is possible that our private sales will equal our auction sales." Some financial analysts now view brand-building investments (consider the efforts for *The Scream*) not only as directed at attracting auction consignments, but also as promoting each house as a destination for private sales.

During the art recession in 2008–2009, there were far more works (and works of higher value) being offered by consignors than auction houses would accept for auction. In the 18 months following September 2008, probably 90 percent of the market for Warhol and Hirst was private. Stephane Cosman Connery added, "In an uncertain market, even those consignors who might have been willing to wait a year or more for their work to be auctioned were willing to forego the upside of an auction for the security of no price downside, essentially accepting what might be the midpoint of an auction price range. The range might be $3 to $4 million with a reserve price of $2.7 million; the private treaty sale grosses $3.6 million, with $3.3 million to the consignor."

When he was at Sotheby's, Connery claimed a high success rate on private sales over a million dollars: "The world is filled with overpriced pictures, but we transact with 90 percent of the works we take on because we're disciplined about price and quality." [The Connery name has appeared several times in the book. If it seems familiar in some other context, his stepfather is screen legend Sir Sean Connery.]

The profit model for private treaty departments depends on the consignor's preferences. Most commonly, the auction house and consignor agree on a selling price and negotiate a percentage commission. Less often, the auction house takes a commission from both seller and buyer. Or the parties

agree on the price the consignor wants to achieve, and the auction house sells for whatever they can, with the difference as their commission.

Sometimes there is a shared commission. A dealer brokers a Maurizio Cattelan work that she hopes to sell for $6 million; the consignor wants an advance of half the promised selling price in the form of an interest-free loan. The dealer gives the Cattelan to an auction house's private treaty sales department, both to take advantage of their database of potential buyers and because the auction house has the financial resources to fund the loan.

The auction house places the Cattelan, initially asking $7 million and negotiating to $6.6 million. The dealer receives $6 million and that amount, minus the dealer's commission, goes to the consignor.

Commissions for private sales are highly confidential. The overall gross profit margin when done by an auction house is about 13 percent, with net profit about 9 percent. The small spread between the two occurs because private sales carry none of the catalog, promotion, and overhead costs of an auction.

Sometimes the commission is fully disclosed to the consignor, sometimes not. Connery and Dominique Lévy, former co-director of L&M Arts in New York, said their firms practice total transparency in private dealing. They disclose to the consignor the full commission, whether there was another intermediary involved, and if so, what part of the commission each received.

At the other extreme, Larry Gagosian described in a 2012 lawsuit a common consignment arrangement as one "where the seller says I want X, and there is no stipulation about what the gallery makes. And in fact, conversations involving those very often will be: 'I want a million dollars. Whatever you make is your business.'"

In the Gagosian example, the consignor knows only the net amount he will receive, and the purchaser knows the final price but not whether the dealer acted as broker or principal, or the amount of commission or profit. That is pretty opaque, but realistically, does it matter to either consignor or purchaser so long as terms are understood? No dealer reveals to a buyer their commission on art sold off a gallery wall.

Absent a recession, why would a consignor choose a private treaty sale rather than selling at auction? Connery says the reasons are not financial but rather relate to the needs of the individual client. The great advantage of private treaty is confidentiality and anonymity. Neither the work nor source is

revealed, matters of special value to those embroiled in a financial crisis or divorce. An auction is a public event. The identity of the consignor may or may not be public, but often someone recognizes the art. The desire for discretion goes beyond financial or family problems. Dominique Lévy points out that in her birthplace, Switzerland, all asset management is private. Individuals do not want the sale of an asset or the resulting inflow of capital to become public.

A work marketed privately can still achieve wide exposure. When a Hirst or Koons is consigned to a private dealer, high-resolution digital images go out to other dealers, auction houses, and collectors with the question "Any interest in this, or might you know a buyer?" Sometimes offers (conditional on seeing the work) come back within the hour.

The other major advantage of a private treaty sale is this immediacy. From consignment to auction to final payment may take six months. A private transaction may be concluded in days.

Certain kinds of art make more sense for private sales. Emilio Steinberger nominates art of great importance but with a limited market. He points out that Frank Stella and Dan Flavin sell less well at auction than privately. "Commercial" Warhols sell better at auction, while nontypical ones sell better privately. Connery says that early and historically important work by an artist often sells better privately, as does work that is important because it influenced other artists; he offers as an example Paul Cézanne.

Steinberger also suggests the example of Balthus (Balthasar Klossowski, French, 1908–2001), an important artist whose best work (comparable to the 1957 *Girl at a Window* in New York's Metropolitan Museum) has not appeared at auction, so auction records do not reflect real value. Connery offers the example of an early "dark" Francis Bacon as a work that would bring a better price if sold privately.

Collectors also turn to private sales for works that are out of favor. Italian artist Francesco Clemente is an example. In the 1980s, Clemente was hot, considered an equal to Julian Schnabel or Keith Haring. At the end of the 1980s, there was one point where three New York galleries showed his work simultaneously. Then Clemente was dropped by Gagosian and his visibility declined. In 2011 his painting *Parabola,* earlier estimated by Sotheby's in 2010 at $80,000, sold for $31,000. Since then, most Clemente paintings have traded privately.

Dominique Lévy offers a different example. A consignor has a major de Kooning at a time when two other de Koonings are known to be coming up

in the next round of evening auctions. It may be better to offer this de Koon-ing privately, after the auction, when interest is still high and the identity of some underbidders is known, rather than dilute the auction offering with a competing work.

Another motive for choosing private treaty is the ability to quickly re-offer a work if it fails to sell. A consignment at auction that fails to meet its reserve is "burned" and devalued. The work is usually not reoffered for at least two years. Delay is not necessary with a failed private sale. The idea of a work being burned has always seemed to me a strange concept, but Connery insists it is important, particularly at the higher levels of the market. "Think of real estate that has been on the market for months; everyone wonders what is wrong with it that it has not sold."

There are always surprises. While I was researching this topic, several dealers told me similar versions of the same story involving Francis Bacon's 1964 *Three Studies for Portrait of Lucien Freud*. This is a difficult and dark Bacon; each panel shows a different perspective of a distorted face. It would seem well suited for private placement.

It was offered in 2009–2010, first privately through a London dealer, then privately through Christie's, finally privately through Sotheby's. As the story is related, the only decent offer for the triptych was $18 million, gener-ated by Christie's and quickly rejected by the consignor. *Three Studies* was then offered at Sotheby's February 2011 London auction, bringing £23 mil-lion ($37 million), double the auction estimate, from an unnamed bidder.

In more robust economic times, private sales offer a way to flip new art without getting caught. A speculator who has risen to the top of a waiting list for a hot artist can immediately resell the work in Japan or Russia, with minimal chance that the artist or gallery will learn of the sale and cut off further sales to the flipper.

If a consignor decides to sell privately, should she use an auction house rather than a dealer? Dominique Lévy says there is a trade-off. The dealer offers more personal service and hand-holding. The auction house offers an unsurpassed database, a great advantage in knowing who is looking for what. The database is updated as cameras record each major auction. The house knows the identity (from paddle numbers and registration) of every person who has bid on a Maurizio Cattelan over the past decade, in person or by phone or online. The auction database is a digitized buyer wish list unrivaled in being able to spit out the names of five collectors domiciled in

Kazakhstan who bid by phone or online but may never have appeared at a dealership or auction in New York or London.

The database also indicates who owns what; it permits the auction house to locate a collector and propose a transaction. If the private transaction does not materialize, the specialist can suggest putting the work up for auction, perhaps guaranteeing the same price the collector was seeking. Or the specialist may call a collector to inform him of an upcoming consignment of interest and point out that a private buyer exists for one of the collector's existing works.

Sometimes, particularly during an art market recession, a dealer almost drives the collector into the hands of an auction house's private dealing facility. If Charles Saatchi or Jose Mugrabi wanted to sell off a collection of works by Chinese artist Zeng Fanzhi, it would not be easy to do so through the artist's dealer, Acquavella. The dealer would view a disposal of Zeng's work in bulk as a threat to the reputation of the artist and to the value of their own inventory.

Knowing he would face resistance or hostility from the dealer, Saatchi or Mugrabi might consider the option of private dealing. This channel keeps both dealer and other collectors from noticing the degree to which Zeng's work is being disposed of.

Another form of auction house/dealer competition arises when an auction house acquires its own dealership. In June 2006 Sotheby's acquired Noortman Master Paintings, an Old Masters gallery in Maastricht and Amsterdam. Eight months later, Christie's acquired Haunch of Venison, a contemporary dealership in London and Zurich. Each transaction gave the auction house access to that gallery's secondary market customers.

Christie's initially wanted to reposition Haunch as a primary market gallery and to fold secondary art sales into their own Postwar and Contemporary Art department. What actually happened, according to Emilio Steinberger of Haunch, is that the gallery did secondary sales on its own, at what he called "arms-length" from Christie's and without access to Christie's customer list.

Christie's announced in late 2012, without comment, that Haunch would focus exclusively on secondary sales and would stop representing artists. The problem seemed to be the perception of the gallery as an arm of its owner, which had caused it to be excluded from major fairs, including Art Basel, Art Basel Miami, and New York's Armory Show.

As a final form of competition, auction houses now mount their own selling exhibitions. On one end of the second floor of Sotheby's headquarters in New York is an all-white, Richard Gluckman-designed "selling exhibition gallery" called S2. Sotheby's stages elaborate opening receptions for a by-invitation crowd, exactly like an East Side gallery. Sotheby's also runs S2 exhibitions in London in a space just behind its auction rooms, and in Los Angeles and Hong Kong.

Christie's runs its own retail space on the twentieth floor of 1230 Avenue of the Americas, in a building connected to its Rockefeller Center headquarters. It has opened gallery space in the old Haunch of Venison space in London and in Hong Kong. Neither the artists involved nor their regular dealers seem to object to the art being shown and sold in an auction house gallery. It is unclear to collectors, although it may not matter to most, whether the auction house is acting as a dealer, an agent, or as the owner of the work.

Christie's also competes with dealers to represent artist estates. In 2012 it was the successful bidder for what Amy Cappellazzo of Christie's says are "many, many thousands" of works that remained in the collection of the Andy Warhol Foundation for the Visual Arts. Foundation documents value these at $104 million; the resale value is thought to be twice that. These will be sold at auction, privately, and online. Will the sales disrupt the dealer Warhol market? Cappellazzo says that Christie's will be a "good steward, the work will be sold over many years, and in many markets worldwide."

Sotheby's also exhibits up to 40 sculptures a year for private sale, from January through April at the Isleworth Country Club near Orlando, Florida, and in September and October at Chatsworth in Great Britain (the home of board member the Duke of Devonshire). The equivalent Christie's exhibition is held at Waddesdon Manor, the former Rothschild estate in Buckinghamshire, United Kingdom. These are billed as "selling exhibitions of monumental sculpture." For example, Sotheby's has exhibited a Henry Moore reclining figure and a Yue Minjun set of 25 bronze figures entitled *Contemporary Terracotta Warriors*. Most of the work presented would not show well in an indoor setting and would be impractical to move to an auction room.

It is auction house involvement in the market for primary art that most terrifies dealers. It suggests a future in which an auction house takes on the whole output of a hot artist. Jeff Koons is most often mentioned as a

possibility. Following the breakup of Gagosian and Damien Hirst, that artist also became a candidate. A branded artist might find the auction offer tempting. If his work sells as fast as he can produce it, why give the dealer 30 or 40 percent, when an auction house will charge nothing (because they forego the commission) and might produce a higher price? It is, of course, just another form of competition. Except perhaps from the perspective of a mainstream dealer, it is hard to see competition as a bad thing.

CHANGING MARKETS

ABU DHABI AND QATAR

A nation devoid of art and artists cannot have a full existence.

—Kemal Ataturk, founder of the Turkish Republic

One of the curiosities of the art market crash was the pattern of falling auction prices. The top 10 percent of contemporary art saw a modest 10 percent average drop in prices from the 2007 peak. The next 30 percent of the market was down 30 to 40 percent. The lower 50 percent of the market saw prices drop by half. The progression was counterintuitive given the pattern of price decline in previous recessions. In the post-1990 art world recession, the top of the market showed the greatest drop in value and lost the greatest number of buyers.

This time a few new museums plus wealthy Middle Eastern and Eastern European buyers replaced financial sector collectors at the top of the market. In particular, museums in Abu Dhabi, Qatar, and Dubai emerged as major buyers, along with royal families and high-end collectors in these city-states. One über dealer estimates the Abu Dhabi and Qatar museums are purchasing 300 museum-quality works a year—an average of one each business day, 52 weeks a year. They will acquire 2,000 to 3,000 works over a decade. Their modern art collections will far exceed those of much larger and more conservative Middle East cities such as Cairo, Beirut, and Tehran.

On the 10.5-square-mile (27 square kilometers) Saadiyat Island, just north of the urban center of Abu Dhabi, workers began in 2010 to build two huge art museums. A Guggenheim Abu Dhabi, designed by Frank Gehry and first budgeted at $800 million, will have 350,000 square feet (30,000 square meters). This is 11 times the floor space of the New York Guggenheim, more than double its art exhibition space, and one and a half times the

exhibition space of the Bilbao Guggenheim. The Abu Dhabi Guggenheim will show post-1965 art from the West, the Middle East, Asia, and Africa. The museum was first scheduled to open in 2012, then rescheduled for 2014. The opening is now planned for 2017.

Down the road will be a Louvre Abu Dhabi, designed by Norman Foster & Partners. This will be almost as large, 260,000 square feet (24,000 square meters), budgeted at $490 million. Scheduled to open in 2015, it will display art and cultural artifacts from antiquity to modern times. Originally it was not intended to show contemporary art, but Laurence des Cars, the curatorial director of Agence France Museums, says the museum's vision is universal, and universal incorporates contemporary.

The Guggenheim Abu Dhabi will be a spectacular structure, situated on a peninsula at the tip of the island, surrounded on three sides by water (illustrated). The Gehry design has huge cylinders, blocks, prisms, and cones, with each block intended as a theme gallery. The design for the Louvre Abu Dhabi is equally dramatic: buildings and canals enclosed in a stainless steel dome. The canals represent Venice, center of the cultural interchange that once existed between East and West. Sunlight comes through the perforated skin of the dome, inspired by "rays of sunlight passing through date palm fronds in an oasis."

Abu Dhabi is the largest of the seven emirates that make up the United Arab Emirates (UAE). The city-state sits on 9 percent of the world's proven oil reserves and 3 percent of its gas reserves. Its *Plan Abu Dhabi 2030* sets out a blueprint for development of the emirate. H. E. Mubarak Al Muhairi, managing director of Abu Dhabi's Tourism Development & Investment Company (TDIC), says "Abu Dhabi's ambition is clear—to become a world center for culture, a creative and artistic focal point positioned on the crossroads of the ancient silk trading route, where west meets east."

In 2005 an agreement was concluded between the Abu Dhabi Authority for Culture and Heritage (ADACH) and the Solomon R. Guggenheim Foundation in New York to create a Middle East version of Spain's Guggenheim Bilbao. The foundation receives payment for providing expertise and direction, and a licensing fee, the details of which have never been disclosed and apparently were not fully revealed even to the Guggenheim's board.

Two years later, ADACH concluded a contract with the French Republic. At French insistence, these details were made public. The Abu Dhabi government was to pay $525 million to use the Louvre name for 30 years.

They will pay an additional $247 million to borrow between 200 and 300 art works over a 20-year period, from the Louvre's collection and from the Centre Georges Pompidou, Musée d'Orsay, Palace of Versailles, and other French museums. A further payment, to be negotiated, allows the Louvre Abu Dhabi to share in special art exhibitions each year over 15 years. Finally, $214 million is being paid for management advice from experts from the Louvre and other museums. The total is just over a billion dollars, more than twice the cost of the physical museum.

Rita Aoun-Abdo, the Lebanese-born director of TDIC's cultural department, is the spokesperson for the museum project. She was described in *The Economist* as having "a gift for making policy-speak sound like poetry." She develops the theme that it is crucial to expand cultural opportunities for society. "Growing up in Beirut, my first exposure to an international-level museum and to great art came when my family traveled to the Louvre in Paris. In a very few years, residents of Abu Dhabi and the Gulf will have a similar opportunity here."

The acquisition process is described by Aoun-Abdo: "The collection is being built by the curatorial team according to a rigorous conceptual narrative premised on transnational contemporary art dating from 1965 to the present." The process appears to be proactive—curators decide what they need and search it out. The curatorial role is carried out by officials of the New York Guggenheim. There is a final vetting stage by an acquisitions committee comprised of curators and representatives of the Abu Dhabi government. This is apparently a long process; several dealers say they have sold work elsewhere rather than wait for a committee decision. Dealers who admit to having sold to the museum insist on anonymity and would not discuss details, even off the record.

The Guggenheim Abu Dhabi acquisition budget has been reported in *The New York Times* as $600 million. If that is to be spent pre-2017, it is probably more than the combined acquisition funds of the top 25 art museums in North America, excluding the Getty, over the same period. (In 2013 the Metropolitan Museum in New York had a $39 million acquisition budget; MoMA's budget was $32 million for the same period).

Aoun-Abdo says there is no exact number, but that their acquisitions process "will never compromise on quality." Acquisitions have proceeded with no leaks and only a few disclosures; director Richard Armstrong revealed that approximately one-sixth of the works will be Western art.

The tourism and economic expectations for the new museums are aggressive. An exhibit by TDIC at the Emirates Palace Hotel in Abu Dhabi promoted the new museums by extolling the economic success of the Guggenheim Bilbao in bringing attention and tourists to the economically depressed Basque region of Spain since the museum's opening in 1997.

The exhibit cites Bilbao as generating "9.2 million visitors between 1998 and 2006, 4,355 jobs per year and a 12.8 percent return on investment." That rate of return figure is more than a bit suspect. It assumes, among other things, that almost half of those arriving in Bilbao by air come solely or primarily to see the museum, and multiplies that number by an average visitor's spend-per-day for three days. Even if the figures were accurate, promoting the economic benefits risks masking the art-for-art's-sake argument with a monetary one.

Saadiyat (happiness in Arabic) will also include a performing arts center, a campus of New York University, and two additional museums. One is the Zayed National Museum, a national history museum named for His Highness Sheikh Zayed bin Sultan Al Nahyan, father of the nation. The second is a maritime history museum designed by celebrated Japanese architect Tadao Ando.

Dubai is 80 minutes by road from Abu Dhabi, but a very different place. It is sometimes described as a giant Hollywood sound stage disguised as a city. It is a place that manufactures superlatives. Its oil money (and current $80 billion debt) bought it the world's emptiest building (the 175-story Burj Khalifa); the largest manmade islands; the longest indoor ski slope; and some of the biggest shopping malls and most dramatic architecture anywhere.

Sheikh Mohammed bin Rashid Al Maktoum, ruler of Dubai, has announced his own universal museum project, to be built with the assistance of three German institutions: the Bavarian State Collection of Painting, the State Museum in Berlin, and the Dresden State Art Collection. The three will assist in planning and acquisitions, and will loan works. The Sheikh has also announced a Museum of Middle East Modern Art, designed by Amsterdam architect Ben van Berkel. Nothing has been announced about what will be shown in the museums, and their construction has been delayed by Dubai's economic woes. The economy has made a rapid recovery, and dealers report that acquisitions are again being made, albeit on a modest scale.

The most dramatic museum acquisition program is to be found 180 miles (300 kilometers) across the Persian Gulf from Abu Dhabi in Qatar. A little larger than Connecticut, the country is famous as the home of television network Al Jazeera (which now runs Al Jazeera America from a 700-employee headquarters in Manhattan), and for bidding successfully to stage the 2022 World Cup of football.

In three decades, powered by vast oil and natural gas reserves, the capital city Doha evolved from a trading village and pearl fishing center into a modern city. As with Abu Dhabi and Dubai, most residents are foreign workers who can never gain citizenship. Qatar has 1.4 million residents, only 240,000 of whom are citizens. Of the foreigners, 150,000 are Western professionals; most of the others are workers from India and Sri Lanka. Qatar's citizens have the highest per capita citizen income in the world: an annual GDP of $149,000 compared with the United States's $46,000.

Over the same three decades, Doha has evolved into a cultural center, from a city that businesspeople used to describe as threatening death by boredom. In 2009 it opened a Museum of Islamic Art designed by I. M. Pei, and in December 2011, a temporary home for Mathaf: Arab Museum of Modern Art, showing work from the 1840s to the present. (Mathaf is Arabic for "museum.") Mathaf is a far more sophisticated offering than first-time Western visitors anticipate. It is not a home for acquired Western art, but showcases the history of modern and contemporary Arab art. It even includes several nudes.

The Qatar Museums Authority has announced that the country will start work on as many as ten more museums over the next decade, including one focused on Western and Middle Eastern contemporary art. In the interim, it has shown a huge Murakami exhibit and one by Chinese artist Cai Guo-Qiang. Cai is best known for his fireworks art, but in Qatar he showed Arab-themed sculpture, including a stuffed camel suspended in midair.

The Museums Authority helped finance the 2012 Hirst retrospective at the Tate Modern and then brought the show to Doha, Qatar for a show beginning in October 2013. The Authority was able to mount a bigger show than had the Tate, because it could transport works too large and expensive for the Tate. How? It was given use of Qatar Emiri Air Force transport planes. The Doha show had as a centerpiece the artist's diamond skull, positioned so it faced the open jaws of one of Hirst's formaldehyde sharks. The juxtaposition was noted by almost every commentator.

Sheikha al-Mayassa Bint Hamad al-Thani is the 31-year-old daughter (and fourteenth child) of the former Emir, sister of the current Emir, and a driving force behind museum building. The Sheikha does not have a formal background in art history; she studied political science and literature at Duke University in North Carolina, then earned an MBA at Columbia. She is described by those who have met her as very well self-educated in art matters.

She cites her father's belief that "In order to have peace, we need to first respect each other's cultures . . . with the opening of Mathaf we are making Qatar the place to see, explore, and discuss the creations of Arab artists of the modern era and of our own time."

One of Sheikha al-Mayassa's advisors is Edward Dolman, who was hired from his position as chairman of Christie's. The art world believes that the Emir or his daughter would be enthusiastic bidders for that auction house if it became available. Another advisor is Roger Mandel, who was deputy director at the National Gallery in Washington and now directs the Qatari Museums Authority. Mandel says his objective and that of the Sheikha is to "reinvent museums for the twenty-first century."

The Qatar and Abu Dhabi museums differ in a fundamental way. Qatar's Mathaf is based on the personal vision of the Sheikha. Abu Dhabi's vision comes from the institutional history of the Guggenheim and Louvre.

The excitement surrounding the new museums has produced spirited collecting among the royal families and wealthy residents of the three city-states. Abu Dhabi and Qatari purchasers acquired 19 of the 30 most expensive works from Christie's 2009 Yves Saint Laurent Pierre Bergé sale in Paris.

Qatar is thought to be the destination of the Merkin Rothkos, after a $310 million court-ordered sale in New York. J. Ezra Merkin had assembled what was considered the best private collection of Rothkos in the world. Merkin was sued over his role in investing client funds in Bernard Madoff's Ponzi scheme. The story is that Russian collector Roman Abramovich entered the bidding with an amount in the high $200 millions (he later denied it); Qatar then countered with $310 million.

The Qatar Royal Family had earlier been the mystery purchaser of Mark Rothko's *White Center (Yellow, Pink and Lavender on Rose)*, sold by David Rockefeller through Sotheby's in 2007 for $72.8 million. The previous world record price for a Rothko was $22 million. The same year the family purchased a Francis Bacon at $53 million, and Damien Hirst's 2002 *Lullaby*

Spring (a mirrored cabinet containing 6,100 handcrafted, multicolored pills) for £9.7 million ($19.2 million).

Several dealers said that the Qatar purchases included Andy Warhol's *The Men in Her Life* (1962), described in the first chapter. Philippe Ségalot said at the time that it was acquired in the United States, but the buyer may have been acting as an agent.

If Abu Dhabi's annual art acquisition budget exceeds that of the top 25 US museums combined (again excluding the Getty), the Qatar annual art budget, if there is any formal limit at all, appears to exceed Abu Dhabi's.

The power of the new Qatar museums was apparent in early 2011 when the art amassed by Greek collector George Embiricos was dispersed following his death. The most important painting in his collection was Paul Cézanne's iconic 1902 *The Card Players.* Four of his card players paintings are in major museums: New York's Metropolitan, Musée d'Orsay in Paris, the Courtauld Gallery in London, and the Barnes Foundation in Philadelphia.

The reported purchaser was the Qatar Museums Authority (QMA). The widely cited selling price was $250 million, making it the most expensive work of art ever, a third more expensive than the runner-up. (Various prices have been reported for the sale; the differences relate to exchange rates and when the sale was finalized, rather than when it was announced).

Two hundred fifty million dollars is a fortune by any measure. Is *The Card Players* worth it? Probably, if one is seeking to turn a new museum into an art world destination. Every university Art History 101 survey course includes an illustration and discussion of one of the paintings in the series.

The painting might have brought more. Art-world rumor had two dealers, Larry Gagosian and William Acquavella, each making unsolicited offers to the estate of between $220 and $230 million. Qatar then bid, it is said, with the conditions of no quibbling, no seeking a counteroffer, take it or leave it. The Embiricos estate took it.

There are other recent examples of Qatari art buying. In 2009 the Qatar Museums Authority (QMA) purchased William Hoare's 1733 *Portrait of Ayuba Suleiman Diallo,* a freed Muslim slave, for £590,000 at Christie's London. The government withheld an export license so that the National Portrait Gallery could match the amount and retain the portrait in the United Kingdom.

Normally this means the buyer defers to the export license authority and relinquishes the work. Instead, QMA terminated the process by withdrawing

its export application. The portrait must remain in the United Kingdom for a requisite ten-year waiting period before the QMA can reapply. It will probably go on free loan to the National Portrait Gallery in return for their undertaking not to oppose the reapplication.

A second example involves the art collection of the late French collector Claude Berri. Prior to his death in 2009, Berri planned to donate part of his collection to the Pompidou Center under the French system of gift and succession taxes, whereby art works may be donated to the state in lieu of death taxes. The Berri donation was eight works, including a Lucio Fontana and a Dan Flavin light sculpture. The French *Le Journal des Arts* reported that Berri's two sons were then offered 50 percent above the Pompidou valuation, through dealer Philippe Ségalot representing Qatar Museums Authority. The Pompidou was unable or unwilling to match. The sons got the money, the French government got its taxes, and Qatar got the art.

New museums typically are built on the peak of a pyramid: a broad-based community of artists, art schools, writers, curators, and galleries on the bottom, and a community of collectors above them. At some point, private or government money is raised for acquisitions and a building to house them; this completes the top of the pyramid.

Abu Dhabi, Dubai, and Qatar are each constructing an upside-down pyramid. Painting has not been part of the Arab tradition, and museums are a Western invention. There is only one graduate-level art school in the region (in Abu Dhabi) and few curators, contemporary galleries, writers, artists, or collectors. The museums will come first. It may be a long, uphill struggle. In 2012 Qatar's Mathaf averaged 1,800 visitors a month, less than a hundred a day. Half of those visitors were foreigners.

CHINA IS NUMBER TWO

China, since ancient times, has held the value of art to be equal to that of philosophy—which is no small fact, given our relationship with Taoism and Confucianism. Art has a strong, multivalent tradition whether we are speaking in terms of the imperial court or of the noneducated housewife. And this is very different from art's role in the west.

—Ai Weiwei, artist

Very big, China.

—Noel Coward, playwright, *Private Lives*

Forty minutes after unpacking at my Beijing hotel and one block into a walk to stretch my legs after a long flight, I was intercepted by a mid-20s male. After the obligatory "What country are you from?" he launched into "Please, I am an artist and I have a show of my work nearby. Will you honor me by coming with me and see it?"

As you might not immediately suspect, this is a scam, one which I had been warned of. There is an exhibition, but he is not the artist; rather he is a runner on commission. The art is reported to be of good technical quality, but the show is composed of assembly-line copies of existing paintings. Similar shows with the same art are hung in other locations in the city, all priced at five (or 15?) times what similar work might bring in an artists' co-operative. This is the local equivalent of "Please come and see the beautiful carpets in my cousin's shop" in Istanbul or New Delhi. Where but in Beijing or perhaps Shanghai does the most common tourist scam center on contemporary art? "Honor me by coming" was a good introduction to the Chinese contemporary art market.

I was told later by a dealer that when accosted by such an "art student," there is a test. Ask: "Where did you study art; and who was the most famous

teacher there?" If there is no immediate answer, move on. On the rare possibility that the response is "Central Academy of Fine Arts and Xu Bing," it may be worth going with the student.

Xu is an artist and vice president of the Central Academy, one of the best art schools in the world. The Central Academy was, until a few years ago, a Party-controlled school; now it seems to have evolved into one of the more liberal art schools in China. It was Xu's students who built the iconic *Goddess of Democracy* statue, a styrofoam homage to the Statue of Liberty, erected in Tiananmen Square during the student protests of 1989. *Goddess* was crushed by a tank during the subsequent military clearing of the Square.

Beijing is the epicenter of the country's contemporary art scene, where the top artists, galleries, and auction houses come together. The best-known area is the 13-year-old 798 Dashanzi Art District, known to every taxi driver just as 7–9–8, a 30-minute ride northeast of the center. A warren of once-abandoned, brick Bauhaus-style factories and a former East German-built munitions works, the area now houses a collection of boutiques, coffee shops, and 250 galleries ranging from cutting-edge creative to production art. In the run-up to the 2008 Olympics, the Beijing municipality installed new cobblestone streets and lighting, which both beautified the area and drove up rents for the privately owned units. Must-visits include Long March Gallery, with paintings and sculptures; 798 Space, with painting, multimedia, and performance art; Beijing Commune, with both established and emerging artists; and Chinese Contemporary, which focuses on political art and realism.

Several Western galleries are represented in 798, notably Pace in a stunning 22,000-square-foot (2,200 square meter), Richard Gluckman-designed building. Pace founder Arne Glimcher describes the Beijing scene as "The most exciting artistic development I've seen since the 1960s." He said his strategy was to attract the best artists by being the major player in the city.

A 15-minute walk northeast from 798 brings you to the Caochangdi Art District, a sprawl of unpaved roads with larger galleries showing less mainstream artists. The galleries here are spread out; it is best to rent a car and driver to wait at each location. Galleries to see include F2 (by appointment only), Boers-Li, Galerie Urs Meile, Chen Ling Hui Contemporary Space, and Platform China.

Like "Honor me by coming to my show," the Chinese art market is not always what it appears. Start with auctions. There are an estimated 1,600 auction houses on the mainland, 80 percent of which are not licensed by the

government. Chinese collectors seem more comfortable dealing with auction houses, which have existed there since 1994, than with galleries, which are a newer phenomenon. Auction prices are more transparent, and bidders seem reassured by the presence of other bidders. Many artists—even those with gallery representation—prefer selling primary art at auction because the commission is much less than through a dealer, and payment is faster.

Beijing Poly Auctions is the dominant auction house in the Chinese art market. Poly Auctions peaked in 2011 with sales of $1.2 billion, then in 2012 had sales a third lower, at $800 million (reasons for this later).

Poly is a private corporations within the China Poly Group. The Poly Group is the largest public enterprise in the country, controlled by the People's Liberation Army/Navy; their other operating divisions manufacture military tanks and aircraft. Poly in Mandarin Chinese means "defending the victory." The auction company's relations with its parent are opaque. However, Poly Auctions is respected and feared by its competitors for its ability to draw on the resources of the parent group.

Poly Auctions may represent state capitalism, but it is nevertheless known for its willingness to offer deals to attract consignments. It has offered consignors advances of up to 80 percent, and buyers up to 100 percent to finance purchases. Its sister company, Poly Culture and Arts, acts as a state cultural agency. Poly Culture has its own museum and a responsibility to collect important items of Chinese heritage, some of which come through Poly auctions. The People's Liberation Army/Navy also purchases art for its own museum.

China Guardian is the number two auction house with $1.2 billion in sales. It claims to model its operations on Sotheby's. Guardian's founder and president is Wang Yunnan, the daughter of former Communist Party leader Zhao Ziyang, who was purged following the Tiananmen Square protests in 1989.

Poly and Guardian between them have about 60 percent of the Chinese mainland market for high-end contemporary art at auction. Rounding out the top four domestic houses are Beijing Council and Hanhai Art Auction, both in Beijing.

Christie's and Sotheby's suffered multiple delays in their attempts to secure government permission to hold auctions on the mainland. For years they just offered auctions from their Hong Kong locations. In September 2012 Sotheby's invested $1.2 million for an 80 percent share of a joint venture with state-owned GeHua Art. GeHua's parent company, GeHua

Cultural and Development Group, is building the Tianzhu Free Trade Zone near Beijing Airport. Sotheby's will conduct auctions and selling exhibitions within the Zone. Art will be exempt from customs duties so long as it remains within the Zone; those buying for investment will be able to store it there for later resale.

To celebrate their 2012 joint venture, Sotheby's was allowed to be the first international auction house to conduct a sale in mainland China since establishment of the People's Republic in 1949. They auctioned a single work of art, a sculpture by Wang Huaiqing, *Self and Self Shadow,* for RMB 1.4 million ($220,000) with three bidders.

Seven months later, in April 2013, and without the requirement of a joint venture, Christie's obtained a license to hold auctions in Shanghai—and, presumably, anywhere on the mainland. Christie's is able to operate with its own name and thus have gained a jump on Sotheby's in building a reputable brand in this important market. Each auction house held its first regular auction in China in the fall of 2013.

Art dealerships also operate differently in China. A few well-known artists have "exclusive" contracts with as many as three different galleries within the same city. Galleries compete for the best of the artist's work; collectors are known to visit several galleries to negotiate a lower price "for that work in the other gallery." F2 Gallery in the Caochangdi district has several artists with multiple representation. Primary gallery efforts go to promoting their work through F2's Los Angeles gallery, where there really is an exclusive.

Some well-recognized Chinese contemporary artists have representation with a foreign dealer but little domestic representation. In Western markets, Liu Xiaodong is represented by Mary Boone, Zeng Fanzhi by Acquavella, and Zhang Huan by Pace. Xu Zhen is at James Cohan, Liu Ye at Sperone Westwater, Huang Yong Ping at Gladstone, and Yang Fudong at Marian Goodman. None of these artists have representation in every major Chinese city. Some domestic sales of their new work are made at auction, in part because of lower fees but primarily because they often achieve higher-than-gallery prices (more about this later).

Chinese collectors are increasingly exposed to art through overseas travel, firsthand experience, and the Internet. Collectors are also being educated by Chinese television networks CCTV and Phoenix, which produce programs on art and auctions. Collecting art has become acceptable with shifting social attitudes toward the open display of wealth.

There is a slowly growing mainland segment of buyers for high-end Western art, primarily from collectors in Shanghai and Beijing. Most Western art is purchased at auctions in Hong Kong. Almost half the value of this art involves Picasso, Warhol, Koons, and Murakami. In May 2010 a Hong Kong buyer reenergized the art market with the record $106.5 million purchase of Picasso's 1932 *Nude, Green Leaves and Bust*. In 2007 Hong Kong billionaire Joseph Lau set a $72 million auction record for Andy Warhol with his purchase of *Green Car Crash*.

The Chinese contemporary art most sought after in the West is from the decade following 1985, perhaps reflecting the belief that the greatest art comes from periods of great change. For a long time the most popular was the "art of the wounded," which examined the damage done by the Cultural Revolution, and "cynical realism," which reflects the collision of capitalism with communism. However, Cultural Revolution art has become ubiquitous. Most valued is high-impact contemporary art that has wall power in the same way as a Warhol, Hirst, or Rothko. Derivative works, of which there are many, and those mimicking Western contemporary art have not sold well.

As in the West, there is considerable status to be attached to the purchase of high-end art. The Chinese collector is involved in a social as well as an economic transaction. He announces his position by his ability to pay a record price. Art dealer Andrew Kahane says, "Chinese buyers want to be seen spending a lot of money, they want to be seen setting world records." Some Chinese supercollectors present themselves as repatriating works of cultural and historical value from Western owners. Collectors may announce they are spending for the good of the nation as a way of achieving cultural status.

Most sales take place in mainland auction houses. A Chinese collector selling (but not buying) through a foreign auction house is open to criticism for unpatriotic activity. If that individual also has dealings with the government, it could affect his standing.

Artists seem comfortable dealing with almost any social or political topics, although work that explicitly criticizes party leaders or national symbols is widely understood as forbidden. The 798 Arts District of Beijing has what is referred to as the "management office," one of its functions being to monitor and remove art that might be detrimental to the public good.

The market for Chinese art saw four years of strong price appreciation before a sharp price correction following the shock of the 2007–2008 Western economic crisis. The decline lasted 15 months before confidence

returned and prices bounced back. During the downturn, major auction houses and dealerships survived but about 20 percent of all galleries disappeared. In the 798 district, many dealers converted to coffee shops or fashion outlets, then reemerged as galleries in 2010. By early 2011 market prices were close to pre-2008 levels.

Confirmation of the recovery came with the sale of 104 lots from the famed Ullens Collection at Sotheby's in Hong Kong in April 2011. Baron Guy Ullens is the son of a Belgian diplomat; his wealth came from the food industry. In 1984 Ullens and his wife Myriam began to collect Chinese contemporary art in depth. They assembled what was probably one of the two best private collections, what Sotheby's called "a visualization of the Chinese nation's [recent] history . . . museum worthy in its quality and breadth." The Ullens auction totaled $48.7 million, three times the preauction estimate of $16 million. Chinese media reported that just over half the buyers were Chinese; the others were from the West, Japan, Malaya, Indonesia, and Thailand.

The star lot was Zhang Xiaogang's triptych *Forever Lasting Love* (1988) which brought $10 million, triple its estimate and more than six times the $1.4 million it had brought at Christie's Hong Kong in 2007. The day after the Ullens sale, Sotheby's Hong Kong offered another Zhang, this time from the *Bloodline: Big Family* series (similar work illustrated). The *Bloodline* series is based on morose family portraits taken during the Cultural Revolution. This version brought $6.4 million, the artist's second best result at auction. As recently as 2006 (and before the crash), Zhang's *Comrade No. 120,* another *Bloodline* picture, sold at Sotheby's Contemporary Art Asia sale in New York for $979,000, and that was the auction's highest price.

In 2007 an *Artprice* survey concluded that China had taken over third place in the world art market, displacing France and trailing the United Kingdom and the United States. In March 2011, a British Art Market Federation study concluded that China had overtaken the United Kingdom to become the world's second largest market. In May 2011 *Artprice* announced that China had risen to number one, accounting for 33 percent of global fine art sales, with the United States at 30 percent, the United Kingdom at 19 percent, and France at 5 percent.

Is China really now number one, or is this another of those "not what it seems" factoids? The *Artprice* calculation was limited to fine art sales at public auctions, rejecting gallery and private dealer sales figures as opaque

(which they certainly are). In the West, gallery and private dealer sales total more than those at auction.

More than 50 percent of Chinese auction sales are primary, paint-still-wet art that in the West would be sold through dealers. In smaller auction houses the figure may be 80 to 90 percent. Some auction houses do not delete from sales records works that go unsold (in some cases 50 percent of those offered), or are not paid for, or are determined to be fake.

Prices achieved are also suspect because of practices that would be viewed in the West as questionable. Some auction houses have accepted a primary work on consignment only when the artist agrees to produce a bidder. The bidder and artist agree in advance on a purchase price. The bidder goes as high as necessary to win, and the artist refunds to the buyer the amount above the agreed price.

A dealer may bring buyers to the auction to bid up the price and establish a world record price for his artist. The buyer gets a refund. Collectors visiting the gallery can then be offered a huge discount from the auction-record price. I was told an alternative arrangement was "Buy one at auction, get one or two free from the dealer."

In 2010 Chinese independent curator Zhu Qi said on National Public Radio that during the 2008–2009 art price correction period in China, as many as 80 percent of the transactions reported were "fake or pumped up." In September 2012, *Legal Daily*, the publication of the Committee of China's Political and Legislative Affairs, reported that Beijing would crack down on the "three fakes" in the art market: fake works, fake sales, and fake auctions, all of which damage China's reputation on the international art market.

Some verifiable price increases do rival anything seen in the West. Dealers relate the story of a 1993 painting by Yue Minjun, famous for his portraits of broadly grinning men. Yue's 1993 *Gweong Gweong* (illustrated), a painting of the 1989 Tiananmen Square crackdown featuring smiling bombs dropping on the Beijing landmark, sold at Christie's Hong Kong in 2008 for an artist record of HK$54.1 million ($6.9 million). It was originally sold by a Hong Kong dealer in 1994 for $5,000, and was resold at auction in November 2005 for HK$4.9 million ($636,000).

A few of the prices achieved for Chinese art are breathtaking. Chinese artists took 33 of the top 100 auction prices in 2011 for living contemporary artists. Four of the top ten artists in 2011 in terms of total yearly sales at auction were Chinese: Qui Baishi (second, behind Picasso and ahead of Warhol);

Zhang Daqian (fourth, ahead of Giacommeti); Xu Beihong (sixth, ahead of Matisse); and Fu Baoshi (ninth, ahead of Lichtenstein). The Qui Baishi rank may be overstated; it includes an ink painting sale at auction for $65.4 million which was reported but is now generally believed not to have finalized.

The record for a Chinese contemporary work sold at auction was set in October 2013 at Sotheby's Hong Kong, with the hammer falling at $23 million for Zeng Fanzhi's *The Last Supper* (2011). This is a reworking of the Leonardo painting, where the apostles wear communist Young Pioneer uniforms and expressionless masks. The work was purchased by Qatar.

So where *does* China rank in the art world? Certainly third, ahead of France. If we include sales in Hong Kong, the third most important auction city after New York and London, China is probably second. It is still a long way from first.

Given how fast Chinese contemporary art prices have risen, what is the chance of a sudden price correction? The demand for Chinese contemporary is still thin. At the very top of the market, a few mainland supercollectors are said to be responsible for half of the most expensive contemporary works at auction over a three-year period. These include Yu Mingfang of Belle International Holdings; Liu Yiqian with wife Wang Wei, who are opening their own Dragon Museum in the Pudong District of Shanghai; Li Guochang of China Forestry Holdings and his wife Su Yan, who founded the Wall Art Museum; and automobile dealer Yan Bin and his wife Yan Qing, who also own Aye Gallery. If these or other major collectors decide that Chinese contemporary art no longer is the best way to accomplish the job-to-be-done, or if they simply find a new passion, will others come forward to fill the gap?

The Western market for Chinese contemporary is also thin. Much Chinese art appears interesting but "strange" to Western eyes; it does not have the universal appeal of work by Richter, Warhol, or Koons. Will a broad range of work by Chinese artists find its way into the artistic heritage of Western countries? Will major Western museums give it permanent display space?

Several major Chinese banks, including China Minsheng Bank, China Construction Bank, and China Merchants Bank, are promoting art investment funds. Their purchases represent a higher percentage of the Chinese contemporary market than is true of art funds in any Western country. A run of redemptions would risk forced sale of a lot of art.

On the optimistic side, increasing individual wealth suggests the art market has the support to remain buoyant. In 2010 China became the

second largest economy in the world, behind the United States. The *Hurun Report,* the Chinese equivalent of *Forbes,* says there are almost a million millionaires in China and 115 billionaires, second again to the United States. Of course, if earlier collector behavior is repeated, the new wealth may initially be used to bid up and acquire Chinese traditional art or Western modern and impressionist rather than Chinese contemporary.

The Chinese economy itself may be a bubble at risk of deflating. Consider just one statistic. There are reported to be 62 million completed but unsold condominiums in the country, with that number set to increase in each of the next four years. Economist Nouriel Roubini, famous for correctly predicting the 2007–2008 Western economic crisis, now predicts that the Chinese economy may implode and warns investors in any Chinese assets to cash out now.

Government initiatives can either puff up or depress the art market in short order. An encouraging move was the 2011 declaration from the National People's Congress that a goal for the next five years is a "Happy China"—interpreted to mean that more government money will be available for public housing, museums, sports, and the arts. China planned to erect a hundred new museums a year for ten years, and new money would help assure this infrastructure and the resulting demand for art.

Then in March 2012, German citizen Nils Jennrich and his Chinese colleague Lydia Chu, employees of art shipping company Integrated Fine Art Solutions, were arrested in Beijing for allegedly undervaluing art imports to the mainland and evading customs duties (as high as 34 percent on art imports). Several leading collectors were also detained. Some commentators thought there was a possible political motivation behind the arrests because Integrated Fine Art handled shipping for Ai Weiwei's art.

The Chinese government demanded that Christie's and Sotheby's provide lists of bidders, purchasers, and selling prices from their Hong Kong sales. The auction houses claimed to have provided prices but not client lists.

A Beijing dealer reported his clients as saying, "It's just not the time to be buying art." In the next round of auctions in both Beijing and Hong Kong, sales totals were down by almost half from the previous year. Reported contemporary art sales by both Poly Auctions and China Guardian were down a third for 2012, compared to 2011, and down a further 50 percent in the first three months of 2013. Poly and China Guardian suddenly found themselves responding to the same sales deterioration that Christie's and Sotheby's went through in 2008–2009.

Reports of shrinking sales, however, are hard to interpret. In 2012 the Chinese government started monitoring individual auction sale reports to check that purchasers were paying taxes, making it much less likely that phantom sales would be reported.

My favorite Chinese art story concerns that country's attitude toward fakes, and involves superstar contemporary artist Zhang Daqian. In 1967 Zhang was visiting the University of Michigan art gallery for an exhibition of work by the seventeenth-century Chinese painter Shitao. As he passed through the exhibition, Zhang pointed to several of the works, saying, "I painted that, and I painted that."

Was he serious? Zhang had certainly painted many Shitao-style works in the past. To copy Shitao's work was not forgery, it was a way to pay homage. To be considered as good as the master was a huge compliment. Was Zhang serious in claiming attribution? Some at the Michigan art gallery think he was.

A s you stroll the 798 Art District, you come upon an example of the subtle line between political and nonpolitical expression. Several years ago, in response to a wave of Warhol-like images of Mao being produced, the culture ministry put out the word that artists should avoid using the former Chairman's head in their work. One response was a headless Mao sculpture located at the north end of 798 (illustrated).

Rather than denouncing the work and removing it, as gallerists in 798 anticipated, the arts ministry purchased another of the edition for the national collection. The press release explained that the headless body symbolized that the government represents all of its citizens equally.

The questionable nature of many reported statistics should not detract from the incredible contemporary art market that has developed in China. The technical quality and artistic innovation rivals that of any other country. It is both amazing and vaguely unnerving how much vibrancy and diversity flourishes in a society that so closely monitors other aspects of cultural expression.

THE ESTELLA COLLECTION

The Chinese learned the game of [art] speculation from Westerners, who played it first.

—Gong Jisui, professor, Central Academy
of Fine Arts, Beijing

Sometimes even Sotheby's does not follow the rules.

—Zhao Xu, consultant, Poly Auction, Beijing

On April 2, 2008, an auction at the Hong Kong Convention Center had 400 people in a packed Sotheby's salesroom for part one of what the auction company billed as *The Estella Collection*. Sotheby's promotional material described *Estella* as "The largest and most important collection of Chinese contemporary art to appear [to that date] at auction."

Estella was a huge success. The auction brought HK$139 million (US$18 million), far exceeding the preauction estimate of HK$66 million. Of 108 lots offered, 55 sold above their high estimate, 36 within the estimate range, and 7 below the low estimate. The sell-through rate was 91 percent: 10 lots remained unsold or were withdrawn before the auction.

The highlight of the sale and of the collection was Zhang Xiaogang's oil on canvas *Bloodline: The Big Family Number 3* (1995) (similar work illustrated). It was estimated at HK$30 to $36 million (US$2.5 to $3 million) and sold for HK$47 million (US$6 million), the highest auction price to that date for a contemporary Chinese work. The painting depicts a family of three during the Cultural Revolution, when children were sometimes required to denounce their parents.

Other important paintings in the auction included Zeng Fanzhi's *Chairman Mao With Us* (2005), which sold for HK$8.2 million (US$1.1 million); Cai Guo-Qiang's *Two Wandering Tigers* (2005), a signature gunpowder-on-paper

work that brought HK$7.6 million (US$973,000); and Xu Bing's *The Living Word* (2001), depicting Chinese characters rising from the printed page and soaring away as birds, which also brought HK$7.6 million.

The *Estella* sale signaled a dramatic upswing in the popularity of Chinese contemporary art. In the previous three years, no Chinese contemporary work had sold at auction for over $1 million. In the 18 months following *Estella*, 85 Chinese works sold at that level. The twists and turns of the process leading to the auction, and the identity of those involved in creating it and bringing it to market, provide a great case history of the muddled boundaries between collecting, speculating, and investing in the world of contemporary art.

The Estella Collection was assembled by dealer Michael Goedhuis. He is Dutch, and he operates the Goedhuis Contemporary gallery in London and New York, with an office in Beijing. His gallery represents 38 Chinese contemporary artists, including Gu Wenda, Jun Fang, and Wang Dongling.

Between 2004 and early 2007, Goedhuis purchased 200 works of contemporary art at auction and from dealers and private studios in China. Goedhuis worked on a fee basis, representing a group of investors. The purchases included painting, sculpture, works on paper, video installations, and photography. Much of the subject matter related to political and social tensions in China's transformation from a communist to a capitalist economy.

From March to August 2007, about half the objects assembled by Goedhuis were included in an exhibition called *Made in China: The Estella Collection,* held at the Louisiana Museum of Modern Art in Humlebaek, Denmark. The collection was then shown at the Israel Museum in Jerusalem from September 2007 to March 2008.

Goedhuis was the assembler. Who, then, is Estella? She is the love interest of protagonist Pip Pirrip in Charles Dickens's novel *Great Expectations.* Estella had no connection with collecting. Dickens used Estella's life story to make the point that happiness is unrelated to social position. Goedhuis said he chose a name that would be easily pronounced by a Chinese collector.

Prior to opening the Denmark show, the Louisiana Museum published a monumental show catalog, *China Onward: The Estella Collection— Chinese Contemporary Art, 1966–2006.* It is 450 oversized pages, 13 × 10 inches (29 × 22 cm), weighing in at 8 pounds (3.6 kg), with full-page images

and scholarly essays. It was the most important document to that date on Chinese contemporary art and artists.

A controversy arose just after the Israel Museum show, when Sotheby's announced its intention to auction a major part of the Estella collection in Hong Kong the following spring, and the remainder in New York in October. Goedhuis said that neither museum curator knew of the pending auction until after the exhibits had closed.

Anders Kold, curator of the Louisiana Museum, said the museum would not have agreed to host the exhibition had he known of the sale. He added that collection owners who used a museum exhibition to add value to work while intending to sell it raised ethical questions for themselves, for the museum, and for the auction house. James Snyder, director of the Israel Museum, agreed with Kold that there were ethical issues, but added, more pragmatically, "We had been looking for an opportunity to show some new Chinese art to our local public; *Estella* seemed to us to comprise the strongest and most visually powerful such collection available."

Some of the artists and dealers who sold work to Goedhuis claimed they would never have offered price discounts had they known the work would be resold. Artists Feng Zhengjie and He San were the most vocal, claiming they had been led to believe their work would be part of a large, permanent collection and the exposure offered by the collection would benefit their careers. He San said, "Many artists, including me, were convinced by Goedhuis and gave him our best works, some at a relatively cheap price. Then it turned out to be an auction. We feel sold out by him."

Goedhuis said that *Estella* was conceived in 2005, from an interest in contemporary Chinese culture that he shared with one of his investing partners. "We noticed with frustration that there was no reliable publication on the subject of contemporary art. So it was decided to build a collection that could form the basis of just such a book. At the same time we decided to assemble the best possible group that would have a claim to international stature . . . the central idea was to form a great collection that would remain intact." Goedhuis emphasized that at no time did he have an ownership stake in the collection.

In August 2007, "when it was time to sell," Goedhuis said he offered the collection through New York dealer William Acquavella, to Las Vegas-based hotel executive Steve Wynn to display in his new $1.2 billion Wynn Macau

Casino and Resort. Goedhuis said Wynn decided not to buy, so it was offered to François Pinault to be shown in Venice. Pinault offered to purchase only two-thirds of the collection, and the sellers declined. The Acquavella gallery then acquired the entire collection.

Acquavella negotiated the sale to Sotheby's of what was reported as half of their interest in the collection, with the understanding that it would be offered at auction. Goedhuis said he only learned well after the sale to Acquavella, that the dealer had partnered with Sotheby's and the collection was to be offered at auction. Acquavella director Michael Findlay said, "I think this whole thing is surrounded by so much rumor and speculation . . . we bought a group of paintings and we sold a group of paintings, and that's the whole story."

This was not the first time Acquavella had partnered with Sotheby's on an art investment. In 1990 the two formed a joint venture company, Acquavella Modern Art, to purchase 2,300 works from the Pierre Matisse Gallery after the death of its founder. The art was sold off over a five-year period, privately and through Sotheby's and other auction houses. The work sold for a total reported as more than double the $143 million purchase price.

Acquavella was reported to have paid very close to $25 million for Estella. Subsequent sales of the 100 art works remaining after the Hong Kong auction had to net an additional $12 million for Acquavella and Sotheby's to cover expenses and interest costs, and at least break even on the transaction.

If the promise to artists and dealers was of a major museum exhibition and catalog followed by possible donation to an institution, it is important to note that two of the three occurred. The artists and the works shown acquired the provenance of a major museum catalog, two museum shows, sale at a prestigious Sotheby's evening auction, and a lavish auction catalog. The artists and art could now be promoted as "museum quality." Artists and dealers providing work may have received no portion of the increased value of the work in *Estella,* but the high prices later achieved for the artists involved would almost certainly have not occurred except for the collection, and certainly not as early as 2008.

Maarten ten Holder, then managing director for North and South America at Sotheby's, said the firm received inquiries before the sale from several artists in the collection, asking why the works were to be auctioned. There was disagreement about whether Goedhuis had simply promised artists that inclusion in the collection would enhance their reputation and

selling price. Yue Minjun, who had two works in the sale, said no promises were made. Ten Holder pointed out that Goedhuis bought Zeng Fanzhi's *Chairman Mao with Us* from Hanart T Z Gallery in 2005 for the asking price of $30,000, with no discount requested or given. *Chairman Mao* sold for $1.18 million.

Not all the Chinese artists who sold to Goedhuis at a discount were concerned. Painter Yan Lei, sculptor Sui Jianguo and painter Zhang Huan, expressed to *Art + Auction* a very Western, capitalist sentiment: "They are businesses; they can buy or sell any way they think is right." Chinese artists and dealers selling to Goedhuis were aware they could have protected themselves by asking for a "no-resale" agreement. Apparently no one did. In the absence of such a document, it is assumed a purchaser is free to dispose of a work as they desire.

Estella should not be interpreted as implying that Chinese artists or dealers are naïve or unfamiliar with Western art world practices. New York dealer Jack Tilton, who has worked with Chinese artists since 1999, comments: "All of these artists are hoping that their work finds good homes rather than getting churned in the commercial market. But they have also played a part in this market, embracing capitalism more than we have, in funny ways. They are not naïve about any of this stuff."

As it turned out, there was no "Estella Auction Sale–Part Two." Some of the works were included at Sotheby's contemporary Asian sale in September 2008; others were offered privately. William Acquavella said of the transaction, "I don't think [the venture] is going to be an enormous success, but I think we'll make some money on it."

The immediate profit in the *Estella* saga was made by the investors, not by Acquavella and Sotheby's. During the three-year period Goedhuis was assembling the *Estella* collection, prices for Chinese contemporary art increased about 350 percent—and more than that for the top ten artists in the collection. It is reasonable to assume that two-thirds of the consortium's selling price was profit.

What about the role of the museums? Museums become part of "price premium creation through branding and validation" every time they borrow and show art. Both the Copenhagen and Israel museums indicated they were pleased with the publicity, ticket sales, and attendance that came with showing *Estella*. There is no question that many other museums of equal or greater status would have responded positively to the opportunity.

Indeed, if either museum had thought there might be an ethical concern with their exhibition, it could also have asked Goedhuis for a five- or ten-year "no subsequent sale" agreement. If either had, and whether such a clause was enforceable or not, that museum might have found itself excluded from consideration for *Estella*, and less able to obtain art needed to assemble a balanced show in the future.

What do we learn from this tale? There are many more ways of creating art interest and an art market than we are familiar with on a regular basis. There are ethical uncertainties but no well-defined rules. The boundaries between collecting, marketing, and investing are blurred, perhaps especially so in an emerging art market such as China.

THE MARKET AS MEDIUM

ART FAIRS

Art Basel Miami has evolved from a simple art trade fair into an almost-obligatory pre-Christmas stopover on the fall flyway of the wealthy.

—Guy Trebay, art writer

It's like taking a cow on a guided tour of the slaughterhouse. You know this sort of thing goes on, but you don't want to see it.

—Chuck Close, artist, on artists attending art fairs

Art fairs are industry trade shows where dealers come together for several days to showcase themselves and a small group of artists. Fairs gained popularity as art dealers lost ground in their three-decade battle with the branding, resources, and private dealing of Christie's and Sotheby's. Dealers found a niche with fairs where the work offered compared in quality and quantity to that offered by an auction house over an entire selling season.

Some dealers now record 70 percent of their annual sales at fairs. These have proved so successful that many dealers are shifting their business model away from the physical limitation of local galleries. Dealer status has now become a major consideration in gaining good booth locations—or in being invited to good fairs at all.

Art Basel Miami Beach, known to all who attend as "Miami Basel," is the most spectacular art fair in the world, the prime example of how the relationship between art and money has simultaneously become glamorous and intellectually numbing. Miami Basel is a combination of art viewing, celebrity spotting, beach parties, sipping a $20 glass of Ruinart Champagne served from coffee carts, and other forms of really conspicuous consumption. Art journalists call it the all-singing, all-dancing art fair.

Held the first week of December, Miami Basel in 2012 attracted 51,000 visitors. Of these, 5,000 sported some level of VIP passes from the fair's

sponsors. Fewer than 2,000 who attended purchased a work of art. Most attendees simply serve to reinforce the glamour and importance of the event. Visitors came from 80 countries. Of those, which country's collectors were the most active purchasers, proportional to their numbers? Every dealer offered the same answer: Brazil.

In 2012, 265 galleries exhibited 1,800 artists, with a total "asking price" of $2.5 billion. The four days of Miami Basel also featured 16 satellite fairs, outdoor exhibits, performances on the beach, and showings of private collections.

Marc Spiegler, director of the fair, says that on opening night "virtually all [of the galleries] have a dinner or cocktail reception." The parties get much more media publicity than the art. One of the most coveted invitations is the pre-opening affair put on by Spiegler and held at a secret location (which everyone seems to know is the W South Beach Hotel). In 2011, 1,100 people received invitations and 1,600 attended. The party featured performance artist Maria José Arjona, wearing a dress made of candy. The garment shrank as guests nibbled on it during the evening.

A coveted 2011 invitation was to the party cohosted by the Russian edition of *Interview* magazine (owned by Peter Brant), Tobias Meyer, and automaker Ferrari. Held in a private 30,000-square-foot home on Indian Creek Island, the twin attractions were a video work by artist Marco Brambilla and a 2012 Ferrari 458 Spider, base price $280,000. On the 650-person list for the invitation-only event were Michael Douglas and Catherine Zeta-Jones, Paris Hilton, Diana Picasso (Pablo's great-granddaughter), and Larry Gagosian. Estimates of actual attendance ranged from 900 to 1,500.

A slightly less serious art party held around the pool of the Mondrian South Beach Hotel that year was hosted by MoMA affiliate P.S.1 Contemporary Art Center. The theme was a Kim Kardashian look-alike contest, with 26 contestants on stage with spray-on tans and bandage dresses. Each "Kim" offered her scripted arguments as to why she should not have to return her $3 million engagement ring to estranged husband Kris Humphries after a marriage that lasted 72 days. The real (the audience thought) Kim Kardashian laughed and applauded in the front row.

In 2012, New York Yankee third baseman Alex Rodriguez hosted a dinner to view additions to his art collection. Featured was an installation by British artist Nick Relph consisting of four automobile tires intended to be

part of an invisible car parked in a batting cage. Rodriguez also showed works by John Currin and Andy Warhol.

Miami Basel is the art world's best example of art market as medium. In a promotion at an earlier fair, artist Joseph Beuys got into a cage with a live (but recently fed) coyote. In the most publicized promotion, burlesque star Dita von Teese took the stage at a dealer-sponsored party, stripped to a G-string and pink pasties, then rode a giant lipstick that bucked like a mechanical bull. An example of the cross-platform marketing found at the Miami fair, Ms. Von Teese's performance art was sponsored by MAC cosmetics: "Lipstick is sexy!"

Miami Basel is the only fair to feature an art category called—I'm not kidding—"Self-loathing neon art." In 2007 collectors raced in at the opening to view Merlin Carpenter's *Die Collector Scum*. Artist Dan Attoe offered a work that spelled out *We're all here because we were too afraid to deal with problems in our real lives*. Peter Liversidge offered *Miami Beach is where neon goes to die*. All three sold.

In 2012 L&M Arts offered a huge Barbara Kruger two-word work, GREEDY *SCHMUCK,* which one critic reviewed as reinforcing that a fair is about collectors, not artists. The Kruger also sold; the collector asked to remain anonymous.

Art Basel Miami accepts 265 exhibitors from 800 applicants. There is an absolute limit of 300. MCH Swiss Exhibitions, the fair owner, says they will forgo revenue from additional exhibitors in order to limit the event to top international galleries. MCH estimates the fair's dealer sales as high as $350 to $600 million. This is an informed guess; dealers are not required to report. Bloomberg estimates sales at $200 to $400 million. Some sales are made before the fair, from the catalog or from dealer emails, some are not finalized until months later, for example if they have to be approved by a museum board.

The satellite fairs—with names like Pulse, Flow, Aqua, Nada, and Scope—feature young artists, digital and video art, and photography and design. They are situated in warehouses and boutique hotels, and in a converted gym called World Class Boxing. They accommodate some of the hundreds of galleries unable to gain entry to Miami Basel. Many dealers come to the satellite fairs not just to sell, but to be able to return home and tell artists and collectors, "We showed at Miami."

In 2012, 150 museums and other organizations organized trips to the fair for trustees and patrons. MoMA, the Guggenheim, the Whitney, the Tate Modern, the Reina Sofia, and São Paulo's MoMA all sent curator-accompanied groups in the hope that some purchased works would eventually be donated.

The principal sponsor, Swiss bank UBS, ranks the fair equal in cross-marketing importance to the America's Cup yacht race. Miami Basel is said to be the only UBS sponsorship event that does not have to be reapproved by the USB board each year. At the opening of Miami Basel, VVIPs invited by UBS and other sponsors gain entry first, then VIPs, and finally those who paid for their tickets. In the overheated art market up to 2007, half of the most important works were sold in the first hour of the VVIP preview, and half of those in the first 15 minutes. Buyers raced from booth to booth, committing to a purchase or asking for a hold, with the dealer responding, "Ten minutes only; give me your mobile number." In part this arose from the collector ethos that one has to return from a major fair with at least one trophy in hand. According to *The Economist,* collector and museum donor Jay Smith says this is related to the sociability of a fair. "Buying makes you feel connected to what is going on. When I don't buy anything, the fair feels dull."

If you are obligated to buy something, there is great regret involved in missing out on your first choice. One über dealer says it comes from a combination of the herd mentality of "When in doubt, do what others are doing," and the mental heuristic (and Veblen rule) that quality and satisfaction equate to the most expensive.

In the recession years of 2008 and 2009, collectors behaved less impulsively. Few deals were done in the first hour; prospective buyers put works on one- or two-day holds, promising a decision after viewing other works. In 2011 and 2012 the front-ended sales rush returned.

Acquiring art at a fair can be a competitive sport. At Miami Basel, dealers with trophy works fronting their booth compile a list of interested collectors to whom they have offered holds. The winner is the collector whose personal brand will bestow the most prestige on the artist and the gallery. The unsuccessful are told, "A museum has reserved the piece."

Art world wisdom says that a non-VVIP should never consider bidding for a trophy work at a fair. There is now an almost universal dealer practice of sending JPEG images of works to their best clients in advance. Some works are presold, others put on hold. However early you arrive at a booth, you may

be told a work is "no longer available." It has already been reserved for more important collectors, or has been borrowed to front the booth, or it is hugely overpriced, or has an undisclosed subtle defect.

Some collectors always want to acquire works that other collectors want, according to New York dealer Andrew Kreps, who offers this great line to *The Economist*: "'Thou shalt not covet thy neighbor's wife' is the commandment that most confuses collectors."

In addition to Miami Basel, there are four other contemporary art fairs whose branding is such that they add provenance and value to art presented there: Art Basel, Art Basel Hong Kong, Frieze (in London), and Frieze New York. These are to art what Cannes, Toronto, and Sundance are to film festivals. They attract über dealers who come because the fairs draw UHNW (ultrahigh net worth) collectors. The collectors come because branded dealers bring their best work. It is what economists call a virtuous circle or network effect; it produces a self-perpetuating oligopoly among a few fairs. These four plus Art Basel Miami attract an overlapping set of dealers, art advisors, curators, and museum directors.

An equally distinguished fair to these five is TEFAF, held in Holland each March by the European Fine Art Foundation and known by its location, Maastricht. However, in 2013, only 46 of 260 galleries at Maastricht featured contemporary art. In past years Gagosian, Hauser & Wirth, L&M, and Michael Werner have stopped attending TEFAF, lowering its standing in contemporary art. Maastricht's distinction remains with historical art, fine arts, furniture, silver, and porcelain.

Below these über fairs are 25 "important-to-see" fairs mostly populated by mainstream dealers. The important-to-sees recognize the distinction. Their niche is collectors with a sweet-spot up to $100,000. Below those are 300 fairs that focus on art in the $5,000 to $50,000 range. These feature mainstream or lower galleries showing local artists or works that have spent a long time in a dealer's storeroom.

The art fair season runs year round. Mixed in are art biennials and hotel fairs. At the peak of the informal Art Week in New York City in March 2013, there were seven competing art fairs with 640 galleries. The epidemic of fairs produces the malady of "fair fatigue" among both dealers and artists.

Fairs offer a culture change in the process of acquiring art. Quiet evaluation in a gallery setting is replaced with an experience more like shopping in a high-end mall. These art malls also feature über anchor tenants, boutique

dealers, and a food court, albeit one featuring Petrossian Ossetra caviar. The art mall is recognized by all as a bad physical environment, "the best example of seeing art in the worst way." Crowded booths are not conducive to prolonged evaluation. The display is random, with little sense of curatorial involvement. The lighting is excessive to satisfy legal liability concerns. But with each fair and each purchase, collectors seem to become more accepting of seeing art in this setting.

Collectors are attracted to fairs because they combine socializing and convenience. Many of the UHNW individuals beloved by dealers are time-poor. With fairs they can consolidate search and purchase, networking, and partying in a single location. Fairs also offer the promise of comparison shopping. A single dealer might with some difficulty assemble three Gerhard Richter paintings to show a client. Dealers at Miami Basel or Frieze may collectively offer 12.

Fairs offer a different purchase process than an auction showroom or a gallery in yet another way. The absence of competing buyers in a gallery produces a very different climate than the now-or-never immediacy of an auction. Walking through an über fair with hundreds of art works in line-of-sight offers a perception of abundance, but the mobbed VVIP opening creates immediacy, the concern that "I had better commit now."

The number of "sold" stickers found in booths alleviates collector uncertainty that estimates are reasonable, in the same way that lots selling over estimate and the presence of underbidders reassure the successful bidder at auction. When a buyer does not have sufficient information to make a reasoned decision, reassurance comes from the behavior of others.

Collector uncertainty at a top-five fair is also reduced by knowledge that dealers, and sometimes the art to be shown, are vetted in advance—at Miami Basel by a committee composed of seven dealers, curators, and academics. Galleries present their best work for inspection. Five to 10 percent of galleries are dropped each year, usually for not bringing work of consistently high quality. Vetting adds value in the same way as expert appraisal and acceptance by a major auction house. However, the most important consideration when vetting contemporary art at a fair is often neither quality, nor scarcity, nor value; it is the status of the gallery.

Sometimes the criteria are less subtle. In 2005 Miami gallery owner Bernice Steinbaum held a press conference to complain that she was rejected by Miami Basel selectors for wearing bedroom slippers while greeting guests

at her booth the previous year. Steinbaum sought revenge in handing out slippers stamped with her gallery name to patrons entering that year's edition of the fair.

The parent of Miami Basel is Art Basel, a fair held each June in that medieval city on the Rhine. Many dealers view Art Basel as the world's leading contemporary art fair. In 2013, 530 galleries from 40 countries competed for 300 booths at Art Basel, and 60,000 people attended.

The art on offer is more understated than that at Miami Basel. There is more of a mood of conservatism; parties, but no coyotes, no candy dresses, and no reported Kardashian sightings. The most prized invitation is to dinner at the Foundation Beyeler, Basel's museum of twentieth-century art.

In 2012 the fair cut back the hours available to the general public and allocated the entire first day to VIPs. However, not all VIPs were equal. VVIPs who flashed coveted shiny black passes were allowed to enter at 11 a.m. Ordinary VIPs carrying purple passes—many of whom had not previously understood that they were ordinary—were not allowed in until 3 p.m. The problem, said Marc Spiegler, was overcrowding, not for the public, but for the VVIPs. Dealers thought the separation led to postponed decision-making and removed the excitement of "immediate purchase highs."

The third must-attend fair is Frieze, held in London each October, with a reputation just below the first two. Begun in 2003, it was created by Matthew Slotover and Amanda Sharp, founders of the art magazine of the same name. In 2012, 330 galleries from 38 countries applied for 155 booths.

Frieze London has a pricing sweet-spot a bit below Miami Basel or Art Basel, and shows fewer very expensive works. Most sales are in the £50,000 to £100,000 ($77,500 to $150,000) range. The fair shows smaller works and more intellectually interesting ones, with a few that would be at home in Miami. In 2009 New York's Gavin Brown Enterprises devoted its whole booth to Argentine artist Rirkrit Tiravanija; his canvases at the fair were covered in newspapers with the legend THE DAYS OF THIS SOCIETY IS NUMBERED in large colored letters. One sold in the first five minutes of the VVIP opening.

Like Art Basel, Frieze maintains the divide between insiders and outsiders. Favored collectors and agents enter early, eat and drink free in sponsored VIP lounges, and hear dealers whisper, "For you, my friend, a special discount." VOPs wearing sneakers queue two hours on opening day, and drink £15 white wine from plastic glasses. If they manage to corner a dealer and ask about prices, they may simply be told that the work is "not available."

Number four on the must-attend list is Frieze New York, an offspring of the London show, first offered in June 2012 in an enormous $1.5 million custom tent on Randall's Island in the East River. Frieze New York makes the list because of its parent, because it is held in the world's art capital, and because it attracts über dealers. It offers an impressive range of curatorial and marketing resources and can bundle dealer invitations with its London event.

Prior to Frieze New York, there was no über fair in the Manhattan area. There was the Armory Show, whose origins date back to 1913 when it showed Marcel Duchamp's then-scandalous *Nude Descending a Staircase*, but Armory has lost major dealers in recent years. There was also The Art Show, an offspring of the Art Dealers' Association of America held at the same time as Armory. The Art Show focuses on lower value art and on categories other than contemporary.

The first edition of Frieze New York produced a truly strange art fair story. Before the fair, Swiss artist Christoph Buchel (who shows with Hauser & Wirth) toured Manhattan searching for homeless people, offering to purchase their shopping carts filled with personal belongings. The average accepted offer was said to be about $425. Buchel then installed the carts around the fair. Offering them to collectors as sculptures, the listed purchase prices were $35,000 to $50,000, depending on the contents of the cart. Reportedly, two sold. Fair art can on occasion be emotionally as well as intellectually numbing.

Number five is the Hong Kong fair, founded in 2008. Hong Kong is the world's third largest auction market after New York and London. One of the fair's attractions is Hong Kong's lack of an import or export tax on art. In 2011 MCH, the parent company of Art Basel, became a controlling shareholder in the Hong Kong fair. For its May 2013 offering, the fair was renamed Art Basel Hong Kong, and featured 245 galleries from 35 countries and a 50–50 split between Western and Asian dealers. The fair shifted from its original date in February, when it conflicted with the Chinese Lunar New Year. The new date comes two weeks after Frieze New York, awkward timing for collectors, and financially and artistically awful for midrange galleries scrambling to meet the requirement of showing their best works at each fair.

MCH now produces three of the five major art fairs, on three continents in three time zones, with the same important lead sponsors (including UBS,

which in 2014 replaces Deutsche Bank in Hong Kong). Dealers who want to be invited to Miami Basel or Art Basel might want to express enthusiasm about attending all three, even if it means skipping Frieze New York.

While artists seek international exposure and prestige, some are ambivalent about being shown at even these five. Artist careers used to be divided into discrete periods of development, each with a different series of work. But with multiple fairs, there is pressure to continue to produce what has previously sold, what was well received at the last fair: "Art fair art." Artists weigh that against the opportunities that come from discovery by foreign collectors and galleries, the press coverage, and the cash.

The five fairs contribute to an artist's worth beyond producing sales. Artist careers progress through a process that the art world calls validation and the business world knows as brand equity. The hurdles for an artist are to find representation with a mainstream dealer, then to gain international exposure, with the dealer taking work first to local fairs, then to more major ones. In the next step, art is "placed" with respected international collectors, and then donated (or sold) to a major museum. The artist may move up to representation by an über gallery somewhere in this process. Being shown at major fairs and to an international audience is the second most important part of the process.

In some circumstances, a commercial art fair serves as a culture platform for a city, to the point that it attracts government subsidies. In 2007 the Art Paris fair, in conjunction with the Emirate of Abu Dhabi, launched Abu Dhabi Art. The fair was to be a showplace for modern and contemporary art, part of the plan to establish the capital of the United Arab Emirates as the art capital of the Middle East, and ultimately a cultural destination alongside London and New York.

In 2008, in the midst of the global financial meltdown, the Abu Dhabi fair had such poor attendance and sales that the French partner withdrew. The Abu Dhabi Tourism Investment Company and the Abu Dhabi Authority for Culture and Heritage (ADACH) declared that the fair was a cultural platform "too important to be allowed to fail" and stepped in to provide financing for the 2009 edition.

When dealer interest seemed to waver, ADACH offered inducements to several branded galleries to take part. White Cube, L&M Arts, Gagosian, and Acquavella were mentioned as recipients. It was said that dealers agreed to bring museum quality art to Abu Dhabi in return for at least one assured

sale to the ADACH or to the ruling al-Nahyan family. ADACH denied there were direct subsidies, but it did make purchases. Total costs to subsidize the fair, including purchase premiums, were probably in the $15 million range. The fair is the only one in the world that is not front-loaded, with most sales made at the VVIP preview. Most sales at Abu Dhabi are made in the last few hours; there is one major buyer who can't be rushed.

The 2012 Abu Dhabi event featured 50 galleries from 18 countries—still far from being major but large enough to maintain art world attention. ADACH said the fair will in the future come to be considered one of the majors, and they will subsidize it at the same level for a decade to assure that happens. With Abu Dhabi, as with Miami Basel, the market becomes the medium.

THE END GAME
CLICK ON A WARHOL

I've dated on line, got an apartment on line, found a pet on line. To not look at art on line would be terribly provincial.

—Benjamin Godsill, The New Museum, New York City

So the dentist in Des Moines can deal with his patients while continuing to pursue his passion for contemporary art, that is the beauty of this.

—James Cohan, New York art dealer and founder, VIP Art Fair

Two questions spurred my initial interest in the peculiar economics of contemporary art. Who determines which artists rise to the peak of the art pyramid? And by what alchemy is a work of contemporary art—by a living artist who is still producing—worth $10 million rather than $100,000? A third question surfaces in each discussion with a dealer or auction specialist; where is the contemporary art market going?

The answer to the third is still open, although all trends are unfavorable to brick-and-mortar, mainstream dealers. One of the uncertainties centers on the sale of high-end contemporary art online, at much lower transaction costs than through dealers or art fairs. Online marketing seems a logical step in making art available to a global audience that already uses the Internet to buy jewelry, electronics, and books, and to bank. However, early experiments have had mixed results. One of the earliest involved Donna Rose, a Beverly Hills dealer who offered blurred art images and brief descriptions on her website in 1995 but abandoned the experiment after a few months.

Sotheby's invested tens of millions in its online art business around 2000, first partnering with Amazon, then with eBay, then going it alone. There was

considerable initial enthusiasm. President Diana Brooks said, "The art world has become too intimidating . . . we want our site to be a friendly place to the potentially millions of people who've never bought art before."

Sotheby's formed partnerships with 5,000 "internet associates," dealers who offered works for sale over Sotheby's.com, with the auction company taking a commission. Until 2012 Sotheby's held the online auction price record, for an original copy of the Declaration of Independence sold to sitcom producer Norman Lear in 2000 for $8.1 million. It was an online transaction only in format. Lara Bergthold, acting as agent for Lear, flew from Los Angeles to New York to see the document. Distrusting the web connection, she entered Lear's winning bid from Sotheby's office.

Brooks's "friendly place" turned out not to be enough. Sotheby's incurred high continuing costs trying to reassure concerns about authenticity and merit. In 2003 they folded the associates project, with $80 million in accumulated losses.

Apparently after a lot of internal debate, Christie's chose not to try to improve on the Sotheby's experiment. It was 2012 when Christie's got rolling under new chief executive Stephen Murphy, who brought a more technological focus to his role. Christie's offered seven online-only auctions in 2012 and 50 in 2013. Sotheby's was to that date still reluctant to commit to online-only auctions.

In the 1990s, eBay.com tried to offer more expensive art at auction with "Great Collections." That flopped; the company reverted to regular online auctions and "buy it now." It now offers 65,000 art works at any given time, almost all at low prices.

The saatchionline.com art website is by far the most successful at offering art online at modest prices. It has a reported 800 sales a day, 80 percent of those under $1,000. At that price level there are few issues of authenticity or historical merit.

1stdibs.com offers online design and art. Artspace.com and Artnet.com also have some success with lower-priced art. Artnet.com achieved some fame for selling Andy Warhol's *Flowers* (1978) for $1.3 million in 2011, but that is an image familiar to every serious collector, and the work had been authenticated by the Warhol Authentication Board.

Heritage Auctions in Dallas has held successful online auctions since 1995, also with lower-priced fine and decorative arts. There are a hundred other dealer and private Internet sale sites; the perception is that many of

these use the Internet to unload works that did not sell at exhibitions or in a gallery.

Christie's now has a "private sales online gallery," offering art in the $250,000 to $1 million range, aimed at a younger demographic than frequents their regular auctions. Sotheby's has no similar operation but says they intend to start one.

Both Sotheby's and Christie's have online platforms to accept bids on their regular auctions. Sotheby's is BIDnow, Christie's is ChristiesLIVE. LIVE produced $350 million in sales in 2012, including an Edward Hopper painting that in November became the most expensive art work sold online when it brought $9.6 million. The most common LIVE price point is around $10,000, with most sales under $50,000.

The Gagosian Gallery regularly sells million-dollar works from JPEGs on their private website, but that is more related to the Gagosian brand and the reputation of its artists than to the medium. For years there has been speculation that major fairs would create parallel, online art markets, most likely starting with Art Basel. It has not yet happened.

As the technical obstacles to selling art works online were overcome, the social and cultural obstacles remained. Some surfaced with the introduction of the most interesting online experiment to date, the VIP Art Fair. With the contemporary art world offering several über fairs and hundreds of minor ones, was there any market niche for a full-scale online art fair not affiliated with one of the majors? Or for a fair physically located in a second-floor loft in the greengrocer district of New York City?

VIP is an acronym for (surprise, chuckle) *Viewing in Private*. The online fair opened in January 2011 for an eight-day run. Many heavyweights of the art world thought it offered promise; the founding galleries included Gagosian, White Cube, David Zwirner, Gallery Toyanagi in Tokyo, and Hauser & Wirth in New York. Each dealer had good reason to ignore an online venture that threatened to disrupt their own business model. Instead, they embraced the new model, wanting to be in on the ground floor of something that might prove transformational in the way high-end art is offered.

The inaugural VIP fair had 138 invited galleries from 30 countries, including branded Western galleries. The inviters were James and Jane Cohan, art dealers with galleries in both New York and Shanghai. They created the virtual fair idea with Internet entrepreneurs Jonas and Alessandra Almgren.

The artists shown at VIP included Pollock, Richter, Bacon, Basquiat, Murakami, and Hirst, along with promising newcomers.

Four reasons were offered to galleries in soliciting their participation: Collectors from Brussels to Singapore to Dubai are not always able to travel to fairs or are daunted by the mob scenes, but don't want to miss out. Dealers in art centers need to reach new collectors in China, Russia, and the Middle East. Dealers in more isolated art centers such as Buenos Aires need to extend their reach, without the high costs of booths in conventional art fairs around the world. Finally, collectors comfortable enough to buy art online from dealer JPEGs would do so at an art fair, so long as a trusted dealer provided assurances of the work's authenticity and condition.

The Cohans also argued that less-expensive art would appeal to new tech-savvy buyers from around the world who were comfortable with Facebook and Amazon, and could extend that familiarity to embrace contemporary art on the web.

The 2011 VIP offered three distinct "exhibition halls": a *Premier* hall for established international artists; a *Focus* hall with 23 galleries, each offering up to 8 works by a single artist; and an *Emerging Artist* section with 24 galleries. Cost to dealers was a tenth that of renting a conventional art fair booth and transporting paintings and people. VIP charged $3,000 to $20,000 for a virtual booth, equivalent to, as James Cohan described it, "at the high-end, the cost of four ads in an art publication."

Gagosian showed a cross-section of work, including a 2.8-meter-high (107 inch), 1,400-kilo (3,080 pound) Franz West aluminum sculpture that was too big and unwieldy to take to any conventional fair. Apparently it did not sell. The most expensive work was a large Basquiat canvas listed by Zurich Galerie Bruno Bischofberger at $5 million. This also did not sell.

VIP tried to mimic online a traditional art fair, absent champagne lounges and air kisses. Visitors signed up and entered an atrium, with a map showing the location of participating galleries. From there, they wandered, or clicked and went directly to a gallery or a particular artist. Each booth had art works on virtual walls. There was a virtual human beside each exhibit to provide a sense of scale. Visitors could zoom in and see texture, brushstrokes, and detail of the work, or view it from different angles—all impossible on gallery websites or with auction catalogs.

Basic VIP admission was free. If the guest was referred by a participating dealer or paid a $100 fee, she got access to a second-level digital space

with videos, additional information on the artist (in multiple languages), and a price range for each art work. The latter was a first. No über dealer had ever published price information before, either at the gallery or at a fair.

The guest could connect to dealers through an integrated chat or messaging system or via Skype or telephone. Dealers discussed the works and provided access to their in-gallery inventory on the visitor's computer screen, just like a dealer taking out his iPad to show works not in the fair booth. Collectors and dealers interacted in real time as though they were sitting in the same room. There was no "click-to-buy" button; purchases were made through the dealer, not through the VIP site.

VIP tried to replicate some of the interaction and social excitement characteristic of a conventional fair. The visitor browsed dealer booths, created a favorite art list that became a guided tour and could be emailed to friends. "Favorites" was also a tool used by art advisors and curators to send their patrons on tours.

For the first VIP fair, there were 2,250 artists, 2,600 works in virtual booths, and 6,000 more in dealer private rooms. There was a wide range of prices: 100 works were offered under $5,000 and 50 over $1 million. Some dealers just replicated their brick-and-mortar offerings. New York's Washburn Gallery was in the midst of a show of work by Jackson Pollock; VIP allowed the show to be seen by a worldwide audience. Tehran-based LTMH gallery offered work by 12 Iranian artists, each piece created especially for the fair.

When VIP opened, art journalists posed the obvious question: Would anyone buy art in their pajamas and over morning coffee? Would they spend significant money for art they had not experienced in person? Would they care that every time they signed in on a VIP setting and looked at a work, the gallery captured their email address?

The more challenging issue was whether a fair could both offer exclusivity for clients of branded galleries and at the same time be welcoming to browsers. VIP lacked Miami Basel elbowing and Darwinian competition between Wall Street and Hollywood types. There were no condescending looks from dealers, no need to wear Prada, no art schmoozing—but also, no interaction with other collectors.

A final concern was that VIP did not carry the cachet of a branded fair. No one would brag to friends "I bought this at VIP" the way they would say

"at Miami Basel." Maybe branding of the dealer or artist—"I bought this from Zwirner"—would be enough.

Online selling also focused on the art rather than the back story: Unless the buyer was very familiar with the artist, the period, or the work, or used the chat-with-dealer feature, there was no back story.

The initial response to VIP suggested the idea really might be transformational. Registrants signed in from 126 countries, including Namibia, Ghana, and Afghanistan. Fifteen minutes after the opening, traffic was so great that the site temporarily crashed. In spite of this, the first 24 hours saw 2.2 million views from 126 countries. On the second day, the site shut for 30 minutes for repairs and a software upgrade. The delays produced snarky reviews: Artinfo called VIP an "Art-Market 'Ishtar.'" One dealer said the initials stood for "Very Inactive Page."

VIP produced sales, but at a level far below expectations. The most expensive confirmed transaction was Rudolf Stingel's 2002 *Die Birne,* sold at $800,000 by London's Sadie Coles HQ. David Zwirner sold a bronze Chris Ofili sculpture *Mary Magdalene (Infinity)* for $375,000 in the first hour of the fair and then sold nothing else. A Zwirner associate said they anticipated selling $2 to $4 million.

Most reported sales were under $50,000, with a few in the $50,000 to $250,000 range. One estimate was that 75 percent of sales were to collectors who were not on the dealer's "free VIP lounge" list, so had probably never before purchased from a major dealer or at an art fair.

VIP did produce a lot of browsing. Eight days saw 7.7 million page views, about 500 per day per image, or 60,000 per average dealer over the 8 days of the fair. The average number of passersby who stop and browse a dealer booth during Miami Basel is about 8,000. However, the median time per page view was under 10 seconds, suggesting lots of mouse clicking.

The statistics were not surprising given that most visitors came because the barriers to doing so were so low. Most did not pay to get in, a perk that no serious art fair has ever offered. They did not have to travel or even get dressed.

Some dealers nevertheless found the statistics impressive. Toronto dealer Jane Corkin concluded: "This is really twenty-first century. VIP won't soon replace the top four art fairs, but about 200 of the secondary fairs should watch their backs." All dealers were left to decide whether to continue to take part based on follow-on visits and sales rather than sales at the fair.

January 2012 saw VIP Art Fair 2.0, with 115 galleries, down 25 percent from the first year. Gagosian, Zwirner, White Cube, and Hauser & Wirth returned. VIP received $1 million in venture financing from Brazilian investor Selmo Nissenbaum and Australian Philip Keir at the end of the fair. The founders promptly announced three more online fairs: photography, works on paper, and vernissage for secondary market works.

It was not to be. In September 2012 the Cohans announced that VIP and the others were canceled; dealers apparently no longer found the concept compelling. David Zwirner took part in both online fairs and said of the second, "It was a waste of time for us this year. We had no significant traffic in the booth, nor did we meet new collectors."

The fairs were replaced by VIP Art, an ongoing art sales portal. Dealers present a rotating selection of art works that parallel their gallery program.

It is not clear whether the VIP fair experience will encourage or discourage future online efforts. VIP achieved great geographic reach and offered very low transaction costs. But the accepted model for breakthrough e-commerce companies is that they see sales at least triple from year one to year two. This did not happen with VIP and has not happened with any digital entrant to the art sector. Art market analyst Sergey Skaterschikov sums it up: "I am not sure anyone has cracked the model yet."

In August 2013 Amazon made the decision to diversify into Internet art marketing. It partnered with 180 galleries to offer 45,000 artworks by 4,500 artists online. Prices range from $10 to $4.85 million for Norman Rockwell's *Willie Gillis, Package from Home* (1941): 95 percent of the works are priced under $10,000. Galleries (most of them little known) list up to 4,000 works each. Amazon charges commissions of 20 percent up to $100, decreasing to 5 percent over $5,000.

Amazon.com is the most popular online retailer in the world and the eighth most popular website. Amazon brings to Internet art a user-friendly interface, plus its long experience in marketing a vast range of products. Amazon does not guarantee works, but does offer a 30-day money-back guarantee, no questions asked.

Most intriguing is that Amazon sees no need to justify its art offerings from a financial standpoint; it may be enough that they draw visitors to the website. It will be a while before Amazon's experiment can be evaluated in terms of sales and price levels. The most common industry guess is that

Amazon online art will sell well, at a price range about the same as saatchi online.com.

If VIP seemed transformational when compared to conventional art fairs, what could happen online to directly complement (or substitute for?) the roles performed by branded art dealers? One attempt is Artsy (www .artsy.com), a site designed to appeal to the same tech-savvy generation targeted by VIP.

Artsy was developed by then 24-year-old Princeton computer engineer Carter Cleveland, to help collectors find contemporary and modern art online based on their art preferences (color, size, style, period, and artist), and their previous purchase history. Artsy is based on the Art Genome, similar in concept to one used by the music genome site Pandora. This is a music recommendation service where users enter a song or artist they like and the service plays songs similar in terms of instrumental groups, rhythm syncopation, key tonality, and other traits. Users provide like-dislike feedback on each song, and Pandora updates their preferences before making subsequent recommendations. Apply the Pandora idea to art, and you get Artsy. Up to 800 descriptive labels called "genes" are assigned to each artwork. Based on a user's browsing activity, Artsy recommends paintings and other art with many of the same genes.

The company offers the example of someone who admires a Warhol *Flower* painting would be shown other flowers from the same series, plus works by Lichtenstein and others who did flowers in the same style or period. There are still fun glitches in this matching process. Tell the service you like Christian Marclay's *The Clock* (which is a 24-hour cinematic experience), and Artsy delivers a mix of artists and art styles, the commonality being that all paintings include a clock.

Artsy attracted a distinguished set of investors and advisors. They included Pandora CEO Joe Kennedy; former Google CEO and executive chairman Eric Schmidt; Russian collector and gallerist Dasha Zhukova; Twitter cofounder Jack Dorsey; Larry Gagosian; Wendi Deng Murdoch, then-wife of the CEO of News Corp; and venture capitalist Peter Thiel. As of mid-2012, the company had attracted $7 million in early-stage financing.

Artsy's chief operating officer Sebastian Cwilich (formerly of Christie's and the Haunch of Venison gallery) said 130 galleries had signed on, including Pace, Acquavella, and David Zwirner. The galleries do not pay a subscription fee, but rather pay Artsy a sales commission for referrals—15

percent of the first $10,000 profit (after deductions of the artist's share plus direct selling costs) plus 10 percent on anything above $10,000. Artsy has also partnered with the Armory Show in New York to show selected works.

At first it looked as though its commission model would provide Artsy with a price index of the private market, conflicting with the obsessive privacy of major galleries as to sales and customer identity. In practice, the Artsy commission structure is an honor system; they rely on the gallery making honest disclosure. The gallery never reveals what painting sold, or to whom, or at what price. Artsy gets an aggregate profit "number" and a commission check.

This has been compared to the commission that art advisors receive for introductions, but it is quite different. The advisor has a continuing relationship with the client and knows what they have preferred and purchased in the past. Artsy knows only the email identity of those who used their software.

Will Artsy work? Dennis Scholl, a Miami contemporary art collector, has been quoted as saying: "How can [a computer model] tell you exactly how their head works when they look for art? You collect via your subconscious, and it's hard to write an algorithm for that." Then, he continued, "The funny thing is, I use Pandora all the time."

But music is not a status consumable, and it has no physical presence. Another comparison is that Artsy is like shopping for designer clothes online. You focus on the look of the fabric and flow rather than how the clothes might feel on your body. David Zwirner comments that "the emotional quality around the Internet is nonexistent—there is cold, cold energy in the art."

Some dealers think that, if only because of the lack of authentication, the most optimistic comfort price for online art the buyer has not previously seen is $100,000. Others argue it is closer to $50,000 or even $25,000. Even at the lower figure, that still covers half or more of the sales made by mainstream galleries. At the top figure, it overlaps 95 percent of those sales.

In thinking of these innovations, one could ask: "Could *Stephanie* have been sold online or been sold for the price it was?" Almost certainly the answer is no. Limitations go beyond actually seeing and experiencing the work. At the highest levels, contemporary art auctions and über dealers produce astonishing prices through a mix of brand, event, celebrity, and back story. No online experience has yet replicated this or provided an adequate substitute.

POSTSCRIPT AND REFERENCES

POSTSCRIPT

The material in this book comes from my own experiences in the contemporary art world, from personal interviews, and from secondary sources. Some of the anecdotal material and some estimates are single-source. Often when I tried to confirm a story by a dealer or auction specialist, other sources would agree that it "sounded right." This may just mean the version they heard originated with the same source as mine. Art world tales get embellished in retelling; material confirmed by multiple sources may nevertheless prove to be an art world urban legend. Was *Stephanie* actually modeled on a trophy gazelle? Did Qatar pay more or less than $250 million for Cézanne's *The Card Players?* Treat anecdotal material in the book as legend that closely mirrors art world reality. I hope that any errors do not compromise the central themes. Corrections and clarifications for subsequent editions are invited.

The best example of limited-source material is the chapter on Larry Gagosian. Some of that information comes from secondary sources, some from former gallery specialists, some from clients who were unwilling to talk until I agreed to prick my finger and sign a blood oath of anonymity. I have talked to Gagosian once, in London, for about nine minutes, mostly eliciting one-word answers to totally banal questions ("Is that painting actually for sale?")

It is said that over more than a decade, Gagosian has given only two formal interviews to anyone profiling him. One is a "Lunch with Jackie Wullschlager" interview published in London's *Financial Times* in October 2010, during which he admitted to liking a good beer and a good ball game, and noted that the art world is becoming globalized. The second is an interview with Peter Brant, one of his oldest and best clients, for Brant's magazine *Interview* in 2012. He spoke of his friendship with dealer Leo Castelli and

artist Cy Twombly, and mentioned that he once owned a boa constrictor and attempted to buy an anaconda but found the reptile too scary.

A disclaimer: It is a journalistic maxim that the writer should never be part of the story. I am not a journalist, just an economist and contemporary art lover trying to make sense of some features of art markets. The artists, collectors, dealers, and auctions I write about have been chosen by me to illustrate those features. In a few cases I have been part of the story. In other cases the subject of a story has been invited to read a draft and has offered factual suggestions or additions.

The book contains representative illustrations of contemporary art, to provide the reader with a better sense of what these works are like. The set is not as complete as I would have liked; there were some images I could not use because of cost, others because the artist's representative asked for editorial approval of the text or for conditions that I or the publisher could not meet. In particular this explains the absence of images I would have liked to include, for example, the work of Jacob Kassay. Work by Kassay and other artists mentioned can be viewed on Google Images.

This book is not footnoted because it is intended as a journey through the world of contemporary art, not as an academic reference. Following this postscript is a list of Internet sites and background reading specific to each chapter.

Some material in the book has previously appeared in different form, in my articles for *The Art Economist, The Times* (London), *Harper's Art* (China), *Think, Canvas Daily* (Dubai), and the *National Post* (Canada). Some of the material on art fairs earlier appeared in a chapter in *Fairs, Festivals and Competitive Events: Negotiating Values in the Creative Industries,* edited by Brian Moeran and Jesper Strandgaard Pedersen (Cambridge University Press, 2010).

I have had extensive input from active and former dealers and auction house specialists. Each tried to answer my questions, and many showed me documents and introduced me to new sources. Many asked not to be quoted directly, others not to be identified by name or position. This meant that I have had to refrain from retelling some of the best stories as the source would be too readily apparent. Each contributor added to the depth and originality of my writing. I use "originality" as did American Laurence J. Peter, father of The Peter Principle: Originality is the art of remembering what you hear while forgetting where you heard it.

Many of those I talked with, for this book and my earlier one, did not ask for anonymity. They are, in alphabetical order and again with my thanks: Rita Aoun-Abdo, TDIC, Abu Dhabi; Richard Armstrong, Guggenheim Museum and Foundation; Oliver Barker, Sotheby's; Heinz Berggruen, collector and former dealer and critic (who passed away in February 2007); Isabelle de La Bruyere, Christie's; Charlotte Burns, *The Art Newspaper;* Carol Chehab, Agial Art Gallery, Beirut; James and Jane Cohan, James Cohan Gallery; Stephane Cosman Connery, formerly Sotheby's, now with Connery Pissarro Seydoux; Gerard Faggionato, Faggionato Fine Arts; Rami Farook, Traffic Gallery, Dubai; Michael Findlay, Acquavella Gallery; Christiane Fischer, AXA Art Insurance; Lucy Fryns, F2 Gallery, Beijing; Larry Gagosian, Gagosian Galleries; Bruce Helander, artist and former editor of *The Art Economist;* Michael Goedhuis, Michael Goedhuis Gallery; Philip Hoffman, The Fine Art Fund Group; Robert Hughes, art critic and historian (who passed away in August 2012); Thomas Krens, consultant, formerly Guggenheim Museum and Foundation; Dominique Lévy, art dealer, New York; Shasha Liu, F2 Gallery, Beijing; Tim Marlow, White Cube, London; Aaron Milrad, collector and art lawyer, Toronto; Takashi Murakami, artist; Pilar Ordovas, Ordovas Gallery, London; Rochelle Ohrstrom, artist and author, New York; Beatrice Panerai, art writer, Classeditori (Milan); Richard Polsky, private dealer, Sausalito, California; Simon de Pury, formerly with Phillips de Pury; Philippe Ségalot, art advisor; Emilio Steinberger, Haunch of Venison, New York; David Schick, Stifel Nicolaus (Baltimore); Matthew Teitelbaum, Art Gallery of Ontario; and Franz West, sculptor (who passed away in July 2012).

As this book was underway, word came of the death of one of the great dealers of the twentieth century. Giuseppe Nahmad (1932–2012), known as Jo, was the patriarch of the Nahmad clan, which included his brothers David (mentioned in the chapter on *The Scream*), Ezra, and two nephews, both named Helly (for Hillel). The extended Nahmad clan are reputed to be responsible for 5 percent of all sales at New York's evening art auctions and to bid (or be prepared to bid) on a quarter to a third of all lots offered. Jo was known for his vast inventory of art, for selling at the top of a market swing, and for buying to support the market during downturns. He and the extended Nahmad family were active participants in auction houses' irrevocable bid arrangements during the 2008–2009 period when most others withdrew from the market.

His intent was profit; his impact was to moderate market swings. No dealer in the postwar period has had a greater impact on the art market than the Nahmads. I regret never having had the opportunity to meet him.

My great debt in the preparation of this book is to my partner Kirsten Ward, for her support in the trials and frustrations of the writing enterprise. Kirsten is a wonderful editor and helpful critic. Thanks also to my editor Celia Hayley in London, who unerringly identifies the organizational flaws in the "finished" manuscripts I send her, to John Pearce and Lien de Nil, my literary agents at WCA in Toronto for their patience and support, and to Karen Wolny, my editor at Palgrave Macmillan for the English-language versions of this book, and Donna Cherry and Roberta Melville for their many suggestions on the manuscript.

REFERENCES

Since the publication of *The $12 Million Stuffed Shark* in 2008, there has been a wave of new online sources of information about the contemporary art market. A good example is Skate's Art Market Research (www.skatepress.com), which offers information on artists by nationality and repeat sales, and provides economic indicators for the overall art market. Skate's provides information on publicly traded companies in the art industry for investors who want exposure to the art market without the need to purchase art works. They also offer an art valuation service used by buyers, sellers, insurers, and lenders for their own (or other's) art collections, and to value the guarantees offered to third parties for auction consignments.

The continued development of online sales databases like *Artnet* and *Artprice* has greatly improved the transparency of art market transactions for collectors. *Artnet*, based in New York, has a widely referenced archive of auction prices. *Artprice,* its French rival, has a subscription database covering auction sales transactions. Each reports only auction prices, with dealer and private dealing prices remaining opaque. Historically, participants in the art market had uneven access to information. Now it is possible for a collector to research the artist's record online and come to the market almost as well equipped as a dealer.

While a database provides a first point of reference, it does not tell the collector what it is like to experience a work. Does a quoted price reflect past sales or has it been pulled out of the air? Michael Findlay says, "I can show someone a painting and tell him I'm asking $2 million, and they can call me back in five minutes saying that is outrageous because an Internet site says there is a similar painting that sold at Christie's for $1 million." Findlay says he reminds them that there are other things to consider: the period in the artist's output, the condition, and the overall impression of the work. Some dealers grumble that online price transparency makes their job harder, but in the long term, it would seem that the market as a whole benefits from widely available information.

There are ways to engage with technology in the art market that would not have been dreamed of even 15 years ago. During an attic clean-out in Surrey, England, in 2010, the homeowner found two paintings, both badly in need of cleaning. He was about to throw them away; instead, during a tea break, he downloaded Christie's app on his iPhone and checked out the artist whom he identified by a faded signature on the back of one of the canvases. The owner then sent digital photos to a Christie's expert, who confirmed the artist as Australian William Blamire Young, known primarily for his water colors. The paintings were sold as a pair at Christie's South Kensington for £50,000 ($77,000).

Some of the interesting writers on art markets, all worth following, are, in alphabetical order: Georgina Adam, Charlotte Burns, and Melanie Gerlis, all of the *Art Newspaper* (Adam also writes for *Financial Times*); Kelly Crow of *The Wall Street Journal*; Sarah Douglas of the *New York Observer*; David Galenson, a University of Chicago economics professor whose books are creative and insightful; Katya Kazakina of *Bloomberg* (US); Armelle Mavoisin of *Le Journal Des Arts,* France; Souren Melikian, a columnist for *Art & Auction Magazine* and art editor of the *International Herald Tribune;* Jerry Saltz, art critic for New York's *Village Voice;* Kelly Devine Thomas of *ARTnews;* Judd Tully of *Art & Auction;* and Graham Bowley and Carol Vogel of *The New York Times.* Many of these are also freelance writers.

ART PUBLICATION WEBSITES WITH ART MARKET COVERAGE

art-and-auction.com The home of *Art + Auction* magazine, with market information, news stories, reviews, and auction sales reports.

artforum.com A contemporary art journal with articles, art world news, and critical reviews.

artinamericamagazine.com The home of *Art in America* magazine, which covers artist information, columns, and news.

bloomberg.com/luxury/art The arts branch of *Bloomberg News* that provides art market coverage.

theartnewspaper.com The home of the *Art Newspaper* that reports on art issues and events, and provides updates on auction house sales and major exhibitions.

artnews.com *ARTnews* magazine, which claims to be the world's most read art magazine, includes features, art market news, gallery openings, and related topics.

frieze.com This is a leading UK and European magazine for art features, columns, and reviews; published by the organizer of the Frieze London and Frieze New York art fairs.

ART MARKET INFORMATION AND DATABASES

artfacts.net Information on artists, exhibitions, and galleries.

artnet.com A price database, online auction site, analytics site, and art-world calendar.

artprice.com Art market information from 4,500 auction houses worldwide, including a price database by artist back to 1997, survey results, artist biographies, and a great many images, for a yearly fee that begins at $130 (€99) per year.

artfact.com Allows you to browse and bid on hundreds of auctions around the world.

artinfo.com The Blouin Art info news site.

artmarketresearch.com A subscription site with data on art prices over time, on both nominal and inflation-adjusted bases.

chubbcollectors.com Articles relating to art, collecting, and insurance.

groveart.com A subscription-based site with information on the visual arts, including a number of Oxford University Press art data sources.

meimosesfineartindex.com Home of the family of Mei/Moses art indexes, with comparisons of the financial performance of the art market compared to other assets.

metmuseum.org/research/metpublications A resource from the Metropolitan Museum in New York that lets you search publications online by title, keyword, publication type, or theme.

pestcontrol.com, banksy.co.uk, and picturesonwalls.com are websites associated with the artist Banksy.

skatespress.com and skatesartinvestment.com Skate's Art Market Research offers research supporting art investment decisions.

ART SELLING WEBSITES

artshare.com Focuses on contemporary and modern Asian art, with curated exhibitions monthly; prices start at $10,000.

artprice.com Mentioned earlier under databases, Artprice also offers online auctions for a 5-9 percent fee with a third-party online escrow service, and free classified ads to sell art, design, and antiques.

artspace.com A selling site for primarily middle-market priced art.

artsy.com Suggests possible purchases from member galleries, with 25,000 art works by 3,700 artists.

artviatic.com Art Viatic posts an online art catalog and allows buyers and sellers to negotiate prices directly, without intermediaries.

auctionata.com An online art auction site in German.

theauctionroom.com An online auction site for middle-market paintings and collectibles; bids are placed online for 48 hours, followed by a 40-second, online, real-time auction among top early bidders; items on view preauction in a London showroom.

blutulip.com Focuses on backroom art that dealers have been unable to sell; membership fee.

curatorseye.com A selling site for art and collectibles; 70 dealers and 2,200 items listed.

eBay.com Up to 65,000 art auction listings at any one time, most works by little-known artists at very low starting prices.

eyestorm.com An online publisher and retailer of limited edition contemporary art.

Paddle8.com A virtual auction house that conducts online auctions from dealers and collectors as well as benefit auctions.

saatchionline.com The world's best site for buying and selling modestly priced primary art online.

saffronart.com An online auction house for Indian art and collectibles.

spotlist.com An online art auction site for works under $100,000.

AUCTION HOUSE WEBSITES

bonhams.com Bonham's auction house home page.

christies.com Christie's auction house home page.

icollector.com A single site that allows bidding on auction house offerings from around the world.

english.cguardian.com China Guardian auction house home page.

ha.com Heritage Auctions home page for one of the most successful of the online sales auctioneers.

phillips.com Phillips (formerly Phillips de Pury) home page.

polypm.com.cn/english Poly auctions (China) home page.

sothebys.com Sotheby's auction house home page.

tajan.com Tajan auction house home page.

MUSEUMS AND ART FAIRS

artbasel.com Website for the Art Basel, Art Basel Miami Beach, and Art Basel Hong Kong art fairs.

friezelondon.com Website for the Frieze London art fair.

friezenewyork.com Website for the Frieze New York art fair.

metmuseum.org Website for the Metropolitan Museum of Art, New York.

moca.org Website for the Museum of Contemporary Art, Los Angeles.

moma.com Website of the Museum of Modern Art, New York.
tate.org.uk Website of the four Tate museums in the United Kingdom.
TEFAF.com Website of the TEFAF Maastricht fair.
warhol.org Website of the Andy Warhol Museum in Pittsburgh.

ART IMAGES

artres.com Art Resource is probably the world's largest fine art stock photo archive, with more than 600,000 searchable fine art images, most from museums. It licenses reproductions.

ART INVESTMENT FUNDS

anthea-art.com The Anthea Fund, based in Zurich and registered in Luxembourg, is an eight-year, closed-end fund that buys and holds contemporary art.
artemundiglobalfund.com The Artemundi Global Fund, based in the Cayman Islands, is a five-year closed-end art fund, with acquisitions from old masters to contemporary.
artfunds.com Tel-Aviv-based Art Partners have two funds, a five-year term and a ten-year term.
braziliangoldenart.com.br Brazilian Golden Art focuses on blue-chip Brazilian contemporary works; website in Portuguese only.
thecollectorsfund.com The Collectors Fund, run from Kansas City, has 120 works and a target ten-year holding period, acquiring works priced at $50,000 to $500,000.
thefineartfund.com Philip Hoffman's Fine Art Management Services has four funds; the most recent, a partnership with Emirates NBD private bank to acquire Middle Eastern and Western art.

REFERENCES FOR CHAPTERS

Suggested reading related to individual chapters of the book.

Many of the quotes I have included from art market participants originated with interviews conducted by others. I have relied heavily on the writings of Sarah Thornton or Fiammetta Rocco for *The Economist,* including many quotes that first appeared in Dr. Thornton's art market articles for the magazine. These are listed separately in chapter credits.

Stephanie

2 **A few were owned by his private clients:** Thornton, Sarah. "A Passion that Knows No Bounds: Philippe Ségalot's 'Carte Blanche,' the Auction as Self-Portrait." *The Economist,* November 19, 2010. http://www.economist.com/node/17551930.

5 **Amy Cappellazzo of Christie's says:** Thornton, Sarah. "Against the Odds: The Strange Case of Maurizio Cattelan." *The Economist,* October 2, 2009. http://www.economist.com/node/14576280.

The World of Contemporary Art

Findlay, Michael. *The Value of Art: Money, Power, Beauty.* New York, London: Prestel, 2012.

Gompertz, Will. *What Are You Looking At? The Surprising, Shocking and Sometimes Strange Story of 150 Years of Modern Art.* New York: Viking, 2012. Gompertz is a

BBC art editor and former director of the Tate Gallery. The book tracks art's evolution from impressionism to 2012.

Martin, Steve. *An Object of Beauty*. New York: Grand Central Publishing, 2010. This is a work of fiction, but the settings are authentic. Martin is an important collector of American art as well as a comic genius, and a former trustee of the Los Angeles County Museum of Art.

McAndrew, Claire, and Arts Economics. *The CINOA Study 2011,* commissioned by the Confederation Internationale des Negociants en Oeuvres d'Art. This is the source of the McAndrew figure for annual art plus antiques sales.

Saltz, Jerry. *Seeing Out Louder: Art Criticism 2003-2009.* New York: Hudson Hills Press, 2009. Saltz is one of the most insightful and funniest of art critics.

Taylor, Brandon. *Contemporary Art: Art Since 1970.* Upper Saddle River, NJ: Pearson/Prentice Hall, 2005.

Thornton, Sarah. *Seven Days in the Art World*. New York: W. W. Norton, 2008. Thornton reports on seven days over a five-year period as she attended evening auctions, art fairs, and artists' studios, gaining extraordinary access to observe the manners and mores of this parallel universe.

Velthuis, Otto. *Talking Prices: Symbolic Meanings of Prices on the Market for Contemporary Art*. Princeton, NJ: Princeton University Press, 2005.

What Jobs Do We Hire Art For?

Christensen, Clayton M., Scott Cook, and Taddy Hall. "What Customers Want from Your Products." *Harvard Business Review,* January 2006. Christensen is a professor at the Harvard Business School; Cook is cofounder and chairman of Intuit; Hall is chief strategy officer of the Advertising Research Foundation in New York City.

Christensen, Clayton M., S. Anthony, G. Berstell, D. Nitterhouse. "Finding the Right Job for Your Product." *MIT Sloan Management Review* 48, no. 3 (2007). How situational needs for which customers hire products go unnoticed during typical market research studies.

Back Story

Bloom, Paul. *How Pleasure Works: The New Science of Why We Like What We Like*. New York: W. W. Norton, 2010.

Dolnick, Edward. *The Forger's Spell*. New York: Harper Perennial, 2008.

Kandel, Eric. *The Age of Insight: The Quest to Understand the Unconscious in Art, Mind and Brain from Vienna 1900 to the Present*. New York: Random House, 2012. Kandel discusses perception of art in terms of the functions carried out by the brain.

Authenticating Warhol

54 **The most expensive known Warhol:** Thornton, Sarah, and Fiammetta Rocco. "The Pop Master's Highs and Lows: Andy Warhol Is the Bellwether." *The Economist,* November 26, 2009. http://www.economist.com/node/14941229.

64 **a bellwether for the art market:** Thornton, Sarah, and Fiammetta Rocco. "The Pop Master's Highs and Lows: Andy Warhol Is the Bellwether." *The Economist,* November 26, 2009. http://www.economist.com/node/14941229.

Aldrich, Megan, and Jos Backforth-Jones, eds. *Art and Authenticity*. London: Lund Humphries/Sotheby's Institute of Art, 2012.

Dorment, Richard. "What Is an Andy Warhol?" and a response: Ekstract, Richard, David Mearns, and Richard Polsky. "An Exchange in Response to 'What Is an Andy Warhol?" *New York Review of Books,* October 22, 2009.

Dorment, Richard. "What Andy Warhol Did." *New York Review of Books,* April 7, 2011. Summarizes the background to the Simon-Whelan law suit with the Warhol Authentication Board.

Dorment, Richard. "Andy Warhol and His Foundation: The Questions," *New York Review of Books,* June 13, 2013. Goes beyond the material on authenticity included in this book; discusses materials from a subsequent legal case between the Andy Warhol Foundation and Philadelphia Indemnity, the company the foundation had contracted to provide liability insurance. For a number of reasons, they refused to indemnify the foundation for its costs in defending the Simon-Whelan law suit.

Mugrabi, Saatchi, Sandretto, and the Vogels

Konigsberg, Eric. "Is Anybody Buying Art These Days?" *New York Times,* March 1, 2009. This article is the source for some of the Mugrabi anecdotes.

Saatchi, Charles. *My Name is Charles Saatchi and I am an Artoholic: Everything You Need to Know about Art, Ads, Life, God and Other Mysteries.* London, New York: Phaidon Press, 2009. Saatchi in a question-and-answer format with inquiries that have come from "leading journalists." It is frank and funny, even for nonfollowers of the art world.

Stouraton, James. *Great Collectors of Our Times: Art Collecting Since 1945.* London: Scala Publishers, 2007.

Contemporary Art as an Asset Class

Galenson, David. *Old Masters and Young Geniuses: The Two Life Cycles of Artistic Creativity.* Princeton, NJ: Princeton University Press, 2006.

Horowitz, Noah. *Art of the Deal: Contemporary Art in a Global Financial Market.* Princeton, NJ: Princeton University Press, 2011. The title is a bit misleading; it is not about art deals as much as about video art, experiential art, and art investment funds. Horowitz studied at the Courtauld Institute of Art in London. Sometimes dense reading, but worth the effort.

Moses, Michael, and Jianping Mei. "Art as an Investment and the Underperformance of Masterpieces." *American Economic Review* 92, no. 5 (1992).

Rand Corporation. *Gifts of the Muse: Reframing the Debate about the Benefits of the Arts.* New York: Wallace Foundation, 2005.

Cattelan, Murakami, and Ai

85 **representing the question, "If the Fuhrer asked for absolution":** Thornton, Sarah. "Against the Odds: The Strange Case of Maurizio Cattelan." *The Economist,* October 2, 2009. http://www.economist.com/node/14576280.

85 **"When people see this, they react with gasps":** Thornton, Sarah. "Against the Odds: The Strange Case of Maurizio Cattelan." *The Economist,* October 2, 2009. http://www.economist.com/node/14576280.

Ai Weiwei. *Ai Weiwei-isms.* Princeton, NJ: Princeton University Press, 2012. A collection of the artist's thoughts on contemporary art and issues, the book mimics the format of Chairman Mao's *Little Red Book.*

Tomkins, Calvin. *Lives of the Artists.* New York: Henry Holt, 2008.

Damien Hirst, Artist and Marketer

95 **Dunphy quoted Larry Gagosian, "It sounds like bad business":** Thornton, Sarah. "Hands Up for Hirst: How the Bad Boy of Brit-Art Grew Rich at the Expense of His Investors." *The Economist* (print edition), September 9, 2010. http://www.economist.com/node/16990811.

97 **Alexander Machkevitch . . . bought three butterfly canvases:** Thornton, Sarah. "Hands Up for Hirst: How the Bad Boy of Brit-Art Grew Rich at the Expense of His Investors." *The Economist* (print edition), September 9, 2010. http://www.economist.com/node/16990811.

Hirst, Damien, and Robert Violette, ed. *I Want to Spend the Rest of My Life Everywhere, With Everyone, One to One, Always, Forever, Now.* London: Booth-Clibborn, 1997.

Petry, Michael. *The Art of Not Making.* London: Thames & Hudson, 2011. The history of artists' having technicians do much or all of their work, from Rubens to Duchamp to Warhol, Hirst, Koons, and Murakami.

Rose, Volker, and Francesca Casadio. "High-resolution fluorescence mapping of impurities in historical zinc oxide pigments: Hard X-ray nanoprobe applications to the paints of Pablo Picasso." *Applied Physics A* (January 2013). This is the source of the reference to Picasso using house paint. Rose, a physicist at the Argonne National Laboratory, pioneered the use of high-resolution nanoprobe X-ray fluorescence mapping for the analysis of the artist's paints.

Artists Lauded, Artists Disdained

Ellsworth-Jones, Will. *Banksy: The Man Behind the Wall.* New York: St. Martin's Press, 2013.

Jacob Kassay's Wild Price Ride

Haberman, Anthony. "Fields of Light." *Mousse Magazine* (2010). www.collezionemara motti.org/documenti/articoli/mousse-summer_pe10_cont.pdf.

Christie's, Sotheby's, and Their Competitors

Mason, Christopher. *The Art of the Steal: Inside the Sotheby's-Christie's Auction House Scandal.* New York: G. P. Putnam's Sons, 2004.

Strauss, Michel. *Pictures, Passions and Eye.* London: Halban, 2012. Strauss was head of Impressionist and Modern art at Sotheby's London.

The Opaque Side of Auctions

161 **In November 2011 dealer Guy Bennett:** Thornton, Sarah. "Financial Machinations at Auctions." Prospero blog, *The Economist,* November 18, 2011. http://www.economist.com/blogs/prospero/2011/11/art-market.

The decision on the Shafrazi-Orsi case and a longer description of the facts of the case can be found at www.nycourts.gov/courts/comdiv/lawreport/Vol14-No4/Korn reich-Basquiat.pdf.

Gagosian and the Evolution of the Über Dealer

183 "an honest game" "a necessary evil": Thornton, Sarah. "The Bold Standard: A Successful Painterly Life." *The Economist* (print edition), October 8, 2011. http://www.economist.com/node/21531408.

Crow, Kelly. "The Gagosian Effect." *Wall Street Journal,* April 1, 2011.
Konigsberg, Eric. "The Trials of Art Dealer Larry Gagosian." *New York Magazine,* January 28, 2013.

The Artful Dealer

de Coppet, Laura, and Alan Jones. *The Art Dealers.* New York: Cooper Square Press, 2002.
Lindemann, Adam. *Collecting Contemporary.* Cologne, Los Angeles: Taschen, 2006. This has 40 representative interviews with art dealers, auction house experts, museum professionals, art critics, and others.
Polsky, Richard. *The Art Prophets: The Artists, Dealers, and Tastemakers Who Shook the Art World.* New York: Other Press, 2011.

Abu Dhabi and Qatar

Sheikha al-Mayassa al-Thani discusses some of her cultural activities on TED talks at ted.com/talks/sheikha_al_mayassa_globalizing_the_local_localizing_the_global.html.

Art Fairs

236 Jay Smith says "Buying makes you feel connected": S.T. "Why Buy Art?" Prospero blog, *The Economist,* July 22, 2012. http://www.economist.com/blogs/prospero/2012/06/art-market.
237 Andrew Kreps . . . offers this great line: "Thou shalt not covet": S.T. "Why Buy Art?" Prospero blog, *The Economist,* July 22, 2012. http://www.economist.com/blogs/prospero/2012/06/art-market.

Barragan, Paco. *The Art Fair Age.* Milan, New York: Charta, 2008.
Editors of Wallpaper Magazine. *Wallpaper City Guide to Art Fairs.* London: Phaidon Press, 2008.
McIntyre, Morris Hargreaves. *Taste Buds: How to Cultivate the Art Market.* London: Arts Council UK, 2004.

INDEX